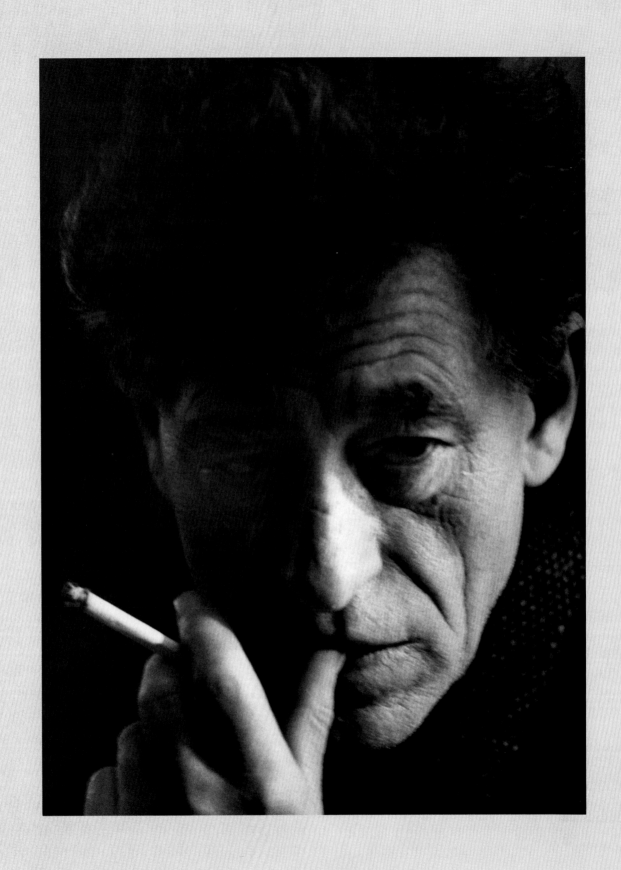

Alberto Giacometti

Christian Klemm

in collaboration with

Carolyn Lanchner

Tobia Bezzola

Anne Umland

The Museum of Modern Art, New York / Kunsthaus Zürich

This volume is published on the occasion of the exhibition *Alberto Giacometti*, organized by Christian Klemm, Deputy Director, Kunsthaus Zürich, and Curator, Alberto Giacometti Foundation, Zürich; Carolyn Lanchner, former Curator, Department of Painting and Sculpture, The Museum of Modern Art; Tobia Bezzola, Curator, Kunsthaus Zürich; and Anne Umland, Associate Curator, Department of Painting and Sculpture, The Museum of Modern Art. Exhibition Itinerary: Kunsthaus Zürich, May 18 to September 2, 2001; The Museum of Modern Art, New York, October 11, 2001, to January 8, 2002

This exhibition is made possible by Joan Tisch.
Major corporate sponsorship is provided by Banana Republic.
An indemnity has been granted by the Federal Council on the Arts and the Humanities.
Additional funding is provided by Presence Switzerland, Margaret and Herman Sockol, and Pro Helvetia.
This publication is made possible by the Blanchette Hooker Rockefeller Fund.

Produced by the Department of Publications, The Museum of Modern Art, New York. Edited by Harriet Schoenholz Bee. Designed by Steven Schoenfelder, New York. Production by Christopher Zichello. Color separations by Barry Siddall, MR Reproduktionen, Munich. Printed and bound by Dr. Cantz'sche Druckerei, Ostfildern, Germany. This book is typeset in Bernhard Gothic, and printed on 150 gsm Luxo Art Silk.

Library of Congress Control Number: 2001089172. ISBN: 0-87070-339-0 (clothbound, MoMA, Thames & Hudson). ISBN: 0-8109-6220-9 (clothbound, Abrams). ISBN: 0-87070-340-4 (paperbound, MoMA). Published by The Museum of Modern Art, 11 West 53 Street, New York, New York 10019, in collaboration with the Kunsthaus Zürich, Heimplatz 1, CH-8024 Zürich. Clothbound edition distributed in the United States and Canada by Harry N. Abrams, Inc., New York. Clothbound edition distributed outside the United States and Canada by Thames & Hudson, Ltd., London.

Cover: Alberto Giacometti. *City Square*. 1948. Detail; see plate 102. Page 1: Alberto Giacometti, c. 1931. Frontispiece: Alberto Giacometti, 1961. Endpapers, clothbound edition: Alberto Giacometti, Stampa, 1960; Giacometti's Funeral, Borgonovo-Stampa, January 15, 1966. Printed in Germany

Contents

Foreword

This book is published on the occasion of the exhibition *Alberto Giacometti*, organized by the Kunsthaus Zürich and The Museum of Modern Art, New York, in close collaboration with the Alberto Giacometti Foundation (Alberto Giacometti-Stiftung, Zürich). Plans for this retrospective go back to the mid-1990s, when the Kunsthaus Zürich and the Alberto Giacometti Foundation approached The Museum of Modern Art regarding the possibility of collaborating on the organization of a centennial tribute to Giacometti. The present exhibition was born out of these discussions, and is held to honor one of the twentieth century's greatest artists. In New York, it is the first full-scale museum retrospective of the artist's work in almost three decades, providing the opportunity for a new generation to experience and evaluate the impact and significance of Giacometti's achievement.

Both the Kunsthaus Zürich and The Museum of Modern Art are institutions with long-standing commitments to the art of Alberto Giacometti. In 1936, Alfred H. Barr, Jr., purchased Giacometti's Surrealist masterpiece, *The Palace at 4 A.M.*, for The Museum of Modern Art, making it the first museum to acquire a work by the artist. Barr himself, along with later generations of curators at the Museum, continued to seek out exemplary works by Giacometti for the collection and to support his work through exhibitions, most notably with a major retrospective organized in 1965. The Kunsthaus Zürich has also long supported Giacometti's work through its exhibitions program; it organized an important retrospective in 1962–63, and has a number of key works by the artist in its collection. Most significantly, it is the home of the incomparable collection of works owned by the Alberto Giacometti Foundation. Established in the mid-1960s through the efforts of a group of Swiss citizens, the Foundation's holdings—including well over a hundred works, among them many fragile, uniquely rare plasters from the artist's avant-garde and post-World War II periods—constitute the most important collection of Alberto Giacometti's art in the world.

Christian Klemm, a scholar with a profound knowledge of Giacometti's work, Curator of the Alberto Giacometti Foundation, and Deputy Director of the Kunsthaus Zürich, has published widely on the artist, including the essential 1990 catalogue of the Foundation's holdings. Christian Klemm developed the concept of the present exhibition and catalogue, in collaboration with Tobia Bezzola, Curator, Kunsthaus Zürich, Carolyn Lanchner, former Curator, and Anne Umland, Associate Curator, Department of Painting and Sculpture, The Museum of Modern Art. Franziska Lentzsch, Curatorial Assistant, Kunsthaus Zürich, in collaboration with Roxana Marcoci, Janice H. Levin Fellow/Curatorial Assistant, Delphine Dannaud, Research Assistant, and Michelle Yun, Administrative Assistant, Department of Painting and Sculpture, The Museum of Modern Art, have helped to put together the complex catalogue under the editorial direction of Harriet Schoenholz Bee, Managing Editor, Department of Publications, and Nicola von Velsen, of Gimlet, Cologne.

The scope and complexity of this retrospective and publication necessarily entail high costs. The Kunsthaus Zürich is deeply grateful to Credit Suisse Private Banking, whose generous engagement contributed most importantly to the realization of Zürich's exhibition and catalogue. The Museum of Modern Art is grateful to Joan Tisch for making the New York showing possible. The Museum thanks Banana Republic for providing major corporate sponsorship of the exhibition. Additional support is provided by Presence Switzerland, Margaret and Herman Sockol, and Pro Helvetia. This publication is made possible by the Blanchette Hooker Rockefeller Fund. The exhibition would not have been possible without the indemnity received from the Federal Council on the Arts and the Humanities.

We owe a debt of gratitude to the many lenders to the exhibition, and to others who have contributed to its realization; these institutions and individuals are listed elsewhere in this volume. We must, however, acknowledge here a special debt, to our colleagues at the Musée national d'art moderne, Centre Georges Pompidou, Paris, in particular to Director Alfred Pacquement, as well as to Curator Agnès de la Beaumelle. Finally, we offer our profound and sincere thanks to Bruno and Odette Giacometti, who have followed closely and generously supported this project from the beginning with expert advice and genuine approval. Together with them, we trust that this centennial homage to Alberto Giacometti demonstrates the power of his art and its enduring relevance to successive generations of viewers.

FELIX BAUMANN, PRESIDENT,
ALBERTO GIACOMETTI FOUNDATION, ZÜRICH

CHRISTOPH BECKER, DIRECTOR, KUNSTHAUS ZÜRICH

GLENN D. LOWRY, DIRECTOR,
THE MUSEUM OF MODERN ART, NEW YORK

Preface

Today, one hundred years after his birth and a generation after his death, Alberto Giacometti is recognized as one of the small group of modern masters who dominated the making of art history during much of the twentieth century. This exhibition and accompanying publication take the occasion of Giacometti's centennial to celebrate his achievement and to reexamine his work.

Over the years, Giacometti's art has engendered much critical and popular commentary. Beginning with the first appreciation of his work by Michel Leiris in 1929 through the present, observers have seen his art in various ways. The predominate interpretations, however, tend to be those fostered by his early association with Surrealism and his postwar involvement with Existentialism. While these movements strongly affected Giacometti's work, their influence has sometimes been seen as more pervasive than was actually the case. The effect of this has been twofold: on the one hand to diminish the expressive scope of the work, and, on the other, to lead commentators to excessive considerations of the artist's psychological makeup. It is our hope that this exhibition and catalogue will contribute to a more focused concentration on the art itself.

We are fortunate in being able to bring together a representative selection of work from the two most intense phases of Giacometti's career—the Surrealist period from 1929 to 1934 and the unfolding of his mature style between 1947 and 1951. Owing to the extreme fragility of the Surrealist sculptures, it has seldom, if ever before, been possible to show them in commensurate weight with those of the postwar years. The unprecedented agreement of the Kunsthaus Zürich, the Alberto Giacometti Foundation, and The Museum of Modern Art that certain objects would be allowed to travel for this centennial event, now affords us an opportunity to see Giacometti's sculpture in its full developmental range, from 1919 through 1965. Giacometti did not, of course, limit his artistic production to the making of sculpture. The some sixty drawings and forty paintings in this exhibition are testimony to his great gifts as a draftsman and painter. The artist himself considered drawing to be at the heart of all his activities, and during the later years of his career he was often consumed by his efforts to commit his "vision" to canvas.

As we wish the exhibition to clarify the fullness of Giacometti's oeuvre, we intend this publication to extend popular and critical understanding of his achievement. The plates are arranged in groups of closely interrelated works and in approximate chronological order. We have attempted through the placement and selection of plates to reveal important formal and iconographic relationships and to communicate ideas about Giacometti's development by the grouping and juxtaposition of particular works. With this in mind, we have sometimes chosen "historical" photographs taken in Giacometti's studio and elsewhere, which seem to us to convey most vividly the conditions of the artist's creativity.

The three essays in this volume were conceived to give a closer comprehension of Giacometti's work and to its multiple levels of meaning. Using Giacometti's great Surrealist work of 1932, *The Palace at 4 A.M.,* as a fulcrum, "Giacometti and Surrealism" examines the Surrealist years through the objects Giacometti produced at the time and through contemporary testimony. The second essay, "Phenomenon and Imagination," locates Giacometti's thought at a discrete distance from the various philosophies that have sometimes claimed him and demonstrates how Giacometti's unique concept of inner and outer vision unites radically different manifestations of his art. The principal essay, in the form of commentaries preceding each group of plates, examines successive stages in the unfolding of Giacometti's career both in formal terms and through the artist's attempts to grapple with the fundamental paradoxes of his lifelong endeavor.

These essays are starting points for a reexamination of Giacometti's identity as a modern artist. The importance of reassessing the work resides not only in each new generation finding a somewhat different artist than its forebears, but also in the fact that each fresh look tends to check the spread of myths and generalizations that shield us from the complexities of a great artist's work. In Giacometti's case, this is especially required because his work has been subject to an aggravated degree of generalization and literary interpretation. We hope that these essays complement the experience of seeing the exhibition, and that its rich display returns the reader to the center of Giacometti's work, where new possibilities can only be revealed by the objects themselves.

CHRISTIAN KLEMM, DEPUTY DIRECTOR, KUNSTHAUS ZÜRICH, AND CURATOR, ALBERTO GIACOMETTI FOUNDATION

CAROLYN LANCHNER, FORMER CURATOR, DEPARTMENT OF PAINTING AND SCULPTURE, THE MUSEUM OF MODERN ART

TOBIA BEZZOLA, CURATOR, KUNSTHAUS ZÜRICH

ANNE UMLAND, ASSOCIATE CURATOR, DEPARTMENT OF PAINTING AND SCULPTURE, THE MUSEUM OF MODERN ART

Lenders to the Exhibition

High Museum of Art, Atlanta

Öffentliche Kunstsammlung Basel, Kunstmuseum and Kupferstichkabinett

Kunstmuseum Bern

Museum of Fine Arts, Boston

Kunsthalle Bremen, Kupferstichkabinett

The Art Institute of Chicago

Bündner Kunstmuseum, Chur

Ny Carlsberg Glyptotek, Copenhagen

Städtische Galerie im Städelsches Kunstinstitut, Frankfurt

Hamburger Kunsthalle

Sprengel Museum Hannover

Tate Modern, London

Städtische Kunsthalle Mannheim

The Museum of Modern Art, New York

Solomon R. Guggenheim Museum, New York

Robert and Lisa Sainsbury Collection, University of East Anglia, Norwich

Musée national d'art moderne, Centre Georges Pompidou, Paris

Musée Picasso, Paris

Fondation Beyeler, Riehen/Basel

Fondation Marguerite et Aimé Maeght, Saint-Paul-de-Vence

Moderna Museet, Stockholm

Staatsgalerie Stuttgart

Art Gallery of Ontario, Toronto

Peggy Guggenheim Collection, Venice

National Gallery of Art, Washington, D.C.

Hirshhorn Museum and Sculpture Garden, Smithsonian Institution, Washington, D.C.

Kunsthaus Zürich

Alberto Giacometti-Stiftung, Zürich

Graphische Sammlung der Eidgenössischen Technischen Hochschule, Zürich

Donald L. Bryant, Jr. Family Trust

Flick Collection

Estate of Annette Giacometti

Collection Thomas H. Gibson

Collection Klewan

Collection Eberhard W. Kornfeld, Bern

Collection Jan and Marie-Anne Krugier-Poniatowski

Collection William Louis-Dreyfus

Collection Charlotte and Duncan MacGuigan

The Patsy R. and Raymond D. Nasher Collection, Dallas

Morton G. Neumann Family Collection

Collection David M. and Betty Ann Besch Solinger

Collection Monica Steegmann

Collection Marianne Steegmann

Judy and Michael Steinhardt Collection, New York

Collection Kazuhito Yoshii

Collection Gustav Zumsteg, Zürich

Anonymous private lenders

Acknowledgments

The exhibition *Alberto Giacometti* was organized by The Museum of Modern Art, New York, and the Kunsthaus Zürich to celebrate the artist's centennial year. The preparation of the exhibition and publication have drawn upon the resources of the many individuals and organizations listed below, whose dedication and assistance are gratefully acknowledged.

The Museum of Modern Art, New York
Ronald S. Lauder, Chairman; Agnes Gund, President; Glenn D. Lowry, Director; James Gara, Chief Operating Officer; Stephen Clark, Associate General Counsel; Nancy Adelson, Assistant General Counsel; Michael Margitich, Deputy Director for Development; Mary Lea Bandy, Deputy Director for Curatorial Affairs; Monika Dillon, Director, Major Gifts; Diana Pulling, Executive Assistant, Director's Office; Deanna Caceres, former Executive Assistant; Katie Waltz, Executive Secretary; John Elderfield, Chief Curator at Large; Kirk Varnedoe, Chief Curator, Painting and Sculpture; Kynaston McShine, Senior Curator, Painting and Sculpture; Robert Storr, Senior Curator, Painting and Sculpture; Cora Rosevear, Associate Curator, Painting and Sculpture; Laura Rosenstock, Assistant Curator, Painting and Sculpture; Ramona Bannayan, Manager, Painting and Sculpture; Esperanza Altamar, Assistant to Chief Curator, Painting and Sculpture; Madeleine Hensler, former Assistant to Chief Curator, Painting and Sculpture; Kristen Erickson, former Curatorial Assistant, Painting and Sculpture; Wendell Hafner, former Administrative Assistant, Painting and Sculpture; Peter Galassi, Chief Curator, Photography; Deborah Wye, Chief Curator, Prints and Illustrated Books; Jennifer Roberts, Study Center Supervisor, Prints and Illustrated Books; Gary Garrels, Chief Curator, Drawings; Margit Rowell, former Chief Curator, Drawings; Kathleen Curry, Assistant Curator, Drawings; Laurence Kardish, Senior Curator, Film and Video; James Coddington, Chief Conservator; Patricia Houlihan, Associate Conservator; Milan Hughston, Chief of Library and Museum Archives; Janis Ekdahl, Chief Librarian; Jennifer Tobias, Associate Librarian; Michelle Elligott, Archivist; Patterson Sims, Deputy Director, Education; Josiana Bianchi, Associate Educator; Francesca Rosenberg, Assistant Director; Amy Horschak, Museum Educator; Elizabeth Addison, former Deputy Director of Marketing and Communications; Mary Lou Strahlendorff, Director, Communications; Kim Mitchell, Press Representative; Anna Hammond, Director, Writing Services; Peter Foley, Director, Marketing; Keisuke Mita, Manager, Information Systems; Astrida Valigorsky, Manager, New Media; Ethel Shein, Director Special Programming and Events; Anne Davy, Manager, Special Programming and Events; Ronald Simoncini, Director, Security; Diana Simpson, Director, Visitor Services; Melanie Monios, Assistant Director, Visitor Services; Vincent Magorrian, Director, Operations; Afrim Dzemaili, Electrician.

Kunsthaus Zürich
Thomas Bechtler, President, Zürcher Kunstgesellschaft; Christoph Becker, Director, Kunsthaus; Felix Baumann, President, Alberto Giacometti-Stiftung; Christian Klemm, Deputy Director, Kunsthaus, and Curator, Alberto Giacometti-Stiftung; Tobia Bezzola, Curator, Kunsthaus; Franziska Lentzsch, Curatorial Assistant, Kunsthaus; Gerda Kram, Laurentia Leon, Judith Schöpf, Exhibitions Office; Hanspeter Marty, Conservator.

Exhibition in New York
Carolyn Lanchner, former Curator, Painting and Sculpture; Anne Umland, Associate Curator, Painting and Sculpture; Roxana Marcoci, Janice H. Levin Fellow/Curatorial Assistant, Painting and Sculpture; Delphine Dannaud, Research Assistant, Painting and Sculpture; Michelle Yun, Administrative Assistant, Painting and Sculpture; Jennifer Russell, Deputy Director, Exhibitions; Elizabeth Peterson, Assistant to the Deputy Director, Exhibitions; Jerome Neuner, Director, Exhibition Design and Production; Maria DeMarco, Coordinator, Exhibitions; Alison Gass, Assistant to Coordinator, Exhibitions; Peter Perez, Foreman, Frameshop; Attilio Perrino, Foreman, Carpenter; Santos Garcia, Painter; Edward Pusz III, Director, Graphics; Claire Corey, Production Manager, Graphics; Diane Farynyk, Registrar; Terry Tegarden, Associate Registrar; Philip Omlor, Manager, Art Handling and Preparation; Robert Jung, Assistant Manager, Art Handling and Preparation; Harvey Tulcensky, Preparator; Stan Gregory, Preparator; Mark Williams, Preparator; Elizabeth Riggle, Preparator; Interns: Deniz Artun, Anonda Bell, Daniela Deul, Martina Ivanus, Katja Canini, Nadia Chalbi, Clara Cot, Heather Cotter, Michele F. Felicetta, Roos M. Gortzak, Bibiana Obler, Susan Ross, Julia Trotta.

Special thanks to all who contributed to the organization of the exhibition: William Acquavella, Acquavella Gallery, New York; Tracey Albainy, Museum of Fine Arts, Boston; Bridget Alsdorf, Solomon R. Guggenheim Museum, New York; Art Focus Gallery, Zürich; Linda Ashton, Harry Ransom Humanities Research Center, The University of Texas at Austin; Anne Barz, Hamburger Kunsthalle; Herbert Beck, Städtische Galerie im Städelsches Kunstinstitut, Frankfurt; Thérèse Berthoud-Tigretti, Geneva; Ernst Beyeler, Fondation Beyeler, Riehen/Basel; Ambassador Donald M. Blinken, New York; Doreen Bolger, The Baltimore Museum of Art; Ivor Braka Limited, London; Laurent Bruel, Paris; Laure de Buzon-Vallet, Musée national d'art moderne, Centre Georges Pompidou, Paris; Hélène da Camara, Estate of Annette Giacometti, Paris; Alessandra Carnielli, Pierre and Maria Gaetana Matisse Foundation, New York; Richard Calvocoressi, Scottish National Gallery of Modern Art, Edinburgh; Pietro Cicognani, New York; Paul Cougnard, Bibliothèque littéraire Jacques Doucet, Paris; Pieter Coray, Galleria Pieter Coray, Montagnola; Ann M. De Simone, William Louis-Dreyfus Collection, New York; Amanda Daly, Sainsbury Center for Visual Arts, University of East Anglia, Norwich; James T. Demetrion, Hirshhorn Museum and Sculpture Garden, Smithsonian Institution, Washington, D.C.; Lisa Dennison, Solomon R. Guggenheim Museum, New York; Søren Dietz, Ny Carlsberg Glyptotek, Copenhagen; Jean Edmonson, Acquavella Gallery, New York; David Elliott, Moderna Museet, Stockholm; Manfred Fath, Städtische Kunsthalle, Mannheim; Marcel Fleiss, Galerie 1900–2000, Paris; Michael Findlay, Acquavella Gallery, New York; Jay McKean Fisher, The Baltimore Museum of Art; Flemming Friborg, Ny Carlsberg Glyptotek, Copenhagen; Kate Garmeson, Sotheby's, London; Ulrike Gauss, Staatsgalerie Stuttgart; Véronique Gautherin, Musée Bourdelle, Paris; Paul Gray, Richard Gray Gallery, Chicago; Phyllis Hattis, Phyllis Hattis Fine Arts, New York; Dot Hendler, Christie's, New York; Wulf Herzogenrath, Kunsthalle Bremen; Lisa Hodermarsky, Yale University Art Gallery, New Haven; Christian von Holst, Staatsgalerie Stuttgart; Nichola Johnson, Sainsbury Center for Visual Arts, University of East Anglia, Norwich; Max Kohler, Galerie Art Focus, Zürich; Ulrich Krempel, Sprengel Museum Hannover; Thomas Krens, Solomon R. Guggenheim Museum, New York; Elizabeth Kujawski, Jo Carole and Ronald S. Lauder Collection, New York; Diana Kunkel, Leon Black Collection, New York; Ulrich Luckhardt, Hamburger Kunsthalle, Hamburg; Herbert Lust II, Greenwich; Dorothea McKenna Elkon, The Elkon Gallery, Inc., New York; Adrien Maeght, Isabelle Maeght, and Yoyo Maeght, Galerie Maeght, Paris; Anne-Louise Marquis, Hirshhorn Museum and Sculpture Garden, Smithsonian Institution, Washington, D.C.; Karin Frank von Maur, Staatsgalerie Stuttgart; Remo Maurizio, Vicosoprano/Stampa; Francesca Visconti di Modrone, New York; Isabelle Monod-Fontaine, Musée national d'art moderne, Centre Georges Pompidou, Paris; Hitoshi Morita, Ohara Museum of Art, Kurashiki, Okayama-ken; Christian Müller, Kupferstichkabinett, Öffentliche Kunstsammlung Basel; Steven A. Nash, Nasher Sculpture Center, Dallas; Christine Nelson, The Pierpont Morgan Library, New York; Claudia Neugebauer, Galerie Beyeler, Riehen/Basel; Hilde Østergaard, Louisiana Museum of Modern Art, Humlebaek; Alfred Pacquement, Musée national d'art moderne, Centre Georges Pompidou, Paris; Mary Lisa Palmer, Association Alberto et Annette Giacometti, Paris; Robert Parks, The Pierpont Morgan Library, New York; Mark Pascale, The Art Institute of Chicago; Alice Pauli, Galerie Alice Pauli, Lausanne; Roberto Perazzone, Paris; Carlo Perrone, Fontainebleau; Susie Peterson, Fine Arts Museum of San Francisco; Yves Peyré, Bibliothèque littéraire Jacques Doucet, Paris; Marc B. Porter, Christie's, New York; Jean-Louis Prat, Fondation Marguerite et Aimé Maeght, Saint-Paul-de-Vence; Carrie Przybilla, High Museum of Art, Atlanta; Simon de Pury, de Pury & Luxembourg Art, Geneva; Gérard Regnier, Musée Picasso, Paris; Maria Reinshagen, Christie's, Zürich; Jennifer A. Ritchie, The Patsy R. and Raymond D. Nasher Collection, Dallas; Alex Ritter, Flick Collection, Zürich; Malcolm Rogers, Museum of Fine Arts, Boston; Nan Rosenthal, The Metropolitan Museum of Art, New York; Phyllis Rosenzweig, Hirshhorn Museum and Sculpture Garden, Smithsonian Institution, Washington, D.C.; Holton Rower, New York; Loren Rubin, Christie's, New York; William Rubin, New York; Raphael Rubinstein, New York; Helene A. Rundell, St. Louis; Phillip Rylands, Peggy Guggenheim Collection, Venice; Helen Sainsbury, Tate Modern, London; Ernst Scheidegger, Zürich; Katharina Schmidt, Öffentliche Kunstsammlung Basel, Kunstmuseum; Uwe M. Schneede, Hamburger Kunsthalle; Lisa Schonemann, Judy and Michael Steinhardt Collection, New York; Patricia Schramm,

Consulate General of Switzerland, New York; Dieter Schwarz, Kunstmuseum Winterthur; Nicholas Serota, Tate Modern, London; Daniel Schulman, The Art Institute of Chicago; Sabine Schulze, Städtische Galerie im Städelsches Kunstinstitut, Frankfurt; George Shackelford, Museum of Fine Arts, Boston; Michael E. Shapiro, High Museum of Art, Atlanta; Anne Simpson, Scottish National Gallery of Modern Art, Edinburgh; Werner Spies, formerly Musée national d'art moderne, Centre Georges Pompidou, Paris; Toni Stooss, Kunstmuseum Bern; Beat Stutzer, Bündner Kunstmuseum, Chur; Paul Tanner, Graphische Sammlung der ETH, Zürich; Matthew Teitelbaum, Art Gallery of Ontario, Toronto; Said Toub, Cosmopolitan Holding Limited, Lausanne; Lucien Treillard, Paris; Joanna Weber, Yale University Art Gallery, New Haven; Jeffrey Weiss, National Gallery of Art, Washington, D.C.; Tara Wenger, Harry Ransom Humanities Research Center, The University of Texas at Austin; Véronique Wiesinger, Paris; Ute Wenzel-Förster, Städtische Galerie im Städelsches Kunstinstitut, Frankfurt; Robyn Wiley, The Schwab Collection, San Rafael; James N. Wood, The Art Institute of Chicago.

Special thanks to those whose knowledge of Giacometti was crucial to this project: Agnès de la Beaumelle, Musée national d'art moderne, Centre Georges Pompidou, Paris; Yves Bonnefoy, Paris; Michael Brenson, New York; Casimiro Di Crescenzo, Paris; Jacques Dupin, Paris; Valerie J. Fletcher, Hirshhorn Museum and Sculpture Garden, Smithsonian Institution, Washington, D.C.; Reinhold Hohl, Magden; Dieter Koepplin, Basel; James Lord, Paris; Maria Gaetana Matisse, New York; Michel Soskine, New York; David Sylvester, London.

Publication

Michael Maegraith, Publisher; Harriet Schoenholz Bee, Managing Editor; Joanne Greenspun, Editor; Christopher Zichello, Associate Production Manager; Steven Schoenfelder, Designer; Nancy Kranz, Promotions Manager; Mikki Carpenter, Director, Imaging Services; Kathleen Keller, Head of Fine Art Photography; Thomas Griesel, Fine Arts Photographer; Interns: Inés Katzenstein, Lianor da Cunha; Translators: David Britt, Fiona Elliott, Russell Stockman.

A debt of gratitude is owed all who helped with photographic research: Teresa Araya, Documentation du Musée national d'art moderne, Centre Georges Pompidou, Paris; Association Alberto et Annette Giacometti, Paris; Valentina Balzarotti Barbieri, Agenzia Letteraria Internazionale, Milan; Timothy Baum, New York; Barbara Bernard, National Gallery of Art, Washington, D.C.; Walter Binder, Zürich; Gilberte Brassaï, Paris; Cécile Brunner, Kunsthaus Zürich; Janet Brooke, Montreal; Kim Bush, Solomon R. Guggenheim Museum, New York; Micheline Charton, Documentation du Musée national d'art moderne, Centre Georges Pompidou, Paris; Victoria Combalia Dexeus, Barcelona and Paris; Crosby Coughlin, Estate of Alexander Liberman, Purdys; Felicia Cukier, Art Gallery of Ontario, Toronto; Hans Danuser, Fondazione Garbald, Zürich; Amy Densford, Hirshhorn Museum and Sculpture Garden, Smithsonian Institution, Washington, D.C.; Sandra Divari, Peggy Guggenheim Collection, Venice; Letizia Enderli, Schweizerische Stiftung für die Photographie, Zürich; Nicole Finzer, The Art Institute of Chicago; Elizabeth Gorayeb, Sotheby's, New York; Elisabeth Heinemann, Städelsches Institut und Städtische Galerie, Frankfurt; Franziska Heuss, Öffentliche Kunstsammlung Basel; Isabelle L'Hoir, Réunion des Musées Nationaux, Paris; Caroline de Lambertye, Réunion des Musées Nationaux, Paris; Julie Lavin, New York; Ursula Lichtlein, Kunsthalle Bremen; Odile Michel, Musée Picasso, Paris; Natasha O'Connor, Magnum Photos, New York; Marilyn Palmeri, The Pierpont Morgan Library, New York; Kay Poludinowski, Sainsbury Center for Visual Arts, University of East Anglia, Norwich; Karen L. Roider, Bryant Group Inc., St. Louis; Leah Ross, Museum of Fine Arts, Boston; Nicole Rüegsegger, Fondation Beyeler, Riehen/Basel; Ernst Scheidegger, Zürich; Schweizerisches Institut für Kunstwissenschaft, Zürich; Stefan Stabile, Moderna Museet, Stockholm; Jennifer Stuart-Smith, Tate Gallery, London; Marc Vaux Archives, Documentation du Musée national d'art moderne, Centre Georges Pompidou, Paris; Brigitte Vincens, Documentation du Musée national d'art moderne, Centre Georges Pompidou, Paris; Cornelia Wedekind, Staatsgalerie Stuttgart; Henriette Murray Wells, Faggionato Fine Arts, London; Barbara Goldstein Wood, National Gallery of Art, Washington, D.C.

Giacometti and Surrealism

Anne Umland

There are many ways to tell a story of Alberto Giacometti and Surrealism; this one begins with a ghost. Captured in photographs that Man Ray took sometime in 1932, Giacometti's fragile plaster sculpture *The Palace at 4 A.M.* glimmers specterlike against a dark penumbral ground. "The original . . . no longer exists," Giacometti wrote a decade and a half later, "nothing remains of it, [although] it was as good" as the subsequent wood version in which the work exists today.[1] Indexically connected to this now invisible object, Man Ray's photographs register the plaster *Palace* as a ghostly image comprising luminous white traces, as ephemeral in appearance as it ultimately was in fact.

All photographs can be considered memento mori, reminders that "whatever was recorded by the camera no longer exists in the state pictured."[2] Here, though, the formal qualities of the object combined with the artist's statement concerning its loss underscore photography's capacity to project what has been described as an "anterior future of which death is the stake."[3] This, the photograph says, will have been. From the moment Man Ray snapped his camera's shutter, the image was frozen out of real time, relegated to the space of memory. Meanwhile, the physical object itself was subject to "time's relentless melt."[4]

Lost objects, memories, the effects of time's passage, the commingling of past and present; the dualism of Eros and Thanatos, life and death; the role of photography in shaping an image of Giacometti's work—these subjects are part of the history of Giacometti and Surrealism, framed literally, metaphorically, and symbolically by *The Palace at 4 A.M.*, perhaps Giacometti's most famous Surrealist work (plate 50). Or, to be more specific, these are subjects framed by Man Ray's photographs of the plaster version of the *Palace*, now destroyed. Looking over Man Ray's shoulder, peering through his camera lens, provides one of many possible points of entry into the enigmatic subject of Giacometti's Surrealist oeuvre.

In one of Man Ray's two images of the plaster *Palace* (fig. 1), most likely staged at his initiative (rather than Giacometti's), the camera's framing action is palpable. We are drawn in close to the *Palace*'s center. The view of the work is clearly partial, as evidenced by the cropping of lines and forms at the edges, signs that the structure exceeds the limits of the camera's gaze. The setting of limits and the posi-

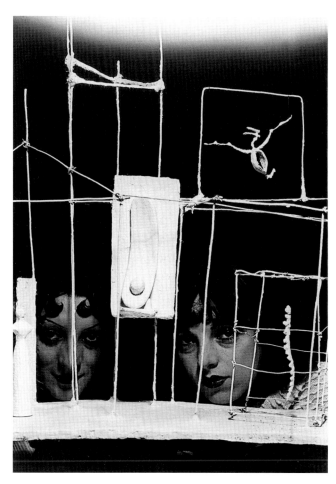

1. Alberto Giacometti. *The Palace at 4 A.M.* 1932. Plaster version. Photograph by Man Ray

tioning of figures or other elements within fixed boundaries are also key features of Giacometti's Surrealist practice, whether these limits are represented by linear scaffolding or "space frames" as seen in the *Palace*, or defined by the perimeter of a work's pedestal or base (often synonymous with the work itself during Giacometti's Surrealist years). At the same time, decisions about framing—what to include, what to leave out—affect all pictures of Giacometti *and* Surrealism, both visual and verbal ones. Man Ray's photographs, *The Palace at 4 A.M.*, and the words they provoke are all but parts of a larger history that is by definition plural, almost inconceivably extensive, and almost inconceivably dense. To begin with an object (the *Palace*) that itself frames objects and is in turn framed by Man Ray's camera lens is to intimate a series of expanding frameworks within which aspects of the subject of Giacometti and Surrealism can be

13

trapped, an approach both limited and potentially limitless (in that it is impossible to state with certainty where the frame ends).

Man Ray's other photograph of the plaster *Palace* (fig. 2), the image chosen by Giacometti in 1932 for publication in *Cahiers d'art*, represents a full view of the work seen from a distance, pictured as a world apart. Iconically isolated against a field of black, the *Palace* appears to float autonomously; all traces of its pedestal or support have been blacked out. Both this overall image and the close-up detail are precious primary documents of a work, a world, a time, and a place far removed from our own. They are also carefully staged and constructed pictures, and the differences between the two are telling, encouraging speculation concerning what sort of image Giacometti was interested in projecting in 1932. How, in other words, did he want his audience to perceive his work? Photographs of artworks are never neutral, those of three-dimensional objects especially so. While Man Ray took the photograph featured in *Cahiers d'art*, Giacometti also played a role, if not, in this case, of codirector, at least to the extent of making a choice, of saying yes or no.

Looking back and forth between the two photographs, visually moving in close and then stepping back, focuses attention on the different types of experiences and information given by each. The close-up view provides more real-world connections. It gives us a sense of the texture of the plaster objects that inhabit the *Palace*; of the tenuous nature of the work's construction, with its marvelously irregular lines of wire and bits of string knotted or cobbled together; and of the skeletal form's exquisite level of detail. It positions the *Palace* in front of two women, Man Ray's companion Kiki de Montparnasse and her friend Lili, thus figuring the work into a Surrealist milieu, a reminder that the term *surrealism* encompasses not only objects but individuals, human countenances, and associations—Giacometti's acquaintances and friends. Most obviously, it puts the *Palace* into play as a prop in what can be construed as an overdetermined Freudian mise-en-scène. In this sense the two women complicate the picture. Positioned to either side and beneath the elliptically erotic, abstract phallic form that occupies the *Palace*'s center—the object that Giacometti would later say he identified with himself—they demand a more literal level of attention for the *Palace*, pushing it away from an aesthetic discourse toward social, historical, and psychoanalytic realms.[5] Unavoidably conjured are the attitudes of the Surrealists—Giacometti among them—toward women, along with the subjects of screen memories, part objects, fetishes, and the gaze. While transparency is essential to the *Palace*'s form, this photograph demonstrates that for all the object's openness to the outside world, when put into play with real bodies its mystery is diminished. Among other things, it is miniaturized, revealed as the haunted dollhouse it is, and yet is not.

As the *Palace* is pictured in *Cahiers d'art*, no hints are given of its actual size. The camera is pulled back, the object is distanced. Severed from real-world referents, dramatically lit so that the whiteness of the plaster and the darkness of the shadows combine to provoke supernatural, disincarnate, ghostly associations, Giacometti's *Palace*, as pictured here, could be any size—from diminutive to literally palatial. In reality, many of Giacometti's Surrealist sculptures appear surprisingly small when confronted for the first time, an effect that can often be traced to the expectations raised by seeing the works in reproduction. This is due, at least in part, to the carefully calibrated relationship in Giacometti's works between figure and frame; he sets the boundaries for determining relational scale. Relative proportions are fixed internally. Each work functions as a contained universe, its actual, realized size often inversely related to its ability to provoke perceptions of monumentality. "Large sculpture is only small sculpture blown up," Giacometti would later say. "The key sculptures of any of the ancient civilizations are almost all on a small scale."[6]

Referring to the image of the *Palace* published in *Cahiers d'art*, David Sylvester, one of Giacometti's most perceptive critics, remarked, "*The Palace at 4 A.M.* . . . is, alas, perhaps never as charismatic in reality as it is in Man Ray's photograph of it."[7] Although the comparison is not strictly a fair one (since Man Ray photographed the original plaster *Palace*, while the work seen "in reality" is the second version realized in wood), the confusion testifies to the power of Man Ray's photograph to function as substitute, as preferable in some way to the original—although, of course, there is no longer an original, only its photographic trace. It also speaks, albeit indirectly, to the visual, material differences between the plaster *Palace* and its wood double, differences that make clear the impossibility of speaking of the *Palace* singularly. The

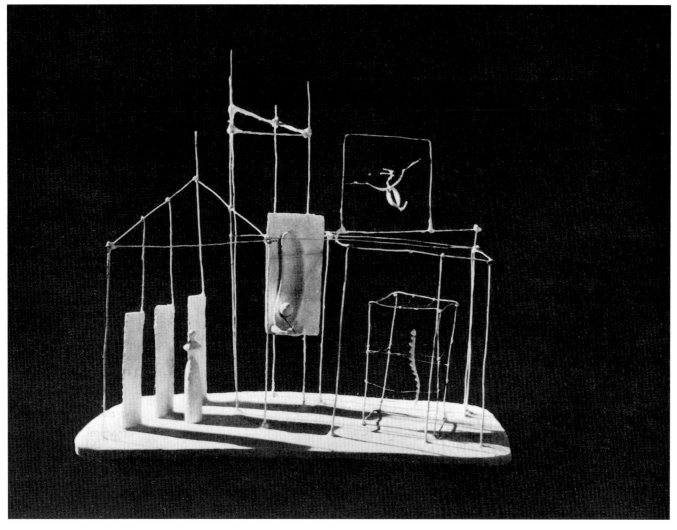

2. Alberto Giacometti. *The Palace at 4 A.M.* 1932. Plaster version. From *Cahiers d'art*, nos. 2–3, 1932. Photograph by Man Ray

wood version re-presents the plaster, and, as will be seen, has its own history and story to tell. The sheer existence of two Palaces, however—a delicate plaster preserved for us in photographic form and its wood doppelgänger, now in the collection of The Museum of Modern Art—highlights the fundamental difficulty of trying to grasp the particular objects, and the particularities of the objects, that comprise Giacometti's Surrealist oeuvre. The very body of work is, in other words, unstable, subject to slippage, to multiplication and reiteration, substitution and reworking. This instability permeates Giacometti's Surrealist period on many different levels, including those of the material fragility of plaster and wood constructions, the incorporation of movement within individual objects, and a semantic sliding that erodes stable or fixed meanings of forms.

The physical delicacy of many of Giacometti's Surrealist works has meant that, to an even greater degree than usual in our age of postmechanical reproduction, their history has become "the history of that which [has been] photographed"[8] or otherwise reproduced. Re-production, re-presentation—these subjects too comprise leitmotifs that traverse Giacometti's Surrealist oeuvre, whether they be multiples made

of objects, photographic documentation made by others, or Giacometti's own drawings and verbal descriptions of his Surrealist works. Sculpture, of course, is often an art of multiples. During Giacometti's Surrealist years, however, initial iterations and subsequent reiterations contribute to an understanding of the way meaning is constructed in and for a group of objects, most significantly by the artist, but also by others. Taken in combination, multiple images of Giacometti and Surrealism are presented here for scrutiny. They constitute an approach only, for without a fixed referent there can be no fixed view.

Giacometti and Surrealism are two separate yet mutually dependent terms. The **first** is the name of an artist still best known for his works of the late 1940s and 1950s: elongated, impossibly slender representations of figures, standing women, and walking men, often interpreted as revealing the anxiety and alienation of contemporary life. The second indicates an art movement founded on October 15, 1924, as announced by the publication of André Breton's first *Manifesto of Surrealism*—an art movement still best known for its promotion of the irrational at the expense of bourgeois rationality,

its pursuit of pure psychic automatism, and its reliance on poetic reverie, psychoanalysis, sexual fantasy, and dreams. Both terms are more complex; Giacometti created a significant body of work before the 1940s, while definitions of Surrealism and its significance are constantly being supplemented, revised, and reworked. The aim here is to present the two as reciprocal, to examine ways in which Giacometti and Surrealism define each other by using Giacometti's objects, drawings, and writings to characterize Surrealism at a particular moment, while also considering how Surrealism during these same years helped Giacometti to create his art.

Giacometti's Surrealist period is difficult to frame precisely in terms of dates. Beginning and end points are prone to shift, due to gaps in the historical record and to interpretive points of view. His letter to André Breton of February 19, 1935, however, marks a definitive break with the movement. Following, it seems, a heated argument (the subject of which goes unmentioned), Giacometti told Breton that the only solution he did not want was rupture.[9] His words, however, seem to have fallen on deaf ears. This letter stands as the last in a series of intimate exchanges begun in the summer of 1933, shortly after the death of Giacometti's father, and extending through February 1935. From then on, there is silence, broken only in 1947 by a letter in which Giacometti refers back to his expulsion from the Surrealist group and refuses to participate in an exhibition Breton is organizing. Criticizing Breton for his willingness to accept a print representing a head, a portrait—precisely the cause, twelve years earlier, of his expulsion from the group—Giacometti stated unequivocally that he found it absurd for Breton to present him as a Surrealist in 1947 when he had, in fact, left the movement years ago.[10]

Although 1935 can, then, be taken as an end of sorts—certainly as an end to Giacometti's affectionate relationship with Breton and to his dependence upon the psychic as a basis for his art—a point of entry is more difficult to fix. Giacometti himself would, years later, date his involvement with the Surrealists from the moment "Dalí and Breton saw my *Suspended Ball* in the exhibition at Galerie Pierre. Then they invited me to take part in their manifestations."[11] This suggests that the story of Giacometti and Surrealism starts in 1930, the year in which *Suspended Ball* (plate 38) is believed to have first been shown. Others argue, with good

reason, that his contact with the Surrealists begins earlier, specifically with his integration "by Michel Leiris into the circle connected to the magazine *Documents* led by Georges Bataille, a circle composed of renegade surrealists." This repositions Giacometti's "precise point of entry" to 1929.[12]

The debate over Giacometti's Surrealist beginnings is both semantic and stylistic, hinging on differing definitions of Surrealism and on how these differences are manifested or played out in Giacometti's work. If Breton is allowed to stand for the whole of Surrealism, as Giacometti himself later seems to suggest, then the date of his first encounter with the artist can be construed as catalytic, functioning as the primary source for Giacometti's Surrealist associations and for his Surrealist oeuvre. If, however, Surrealism is understood to encompass not only Breton but also the so-called dissidents, then Giacometti's initiation does indeed begin in 1929, before Breton and Dalí's discovery of *Suspended Ball*. In this sense Giacometti's connections with the *Documents* group become critical, determining factors in the shaping of *Suspended Ball* and the other Giacometti objects associated with it, as first published by Breton and Dalí in December 1931.[13] Giacometti's associations with some members of the *Documents* group might in fact be pushed back even earlier: he is believed to have met Carl Einstein—well-known German art critic, committed Marxist, and founding co-editor of *Documents*—and possibly the artist André Masson in 1927, for example.[14] Without a doubt, however, 1929 is *the* pivotal year in which to begin any sustained discussion of Surrealism and Giacometti. From sometime around late May or early June on, significant connections between the two multiply; by the next year, there is a perceptible shift in the character of Giacometti's work.

For the Surrealists, 1929 was fraught with change and transition. The last issue of the periodical *La Révolution surréaliste* was published, including Breton's second *Manifesto of Surrealism*; that same year saw the appearance of the first issue of *Documents*. Many of the initial Surrealists left the group, some acrimoniously, in reaction to Breton's authoritarian control. Among them were a number of the friends Giacometti is believed to have made in 1929: Georges Bataille, Robert Desnos, Michel Leiris, and Raymond Queneau. During this same period, new recruits joined André Breton's core group, including the Spaniards Luis Buñuel and Salvador

Dalí—codirectors of the scandalous film *Un Chien andalou*.

Released in Paris in June 1929, *Un Chien andalou* is often claimed to be the first Surrealist film; it captures, perhaps better than any other single work, a shift away from Surrealism's allusive, elliptical *peinture-poésie* of the 1920s toward the more overtly sexually charged, Freudian-flavored, frequently violent imagery of the 1930s. It also speaks to the desire of many of the Surrealist artists to go, in Max Ernst's famous phrase, "beyond painting," in films, photographs, collages, and collagelike objects. In this sense Giacometti crossed the Surrealists' path at a particularly opportune moment.[15] By the time Breton and Dalí are generally believed to have encountered his *Suspended Ball*, sometime in 1930, they were ready for, even needed, the young Swiss artist, and their "discovery" reads retrospectively as a variation upon the strange workings of marvelous, objective chance. This is, however, to get ahead of the story; before Breton and Dalí could happen upon *Suspended Ball*, Giacometti had to conceive and execute it—possibly beginning in 1929 and completing it the following year.

For Giacometti, 1929 marked the beginning of success of a sort, and certainly acclaim. The letters he sent home to his parents in Switzerland that year are filled with promising news—of works exhibited at the respected avant-garde gallery Jeanne Bucher; of a sale to Charles de Noailles, aristocrat and patron of many of the Surrealist artists; of a contract with Pierre Loeb (dealer for Joan Miró among others), to last through the end of 1930, negotiated it seems in close consultation with Carl Einstein; and of the very first article exclusively dedicated to his work, to be written by Leiris and published in the fourth issue of *Documents*.[16] "Einstein telephoned Pierre [Loeb] to tell him in secret that the Sept[ember] issue of *Document[s]* will contain an article on me with reproductions," Giacometti wrote in a letter of June 1929, hinting that this forthcoming publication would play a prosaic as well as poetic role in promoting his work. "Sculptors need influential collectors, and a manager who creates markets for them," proclaimed Einstein in a group review that mentioned Giacometti.[17] They also, he could have added, need passionate, receptive critics. By the end of Giacometti's life, his work would be championed by many different eloquent voices. Leiris's, however, remains among the most resonant and compelling. He was, moreover, the first to devote more than a few lines to Giacometti, singling him out as truly exceptional among contemporary sculptors—and making a vivid, poetic case as to why this was so.

Titled simply "Alberto Giacometti," Leiris's 1929 article was illustrated with photographs taken by the well-known fine arts photographer Marc Vaux. These images, however, were far from straightforward, objective documents. Rather, as the captions made clear, the Giacometti sculptures shown had been "composed" and in one unusual case "cut-out" by Leiris. Considered together with Leiris's text, which itself functions on some level as an extended caption, these overtly subjective, theatrically staged images and the words that accompany them frame and reframe a group of objects often described in the Giacometti literature as proto-Surrealist. In this sense the article as a whole provides, among many other things, a useful *terminus a quo*. After this moment Giacometti's Surrealist period proper can be said to begin; this is manifested in the revolutionary series of objects that followed close on the heels of those that so captivated Leiris. In later years Giacometti remarked that he liked to learn from photographs of his work;[18] he most probably paid close attention to the visual and verbal images that Leiris published in 1929. Reading the *Documents* article with the twenty-eight-year-old Giacometti and his works of 1930–34 in mind introduces a number of different ways of looking and thinking about what would become his Surrealist oeuvre.

"Don't expect me to matter-of-factly call this work *sculpture*," Leiris cautioned his readers, "I prefer *DIVAGUER*."[19] By replacing the noun *sculpture* with an evocative, active verb (*divaguer* means to wander or ramble), Leiris engaged in what has been described as his "lifelong mania for slipping words in and out of their semantic slots, provoking new senses."[20] Here he indicated not a static object but something that moves (and is emotionally moving, as he goes on to say), something that works, performs, acts upon conventional meanings ascribed to "sculpture," untethering the word from its linguistic and aesthetic moorings, transgressing and diverting its official shapes and forms. "These beautiful objects that I've been able to look at and touch," Leiris continued, "stir a fermentation in me of so many memories . . . [They are] real fetishes, meaning those that resemble us and are objectivized forms of our desire."[21] Looking and touching,

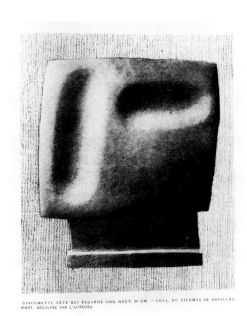

GIACOMETTI. TÊTE QUI REGARDE (1928). HAUT. 34 CM — COLL. DU VICOMTE DE NOAILLES.
(PHOT. DÉCOUPÉE PAR L'AUTEUR.)

3. Alberto Giacometti. *Gazing Head.* 1928. From
Documents, no. 4, 1929. Photograph by Marc Vaux

the relation between self and other, inside and outside, the charged presence of real fetishes: all reflect Leiris's ongoing preoccupations, sparked in this instance by his view of, and interaction with, Giacometti's *sculpture/divaguer.*

To perceive something, including Giacometti's sculpture, as a "real fetish" depends on a particular way of looking and on the power of the object to fix or hold the gaze. For Leiris, "the fetish is the luminous, charged object or moment, cut out of its 'whole' context, [yet producing] the effect of a wholeness. It is an exterior, objectified crystallization of desire, something distant *and* miraculously close, erasing the gulf between inner and outer experience. The sense of erotic plenitude produced by fixation on the fetish is not, however, narrowly limited to sexual experiences; it gives a sense of intense reality to the commonest perceptions and encounters."[22] In cutting out a photograph of Giacometti's slablike sculpture *Gazing Head* (fig. 3), Leiris gave material form to the visual act of fetishistic fixation: isolating the object, tracing its contours with his scissors (eyes), setting it against, pasting it to, and framing it with a fabric backdrop. Frozen in place, eerily autonomous, the sculpture—as signaled by its title, its mysteriously anthropomorphic character, and the two soft, elliptical indentations that traverse its surface—

looks back, gazes out upon, the viewer (Leiris, his audience), trapping subject and object in a space riven by desire, confusing distinctions between gazer and gazed upon. Looking, isolating, framing, creating erotically charged, intensely experienced objects, or worlds, that are close but distant, that touch us yet remain apart: these are among the subjects framed by Leiris's presentation of Giacometti's "real fetishes" that resonate visually and conceptually within the body of Giacometti's Surrealist art.[23]

Giacometti's "cut-out" *Gazing Head* is the first of four illustrations of his work published in *Documents* in 1929. In the second (fig. 4), Leiris placed *Gazing Head* (plate 31) and three other plaster sculptures directly on the floor, between Giacometti's bookshelf and bed, setting forth the possibility of a direct, "nonsublimated relation to art."[24] These are objects, as Leiris makes visually and verbally clear, that he has handled, arranged, and sensuously interacted with, disturbing implicit notions that art is made only for the eyes. Lowering the works to ground level, upsetting the norms of sculptural display, Leiris placed Giacometti's objects into a real space rather than an ideal one. The move has much to do with his, and Bataille's, attempts at a radical reconception of aesthetic value.[25] Positioning *Gazing Head*, along with two other plaquelike sculptures, around the sexually explicit *Man and Woman* (plate 34), Leiris suggests that Giacometti's work, rather than sublimating sexual curiosity and voyeuristic impulses into some "higher" artistic production, reverses the action. Eroticism, violence, and sexual desire, as represented by *Man and Woman,* are placed literally center stage, appealing to what Leiris saw as the "true fetishism" that lives in all of us, at a much deeper, instinctual level than the "transposed fetishism" of our "moral, logical and social imperatives."[26]

One of the remaining photographs (fig. 5) features several of Giacometti's linear, open works, "perforated," as he wrote, "to let air pass through, moving grillworks interposed between inside and outside, riddled sieves nibbled by the wind, the hidden wind enveloping us with its immense dark eddy in those amazing moments making us delirious."[27] In placing *Man (Apollo)* (plate 29) and *Three Figures Outdoors* (plate 35) in front of *Man and Woman* and *Reclining Woman Who Dreams* (plate 33), Leiris confuses their constituent elements. The works join with each other and with their

18

surroundings, playing off the backdrop furnished by Giacometti's studio door. By visually layering Giacometti's transparent, calligraphic works, Leiris accentuates their formal potential to blur distinctions between inside and outside, extending the field of these virtually two-dimensional figures into three dimensions. The superimposition of *Three Figures Outdoors* over *Reclining Woman Who Dreams* (seen on the right), in particular, prefigures the complicated clotted space of what is generally believed to be Giacometti's first extant Surrealist work, *Cage* (plate 37).

All of the sculptures Leiris had photographed in Giacometti's studio were plasters, and their whiteness provoked a dazzling chain of associative metaphors in his writing. Linking Giacometti's forms, "kneaded in the transient sweet salt of snow," to "the dust that falls from our fingernails when we polish them" and to "the marvelous salt so many ancient searchers believed they could extract from the earth's bowels," Leiris traces a progressive dissolve of Giacometti's seemingly solid yet in fact extremely fragile plaster sculptures. "The salinity of waves and the stars . . . the salt, finally, of tears . . . solid drops of water resembling this salt that still stirs our appetites, sea salt, bitter salt, salt of cracking knuckles, salt of teeth, salt of sweat, salt of looks."[28] The processes of liquefaction, dissolution, and entropy are all evoked by Leiris's description of form's decomposition into bodily fluids, base matter, salt, and plaster dust. While "nothing indeed could be crisper than the material forms in Giacometti's Surrealist sculpture,"[29] it manifests a preoccupation with transience, material and perceptual, and with life-and-death cycles, that finds a metaphorical echo in Leiris's words.

Sometime during the following year, 1930, Giacometti is believed to have completed, and exhibited, his *Suspended Ball* at the Galerie Pierre, Paris. The arrival of this work upon the Paris art scene has acquired a quasi-mythic importance, especially in the Giacometti literature, but the particulars of its appearance—understood both physically and chronologically—are remarkably unclear. First, with regard to the object itself, as was Giacometti's common practice, the original version of the *Suspended Ball* is believed to have been executed in plaster.[30] Preserved in a Vaux photograph (fig. 6), the original cage that supports the ball, along with its crescent-shaped partner and the platform on which the

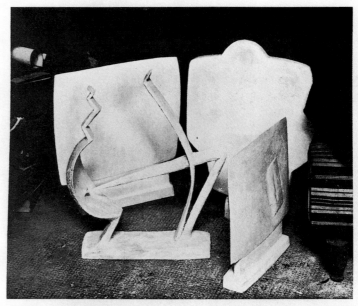

GIACOMETTI. HOMME ET FEMME (1929). HAUT. 36 CM. — GALERIE PIERRE.
PHOT. COMPOSÉE PAR L'AUTEUR.

4. Alberto Giacometti. *Man and Woman.* 1929 (front left); *Gazing Head.* 1928 (rear left); *Man.* 1927–28 (rear right); *Woman.* 1928–29 (front right). From *Documents*, no. 4, 1929. Photograph by Marc Vaux

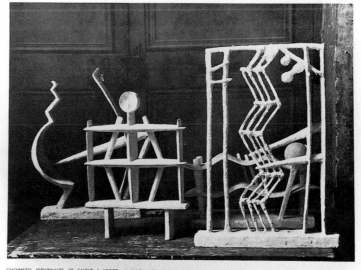

GIACOMETTI. PERSONNAGES. DE GAUCHE A DROITE. (1) HAUT. 34 CM., (2) HAUT. 46 CM. (1929) — GALERIE PIERRE.
PHOT. COMPOSÉE PAR L'AUTEUR.

5. Alberto Giacometti. *Man (Apollo).* 1929 (front left); *Man and Woman.* 1929 (rear left); *Reclining Woman Who Dreams.* 1929 (rear right); *Three Figures Outdoors.* 1929 (front right). From *Documents*, no. 4, 1929. Photograph by Marc Vaux

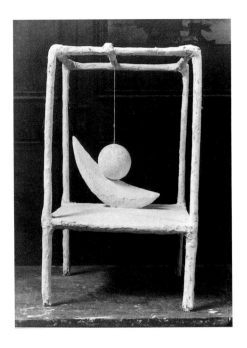

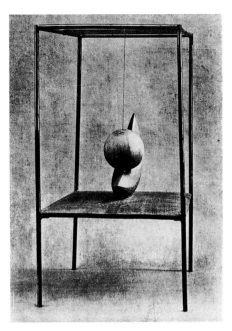

6. Alberto Giacometti. *Suspended Ball.* 1930. Original plaster. Photograph by Marc Vaux

7. Alberto Giacometti. *Suspended Ball.* 1930. Wood version. From *Le Surréalisme au service de la révolution,* no. 3, 1931. Photograph by Man Ray

latter rests, is coated in plaster. This gives the work's linear elements a thick, irregular, almost ungainly character, which, while closely related to Giacometti's preceding "grill-works," is very different from the sleek metal framework seen in Man Ray's photograph of the wood version of *Suspended Ball* (fig. 7).

These visible differences beg the question of what, exactly, Dalí and Breton saw at Pierre Loeb's. Was it the original plaster or was it a subsequent reworking, in which plaster forms were set within a metal cage? Or, was it the wood version, believed to have been executed by the Basque cabinetmaker Ipoustegui? And when, moreover, did they see it? While most agree that *Suspended Ball* was shown in a springtime (possibly April) group exhibition, along with works by Jean (Hans) Arp and Joan Miró, no primary documentary evidence has yet emerged that would establish beyond doubt the precise date of the work's first public appearance.[31] What is certain, however, is that by December 1931, the wood version had been completed, photographed by Man Ray, and published in *Le Surréalisme au service de la révolution.* Purchased at some point by Breton, this work—with its finely wrought, smoothly finished wood surfaces, its metal vitrinelike cage, and its nearly invisible bit of filament—was the version that ultimately held (if not initially captured) the Surrealists' fascinated attention. There is in fact something about the wood version's precision that exaggerates its mechanical qualities: a libidinally charged machine, an object of erotic, symbolic function. These were among the readings set into motion by Dalí and others upon confrontation with and contemplation of *Suspended Ball.*

The title most probably originated with Giacometti.[32] Fundamentally descriptive, it is also metaphorically evocative. In French, the word *suspendu* carries connotations of frustration and delay. Dalí described the object as, "a wooden ball,

stamped with a feminine groove . . . suspended by a violin string over a crescent the wedge of which merely grazes the cavity. The spectator finds himself instinctively compelled to slide the ball up and down the ridge, but the length of the string does not allow a full contact between the two."[33] Suspension, deferral, desire represented, or staged, as perpetually searching, in motion, ultimately unfulfilled: all are part of the content or meaning that Dalí perceived in the work. In Man Ray's photograph *Suspended Ball* is positioned to give a clear view of what Dalí conventionally characterizes, in terms of male and female symbols, as the ball's "feminine groove." This angle encourages a reading of the "groove" as a wound or cut, an interruption in the sphere's otherwise geometrically perfect surface, a negative to the wedge's positive, peaked, visually sharp edge. Giacometti's drawing of *Suspended Ball* (fig. 8), published in the same issue of *Le Surréalisme au service de la révolution,* reinforces the symbolic identification of the crescent shape as a positive, masculine, phallic counterpart to the sphere's negative, feminine "lack."

The ball's identity, sexual or otherwise, is far from stable, however: it moves, figuratively, along an associative axis that includes head, eye, mouth, buttocks, and that subjects its wedge-shaped partner to a similar series of semantic shifts.[34] The operative action is less one of caressing than of cutting, of a scimitarlike slicing, both sensual and sadistic. Castration, enucleation, and the ambiguity of sexual identity are themes, as many have noted, that connect *Suspended Ball* to the world imagined by Buñuel's and Dalí's film *Un Chien andalou.*[35] Also staged within the precisely delineated field of *Suspended Ball*'s vitrine or cage are the visions of cruelty, sacrifice, sexual violence, and sadism prevalent among the *Documents* group, particularly Bataille, Leiris, and Masson. The object has in fact been interpreted as an avatar of

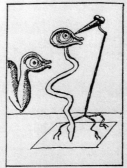
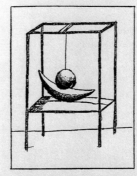

8. Alberto Giacometti, "Objets mobiles et muets," *Le Surréalisme au service de la révolution*, no. 3, 1931, pp. 18-19.

Bataille's notions of the "formless" working away, eroding, performing a categorical blurring by attacking the conditions "on which meaning depends, namely, the structural opposition between definite terms."[36]

For Dalí, *Suspended Ball* did not work against the grain of definitions and categories but announced them. It appeared at the top of what, in *Le Surréalisme au service de la révolution*, he described as his "General Catalogue" of Surrealist objects, under the heading "Objects of Symbolic Function (automatic origins)."[37] Such objects were, according to Dalí, "likely to be provoked by the realization of unconscious acts," among them "distinctly characterized erotic fantasies and desires," given objective form through the processes of substitution, metaphor, and symbolic realization.[38] Often credited with launching the Surrealist vogue for object-making, *Suspended Ball* was, however, as Dalí was the first to note, prophetic of, yet different from, the true Surrealist object. Comprising made objects rather than found ones, it has an erotically tinged simplicity that clearly reveals a shaping aesthetic intelligence. For all that the wood version eliminates telltale traces of the artist's hand—the palpable knead-

ing of malleable materials evoked by Leiris—and is thus more plausibly conceptual, more believably automatic in origin, it is far from the assemblages or fortuitous encounters of ready-made objects prized by Breton and sought out by Dalí. Neither a commonplace object nor a conventional sculpture, *Suspended Ball* instead profoundly enacts a motion of *divaguer*, of moving, wandering, between categorical definitions.

Giacometti's own presentation of *Suspended Ball* immediately followed Dalí's text in *Le Surréalisme au service de la révolution*. Here the work is rendered as a fine line drawing, accompanied by six other images, each set within its own carefully delineated frame, like a series of silent-film stills (fig. 8). Titled "Objets mobiles et muets"—moving and mute objects (*not* sculptures)—this presentation was accompanied by a freeflowing yet temporally and spatially disjunctive prose text. Here Giacometti's words trace a verbal surround for his works while never touching upon them directly, conjuring a psychic space defined by a subject (the artist) looking and listening, aware, to a hallucinatory degree, of the

21

CHUTE D'UN CORPS SUR UN GRAPHIQUE. 1932. Photo Man Ray.

PROJET POUR UNE PLACE (en pierre). 1930-31. Photo Man Ray.

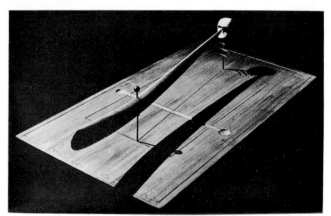

" ON NE JOUE PLUS ". 1931-32. Photo Man Ray.

ÉLATIONS DÉSAGRÉGEANTES. 1932. Photo Man Ray.

9. Alberto Giacometti. *Landscape—Reclining Head*. 1932 (top left); *No More Play*. 1932 (bottom left); *Model for a Square*. 1930-31 (top right); *Point to the Eye*. 1932 (bottom right). From *Cahiers d'art*, nos. 8-10, 1932. Photographs by Man Ray

shifting position of figures, objects, and sounds around him: "All things . . . near, far, all those that passed and the others, in front, moving, and my lady friends—they change (we pass very near, they are far away), others approach, ascend, descend, ducks on the water, there and there, in space, ascending, descending—I sleep here, the tapestry flowers, the drip of the water faucet, the drawings on the curtain, my pants on a chair, they are talking in a room further away; two or three people, of which station? The trains that whistle, there is no station near here, orange peels are thrown from the top of the terrace, into a very narrow, deep street—the night, the donkeys desperately howling, toward morning, they are slaughtered—tomorrow I go out—she brings her head close to my ear—her leg, the big one—they talk, they move, there and there, but all is past."[39]

The concluding phrases are particularly jarring: the deep narrow street conjures up memories of Giorgio de Chirico's haunting paintings; the slaughtered donkeys—shades of a scene from *Un Chien andalou;* the artist leaving; and the abrupt shift from encroaching physical intimacy to passive, distanced, voyeuristic observation. A series of relationships, of connections between two or more things, connections perceived, overheard, or imagined—the self (the artist) and others (his lady friends, his room, the bed from which he

hears the dripping faucet, sees his pants on a chair, dreams, imagines)—the self *as* other, are observed with a passionately dispassionate gaze. Giacometti's drawings of his "Objets mobiles et muets" are similarly distanced yet similarly all about relationships. Rendered (with two exceptions) after completion of the works themselves, they are filled with images of things touching, often just barely, within and without the limits of the object. In the lower right of the magazine spread fingertips graze a clublike phallic form. Above, the orb in *Suspended Ball* cleaves to its partner without penetration. On the left-hand page, in some *ur*-form of *Point to the Eye* (plate 55), vision is menaced but not maimed. Next to it, *Cage*, an image of violence constrained and compressed, evokes the Surrealist fascination with the praying mantis, the devouring female who consumes her mate during or after copulation, inextricably linking sex and death.[40]

Intimations of Eros and Thanatos, desire and pain, pervade these works. The two Disagreeable Objects situated at the lower left and bottom right of the double-page layout are perhaps the most literal in this sense, suggesting weapons to be wielded, agents of sadistic pleasure. Isolating his objects, positioning them within an ambiguously defined space reading variously as floor, tabletop, and landscape, Giacometti's mode of presentation encourages the viewer/reader to focus,

22

to fixate (fetishistically), on his works, which appear severed from real-world connections—frozen, poised between movement and rest. In all but two instances, the exterior frame's rectilinear contours are reiterated, reasserted, within the objects themselves: in the space-frames of *Cage* (plate 37) and *Suspended Ball* (plate 38), in the surface/support of *Disagreeable Object, To Be Thrown Away* (plate 41), and in the pedestal/bases of the two fantastical works (prefiguring *Point to the Eye* and *L'Heure des traces* [plate 36]). Frames within frames, distancing devices—in this series of drawings Giacometti repeatedly sets fixed yet fluid boundaries between real and imaginary spaces, exteriors and interiors, material and psychic realms.[41]

Between the end of 1931 and that of the following year, between the publication of his "Objets mobiles et muets" and the second major article devoted exclusively to his work—written by Christian Zervos, illustrated with Man Ray photographs, and published in *Cahiers d'art* [42]—Giacometti realized an extraordinary group of objects. Ranging from a series of tabletop tableaux, including *Landscape—Reclining Head* (plate 48), *Model for a Square* (plate 43), *No More Play* (plate 54), and *Point to the Eye* (plate 55), to the fragile, vertical, architectonic forms of the plaster *Palace at 4 A.M.*, which appeared as the final image in Zervos's article, these objects (along with those completed in 1930 and 1931) reveal the morphological diversity and innovative structure of Giacometti's Surrealist oeuvre, capturing the shifts back and forth between the pictorial and the sculptural, between verticals and horizontals, between objects or figures set into space and those set into frames.

Man Ray's photographs of Giacometti's works are overtly theatrical, dramatically artificial, and present the objects bathed in a harsh studio light (fig. 9). Cast shadows are exaggerated and exploited, as are contrasts of dark and light. The predominantly black backgrounds suggest some strange twilight zone. While Giacometti's own drawings of his works show them similarly isolated, detached from any real-world context, Man Ray's photographs definitively remove them from the realm of the natural, pulling them instead toward the supernatural, the surreal. Zervos's words meanwhile tug in another direction, away from Surrealist fictions, fantasies, and psychological projections toward the history of modern sculpture and pure plastic form. Claiming Giacometti as the latest in a line of distinguished modern sculptors, from Aristide Maillol to Constantin Brancusi, Jacques Lipchitz, and Henri Laurens, Zervos praises Giacometti for his ability to abstract and synthesize from nature, rather than slavishly imitate its appearance. Predicting that Giacometti will gradually eliminate all that impinges on the pure plasticity of his work, Zervos sees only positives where Dalí had seen negatives. The word *surrealism* goes unmentioned in his article; instead, Giacometti the modern sculptor is brought to the fore. Giacometti's unique achievement, of course, was to demonstrate that Surrealism and modern sculpture need not be mutually exclusive domains, even if the Surrealists' attitudes willed them to be so. His works from the early 1930s are radical on many levels, including that of the history of modern sculptural form. Ranging from portable objects, to works with movable components, to environmental models in which the spectator was intended to move about, Giacometti's preferred formats of the cage, the gameboard, and the fetish object reimagine sculpture as a psychically powerful, ever-shifting terrain.[43]

The word *terrain*, literally connoting the ground on which one stands, evokes the pronounced horizontality of many of Giacometti's works from this moment, as suggested by the four Man Ray photographs reproduced in *Cahiers d'art*. It has been convincingly argued that this shift to the horizontal constitutes one of *the* crucial moves made by Giacometti's Surrealist work of the early 1930s: "The formal innovation of these sculptures, almost wholly unprepared for by anything else in the history of the medium, was their ninety-degree turn of the axis of the monument to fold its vertical dimension onto the horizontality of the earth."[44] Not sculptures without bases, but sculptures *as* "mere" bases, lowered, joined to the ground, to the world of actuality, to the real: photographed by Man Ray from above, they appear as disquieting landscapes, precisely delineated gameboards, and macabre playing fields. Sometimes they mutate into physiognomies: literally in *Landscape—Reclining Head*, suggestively in *Model for a Square*. Essentially reconfiguring the relationship between art and audience, reconceiving sculpture as something to be looked down upon rather than up to, something to be touched and played with, they still declare their separateness (even without the help of Man Ray's dramatic use of black to cut them out). They are miraculously close yet

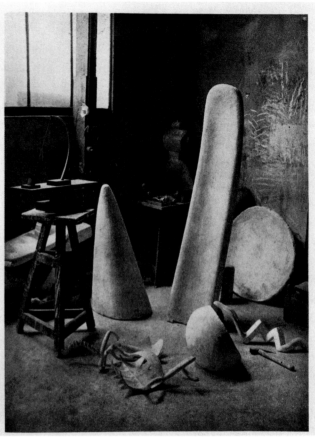

10. Alberto Giacometti. *The Palace at 4 A.M.* 1932 (top left); *Woman with Her Throat Cut.* 1932 (bottom left); the artist's studio (right). From *Minotaure*, nos. 3–4, 1933. Text by Giacometti, photographs by Brassaï

distant, part of this world and yet apart, real and surreal; to position Giacometti's work firmly in one category or another undermines its complexity and profound ambivalence.

In 1933, however, in the pages of the luxe periodical *Minotaure*, Giacometti published what amounted to a profession of Surrealist faith, a fixed position (fig. 10). Set on either side of Brassaï's photograph of the wood version of *The Palace at 4 A.M.* and within a group of images that included a close-up of *Woman with Her Throat Cut* (plate 53) and a studio view, these were the words that helped to make the *Palace* Giacometti's most "famous" Surrealist sculpture, and established it as a reference point often used to define the essentials of Surrealist art. "For many years I have executed only sculptures that have presented themselves to my mind entirely completed," Giacometti wrote. "I have limited myself

to reproducing them in space without changing anything, without asking myself what they could mean. . . . The attempts to which I have sometimes given way, of conscious realization of a picture or even a sculpture, have always failed."[45] Defining his process in automatist terms, Giacometti's statement developed from a draft of a letter to Breton, probably dating from the summer of 1933.[46] This suggests, perhaps, the obvious: while the words Giacometti published in *Minotaure* ultimately reached a vast number of people, they were initially directed to an audience of one. Echoing Breton's own description, in the first *Manifesto of Surrealism*, of images decided "by previous predispositions" produced not by drawing but simply by "tracing,"[47] Giacometti was affirming his commitment to Breton and to prescribed Surrealist procedures.

Giacometti's other letters to Breton from the summer of

1933 are somewhat self-conscious, suggesting a need for approval and acceptance. Written in the months immediately following the death of his father, his letters are filled with vivid, hallucinatory images of things dreamed or observed, with apologies for his inadequate writing abilities, and with references to his fragile, fractured emotional state. In addition to documenting a friendship, the correspondence provokes the impression that, at some profound level, the artist's sense of self and his self-image, as he represented them to Breton, were at stake. This self-consciousness, understood in the most literal way, carries over to his *Minotaure* text. "Once the object has been constructed," he wrote, "I have a tendency to recover, transformed and displaced, images, impressions, forms to which I feel myself very close, although I may often be unable to identify them, and they become all the more troubling for me."[48] Thus described, Giacometti's objects embody a form of self-representation, picturing or trapping memories, images, impressions, and forms that had profoundly affected and psychologically troubled the artist.

Unlike all of his other Surrealist texts (including "Objets mobiles et muets"), which touch only indirectly on his works, here Giacometti exceptionally singles out an object—*The Palace at 4 A.M.* —to illustrate his points: "I take as an example the sculpture reproduced here that represents a palace. This object formed little by little toward the end of summer 1932; it gradually became clearer to me, the various parts taking their exact form and their particular place in the ensemble. Come autumn it had attained such a reality that its execution in space did not take me more than one day."[49] Is Giacometti referring to the plaster version of *The Palace at 4 A.M.* (figs. 1-2) or to the wood version (fig. 10)? Would such distinctions have troubled him? Probably not. His decision to reiterate the *Palace*, to re-create it or have it re-created sometime subsequent to the making of the plaster version, serves only to underscore the work's importance for him. As documented by Brassaï, the *Palace* appears subtly but significantly transformed. Rather than illusionistically floating, it is elevated and set upon a pedestal. Remade in wood, too, the lines that had been tenuous and irregular in the plaster version have been straightened.[50] A slender pane of suspended glass has been added, a translucent canopy connecting the palace's rooms from left to right. Signs of human touch are banished. Conception rather than execution is brought to the fore; the work's impersonal facture suggests that what mattered above all was the idea, not the means of realization. The essential thing, Giacometti later said, was to have his works executed by a woodworker, so he could see them all done "like a projection."[51] In a letter of 1947 on *The Palace at 4 A.M.*, Giacometti clearly states: "I made it in wood" ("*je* l'ai exécuté en bois"),[52] but in the end it makes little difference who made the work; what matters, rather, is that the impersonal look of the execution is understood as an effect desired and achieved. If nothing else, the fact that Giacometti felt free, in the late 1940s, to say *he* made the *Palace* suggests how very little the distinction had come to mean. There was no longer any reason to minimize the role of process or to emphasize the speed of execution: his work, and his audience, had significantly changed.

The year 1933, obviously, found Giacometti at a very different time and place. He takes great care in his *Minotaure* text to connect the *Palace* to particular points in real time, in lived experience. The end of summer 1932, the following fall, a moment in his life "that had come to an end one year previously, a period of six months passed hour by hour in the presence of a woman who, concentrating all life in herself, transported my every moment into a state of enchantment. We constructed a fantastical palace in the night. . . . a very fragile palace of matches; at the least false movement a whole section of this diminutive construction would collapse; we always began it all over again."[53] The woman in question is often identified as one of Giacometti's lovers, known only by her first name, Denise; in the summer of 1933, he told Breton that he was incapable of making anything that did not have something to do with her.[54] His account in *Minotaure*, however, transcends biographical particulars. Instead, it, like *The Palace at 4 A.M.* itself, is best read as a poetic construction filled with powerful metaphors and rhetorical figures of speech. The two, words and image, play off each other, combining to create a compelling analogy between the physical fragility of the *Palace*—its spindly wood scaffolding, its sheet of glass, its delicate skeletons—and the fragility of a relationship between two lovers, "a fragile construction always at the risk of collapsing, like a house of cards," like a palace made of matchsticks.[55]

Giacometti's art throughout his Surrealist period has

11. Alberto Giacometti. *Sketch of the Artist's Studio*. c. 1932. From inside front cover of *Exposition Cuno Amiet*. Paris: Galerie Georges Petit, 1932. Private collection, Switzerland

12. Alberto Giacometti. *Sketch of the Artist's Studio*. c. 1932. From back cover of *Exposition Cuno Amiet*. Paris: Galerie Georges Petit, 1932. Private collection, Switzerland

everything to do with physical and psychological relationships between things: between subject and object, between things that move in relation to each other, and between elements positioned within vertical or horizontal frames. The same of course might be said for his postwar production; the crucial difference resides in the Surrealist works' psychic,

frequently traumatic, origins and in their abstracted, overtly erotic references to interior rather than exterior models. *The Palace at 4 A.M.* sets up distanced relationships among four primary figures, referencing past and present tenses. On one side, a severed spinal column and a skeletal bird appear suspended, each set within its own linear frame or cage. Both are, Giacometti tells us in *Minotaure*, related to his lover, and symbolize respectively the beginning and ending of their passionate affair. On the other side, in the abstracted, armless form of a woman, Giacometti "discovered" his mother. And, in the center, attached to a tower that is either "incomplete" or has "collapsed," appears a podlike form on a rectangular plank, cradling a small perfect sphere, poised as though ready at any moment to slip or slide out. "All the rest vanished, escaped my attention," wrote Giacometti, confirming the work's fetishistic focus. "I can't say anything more about the red object lying on a small board: I identify myself with it."[56]

In two small sketches made sometime after March 1932 (figs. 11, 12), works clearly related to the extraordinary pair of studio drawings (plates 51, 52) that Giacometti presented to the Romanian noblewoman Donna Madina later that same year,[57] the artist represents himself lying in his studio bed, surrounded by his recent works. "What is your atelier?" Breton asked Giacometti in 1934. The reply: "Two walking feet."[58] While the sketches present the artist recumbent, not walking, the implication is similar: for Giacometti, at this moment, the atelier is to be represented as a space of the mind (that of the head that tops those walking feet), not the hands. No traces are included of sculptor's tools, raw materials, or other prosaic paraphernalia. Everything appears autonomous, self-sufficient, prepared for viewing—by Donna Madina and, as the sketches make clear, by the artist, passive witness to the material forms conjured by his sexual fantasies and psychic reveries. While *The Palace at 4 A.M.* occupies a central position in one of the finished studio drawings (plate 52), possibly the later of the two, in the sketches it remains unseen. The figure of the artist in bed, however—particularly as seen in an overhead view (fig. 12)—reemerges, transformed, at the center of the *Palace*, carefully framed, isolated, spatially surrounded by, yet distant from, the forms that haunt his waking dreams. While the connection is perhaps too grossly literal—Giacometti's forms are nothing if not enigmatic and impossible to pin down—the

comparison reinforces the suggestion that in some fundamental sense *The Palace at 4 A.M.* is a "composite self-portrait," and that its relation to Giacometti's studio is essential.[59] Each, *The Palace at 4 A.M.* and the studio, frames and represents a subject, the artist, defined literally, metaphorically, and symbolically through his works.

The *Minotaure* pages also juxtapose *The Palace at 4 A.M.* with an image of Giacometti's studio, a corner view (rather than an overview), and reveal the close formal affinity between the *Palace*'s central object and several of the elements for Giacometti's *Model for a Square* (fig. 10). This relationship begins to turn the discussion away from *The Palace at 4 A.M.*'s inward focus toward its context, within both Giacometti's Surrealist oeuvre and the larger world. The pairing in *Minotaure*, for example, of the *Palace* with Giacometti's *Woman with Her Throat Cut* suggests formal, emotional, and conceptual extremes. From the irrational rationality of *The Palace at 4 A.M.*'s forms and figures, distanced from each other and from the viewer, to the sexual drama and violence conveyed by *Woman with Her Throat Cut*, positioned directly on the floor, Giacometti's Surrealism moves in any number of different directions. Part animal, part insect, part human in form, *Woman with Her Throat Cut* figures a body simultaneously in the throes of sexual ecstasy and in the spasms of death, giving physical form to Bataille's observation that in French, orgasm is often referred to as *petite mort* (little death).[60] *The Palace at 4 A.M.*, by contrast, appears practically puritanical, although it too images—abstractly, distantly, and symbolically—love and its death.

Giacometti wrote in a letter of December 1947 that during the early 1930s, "[I made] objects going in directions quite different from each other."[61] He followed his words with a series of sketches to illustrate his point (fig. 13). This letter is crucial to the understanding of Giacometti's Surrealism, although in this essay it is consciously positioned at the end of the story rather than at the start. The intent throughout has been to approach the subject of Giacometti *and* Surrealism through words and images closer in time to the objects' making, through documents dating from a period before Giacometti deemed his affiliation with the Surrealists "absurd." Allowing the artist, his works, and contemporaneous publications to frame the discussion excludes, of course, any

13. Alberto Giacometti. Page from a letter to Pierre Matisse, December 1947. From *Alberto Giacometti*. New York: Pierre Matisse Gallery, 1948

number of things from the picture: social, historical, and political realities, and the affinities of Giacometti's works with those of fellow artists, past and present—relationships, in other words, outside the walls of Giacometti's far from autonomous, circumscribed world. Still, a particular view of Giacometti's Surrealist project emerges, and distinct moments in a richly varied topography are captured. The subject is approached, drawn near to, passed by; our perceptions change accordingly. Of Giacometti and Surrealism there are always other stories to be told.

Notes

Translations are by the author, unless otherwise indicated. This essay owes much to the impeccable research assistance of Delphine Dannaud, the insightful reading of the text by Carolyn Lanchner and Roxana Marcoci, the essential support of Michelle Yun, and the editorial skills of Harriet Bee.

1. Alberto Giacometti, letter to Pierre Matisse, dated "Paris, jeudi" [1947]. The Pierre Matisse Gallery Archives, The Pierpont Morgan Library, New York, box 11, folder 7, letter 15.

2. Nancy Spector, *Felix Gonzalez-Torres* (New York: Solomon R. Guggenheim Museum, 1995): 125.

3. Roland Barthes, *Camera Lucida: Reflections on Photography*, trans. Richard Howard (New York: Hill and Wang, 1981): 96.

4. Susan Sontag, *On Photography* (New York: Dell Publishing, 1978): 15.

5. This reading is informed by Mignon Nixon's discussion of photographs of Louise Bourgeois and Eva Hesse posing with their own sculptures; see Mignon Nixon, "Posing the Phallus," *October* 92 (Spring 2000): 125.

6. David Sylvester, *Looking at Giacometti* (New York: Henry Holt and Co., 1994): 126.

7. Ibid.: 59.

8. André Malraux, quoted in Geraldine A. Johnson, "Introduction," in *Sculpture and Photography*, ed. Geraldine A. Johnson (Cambridge: Cambridge University Press, 1998): 1.

9. Giacometti, letter to André Breton, dated February 19, 1935. Giacometti's letters to Breton are preserved in the Bibliothèque littéraire Jacques Doucet, Paris.

10. Giacometti, letter to André Breton, dated Paris, June 18, 1947.

11. Jean Clay, "Albert Giacometti: le long dialogue avec la mort d'un très grand sculpteur de notre temps," *Réalités*, no. 215 (December 1963): 138.

12. Rosalind E. Krauss, *Bachelors* (Cambridge, Mass., and London: MIT Press and *October*, 1999): 5.

13. Rosalind Krauss was the first to consider extensively the impact of Bataille and *Documents* on Giacometti's Surrealist production; see Rosalind E. Krauss, "Giacometti," in William Rubin, ed., *"Primitivism" in 20th Century Art*, vol. 2 (New York: The Museum of Modern Art, 1984): 503–529.

14. There is no clear consensus about when Giacometti and André Masson met, but the following sources suggest 1927: Frances Beatty, "Chronology," in William Jeffett, *André Masson: The 1930s* (St. Petersburg: Salvador Dalí Museum, 1999): 142; and Julia Kelly, "Chronology, 1896–1943," in Carolyn Lanchner and William Rubin, *André Masson* (New York: The Museum of Modern Art, 1976): 213. Part of the confusion stems from conflicting opinions over the date of Giacometti's and Masson's collaboration on the work *Metamorphosis*; some believe they collaborated in 1927, others in 1929. See Frances Beatty, Julia Kelly, and Patrick Elliott, "Alberto Giacometti: An Introduction," in *Alberto Giacometti, 1901–1966* (Edinburgh: National Gallery of Scotland, 1996): 19.

15. Giacometti's *Suspended Ball* made its first public appearance in Paris during the same year as the Surrealists' polemical collage exhibition, *La Peinture au défi*, and the notorious screening of Buñuel's and Dalí's second film *L'Age d'or*.

16. See, for example, Giacometti, letter to his parents, Annetta and Giovanni Giacometti, dated Paris, May 26, 1929. Copies of Giacometti's letters to his parents are preserved in the archives of the Kunsthaus Zürich.

17. Carl Einstein, "Exposition de sculpture moderne," *Documents* 7 (1929): 391.

18. Giacometti's correspondence with Pierre Matisse is filled with references to his interest in photographs of his work; see in particular his letter [February–March 1951]: "In two of these photographs, I see things that are very useful for me and that hold no interest for anyone else." The Pierre Matisse Gallery Archives, The Pierpont Morgan Library, New York, box 11, folder 18, letter 83.

19. Michel Leiris, "Alberto Giacometti," *Documents*, no. 4 (1929): 210.

20. James Clifford, "The Tropological Realism of Michel Leiris," *Sulfur* 5, no. 3 (1986): 4.

21. Leiris, "Alberto Giacometti," 210; trans. James Clifford, "Alberto Giacometti," *Sulfur* 5, no. 3 (1986): 39.

22. Clifford, "The Tropological Realism of Michel Leiris": 14.

23. For a useful discussion on Giacometti and fetishism see Dawn Ades, "Surrealism: Fetishism's Job," in Anthony Shelton, ed., *Fetishism: Visualising Power and Desire* (London: The South Bank Center, 1995): 79–80.

24. Yves-Alain Bois, "Base Materialism," in Bois and Rosalind E. Krauss, *Formless: A User's Guide* (New York: Zone Books, 1997): 55.

25. Regarding Bataille's and Leiris's attempts to reconceive aesthetic value, see William Pietz, "Fetish," in Robert S. Nelson and Richard Shiff, eds., *Critical Terms for Art History* (Chicago: The University of Chicago Press, 1996): 202–203.

26. Leiris, "Alberto Giacometti": 209; trans. Clifford, "Alberto Giacometti": 38.

27. Leiris, "Alberto Giacometti": 210; trans. Clifford, "Alberto Giacometti": 39.

28. Leiris, "Alberto Giacometti": 210; trans. Clifford, "Alberto Giacometti": 40.

29. Krauss, *Bachelors*: 7.

30. For a thorough discussion of *Suspended Ball* and photographs of its various known versions, see Agnès de la Beaumelle, in *Giacometti: La Collection du musée national d'art moderne* (Paris: Centre Georges Pompidou and the Réunion des musées nationaux, 1999): 60–63.

31. Most sources suggest that the exhibition took place sometime in spring 1930. See for example Agnès de la Beaumelle, "A l'occasion du centenaire de la naissance d'André Breton, une nouvelle acquisition du Centre Georges Pompidou: *Boule suspendue,* 1930–1931 par Alberto Giacometti," *La Revue du Louvre et des musées de France* 47 (February 1997): 19–20.

32. See Beaumelle, *Giacometti: La Collection du musée national*: 62. The work was first published with the title *Suspended Ball* in Salvador Dalí, "Objets surréalistes," *Le Surréalisme au service de la revolution,* no. 3 (December 1931): 16.

33. Dalí, "Objets surréalistes": 17; trans. Haim Finkelstein in *Salvador Dalí's Art and Writing, 1927–1942: The Metamorphoses of Narcissus* (Cambridge, New York, and Melbourne: Cambridge University Press, 1996): 163.

34. Krauss, "Giacometti": 512–514. Krauss bases her interpretation on Roland Barthes's reading of Georges Bataille's series of ocular forms in *Histoire de l'oeil*, 1928; see also Hal Foster, *Compulsive Beauty* (Cambridge, Mass., and London: MIT Press and *October*, 1993): 92-93.

35. For connections drawn between *Un Chien andalou* and *Suspended Ball,* see Ades, *Fetishism*: 76; Finkelstein, *Salvador Dalí's Art and Writing*: 164–165; Krauss, "Giacometti": 512; and Thierry Dufrène, *Alberto Giacometti: Les dimensions de*

la réalité (Geneva: Editions d'art Albert Skira, 1994): 61.

36. Krauss, *Bachelors*: 5.

37. Dalí, "Objets surréalistes": 16.

38. Ibid., trans. Finkelstein, *Salvador Dalí's Art and Writing*: 163.

39. Alberto Giacometti, "Objets mobiles et muets," *Le Surréalisme au service de la révolution*, no. 3 (December 1931): 18-19.

40. Foster, *Compulsive Beauty*: 92.

41. This discussion is indebted to Dufrène's analysis of the cage format in Giacometti's Surrealist work; see Dufrène, *Alberto Giacometti: Les dimensions de la réalité*: 55–56.

42. Christian Zervos, "Quelques notes sur les sculptures de Giacometti," *Cahiers d'art*, nos. 8-10 (1932): 337–342.

43. See Sylvester, *Looking at Giacometti*: 49, and Foster, *Compulsive Beauty*: 84, for Giacometti's preferred Surrealist formats.

44. Krauss, "Giacometti": 521.

45. Alberto Giacometti, "Je ne puis parler qu'indirectement de mes sculptures. . . ." *Minotaure*, nos. 3-4 (December 1933): [46].

46. Beaumelle, *Giacometti: La Collection du musée national*: 112.

47. André Breton, *Manifestoes of Surrealism*, trans. Richard Seaver and Helen R. Lane (Ann Arbor: University of Michigan, 1972): 21.

48. Giacometti, "Je ne puis parler": [46] .

49. Ibid.

50. Even the position of the unattached "vertebrae" cage on the right appears to have been straightened, although this is just as likely due to Brassaï's hand as Giacometti's. Correspondence with Breton suggests Brassaï's photographs for *Minotaure* were taken while Giacometti was in Switzerland.

51. "Entretien avec Georges Charbonnier," in Michel Leiris and Jacques Dupin, eds., *Alberto Giacometti: Écrits* (Paris: Hermann, 1990): 242.

52. Giacometti, letter to Pierre Matisse, dated "Paris, jeudi" [1947]. The Pierre Matisse Gallery Archives, The Pierpont Morgan Library, New York, box 11, folder 7, letter 15.

53. Giacometti, "Je ne puis parler": [46].

54. Giacometti, letter to Breton, dated August 22, 1933.

55. Dufrène, *Giacometti: Les dimensions de la réalité*: 65. Dufrène is the first to draw an analogy between the *Palace*'s fragile material con-

struction and fragile psychic relationships. His reading of this work, and many others from Giacometti's Surrealist period, is essential, as is Reinhold Hohl's extensive discussion of Giacometti's many iconographical sources; see, for example, his classic monograph, *Alberto Giacometti: Sculpture, Painting, Drawing* (London: Thames and Hudson, 1972).

56. Giacometti, "Je ne puis parler": [46]

57. I am deeply grateful to Casimiro Di Crescenzo for bringing Giacometti's two small, previously unpublished, studio sketches to my attention. For a detailed consideration of Giacometti's finished "presentation" pair of studio drawings, see Reinhold Hohl, "Giacomettis Atelier im Jahr 1932," in *Alberto Giacometti: Zeichnungen und Druckgraphik* (Tübingen: Kunsthalle, 1981): 38–55.

58. Alberto Giacometti and André Breton, "Le Dialogue en 1934," *Documents* 34, no. 1 (June 1934): 25.

59. Dufrène, *Giacometti: Les dimensions de la réalité*: 44, 68–69.

60. Linda Williams, *Figures of Desire: A Theory and Analysis of Surrealist Film* (Berkeley, Los Angeles, and Oxford: University of California Press, 1981): 87.

61. Letter from Giacometti to Pierre Matisse, dated December 1947, first published as "Lettre à Pierre Matisse," in *Alberto Giacometti*, trans. Lionel Abel (New York: Pierre Matisse Gallery, 1948).

Phenomenon and Imagination
Giacometti's Concept of Vision

Tobia Bezzola

In general, the literature on Alberto Giacometti places the beginning of his major work somewhere in the early 1950s.[1] Exhibitions, too, tend to emphasize the sense of fulfillment in the grand finale of his career. The thirty years of work preceding that finale are seen as a preparation for this breakthrough to a culminating authenticity. The formal diversity of Giacometti's earlier work and the late onset of public recognition seem to support this interpretation. Nevertheless, the logic of these assumptions bears reexamining in the light of the present career retrospective. This requires an analytical approach, and the argument should aim to make the sequence of discrete phases, periods, and stylistic levels plausible as a formal continuum of cause and effect. Yet the purpose of a retrospective is not only teleological and analytical but synthetic as well. Hindsight enables us to grasp the unifying principles within the diversity of the work itself—the unity within multiplicity—and to look beyond the mutability of the form to the consistency of the intention.

In 1962 Giacometti remarked that his day-to-day work was governed by "exactly the same concern"[2] that had prompted him to embark on his first sculpture at the age of thirteen, in 1914. He viewed his own development as a constant process of working on a single basic problem, which remained the same, whatever the form assumed by his successive attempts to resolve it. Since this consistency is not immediately apparent to the viewer, he never tired of pointing it out in his own statements.[3]

The unity of Giacometti's artistic ambition resides in a single, constant preoccupation, which he himself defined on several occasions as "rendering my vision."[4] He meant that to match the visual experience and at the same time capture visions of the transcendental are the twin conceptual poles that govern his interpretations of his own formula. His equivocal use of the word *vision* tends to mask the inherent contradictions within his artistic intention. But these contradictions manifest themselves as part of a conscious methodology: a distinctive *via negativa* of infinite reflection driving his attempts to grasp the ephemeral phenomenon that reveals itself only through the ways in which it constantly evades the artist's intervention. The aporias (paradoxical impasses) of mimesis disclose the outlines of the latent aesthetic idea, namely, that in the moment of revelation the aesthetic epiphany is not mimetic but ecstatic.[5]

Giacometti and Existentialism

An examination of the theoretical aspects of Giacometti's work must start with the conventional wisdom that the work in question exemplifies "existentialist" thought. Giacometti is said to formulate a metaphor for the human individual as, for example, a "scrap of humanity struggling for life in the tide of time."[6] It is not easy, however, to find a discussion of his work in which this sweeping assertion is worked out in any detail.[7] Here, commentators tend—and probably always have tended—to refer to existentialism in rather "atmospheric" terms, as an "ism": a postwar Parisian syndrome, a culture and a way of life among academic philosophers and writers of essays, journalism, plays, novels, films, and *chansons*.[8] Such interpretations typically present the Existentialist worldview and philosophy of life as a fashionable cultural medium: nihilism, angst, nausea, loss of meaning, the absoluteness of finitude, the triumph of the absurd. Giacometti's work is enlisted as a metaphor for alienation, the existential sense of dread and oppression, or the isolation of monadic subjectivities: the human condition as aporia. "Giacometti" becomes a name to contend with: Portrait of the Artist as Existentialist. The artist is identified with his work, and "man capsizing" [*l'homme qui chavire*], comes to encapsulate an Existentialist philosophical anthropology.

It is true that Giacometti's late self-analyses often tend to take the form of self-indictments. He recounts the history of his work as a history of failure; the horizon of his expectations is defined no longer by the possibility of success but by the possibility of understanding something of the reasons for total failure.[9] This self-interpretation then generates ways of reinterpreting Giacometti's failure as success: either by regarding it as a matter of temperament—hybrid modesty, whimsical coquetry, or rationalized obsession [*folie raisonnante*]—or by erecting the negativity of failure into the defining principle of an aesthetic or metaphysical system.[10] Here a clear contemporary analogy exists with the philosophies of failure propounded (in partly explicit reference to the work of Karl Jaspers) by Albert Camus, Jean-Paul Sartre, and Samuel Beckett.[11] The mere fact that Giacometti knew these three men personally appeared to justify the interpretation of his work as an exemplary articulation of an Existentialist world-view.[12]

Some famous Existentialists may well have recognized themselves in Giacometti's work, but that does not make *him* an Existentialist. There is nothing Existentialist anywhere in his writings or in his recorded conversations. Giacometti's way of talking about failure is highly specific to him. He uses the term in a reflection upon the historical and systematic unity of his work. This failure is a methodic failure. First, it is the means whereby progress is made in clarifying fundamental epistemological and creative issues through a radical and self-critical reevaluation of work done; as such, it is analogous to the "method of doubt" [*doute méthodique*] of René Descartes. The creative process cannot attain ultimate truth; the creative artist therefore seeks to attain at least certainty as to the limitations of the method that underlies that process. Self-criticism is the definition of an artistic problem; the artist's productive failure, through and with his method, becomes the motive power of the prosecution of the work.

Giacometti establishes for himself the coherence and consistency of his own development, first of all, through the literary stylization of a narrative of key experiences: childhood memories and sexual fantasies, retailed in the manner of the Surrealist "artist's text";[13] youthful experiences;[14] earliest encounter with death.[15] His commentators have produced exegeses of the psychological factors that are implicit in these narratives.[16] But when we come to Giacometti's later accounts, given in conversation, of experiences that sharply disrupted his whole relationship with the world and with reality, the emphasis is quite different.[17] His texts, which were written as literature, contain a stratification of biographical and theoretical elements; his numerous interviews of the 1950s and 1960s, on the other hand, are all about problems in his practical work: crises of perception, problems of a disciplined vision of an unruly world.[18]

Epistemology

Just as Paul Cézanne's paintings can be described as "a painted epistemological critique,"[19] the work of Giacometti, too, is inspired by a rigorous pursuit of truth: "Art interests me greatly, but truth interests me infinitely more."[20] His path to truth takes him by way of an idiosyncratic artistic phenomenology. That is to say, the adequate representation of the phenomenal world, the world of appearances, requires first of all a thorough investigation of the process of visual cognition.

We cannot assume that Giacometti consciously adopted the method of inquiry known as phenomenology, described by Edmund Husserl, although in August 1926 Husserl and his former student Martin Heidegger **discussed** the "style and vision of essence" [*Wesensstil* and *Wesensschau*] at Silvaplana, a stone's throw away from Giacometti's parental home at Maloja, where the artist was spending the summer.[21] It is hardly likely that the young sculptor would have fallen into conversation with the two German professors. But in Paris in the 1930s, and in Giacometti's own circle (Michel Leiris, Georges Bataille, Jacques Lacan), phenomenology and phenomenological readings of Georg Wilhelm Friedrich Hegel were everywhere, as a consequence of Husserl's lectures at the Sorbonne in February 1929[22] and of Alexandre Kojève's course, "Introduction to the Reading of Hegel" at the École Pratique des Hautes Études (1933–39).[23] The marriage of phenomenology and the Hegelian dialectic forms the connecting link between the heterodox Surrealism of Bataille's circle (in the 1930s) and the early Existentialism of Sartre's *Being and Nothingness* (1943). Simone de Beauvoir later introduced Giacometti to Maurice Merleau-Ponty's *Phénoménologie de la perception* (1945).[24] As an alert and sociable contemporary, Giacometti could not possibly overlook the many phenomenological trends within the Parisian intellectual milieu. However, all this represented a convergence of interests rather than a case of theoretical inspiration. Giacometti's phenomenological problems sprang from his work as an artist. He had inherited the Post-Impressionist interest in the theory of optical perception that had led many late-nineteenth-century artists to borrow from contemporary work in epistemology and the psychology of perception. To this extent, phenomenological research was part of the contemporary frame of reference that enabled Giacometti to communicate his ideas about his work.

The exploration of the perceiving consciousness and of what is perceived by it, the experience in relation to that which is experienced, and the analysis of the perception of the real as a phenomenon, define Giacometti's project of creating an "art as the science of sight."[25] This approach—with its analyses of the object, of perception, and of representation—is genuinely phenomenological. The method both fulfills and validates itself in the representation of the phenomenon

that appears. Its aim is not knowledge but mimesis: rendering, copying, representing, making are the actions that are required to do justice to the reality of the object as it presents itself to the "vision" of the observing subject. From the outset, Giacometti's theory of representation thus transcends the traditional theory of sculpture, with its Platonic dichotomy of *eikastic* and *phantastic* representation;[26] in other words, it abolishes the distinction between geometric and optical likeness. That truth in sculpture is not attained through geometric conformity—that a sculpture must differ in form from that which it represents—is a basic presupposition. The key relationship here is not between the observing subject and the geometric ideal but between the observing subject and the phenomenal world. This is not to say that Giacometti entirely dispenses with ideality. For him, the "reality" of the object as an artistic conception manifests itself to "vision" in two ways. It is a contingent phenomenon at a specific moment, in a specific light, at a specific distance, and from a specific angle of sight; but it is also a phenomenon of identity, synthesizing ephemeral experiences within the manifold modes of givenness. The quest for adequate representation through a methodical examination of perception thus amounts—and this is the curious parallel with Husserl—to a kind of "inquiry into essences" [*Wesensforschung*]. The artist's action is not directed solely toward individual existence at a random moment in time but always also toward an abstract essence, an *eidos*, which manifests itself through the many contingent modes of givenness but ultimately transcends them: "The form must be fixed in an absolute manner."[27] Disciplined by method, the artist's vision is a vision of essence(s), pursuing invariant forms through all their "adumbrations."[28] In working from life, the artist performs an "*eidetic* reduction" with brush and spatula, oil and clay, predicated on the assumption that artistic experience, through its isolated concentration on representational analysis (and analytical representation), permits us to transcend contingent form and attain essential form. Both aspects are preserved in the likeness afforded by the finished artwork. In the work of art, the process of abstraction is mediated by the style, just as in the work of theory it is mediated by the concept: "Have you noticed that, the more true a work is, the more style it has?"[29]

Neither the measured, perspectival correctness of veristic rendering (which Giacometti identified with the discarded Greco-Roman tradition of sculpture) nor the contingent phenomenon, as seen in Impressionism, is meant here; this is a form of stylization, whereby the phenomenon is reduced to its essence, into which direct sight is subsumed, and which confirms the oneness of the gestalt despite the multiplicity of its aspects. For Giacometti, this ideal of a "conception" that preserves the contingent aspect of the phenomenon in a higher knowledge of reality is perfectly exemplified by Egyptian sculpture,[30] which he likens, significantly, to the painting of Georges Seurat.[31]

Aporias

Methodological reflection on the artist's work evokes problems that *poiesis*, the making of art, cannot solve. "Art as a science of sight" means knowledge not *about* sight but *through* sight (or vision). This aspiration to grasp the truth of the world through mimesis encounters problems that are not so much practical as theoretical. As Giacometti realized, "appearance" can mean two different things: the experience and the object that is experienced.[32] The representation can never get at the whole truth of the appearance through concentrating on appearance as experience. This is because, in Husserl's somewhat labored formulation, "on principle, the spatial gestalt of the physical thing can be rendered only in mere one-sided adumbrations."[33] Giacometti seeks truth in the totality of possible experience of the object, and is obliged to recognize that no experience can ultimately contain within itself all possible experiences, because, in Husserl's words, "all multiplicity of experience, however far extended, leaves open the possibility of even closer, new definitions of things."[34]

To Giacometti, this is a matter of everyday practical experience: "If I look you full in the face, I forget the profile. If I look at the profile, I forget the full-face."[35] The artist can always make (i.e., define) only *one* contingent phenomenon in oil or clay. This is then falsified as soon as the artist looks back at the object, which will appear infinitesimally different: "Every time I look at the glass, it seems to remake itself."[36] Given the nature of Giacometti's intention, his discipline of sight results in a work that is essentially unfinishable: "It is impossible to capture a figure as a whole."[37] The principle is not so much *non finito* as *non finibile*. Representation becomes a

process without an end—not on account of any empirical defect, but by definition: an endless overpainting of what has been painted, a repeated scraping away to reveal what was previously rejected but now appears new or at least different.[38] Giacometti's often-lamented inability to finish anything, his discontent with any fixed state, has its foundation in the fact that beyond the impossibility of capturing a momentary phenomenon lies the ambition of making an *eidos*, an essential form (*Wesensform*). The ambition of representing the essence overrides the representation of mere existence. Merleau-Ponty described Cézanne's vain effort (which is Giacometti's, too) to arrive at the physiognomy of a thing or a face by means of a complete reconstitution of the sensory configuration.[39] This theory subsumes perspective into bodily presence; the synergetic constitution of bodily perception as a whole obtains and guarantees the consistency of ideal types.[40] This solution is not accessible to mimesis. Giacometti's aim (to obtain for the form a sculptural or pictorial equivalent that subsumes all of the perceptual aspects of the thing) remains unattained: "The heads, the figures, are nothing but continual movement They constantly remake themselves."[41] Nor can phenomena be reduced to geometrical essences: "They are neither cube, nor cylinder, nor sphere, nor triangle."[42] Anything that can be captured by mimesis is of dubious ontological status: "it is always squarely caught between Being and Nonbeing."[43] As we seem to come closer to Being, it becomes more evident that the work of art cannot render the intentional unity of the object as experienced: "The nearer you get, the farther away the thing goes. It's an endless quest."[44]

Giacometti thus acknowledges the naïveté of his own initial assumptions: "You never copy the glass on the table; you copy the residue of a vision."[45] Ultimately, the formal creation evades the making of an "absolute form"; what is more, the simple reproduction of a thing in itself defeats one's best efforts. Not only is it impossible to synthesize experience through mimesis; it is far worse than that: the real is by definition inaccessible to mimesis. "Visual things" [*Sehdinge*], as objects, are by definition inaccessible.[46] Giacometti's analysis of his perception and of the concept of the phenomenon leads him to the theoretical crux of the "transcendence of the thing versus its perception."[47] No bridge leads from the experience to the object. Between any perceptible adumbra-tion of the object as experience and the thing that is adumbrated there is a distinction of principle, and no refinement of experience can bring us to the pure object.[48] This shock of the loss of reality, the realization that in the strict sense it is impossible to render a thing either in perception or in consciousness, left only one way open to Giacometti in his early efforts to subsume the object into experience and absorb it into the work of art. Intuitively, he turned away from empirically based sculpture and toward the "object" generated in a process of ideation—the image of pure *phantasía*. Only an "object" unmediated by perception can be adequately represented as a three-dimensional object. The Surrealist approach of inventing *objets* thus stands revealed as a specific attempt to solve phenomenological problems.

Phantasía

One way out of this problem is to redefine appearance. In the late 1920s the *phainómenon* gave way to the *phantasía*. However, the name stayed the same. Giacometti went on using the French word *vision*, and this enabled him to assert the identity of all his efforts; but the meaning attached to it was an entirely new one. The supreme goal of art, he said, was to give adequate expression to vision; but he now defined this not as the visual act—not as an experience of something palpably given in time and space through its phenomenal appearance—but as the visionary experience. "Vision" was now receptive to memory, mental representation, intuition, dream, enthusiasm, delusion, and ecstasy. "Appearance," for Giacometti, ceased to refer to the phenomenon and its *apparence*; it was now the imagination—*phantasía*—and its apparition. It was not the power of productive imagination, but its product: the imaginative image, the inner image that appears.

In this interpretation of the concepts of *vision* and *appearance*, Giacometti discovered his affinity with the Surrealist movement. In the late 1920s, the Surrealist quest for a super-reality did for Giacometti just what the ubiquitous debates on phenomenology were to do in the 1950s: it offered him a conceptual context in which to formulate and develop problems related to his work. The earliest full exegesis of this new definition of *vision* (under the title "Crisis") is to be found not in a text by Giacometti but in the earliest published

article on his work, written by Michel Leiris for Bataille's journal *Documents* in 1929.[49] Leiris's brief text is an attempt to extract the key factor in Giacometti's objects that enables them to trigger an intensity of physical excitement that is otherwise achieved only by erotic fetishes. His conclusion is that they do this because they are the "petrifaction" of moments of "crisis": "Such are the moments when, abruptly, the outside seems to respond to the summons that we issue to it from inside; when the external world opens up and suddenly there is communication between our hearts and it."[50]

Leiris's examples of such moments of profane illumination, in which the relations between inner and outer worlds are shockingly [*brusquement, soudain*] brought to a head, anticipate—almost word for word, at times—some of Giacometti's accounts of his own unmediated experience.[51] For, in due course, Giacometti did describe his own visionary episodes. Thus, vision offers itself to him (in a way that has an ancient tradition behind it)[52] in moments of violent emotion: horror, terror, or shock. The presence of a neighbor's corpse provokes an apparition that abolishes the barrier between the self and the world. The living and the dead, the body and its boundaries, blur into indistinguishability: "I was overcome by a real terror and . . . I had the vague impression that T. was everywhere."[53] At the same time, in this experience Giacometti recognizes an analogy with the no less horrific experience of perceiving his living models as lifeless objects: "The first time I looked at a head and clearly saw it freeze and immobilize itself in an instant, irrevocably, I trembled with terror as never before in my whole life. . . . All the living were dead; and this vision repeated itself often."[54]

The association between these two modes of sight is instructive. The controlled, methodical sight (or vision) of the phenomenon within the day-to-day discipline of sketching and modeling attains its peak of urgency in an unintended, sudden, unmediated form of sight: vision as an invasive moment of revelation. With radical suddenness, the artist receives a knowledge of reality that can never be lost or evaded—although the intensity of the initial experience cannot be recalled at will.

These epiphanies are not always associated with death. For Giacometti, the sight of young girls on the Corso in Padua, one evening, far exceeded the intensity of vision provoked not long before by Tintoretto and Giotto. Eros put all the efforts of art to shame: "I looked at them in a state of hallucination, overcome by a sensation of terror. It was as if reality had been ripped apart. The whole meaning and relationship of things had changed."[55] In the 1940s, a visit to the movies precipitated a similar experience. Giacometti was suddenly unable to see anything on the screen but meaningless shapes. Back on the street, he was overwhelmed by the enormous gulf between the two-dimensionality of the world on the screen, projected in a geometric and optical reduction, and the immense complexity of real perception: "All of a sudden, there was a schism. . . . I felt that I was in the presence of something I had never seen before, a completely changed reality. . . . Then the vision of everything was transformed."[56] Here it is particularly clear how aspects of "vision" (in the sense of *phantasía*) govern the praxis of vision (in the sense of a methodical, disciplined artistic treatment of the phenomenon). In Giacometti's thinking, the concept of appearance as *phainómenon* is inseparably bound up, in a single vision, with appearance as *phantasía*. Both combine in the schism, the ripping apart (*déchirement*) of reality. All three of the narratives just cited are about the relation between artistic, disciplined, "energetic" sight, on the one hand, and passive, unmediated, meta-optical experience on the other.

All of these stories are allegories of art; they are about the inability of a schooled and competent artistic vision to compete with those visions that life unleashes on you unsought: the practiced "killing" of the model by the artist's eye contrasts with the powerful presence of the look of a dead man; the concentrated vision of the works of Giotto and Tintoretto is obliterated by the blazing apparition of the young women of Padua; the flat, perspectival projection on the movie screen—which has been a standard model for art since the Renaissance—fades into a dull patchwork when confronted with the sudden, visionary revelation of the unimagined riches of everyday sensory perception.

Sight and Vision

It was, as I have said, this version of the concept of *vision* that made possible Giacometti's effortless approach to Surrealism. For him, no doubt, it also had a specific biographical relevance. His father's generation was marked by a strong

antirationalistic tendency. On all sides, readers of Friedrich Nietzsche were urging artists to transcend the various drab, sociological, or mathematical-empirical versions of Realism and Naturalism and the scientific ideals of Impressionism, and to attain an *Überrealismus,* or Superrealism. Abandon the stolid passivity of recording and analysis, they said, and give shape to higher realities warranted by inner experience. Symbolism, with its use of the word *vision,* was rebelling against the patient technique of the eye, the rhetoric of pure "sight," *à la* Cézanne. The word *visione* (which in Giacometti's native Italian denotes not only sight but appearance, hallucination, and apparition) was present in his mind from the cradle. Growing up between two competing tendencies of the late nineteenth and early twentieth centuries, he observed their conflicting effects in his father's artist friends (Giovanni Segantini, Cuno Amiet, and Ferdinand Hodler) and to some extent in Giovanni Giacometti himself. Cézanne's example led to a meticulous analysis of appearance as a complex body of visual impressions. At the same time, many turn-of-the-century painters modified the sober reconstruction of optical experience with an expressively intensifying color and by introducing elements of fantasy into their pictorial invention. Segantini's dictum that the artist must "draw new impulses from his inner sight," while simultaneously doing justice to the "constant shifts of colours and light"[57] in objects, embodies the polarity inherent in Giacometti's quest for a synthesis of the two meanings of *vision.*

"As I did want to realize in some way what I saw, I started . . . to work at home, from memory."[58] As this paradoxical formulation shows, the implicit polarity took on a practical relevance in Giacometti's complex approach to the issues of principle involved in choosing whether to work from life or "from memory."[59] In the course of his life, there are some famous outbursts of fierce determination to work exclusively from life; there are the mediating attempts to "realize from memory what I had seen";[60] and there are times when both aims are pursued in parallel—since Giacometti's drawing and painting, unlike his sculpture, remain broadly committed to the paradigm of Cézanne. (It also seems as though *vision,* in the sense of *phantasía,* never prospered in his native Stampa but remained confined to Paris.) There is the phase—generally described as "Surrealist"—of exclusive concentration on the inner image of "interior and affective vision" [*vision affective et intérieure*]; and, behind the stylistic development and the sequence of phases in his output, we always detect a corresponding level of work on the concept of *vision.* There is no linear progression. Giacometti oscillated between two extremes: on the one hand, self-schooling in a phenomenological, prelapsarian mode of sight ("academic" periods, 1935–40 and 1956–66) and, on the other, the realization (or, as he called it, the *construction*) of the inner vision (1925–35). The period that has been most extensively discussed is his final phase of radical empiricism, in the late 1950s and 1960s, in which the descriptive analysis of the model, seen in isolation, dominates, and in which, as has been shown, Giacometti tackles and elucidates phenomenological problems.

This was preceded by an intermediate phase of mimetic reconstruction of moments of sudden, inspired vision. Those works of about 1950 (*The Chariot, The Cage* [*Woman and Head*], *Four Women on a Base,* etc.) that universalize the experience of a precise moment[61] may be understood as attempts to mediate the concept of vision, which had dominated Giacometti's surreal and primitivistic phases, by returning to the observation of Nature: each work was the formal realization of a *phantasía* that had its factual origin in a "privileged moment" of visual experience: in the momentarily intensified lucidity of a specific observation of the real world.

In the work of Giacometti's last period, the wheel came full circle. After many and varied forms of reflection, he returned to the aspiration of his youth: "rendering my vision" [*rendre ma vision*] in the sense of "rendering what is seen" [*rendre ce que l'on voit*]. As at the beginning of his career, he now confined himself to representing what was before his eyes. "To realize a thing that is external to myself" [*réaliser une chose qui m'est extérieure*] now once more appeared to him as the true challenge.

As for the *vision intérieure* of Surrealism, this had become artistically unattractive to him. Because it was a mental representation that offered itself suddenly and completely, and required only to be put into execution, it now offered "no difficulty."[62] Surrealist objects, being based on a *vision intérieure,* require no prior spatiotemporal experience. The Surrealist object does not represent an *objet;* it merely presents it. This means that it is free *phantasía,* transcending empirical reality but at the same time losing it. To that extent,

inner vision, and the art derived therefrom, are "outside truth,"[63] which is why Giacometti ultimately rejected them.

The metamorphoses of the concept of *vision* that I have outlined here may serve to explain how it became possible for Giacometti to declare that his abstract and Surrealist works sprang from the same source as his earlier and later "figurative" work: the effort to "render my vision." The Cubistic, primitivistic, and archaizing sculptures, and the Surrealist objects, are direct attempts to create an *eidos* that synthesizes the multiplicity of experience: by abstracting and reducing the multiplicity of appearances, by reinventing the modes of appearance of the transcendental in preliterate peoples or vanished cultures (here, Giacometti speaks of the *double*), and by outward realization of inward experience. Abstraction, primitivism, archaism, and Surrealistic ideation are consequences of Giacometti's perennial, self-imposed project of reproducing the essence of the real and subsuming the totality of all possible moments of empirical perception into a pure form born of pure vision.

This essay has been translated from the German by David Britt.

1. Yves Bonnefoy, *Alberto Giacometti: Biographie d'une œuvre* (Paris: Flammarion, 1991): 371 ff.

2. [*exactement le même souci*]: "Entretien avec André Parinaud" (1962), in *Écrits/ Alberto Giacometti*, ed. Michel Leiris and Jacques Dupin, 2nd ed. (Paris: Herrmann, 1997): 269.

3. The interpretation of those statements involves difficulties that can be no more than mentioned here. Giacometti's terminology is not consistent, and both kinds of utterance, the poetic fragment and the interview, have specific problems of their own.

4. [*rendre ma vision*]: *Écrits:* 266 f.

5. For a discussion of "profane illumination," see Walter Benjamin, "Der Surrealismus: Die letzte Momentaufnahme der europäischen Intelligenz," in idem, *Ausgewählte Schriften*, vol. 2 (Frankfurt: Suhrkamp, 1988): 202; and Karl Heinz Bohrer, *Plötzlichkeit: Zum Augenblick des ästhetischen Scheins* (Frankfurt: Suhrkamp, 1981).

6. Paul Nizon, *Diskurs in der Enge* (Frankfurt: Suhrkamp, 1990): 212.

7. "In his prolific utterances, no Existentialist philosophy emerges, and yet visual metaphors for Existentialist conceptions are to be found in his sculpture." Alfons Grieder, "Existentialistische Skulptur? Betrachtung zu Richiers und Giacomettis Werk," in *Raum und Körper in den Künsten der Nachkriegszeit* (Berlin: Akademie der Künste, 1998): 158.

8. Visual art had its place within this. Giacometti shares the Existentialist label with a number of other artists in Paris in the 1940s and 1950s with whom he had no compelling stylistic affinities, among them Jean Dubuffet, Jean Fautrier, Francis Gruber, Bernard Buffet, Germaine Richier, and Wols. Even Picasso is credited with an Existential period. For a discriminating account of all this, see Sarah Wilson, "Paris Post War: In Search of the Absolute," in Frances Morris, *Paris Post War: Art and Existentialism 1945–55* (London: Tate Gallery, 1993): 25-52; see also Barbara Regina Renfle, *Picasso und der Existentialismus: Existentialistische Grundstrukturen im Werk Pablo Picassos* (Frankfurt: Peter Lang, 1998).

9. "This is no longer in order to realize the vision that I have of things, but to understand why it doesn't work." [*Ça n'est plus pour réaliser la vision que j'ai des choses, mais pour comprendre pourquoi ça rate*], *Écrits*: 284.

10. Such references include those to Sisyphus, Prometheus, or Pygmalion, Balzac's Frenhofer, and "Cézanne's doubt." On the last-mentioned, see Maurice Merleau-Ponty, "Le Doute de Cézanne," in idem, *Sens et non-sens* (Paris: Gallimard, 1948): 15-50.

11. Karl Jaspers, *Philosophie*, vol. 3 (Berlin: Springer, 1934): 220 f.

12. The first skeptical response came from Hilton Kramer, "Giacometti," in *Arts Magazine* (November 1963): 52-59. His doubts were reiterated in Reinhold Hohl, *Alberto Giacometti*, 2nd ed. (Stuttgart: Hatje, 1984).

13. "Hier, sables mouvants" (1933), *Écrits*: 7 ff.

14. "Mai 1920" (1952), ibid.: 71 ff.

15. "Le rêve, le sphinx et la mort de T." (1946), ibid.: 27 ff.

16. On Giacometti's texts in the context of Surrealist artists' writing, and specifically their writing on art, see André Lamarre, "Giacometti est un texte: Microlectures de l'écrit d'art," Ph.D. diss., Université de Montréal, 1992. A synthesis of the psychoanalytical interpretations that have arisen from Giacometti's texts is provided in Bonnefoy, *Alberto Giacometti: Biographie d'une oeuvre*.

17. What follows is based on interviews with Georges Charbonnier, Pierre Schneider, André Parinaud, Pierre Dumayet, and David Sylvester, *Écrits*: 241-295.

18. See ibid.: 269 f.

19. [*eine gemalte Erkenntniskritik*]: Fritz Novotny, "Das Problem des Menschen Cézanne im Verhältnis zu seiner Kunst," *Zeitschrift für Ästhetik und allgemeine Kunstwissenschaft* 26, no. 6 (1932): 278.

20. [*L'art m'intéresse beaucoup, mais la vérité m'intéresse infiniment plus.*]: *Écrits*: 267.

21. On the conversations at Silvaplana and their importance for the transition between phenomenology and Existential philosophy, see Hans Blumenberg, *Lebenszeit und Weltzeit* (Frankfurt: Suhrkamp, 1986): 16 ff.

22. See Edmund Husserl, *Méditations cartésiennes,* trans. E. Lévinas and G. Pfeiffer (Paris: A. Colin/Bibliothèque de la Société Française de Philosophie, 1931).

23. According to Kojève, Hegel's *Die Phänomenologie des Geistes* (1807) affords "a phenome-

nological description of human existence" [*une description* phénoménologique *de l'existence humaine*]. See Alexandre Kojève, "Introduction à la lecture de Hegel," ed. Raymond Queneau (Paris: Gallimard, 1947): 576. Among those who attended the lectures were Sartre, Merleau-Ponty, Lacan, Bataille, Breton, and Queneau.

24. See Simone de Beauvoir, *La Force de l'âge* (Paris: Gallimard, 1960): 499 ff.

25. This revealing definition of the project was coined by Reinhold Hohl, "Alberto Giacometti: Kunst als die Wissenschaft des Sehens," *Schweizerisches Jahrbuch "Die Ernte"* (1966): 133–150.

26. *Sophistes*: 236 a–c.

27. [*La forme doit être fixée d'une manière absolue.*]: *Écrits*: 241.

28. [*Abschattungen*]; the accepted French translation of the term is *silhouettes*. See Jean-François Lyotard, *La Phénoménologie* (Paris: Presses Universitaires de France, 1954): 20 and *passim*.

29. [*Avez-vous observé que plus une œuvre est vraie plus elle a du style?*]: *Écrits*: 273.

30. Ibid.: 245, 273 f.

31. Ibid.: 245.

32. "Not only the experience in which the appearance of the object consists but also the appearing object as such." [*Nicht nur das Erlebnis, in dem das Erscheinen des Objekts besteht . . . , sondern auch das erscheinende Objekt als solches*]: Edmund Husserl, *Logische Untersuchungen: Untersuchungen zur Phänomenologie und Theorie der Erkenntnis*, 2nd ed., vol. 2 (Tübingen: Max Niemeyer, 1913): 349.

33. [*Die Raumgestalt des physischen Dinges prinzipiell nur in blossen einseitigen Abschattungen zu geben ist.*]: Edmund Husserl, *Ideen zu einer reinen Phänomenologie und phänomenologischen Philosophie*, 2nd ed. (Tübingen: Max Niemeyer, 1922): 10.

34. [*Jede noch so weit gespannte Erfahrungsmannigfaltigkeit noch nähere und neue Dingbestimmungen offen lässt.*]: ibid.

35. [*Si je vous regarde en face j'oublie le profil. Si je regarde le profil j'oublie la face.*]: *Écrits*: 271.

36. [*Chaque fois que je regarde le verre, il a l'air de se refaire.*]: ibid.: 273.

37. [*impossible de saisir l'ensemble d'une figure*]: ibid.: 38.

38. See David Sylvester, *Looking at Giacometti* (London: Chatto & Windus, 1994): 125 ff.

39. Maurice Merleau-Ponty, *Phänomenologie der Wahrnehmung*, trans. Rudolf Boehm (Berlin: Walter de Gruyter, 1966): 373.

40. "To have a body means to have at one's disposal a comprehensive apparatus that comprehends and constitutes the typical aspects of all perspectival developments and intersensory correspondences beyond the portion of the world that is actually perceived in each case." Ibid.: 377.

41. [*Les têtes, les personnages ne sont que mouvement continuel, . . . ils se refont sans arrêt.*]: *Écrits*: 218.

42. [*Elles ne sont ni cube, ni cylindre, ni sphère, ni triangle.*]: ibid.

43. [*Il se trouve bel et bien toujours entre l'être et le non-être.*]: ibid.: 274.

44. [*Plus on s'approche, plus la chose s'éloigne. C'est une quête sans fin.*]: ibid.: 275.

45. [*Vous ne copiez jamais le verre sur la table; vous copiez le résidu d'une vision.*]: ibid.: 273.

46. Husserl, *Ideen*: 76.

47. [*Transzendenz des Dings gegenüber seiner Wahrnehmung*]: ibid.: 74 f.

48. "Experience is possible only as experience and not as something spatial. That which is adumbrated, however, is by definition possible only as something spatial (it is spatial in its essence), but not possible as experience." [*Erlebnis ist nur als Erlebnis möglich und nicht als Räumliches. Das Abgeschattete ist aber prinzipiell nur möglich als Räumliches (es ist eben im Wesen räumlich), aber nicht möglich als Erlebnis*]: ibid.: 75.

49. Michel Leiris, "Alberto Giacometti," *Documents*, no. 4 (Paris 1929): 209 f.

50. [*Il s'agit des moments où le dehors semble brusquement répondre à la sommation que nous lui lançons du dedans, où le monde extérieur s'ouvre pour qu'entre notre cœur et lui s'établisse une soudaine communication.*]: ibid.: 209.

51. Christian Klemm has pointed out the "retro-active" nature of this text, in idem, *Die Sammlung der Alberto Giacometti Stiftung* (Zürich: Kunsthaus, 1990): 14.

52. See Rudolf Otto, *Das Heilige* (Breslau: Trewendt and Granier, 1917): 18 f.

53. [*Je fus pris d'une véritable terreur et . . . j'eus la vague impression que T. était partout.*]: *Écrits*: 30.

54. [*Quand pour la première fois j'aperçus clairement la tête que je regardais se figer, s'immobiliser dans l'instant, définitivement, je tremblai de terreur comme jamais encore dans ma vie. . . . Tous les vivants étaient morts et cette vision se répéta souvent.*]: ibid.

55. [*Je les regardais halluciné, envahi par une sensation de terreur. C'était comme un déchirement dans la réalité. Tout le sens et le rapport des choses étaient changés.*]: ibid.: 72.

56. [*Tout d'un coup, il y a eu une scission. . . . J'ai eu l'impression d'être devant quelque chose de jamais vu, un changement complet de la réalité. . . . Alors il y a eu une transformation de la vision de tout.*]: ibid.: 265.

57. Giovanni Segantini, letter to Alberto Grubicy, dated 1890, cited in Hans A. Lüthy and Corrado Maltese, *Giovanni Segantini* (Zürich: Orell Füssli, 1981): 42.

58. [*Comme je voulais tout de même réaliser un peu ce que je voyais, j'ai commencé . . . de travailler chez moi de mémoire.*]: *Écrits*: 39.

59. See especially, "Lettre à Pierre Matisse," in ibid.: 37–50.

60. [*réaliser de mémoire ce que j'avais vu*]: ibid.: 44.

61. The titles of Giacometti's works define the nature of the moment in each case (*qui pointe, qui chavire, traversant une place*, etc.). But Giacometti also explained other works (such as *Four Women on a Base* and *The Chariot*) in relation to a specific visual experience at a precise moment; see, especially, the catalogue (*Alberto Giacometti*) of the exhibition at Pierre Matisse Gallery, New York, 1950.

62. [*aucune difficulté*]: *Écrits*: 242.

63. [*en dehors de la vérité*]: ibid.: 271.

Alberto Giacometti, 1901–1966

Christian Klemm

I. The Early Years

Childhood and Youth in Stampa

Alberto Giacometti, the elder son of the painter Giovanni Giacometti and Annetta Giacometti-Stampa, was born on October 10, 1901, in Borgonovo near Stampa in the Bregaglia valley in the southeastern Swiss Alps. High in the mountains and filled with glittering lakes, the broad valley of the Engadine comes to a sudden end beyond the town of Maloja, and a precipitous road leads down through a pass into the narrow Bregaglia valley, which lies deep in the shadow of Monte Disgrazia in nearby Italy. The air of closeness and danger in this southern valley made a deep impression on Alberto's imagination.[1] Italian is spoken here, although the valley is part of the Swiss canton of Grisons. Life in the intimate valley is simple and harsh; the barren ground can barely nourish the population, and for many generations it has been the norm to seek employment elsewhere for a time. Alberto's grandfather had left and returned with his savings after many years away; this enabled him to build the Hôtel Piz Duan on the road through the pass, and in 1906 his son Giovanni moved with his growing family into a house diagonally opposite the hotel. Their home consisted of two medium-sized rooms, two smaller rooms, and a kitchen; here the children grew up under the strict and loving guidance of their mother. In 1902 Diego was born, followed by Ottilia in 1904,[2] and Bruno in 1907.

Although small and simple, the Giacometti home was carefully furnished, and provided an inexhaustible fund of pictorial motifs for both father and son. The Giacomettis were one of the better families in the mountain village, yet during the summer, when the area was full of vacationers, the family's status was reduced by contrast with the international set who patronized the luxury hotels in the Engadine. Nevertheless, it always seemed that Alberto occupied a special sphere all his own.

His intense nature and extraordinary artistic gift were recognized early on by his parents. His relationship to his mother Annetta—a strong, encouraging yet exacting personality—was unusually close and remained so into her old age.[3] His father, too, was an important figure in Alberto's artistic development. In the provincial Bregaglia valley, Giovanni's occupation as a painter was most uncommon, and when he returned to the village after his training in Munich, Paris, and Italy, it seemed that his career as an artist might be over.[4] But he persisted; in 1894 the renowned artist Giovanni Segantini moved to nearby Maloja, and there was much to be learned from his divisionist technique and use of color. Above all, he gave Giovanni

Giacometti the courage to pursue his art and directed him toward subjects in his immediate surroundings, in his native landscape, and in his own family. He could render the subjects closest to him in a manner that was both authentic and symbolic—and Alberto was to follow the same path. Later Giovanni was inspired by the less-constrained work of Vincent van Gogh, and around 1906 his thinking came to be dominated by the work of Paul Cézanne, the artist who was also to become Alberto's guiding star.

As a child Alberto was happiest when he was working with his father in the studio, so his early training occurred naturally. Even when Giovanni gave him pointers and made certain recommendations, he always allowed his son to decide for himself. In the double pair of portrait drawings of his mother and himself (plates 2, 3, 4, 5) the seventeen-year-old Alberto was already secure in his use of form, and he displays at the same time an astonishing, wide-ranging conscious will to find his own style. The two portraits in three-quarter view reflect Alberto's engagement with a great tradition in European art, which he had studied with intense concentration and copied from books; in the self-portrait there are reminiscences of Albrecht Dürer, Nicolas Poussin, and the German Romantics. The two frontal views, on the other hand, recall the consistently stylized art of Ferdinand Hodler, a family friend who had recently died.

In these early works the rigor of delineation and composition sets the son's work apart from his father's empathetically softer painting, mainly carried by color. In the *Self-Portrait* of 1921 (plate 6) Alberto drew together what he had learned from his father: his sure touch with the paintbrush and rich, densely intertwined bright tonal values. But a very different artistic temperament manifests itself in the highly charged, analytical approach, as the composition bows to the rectangular shape of the picture. And we see a motif whose metaphorical content was to spur the artist on throughout his life: kneeling on one knee, with his gaze turned toward the viewer, Alberto's self-image evokes archaic depictions of Medusa, one of the three Gorgons with snakes for hair, whose sight turns all who gaze upon her to stone.

Between the time he left high school in Schiers, near Chur, in spring 1919 and his departure for Paris in early 1922, Alberto had a number of crucial experiences to which he later gave literary form.[5] After an unproductive semester studying

in Geneva, in May 1920 he accompanied his father to Venice, where the deep impression that Tintoretto's paintings made on him was immediately overshadowed by the power of Giotto's frescoes in Padua. It was on this journey that the sight of three girls in the street brought with it the first instance of a hallucinatory, vivid perception—breaking into his consciousness like a vision—that was to occur again in the late 1930s, and after 1946, and which was to be fundamental to the style and artistic conception of his late work. In late autumn 1920 he traveled to Rome via Florence, where he saw an Egyptian head that made an unforgettable impression on him. He spent six months in Rome, staying with an uncle; he recorded that while he was making a portrait of his cousin Bianca, the artistic confidence that had been his suddenly failed him. This was the first of the dramatic "crises" in which his acquired skills seemed to vanish, previously viable solutions lost their validity, and he had to rethink his artistic quest.[6] The last of these decisive experiences came in September 1921, when an acquaintance, an elderly Dutch archivist named Pieter van Meurs, invited Alberto to join him on a trip to the Tyrolean Alps. By the second day, van Meurs had fallen ill, and on the third day Alberto witnessed his death. The trauma of seeing, within a few hours, the transformation of a living countenance into a dead object was profound, in existential terms, for the twenty-year-old artist. From that day on he was haunted by a fear of death, which became a growing factor in his work.

1. Head of Bruno. 1919

45

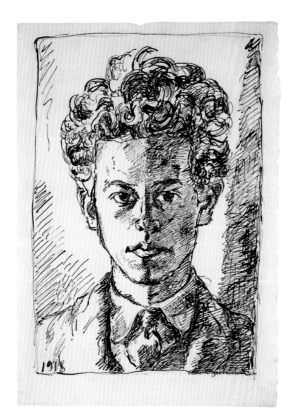

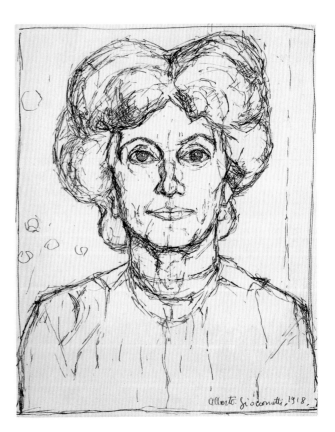

2. Self-Portrait. 1918 / **3.** The Artist's Mother. 1918 / **4.** Self-Portrait. 1918 / **5.** Portrait of the Mother. 1918

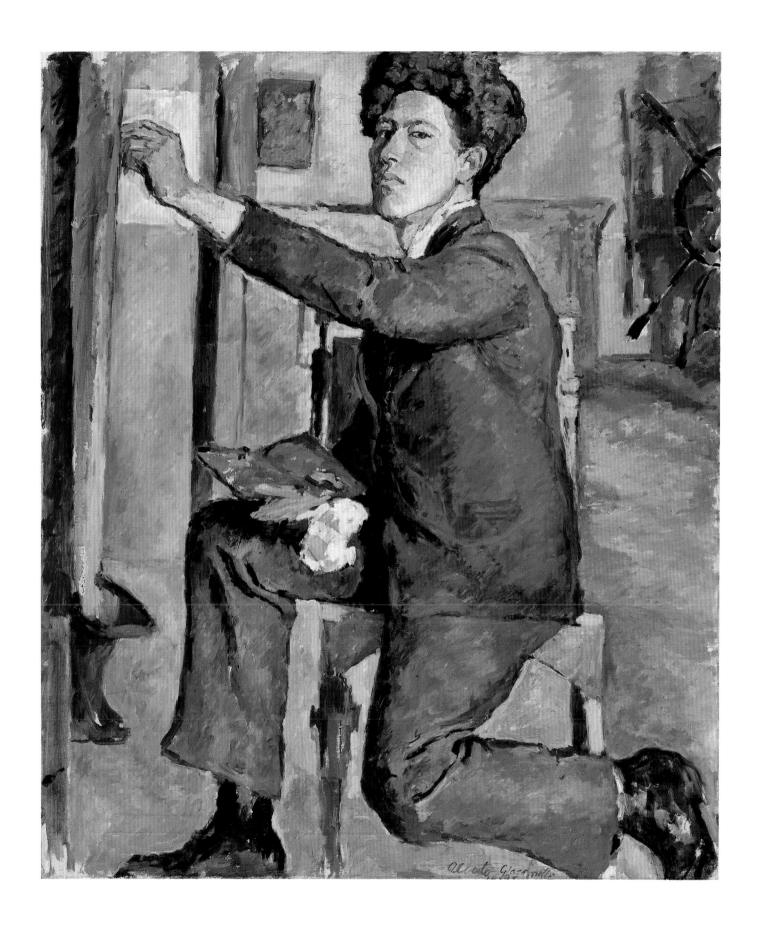

6. Self-Portrait. 1921

First Years in Paris, 1922–25

Giacometti always wrote to his mother in the vivid Italian dialect with which he was raised. At school in Schiers, he quickly learned German; his letters to his school friends reveal a poetic feel for the language. At school he also learned Latin and French; the latter was to become his second language when he moved to Paris, although his speech always retained an individual, slightly raw, foreign sound. His multilingual abilities were paralleled from 1925 to 1934 by his use of different modes of artistic expression.[7]

Giacometti was at first uncertain as to whether he wanted to become a painter or a sculptor; once he had chosen in favor of sculpture, however, it seemed only natural that he should enroll at the Académie de la Grande Chaumière in early 1922 in Paris, where Émile-Antoine Bourdelle's teaching studio was reputed to provide the best training for sculptors. Here Giacometti met up-and-coming colleagues of many different nationalities, including the French-born Germaine Richier and the German Otto Charles Bänninger, who—like the American Flora Mayo—made a bust of him.[8] Here he also met Pierre Matisse, the son of Henri Matisse, who was to emigrate to the United States and later become the most important art dealer of Alberto's work. The training at the Académie comprised modeling and drawing from life, occasionally with comments and corrections from Bourdelle. Despite the great differences between master and student, Bourdelle's influence was significant and enduring.[9] Although Giacometti saw himself as a successor to Auguste Rodin, producing work in the great tradition of figurative sculpture, he also addressed the fundamental problems of sculpture; his study of the work of Cézanne had led him to that crucial point in the relationship between three-dimensional form-making and the body to be depicted where the latter's organic coherence and self-containment are endangered. Although Giacometti turned to abstract figuration in 1925, he attended the Académie sporadically for another two or three years. It was to the Académie that he owed his professionalism as a sculptor and complete mastery of three-dimensional form.

The few experiments in sculpture that have survived from Giacometti's student years were made in Stampa, to which he would regularly return for months at a time. His many meticulous life drawings and later comments reveal the problems already besieging him when it came to rendering the model as a coherent form. There seemed to be no hope of capturing the complexity of the whole figure; yet if, as he said, he concentrated on a single detail, the small area directly below the nose, for instance, that minute spot would turn into the "Sahara Desert," dissolving into dots. The drawn *Self-Portrait* (plate 9) shows this situation; the painted portrait (plate 11) reveals the artist's intense efforts to overcome it. The life studies are not built up of rounded forms merging into each other, but—in keeping with academic studio practices—are composed of points that are formed into spatial structures by lines and planes.[10] Giacometti's highly developed plastic sense of form came to the fore in his evident opposition to sculptural weight and solidity, and his equally strong aversion to plastic rhetoric. In his sculpture bodily feelings rooted in the animal disposition of the individual find a form of expression of the utmost immediacy. Probing deep into the realms of the imagination and spirit, Giacometti expressed the ungraspable relationship of the body to the world. A childhood drawing of Snow White in her glass coffin[11] (repeatedly mentioned by Giacometti) gives a foretaste of these concerns and of his obsession with death, seen here in *The Skull* (plate 10), a motif on which he spent a whole winter season.[12]

7. Mountain at Stampa. c. 1923 / **8.** Three Nudes. 1923–24

9. Self-Portrait. 1923-24

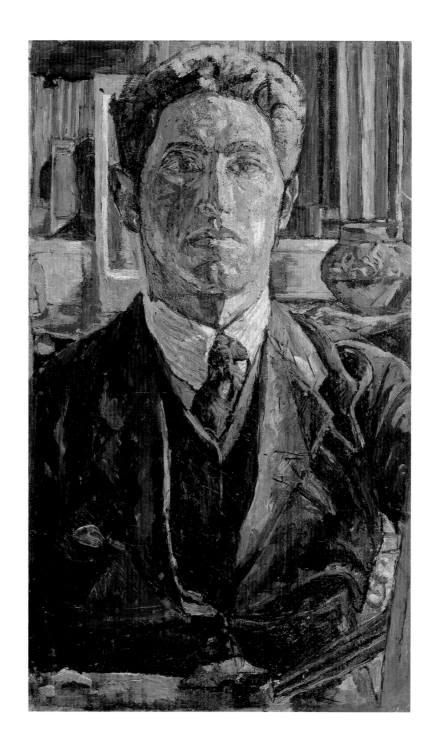

II. Self-Portrait. 1923

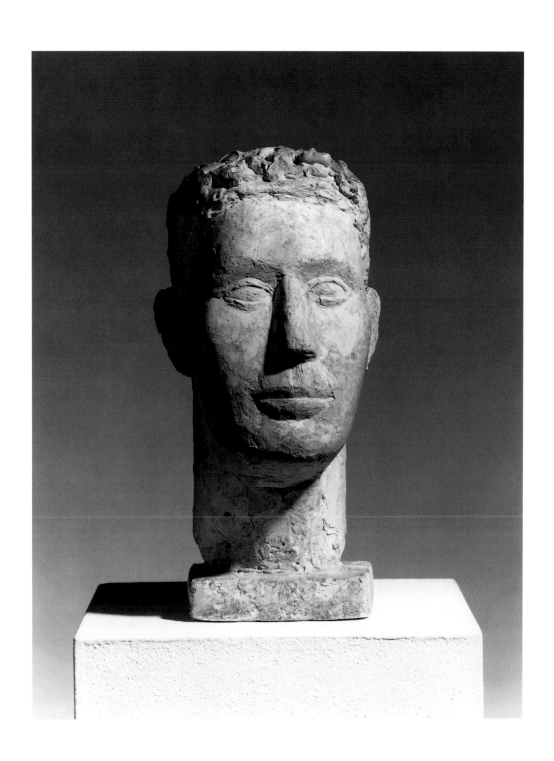

12. Self-Portrait. 1925

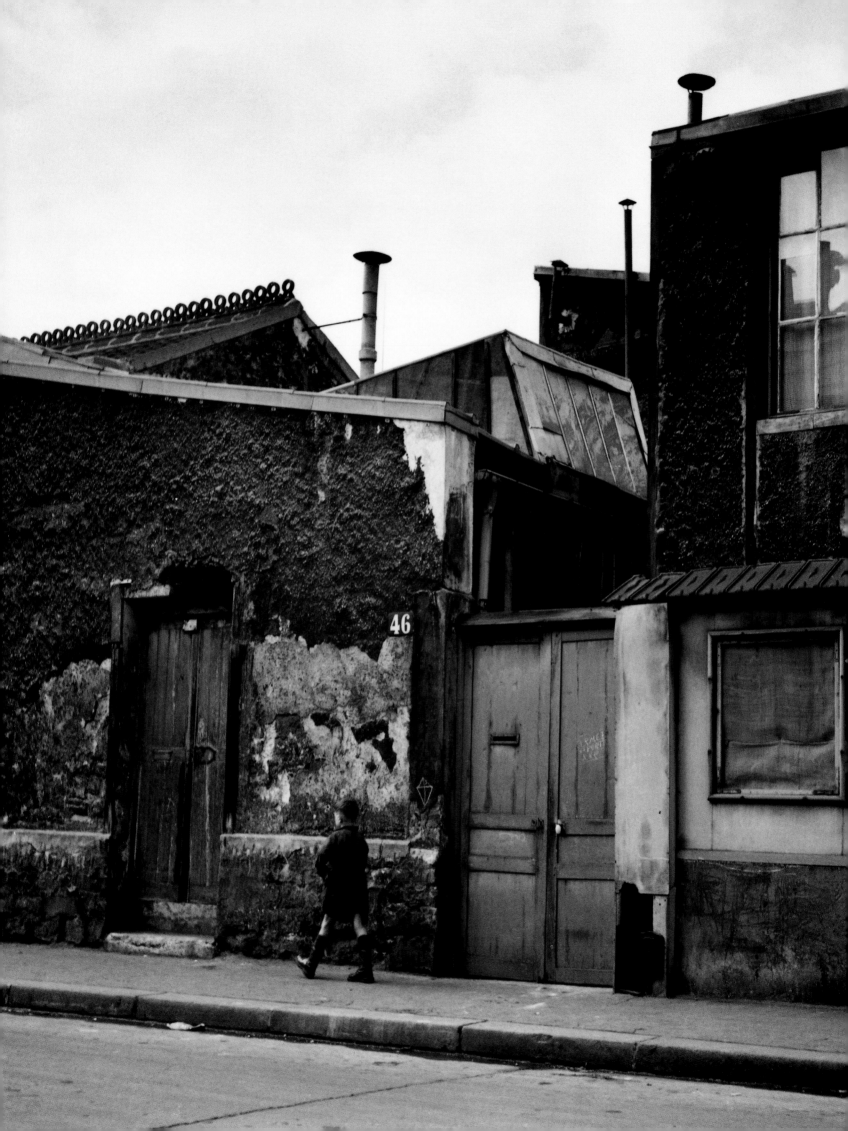

II. Avant-Garde Beginnings

First Abstract Sculptures

In 1925 Giacometti's dissatisfaction with his figurative sculptures was approaching a critical level. In the summer, when he was modeling a bust of his mother in Stampa the situation became even more acute. Having absorbed the lessons of his father, a painter who had abandoned the realist paradigms of the nineteenth century in favor of Cézanne's "harmony in parallel with nature," and having completed his own studies, Giacometti began to turn his attention to the consequences of the new principles explored by Cubism. Many of the decisive formal developments in twentieth-century art had taken place before World War I, and they were initiated and carried forward by the generation born around 1880. Giacometti had thus encountered mature work by sculptors such as Constantin Brancusi, Alexander Archipenko, Henri Laurens, and Jacques Lipchitz. Whether working directly from or in tandem with Cubist ideas, all had reshaped the organic figure, sometimes as geometric elements, and sometimes had abandoned it in favor of an entirely nonfigurative form of composition.[13] By the mid-1920s, however, the new forms had largely been reduced to an empty vocabulary that lent itself to purposes of decoration in the style called Art Deco.

With his characteristic concentration and persistence, Giacometti applied the new style to the main themes of the classical tradition.[14] In 1925 he made his debut in the Salon d'Automne with *Torso* (plate 13), which echoes Brancusi's torso of a youth without, however, attempting to emulate its predecessor's almost overly elegant, iconic simplicity.[15] The three elements of *Torso'*s form are recognizable as a human body and legs, but they are altered in the direction of geometric clarity. Its taut forms and upward-striving contrapposto radiate an organic vitality that derives from years of life drawing. The preparatory drawings for *Torso* point to Fernand Léger as a further source of inspiration; his work may also have informed the solid *Cubist Composition: Two Heads*, in which a misshapen cube and a half-cylinder are set against each other on a number of levels. Here central concerns of Giacometti's sculpture, such as the act of seeing and the presence of voids, emerge for the first time.[16] The *Cubist Composition: Man* (plate 16) goes a stage further, in the almost violent dissection of the figure and in the piling up of stereometric elements. Again, the work is less reminiscent of the complex sculptural forms in the Cubism of Braque and Picasso than of the elemental license of Léger's *Contrast of Forms* of 1913–14.[17]

Just as Giacometti was addressing the polarity of geometric forms and organic vitality, he was also deliberating on another problem: how to isolate and clarify individual elements so that each could become a succinct sign, while at the same time making each dynamically indispensable to the configuration as a whole. In a succession of different ways these seemingly irresolvable issues would define his entire œuvre.[18] The contradictions intrinsic to Giacometti's work mean that directional impulses do not flow freely outward nor do they work together as a unit. Rather, they remain as though caught within the sculptures—giving them a tormented quality and imbuing them with the unattainable quality of magic. In *Figures* (plate 17) the static isolation of the elements prevails, any exchange between them is if anything symbolically indicated by a system of tubes. In *Composition: (Reclining) Couple* (plate 18) Giacometti made a breakthrough by dissolving the solid, plastic form and allowing space to penetrate it. While it still has an almost mechanical, superficial feel, it is the first work to realize an integrated dynamic. The form of the piece may well be indebted to Raymond Duchamp-Villon's great sculpture *The Horse* of 1914, while the influence of Lipchitz is especially evident in other of its aspects.

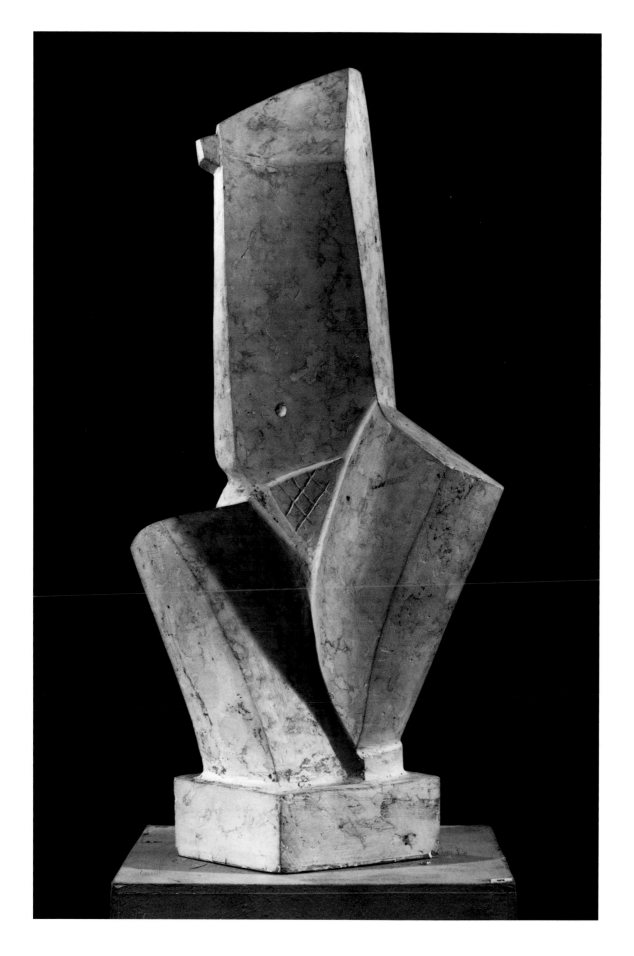

13. Torso. 1925

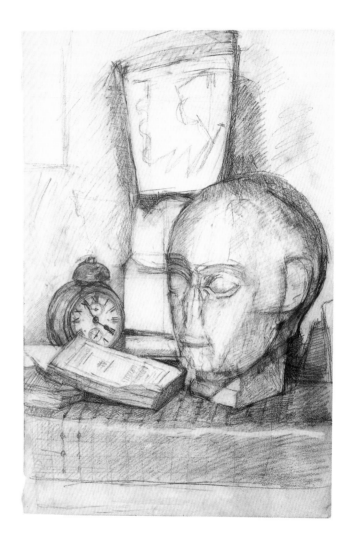

14. Studio with Sculptor's Turntable. 1931(?) / **15.** Still Life with Gudea Head. 1927

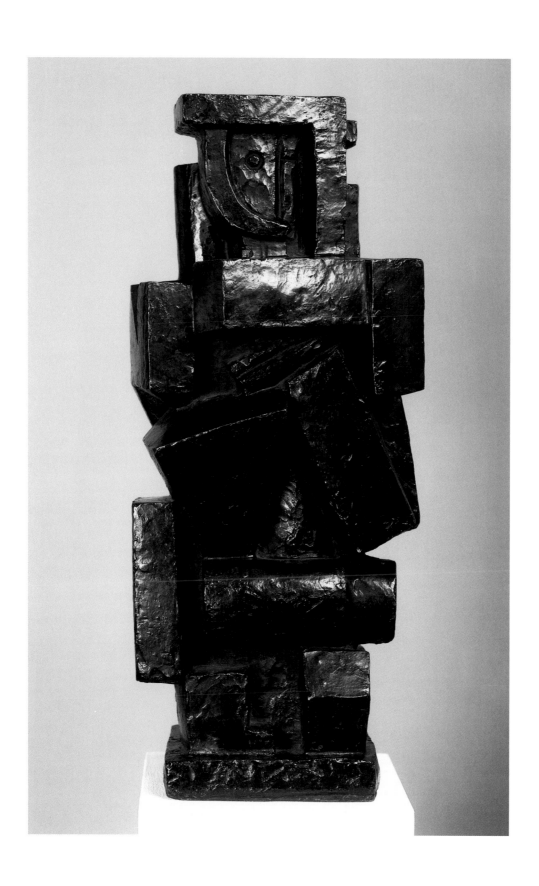

16. Cubist Composition: Man. 1926-27

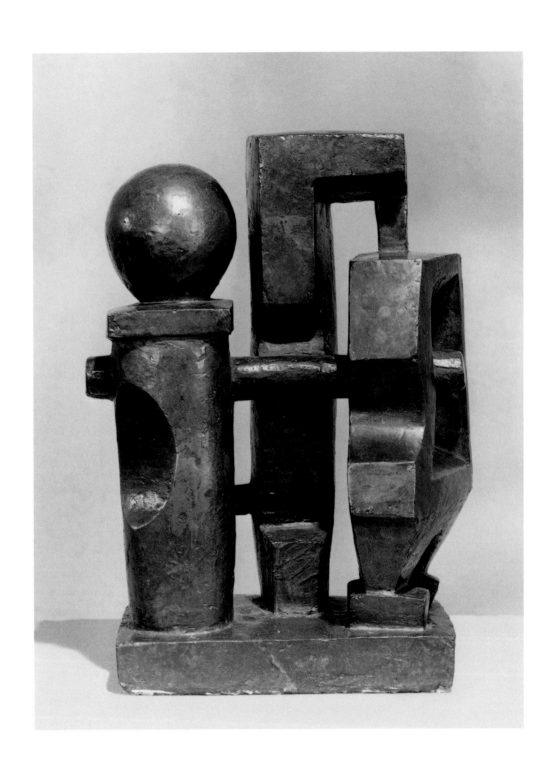

17. Figures. 1926–27

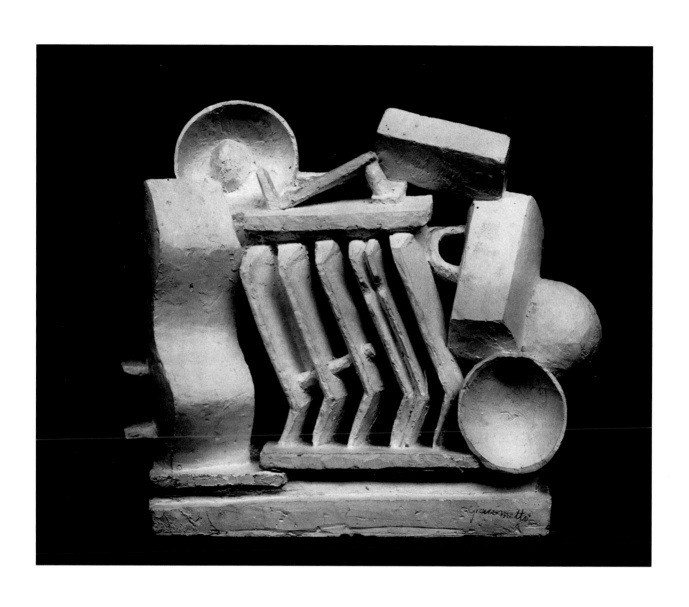

18. Composition: (Reclining) Couple. 1927

Influence of Tribal Art

In the years before World War I the bold design and magical aura of African and Oceanic sculpture had a deep fascination for artists who wanted to overcome realist traditions and were searching for more primal modes of expression. When Giacometti found himself similarly challenged in 1925, such forms had long been familiar and had lost much of their power to shock. Thus he was all the more thorough in his study of tribal and other traditions in his search both for hieratic design forms free of individual whimsy and for a language of signs for elemental human situations.[19] While the content and the formal construction of Giacometti's sculpture as well as its essence as a work of art are Western, his figures, nevertheless, have an unforced evocative power that makes them appear to be more closely related to primitive idols than many other roughly contemporary works that more anxiously display their sources.

Giacometti's striving for a symbolic representation of reality is evident in the early sculpture *The Couple* (plate 20), where, isolated and raised up on individual pedestals, two figures appear as symbols of their gender. The woman's open form is indicated by the frame, while the overall shape of the man recalls the *Self-Portrait* of 1925 (plate 12). The details, applied or incised signs, may be read as elements of the face or of the whole body, and thus, like the chiasmic transposition of the sexual features of one into the eyes of the other, indicate other dimensions of the figures' sexuality. This pair of figures—utterly static yet with a latent dynamism in their challenging and complementary plasticity—introduced the dialogue of the sexes that Giacometti depicts in many of his subsequent sculptures.[20]

Inspired by the human-shaped spoons used by the Dan tribe in Africa, the *Spoon Woman* (plate 19) possesses a near-magical evocative power almost daunting the viewer with its seemingly ineluctable presence. The mighty spoon shape, reminiscent of primitive fertility idols, curves half toward the viewer and partly away. A bewildering tension is created as the leg-pedestal slips toward the ground while the crystalline shapes of waist, breast, and moonlike one-eyed head take flight upward, thus emphasizing its floating quality. Giacometti later employed expressive abbreviations of this kind primarily in his postwar output, in which the theme of the "large woman" was significant.[21]

The purity and concision of the *Spoon Woman*'s geometrically rigorous individual shapes not only witness lessons learned from Cubism but also those of tribal art. Giacometti pursued his studies in both directions concurrently after 1925, concentrating more on problems of form in one and questions of content in the other. The Cubist-influenced female torso (plate 13) soon found a counterpart in a very simple figure of a man (a lost work), inspired by pre-Columbian art.[22] Among the several successors to that small figure, an early example may be seen in *Head* (plate 22), which is enriched with elements from *The Couple*. A later male figure in marble, which approaches the Plaque sculptures of 1928,[23] introduced a swinging movement into the form; this later became explicit in the *Dancers* (plate 21) and achieved a diagrammatic purity in the *Suspended Ball* (plate 38). The curious conical "legs" of the *Dancers* take up a feature of the *Spoon Woman* and, as before, are as much part of the pedestal as of the figure; then there is the platform, related to the base in the later *Vide-poche* (plate 39) and to the base in the *Model for a Square* (plate 43), where the two figures find geometric counterparts. In these works we see that even before coming into direct contact with the Surrealists, Giacometti had already laid the foundations of a vocabulary and a syntax that were capable—in keeping with typical Surrealist, associative thinking in analogies—of developing into an abundant art of correspondences.

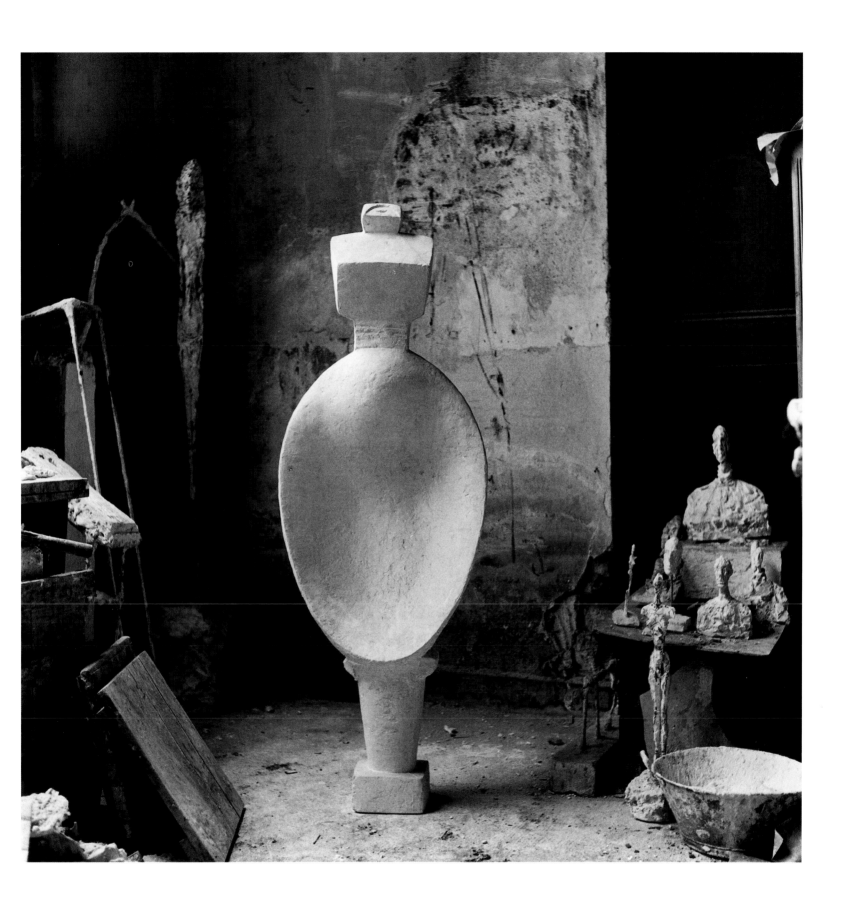

19. Spoon Woman. 1926–27

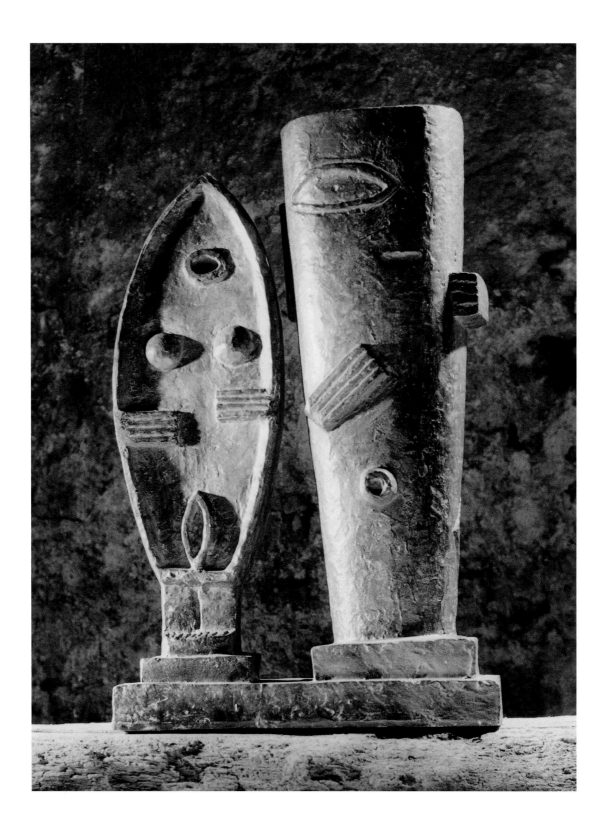

20. The Couple. 1926

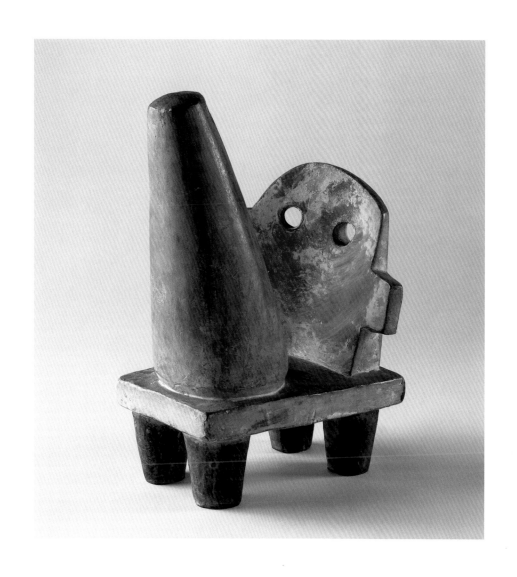

21. Dancers. 1927

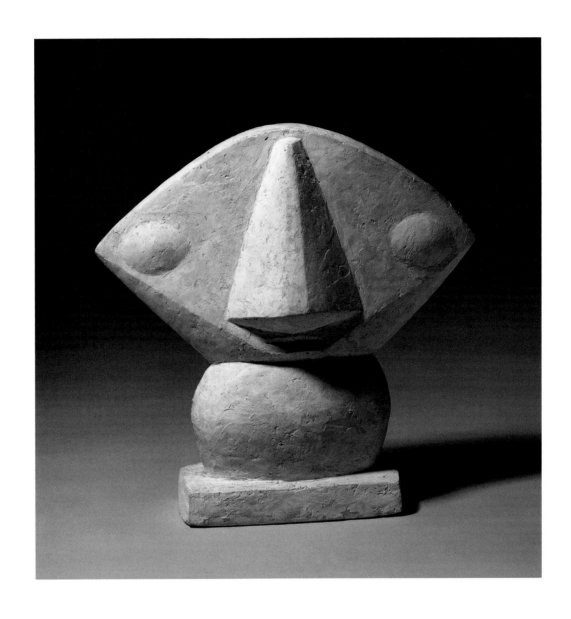

22. Head. 1926

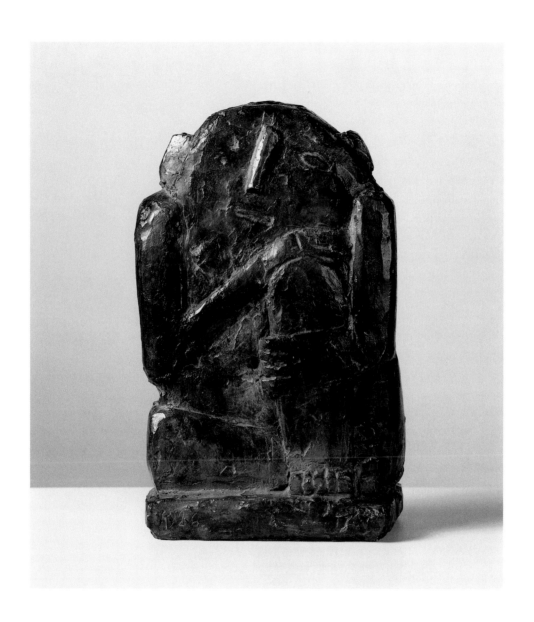

23. Small Crouching Man. 1926

Portrait Heads of Giacometti's Parents

Perhaps the most idiosyncratic of the small male figures that Giacometti made between 1925 and 1930 is the *Small Crouching Man* (plate 23). Its more realistic appearance is distinctly different from the others, and it is obviously related more to the environment of Stampa than to the avant-garde circles of Paris.[24] At the time, Giacometti continued work in realistic idioms alongside his Cubist-influenced and ethnographic forms, creating a degree of mutually enriching tension between different artistic possibilities. It was this interchange of ideas that led to Giacometti's first truly original work, the *Gazing Head* (plate 31).

In order to achieve a flatness similar to that of his small Paris figures—square rather than reaching upward—Giacometti had bent the limbs of his figure into a crouching form to make the *Small Crouching Man*. That figure's closeness to the ground, and the compact orthogonal configuration of arms, legs, and diagonal head recall two self-portraits he had earlier painted in Grisons.[25] Its rough relief—displaying cubic elements and sign-like incisions—echoes the Romanesque archaism of that region.[26] But, contrary to custom, Giacometti articulated the narrow sides of the small male figure and also modeled the back. This fully rounded yet flat form may also be seen as an illusionistic figure, foreshortened from back to front.

When Giacometti returned to Stampa in the summer of 1927, after having produced the *Spoon Woman* (plate 19), he addressed the basic questions of representational sculpture in a series of heads of his parents. Having, over two years, directed his comparative study of stylized geometrical forms and realistic illustration toward discovering abstract configurations, he set his sights on the other pole, working from the head initially modeled closely after nature toward more strongly stylized forms. However, this process was not restricted to the step-by-step generalization and geometrification of the motif, as was often the case with other modern artists; Giacometti was analyzing the inherent potential for both representation and stylization possible in sculpture by returning to basics. Thus, what soon followed was a roughly hewn head of his father in hard, coarse granite: in effect, a rough version with little detail and, as such, reaching back to his memories of ancient Alpine stonework.[27]

By contrast, *The Artist's Father* (plate 25), although seen here in bronze, displays the original additive technique of clay sculpture; the build-up and accumulation of material also serve to give character to details, such as the strands of hair. In artistic terms the most demanding of the sequence, it seeks to do justice to two central yet sometimes conflicting demands of Giacometti's new sculpture: that a work should be enlivened by the break-up of the surface and that the integrity and visual importance of the basic stereometric form be maintained. In the marble head of Giovanni (plate 26), the medium seems entirely in the service of the basic form and yet the piece bears a striking likeness to its subject, even without details. It is only in certain lights that features appear on the front surface of the head in most delicate relief, as though gleaming from within the crystalline stone, but it is the haptic-plastic aspect that dominates. The purely optical-painterly counterpart of the marble head is to be found in bronze (plate 27). Here, in the boldest of the series, the front half of the head is cut away flat, parallel to the line of the face, and the individual features are scratched in as though in a drawing.

In *The Artist's Mother* (plate 24) Giacometti pursued the same questions, setting out to create a sculpture that would appear to be fully three-dimensional and could be viewed from all sides, and which appears, at the same time, to have been stripped of its mass, thus completing what he had attempted perhaps only playfully in the *Small Crouching Man*. In this portrait of his mother we see for the first time the central problem of Giacometti's mature work: the difficulty of embodying what he saw with visionary intensity, namely, the reality of the human being in its double role as a visible presence but also, in physical terms, as reified ungraspability. The temporary solution found here takes the form of a plaquelike, flat three-dimensional work, an illusionistic sculpture which thereby creates a new category midway between traditional sculptures in naturalistic three-dimensionality and the flat relief.[28]

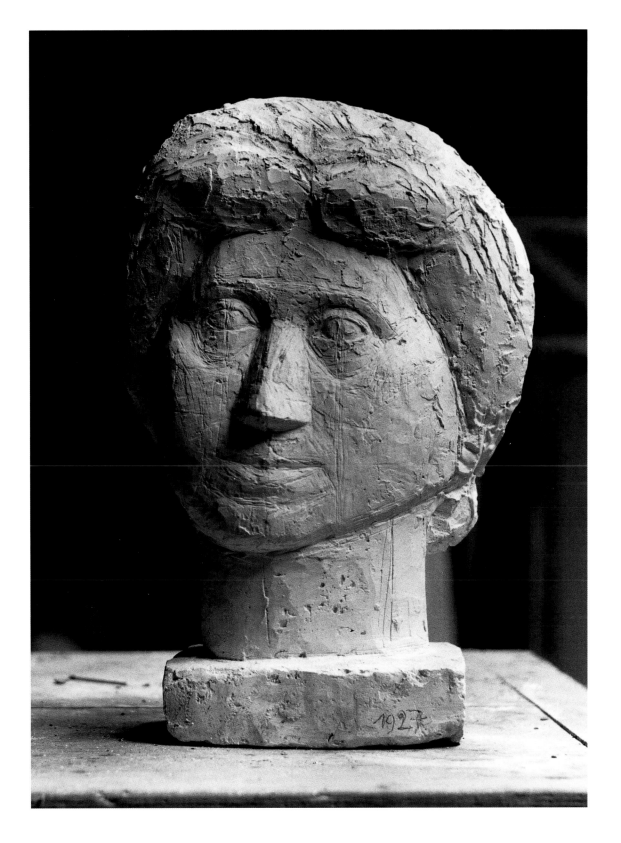

24. The Artist's Mother. 1927

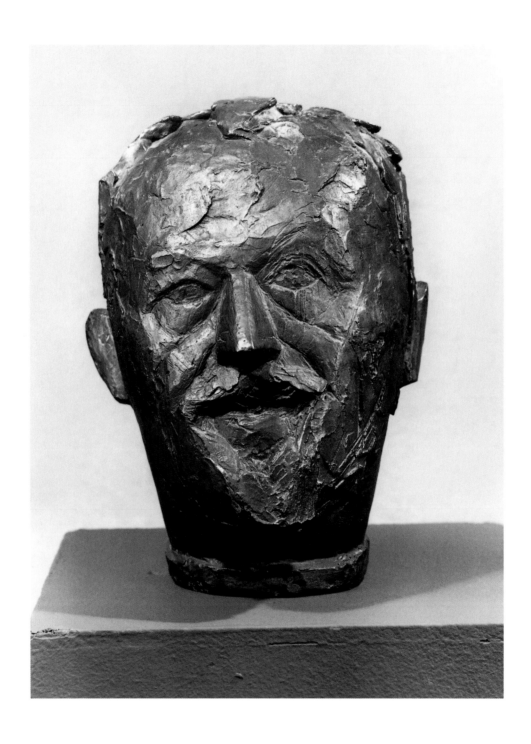

25. The Artist's Father. 1927

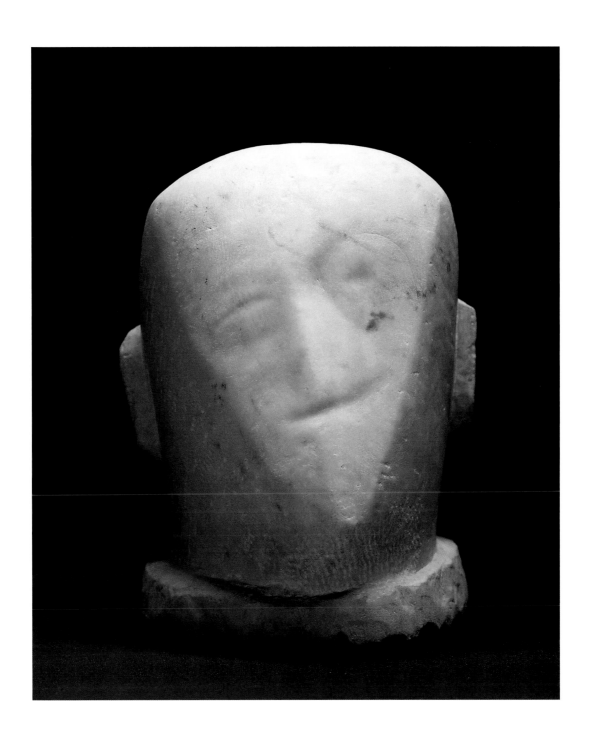

26. The Artist's Father. 1927

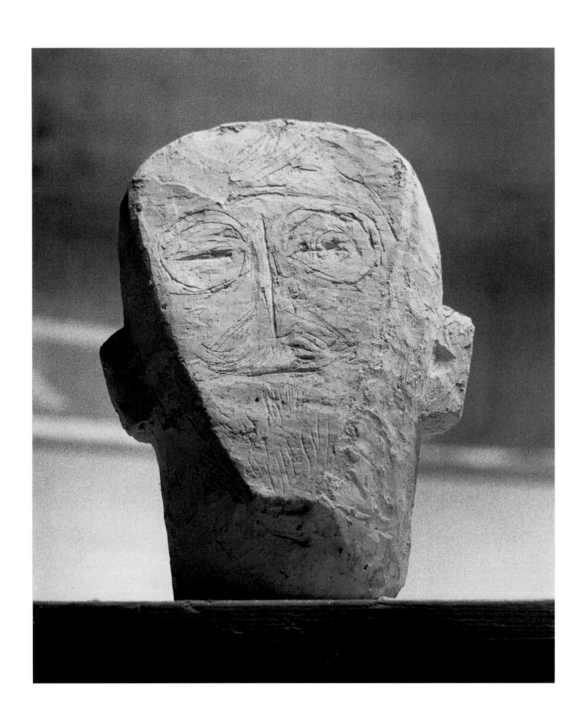

27. The Artist's Father (flat and engraved). 1927

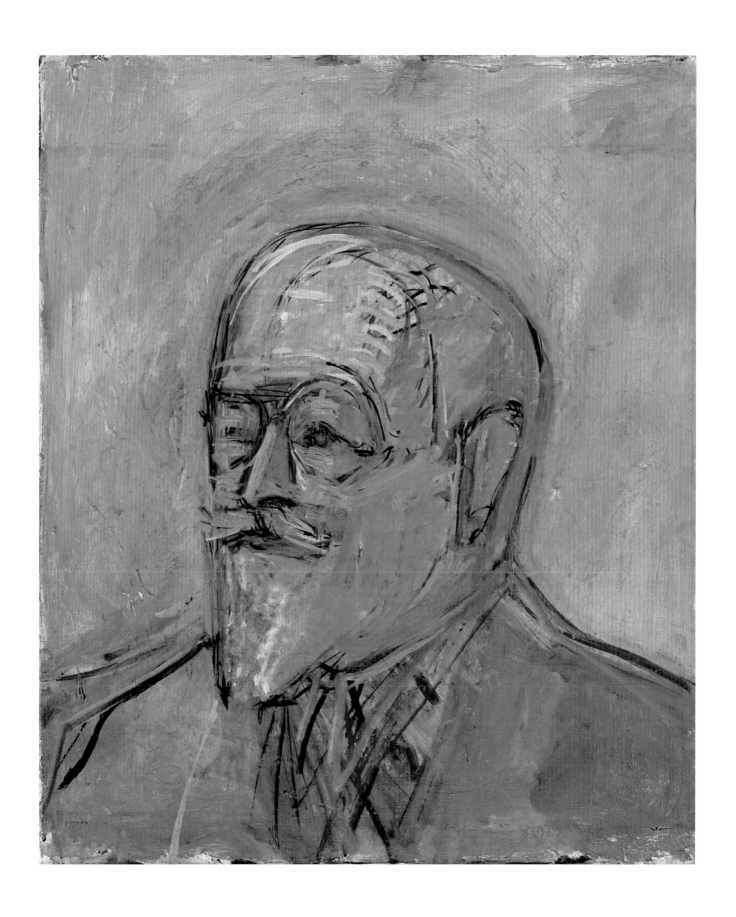

28. The Artist's Father. c.1932

Plaque Sculptures and Signs in Space

With *Gazing Head* (plate 31) Giacometti succeeded in making an elusive noncorporeal sculpture, as plain and obvious as it is bewildering: this work is the completely innovative starting point for future developments. The flattened face of the head of his father (plate 27) and the foreshortened head of his mother (plate 24) are here carried to an extreme, resulting in a sequence of flat figures with applied or incised signs for facial features and bodily parts. Decades later Giacometti described how, having failed to achieve what he wanted by working from life, he had started to work from memory, and said that it was not until he made *Gazing Head* that he felt he had achieved a proper likeness. His recollection was, in fact, a form of forgetting, where the subject is reduced to the ultimate core of its being, to the horizontals and verticals that seemed to the artist to define all bodily forms.[29] What is left is the overall form with organic overtones in the lightly convex tension of the outline, the line of the neck from *The Artist's Mother* and the two large indentations. These cavities relieve the sculpture of a sense of solidity, allowing it to vibrate like a membrane in space. The three-dimensional elements applied to the back, which were still in evidence on the small model, have since disappeared.[30] *Gazing Head* is no longer an idol, but a vision, a thing, and yet not a thing. Here, he sculpted the ungraspable, a self-contradictory undertaking which was to become obsessive in the postwar years. Furthermore, the theme of this sculpture—the act of seeing—also points to his future work. The fascination that surrounds the phenomenon of the gaze emanates from the work's flat surface; at the same time the viewer is struck by the penetrating gaze of the deep-set eye, and is confronted with the presence that issues from this vision. If the viewer wants to look into its eyes, the *Gazing Head* switches to a profile view; it looks, but allows no one to look it in the eye.

With these ambiguities *Gazing Head* marked the threshold where an admittedly highly abstract, yet ultimately statuary, art blends with a realm of autonomous objects, whose richly associative constructs are models of psychic states. The basic form evolved along various lines of development. Initially Giacometti changed the syntactic principles of his flat Plaque sculptures by using geometric signs and imperceptible surface movement to evoke female figures.[31] In a typical about-face, these were followed by sculptures in which the inner drawing became a linear composition in space and the flat surface a virtual, open plane, as in *Man (Apollo)* (plate 29), probably the earliest of the spatial delineations. In *Reclining Woman Who Dreams* (plate 33) Giacometti laid a weightless planar plastic form down horizontally; the cosmic dimension evoked in the title *Apollo* resonates here, too, when the work is read as a dream landscape with a heavenly body above waves.

From 1925 onward Giacometti worked consistently at dissolving sculptural mass, yet even so the perforated forms in Lipchitz's and Picasso's experiments, such as those for a monument to the poet Apollinaire, may have had a certain influence. A comparison of Giacometti's "dreaming" and "recumbent" women with their predecessors by Archipenko and Lipchitz reveals the ultimately traditional character of the earlier figures; despite their modern form, they are far removed from the highly associative poetic, autonomously symbolic quality of Giacometti's figures.[32] Each of these sculptures added important new elements: the separation from the pedestal, the move into the horizontal, and in the last ones—*Man and Woman* (plate 34) and *Three Figures Outdoors* (plate 35)—a heightening of erotic aggression that points toward the Surrealist works. Above all, these works also lay the groundwork for the principle of the Cage.

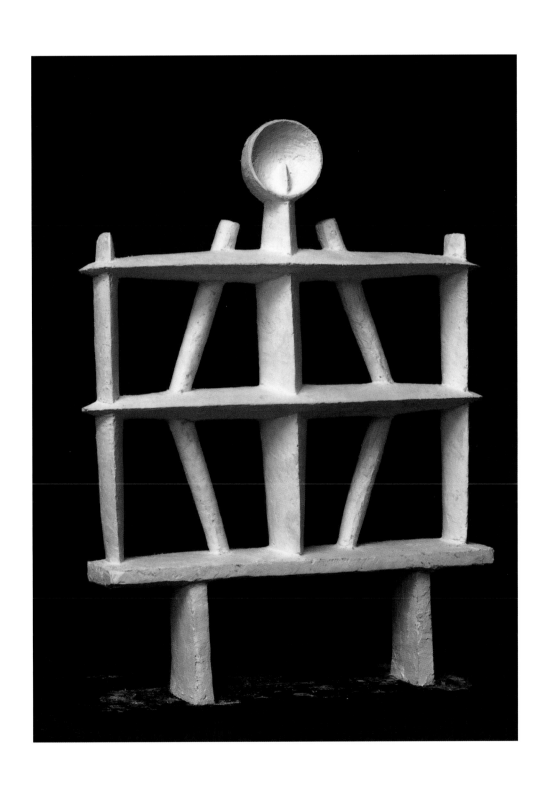

29. Man (Apollo). 1929

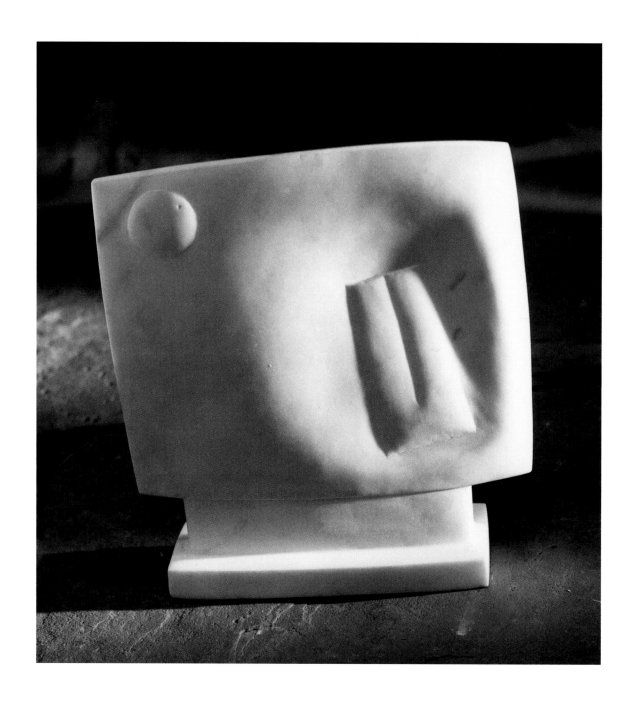

30. Woman. 1928-29

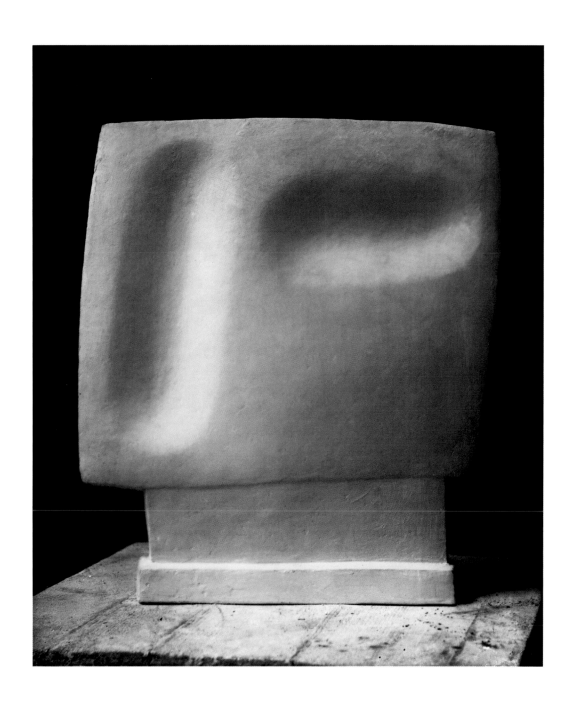

31. Gazing Head. 1928

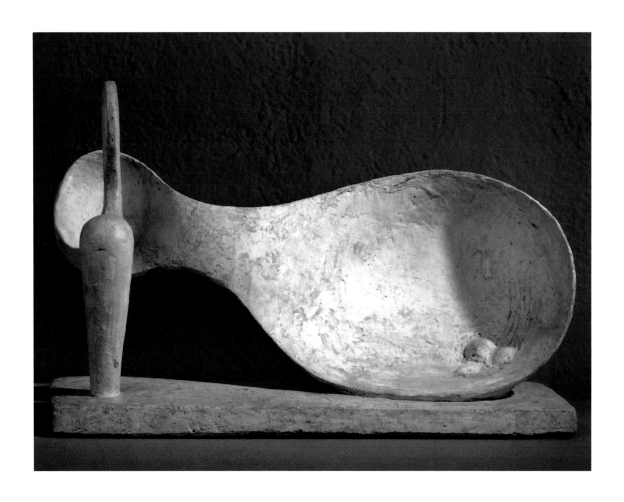

32. Reclining Woman. 1929

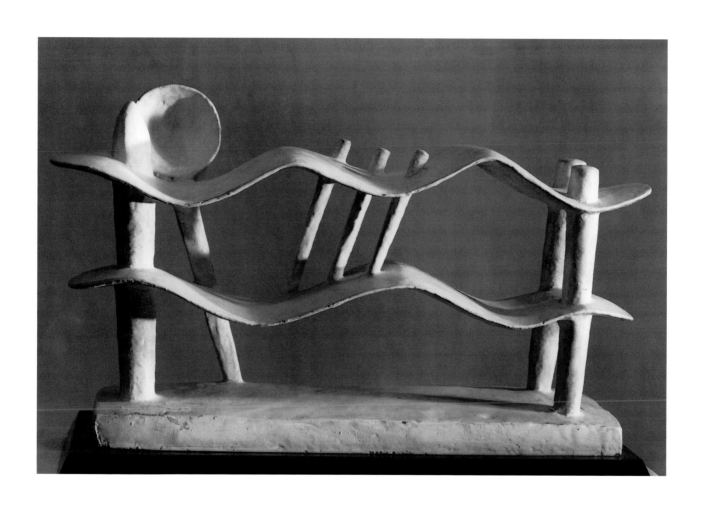

33. Reclining Woman Who Dreams. 1929

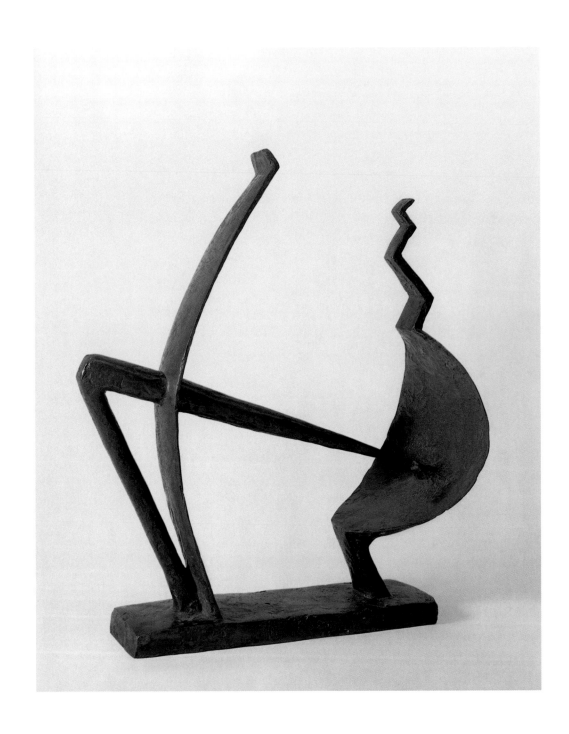

34. Man and Woman. 1929

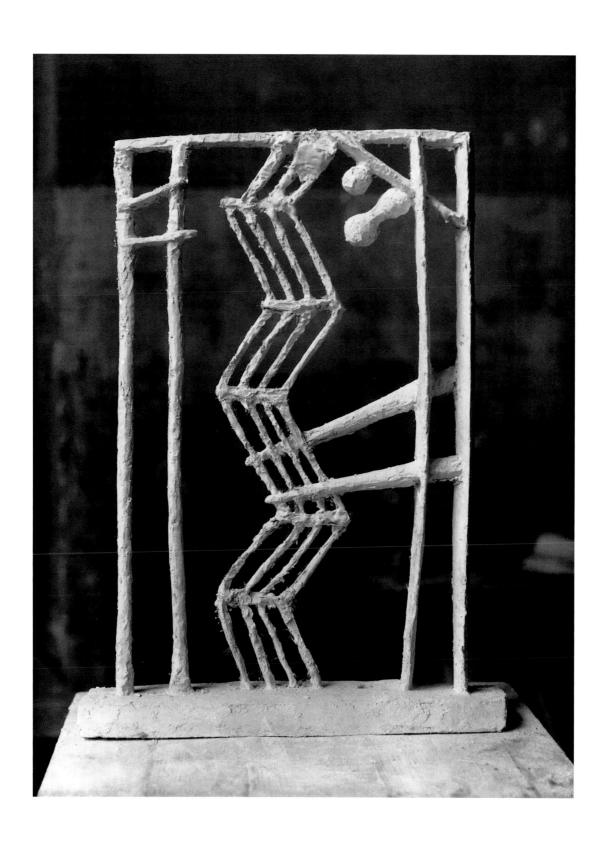

35. Three Figures Outdoors. 1929

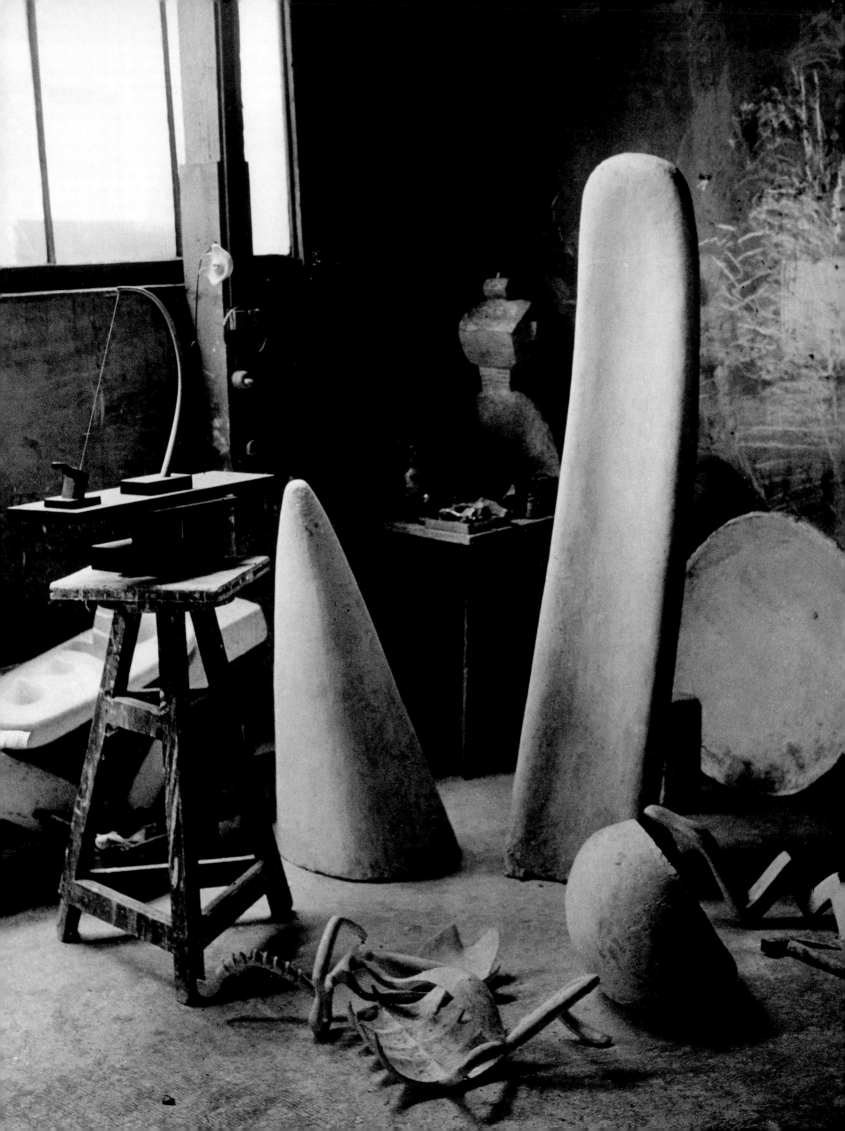

III. Surrealism

"Moving and Mute Objects"

When *Gazing Head* (plate 31) and another Plaque sculpture[33] were shown in June 1929 in the Galerie Jeanne Bucher, Paris, along with works by Massimo Campigli, they immediately caught the attention of the Surrealists.[34] André Masson reportedly told Michel Leiris of his discovery of Giacometti.[35] A subsequent visit to the artist's studio more than fulfilled Leiris's expectations, and in September he published the first article about Giacometti. Crucial to the reception of his work, Leiris's article was also important to Alberto's self-image and further production. According to Leiris, this young, unknown sculptor could create "true fetishes," "objective forms of our desire, of our wishful thinking." Until that point Giacometti had moved in a peripheral circle of young Italians; thereafter he found himself associated with the leading avant-garde circles of literati and art connoisseurs.

Giacometti's personality and work up to that time demonstrated that his disposition was in harmony with Surrealist thinking. A keen awareness of the natural world, expressly nurtured by his familiarity with the German Romantics, and his own visionary experiences and obsessions had already marked Giacometti at school and as a young man. He had freed himself from any desire to produce realistic portrayals of the everyday world—not only because he saw no interesting formal potential in it but because he was seeking his own forms for internal, psychic processes. His newest works, particularly the Plaques and especially the "transparent" sculptures, such as *Reclining Woman Who Dreams* and *Man and Woman* (plates 33, 34) seemed to meet Max Ernst's requirement that the sculptor "bring to light genuine finds from the subconscious which, linked together, could be described as irrational cognition or poetic objectivity."[36] The dreamlike matter-of-factness and the sexual aggression in Giacometti's work appealed to the Surrealists equally with the ethnological and archaic bearing of works such as the idol-like *Spoon Woman* (plate 19).

In all likelihood Giacometti was aware of Surrealist work before he was noticed by Leiris. His direct contact with Surrealist artists by no means led to a rupture in his own work, but to its continued organic development and to his own creative liberation. The evolution of the motif of *Three Figures Outdoors* (plate 35),[37] through *Woman, Head, Tree,*[38] to the first *Cage* (plate 37) shows how greatly he was stimulated by his new circle of acquaintances and how much it increased his confidence in his work. In fact the motif of the space-cage outlined with bars, which—like a picture frame—defines the location of the plastic event, making it visible to the outside and holding it captive as a mental process, was to be of great consequence in sculpture. Here he took the dissolution of the sculptural block to its logical conclusion.[39]

Giacometti initially gained entry to the circle of "dissident" Surrealists around Georges Bataille, publisher of the journal *Documents,* through Michel Leiris.[40] Bataille's thinking, which centered on the basely material, the formless, the destructive, the obscene, and the absurd, at first influenced Giacometti in terms of content; in the postwar years its influence is seen more in terms of form.[41]

In 1931, the third issue of *Le Surréalisme au service de la révolution* published Giacometti's own "Objets mobiles et muets" (Moving and Mute Objects).[42] In this, the artist's first public commentary on his work, seven precise drawings of sculptures are framed by a short text. Two of the drawings feature what Giacometti called Disagreeable Objects. Sometimes he referred to these pieces as "objects without bases," indicating that they were outside the category of "art." Without pedestals and sometimes designated by the artist à *jeter* (to be thrown away), these groundless, suggestively sinister small sculptures seem to have no purpose other than to be grasped and hurled into space. The *Disagreeable Object, To Be Thrown Away* (plate 41) deforms the visionary *Gazing Head* into something low, crooked, and directionless with obscene, aggressive protuberances. One could certainly talk of "fetishes" here in the original sense of something "made," which is imbued with sinister psychic forces; yet this reified vulgarity is embodied in a form that may be disturbingly incomprehensible and, as such, "formless" but, nevertheless sculpturally perfect.[43]

The concept of the Surrealists, that works of art should be "found" items from the subconscious that are lifted into everyday reality, was demonstrated by Giacometti with programmatic clarity in *Vide-poche* (plate 39). In place of the pedestal there is an everyday object—a little bowl into which one empties the contents of one's pockets. This object does not separate the spheres of art and ordinary life but, rather, inextricably binds one to the other. What comes out of the trouser pockets now—two shrunken offshoots of the Plaque sculptures—does not deny their deeply hidden origins. They no longer stand, they are lying in the cavity, evoking the notion

of a swinging movement which also threatens to unbalance the everyday object. The object fully meets the demand made by Leiris that the work of art should be compact and matter-of-fact like a piece of furniture for everyday use. Accordingly, Giacometti had many of his finished plaster sculptures realized in wood by an artist-craftsman joiner, thereby markedly setting them apart—as objects—from traditional sculpture.[44] At the same time he also started to design decorative furnishings such as lamps and vases for the exclusive interior decorator Jean-Michel Frank.

Just as one can see *Vide-poche* as a metamorphosis of the figurative *Dancers* (plate 21) into a surreal object, it also already contains the plastic elements that—incorporated into the syntax of *Cage*—would mutate into *Suspended Ball* (plate 38). The moment of movement shifts from depiction of content through formal evocation to real movement that may be instigated by the viewer's hand: a further step in the incorporation of the art object into everyday life and at the same time an epoch-making extension of the expressive possibilities of sculpture.[45] But the seduction of being physically able to intervene in the object, and the satisfaction of being able to optically grasp the charged polarity of the two simple bodies, is soon disturbed by countless ambiguities in form and content.[46]

Unlike the fixed geometric forms favored by some modern artists of the time,[47] the elemental forms of Giacometti's work are organically animated and connected by psychically fluctuating relationships that imbue them with seemingly inexhaustible powers of poetic evocation. In May 1930 the Galerie Pierre in Paris exhibited Giacometti's work in a group show with Hans Arp and Joan Miró, both older than he and already considerably better known. Arp's sculpture became a model for him, and he was able to study the evolution of an elemental sign language in Miró's paintings. Giacometti's *L'Heure des traces* (plate 36)[48] shows the influence of Miró most clearly.

Suspended Ball was displayed in the window of the Galerie Pierre and became the artistic sensation of the day. Dalí proclaimed it the prototype of a new category of "Objects of Symbolic Function," shortly to be something of an obsession for the Surrealists.[49] André Breton, Surrealism's Pope, recruited Giacometti to his orthodox group, and up until 1934 the artist took part in the movement's meetings and activities.

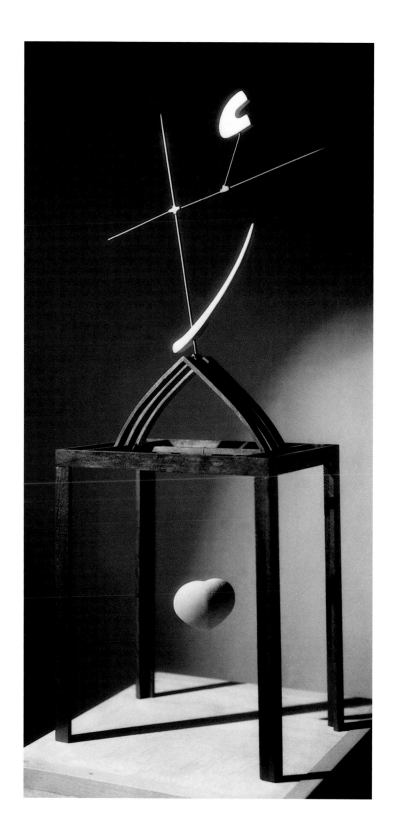

36. L'Heure des traces. 1930 (lost)

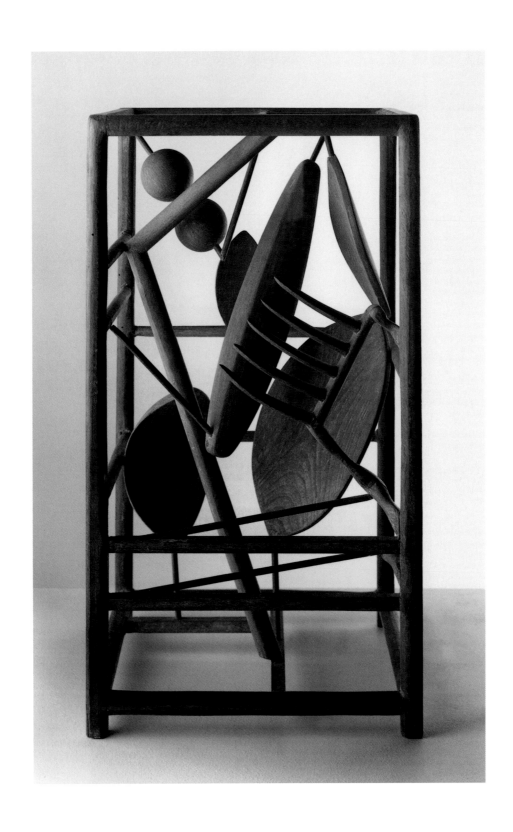

37. Cage. 1930

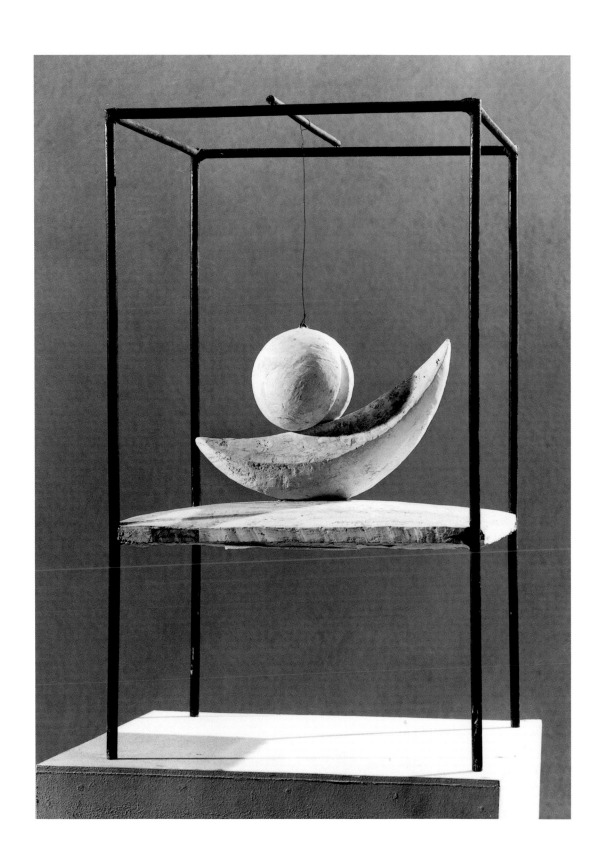

38. Suspended Ball. 1930

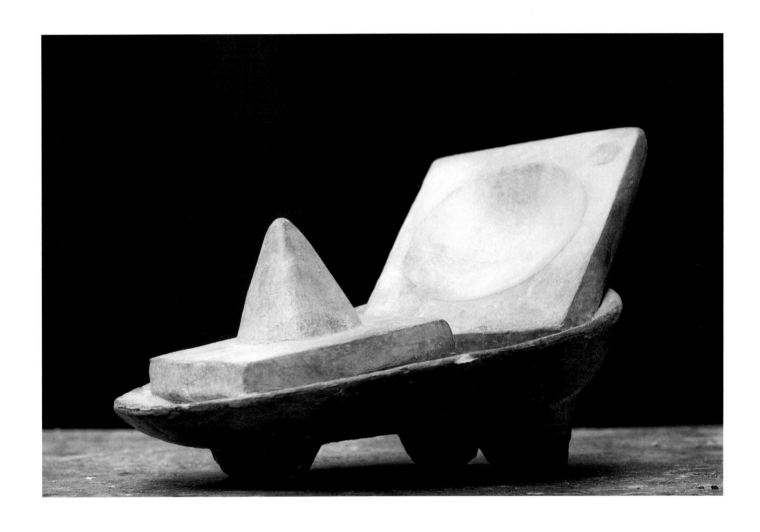

39. Vide-poche. 1930

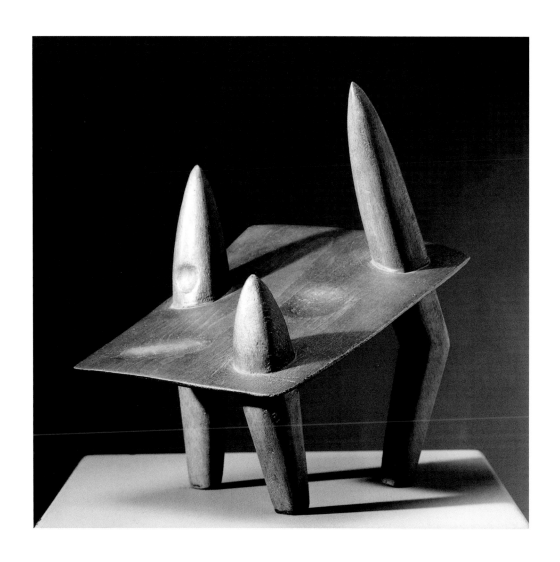

40. Family Portrait. 1930

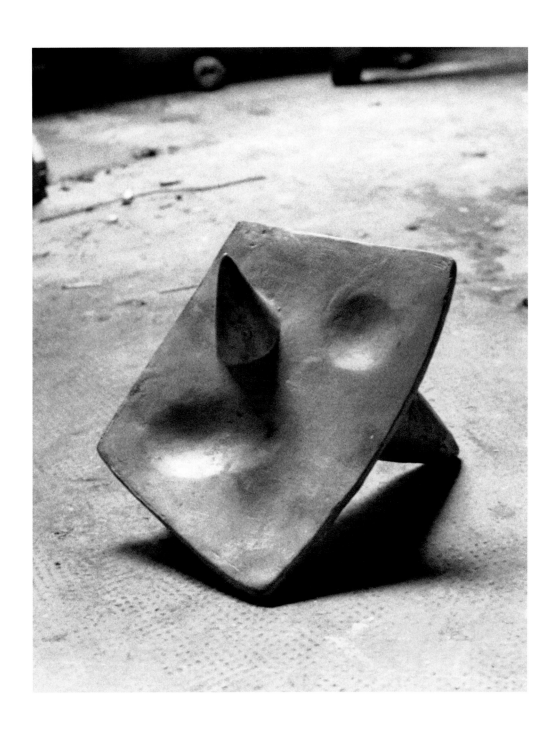

41. Disagreeable Object, To Be Thrown Away. 1931

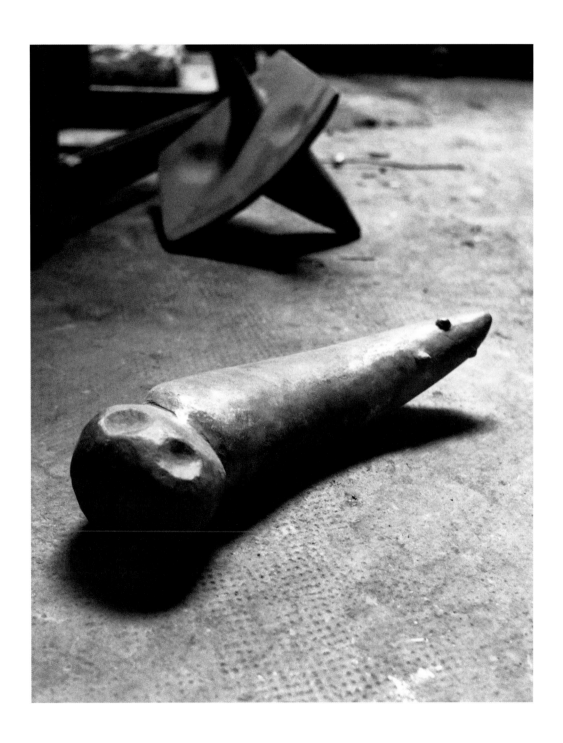

42. Disagreeable Object. 1931

Models for Public Squares

In representing the psyche, with its dreams and hallucinations, sculpture offers the attraction of graspable actuality, of sensual immediacy (as opposed to the fictive nature of the flat picture). For this very reason, however, it runs the risk of mundane, reified banality, as may be seen in most Surrealist objects. To transcend this problem, the work must have a resonant space for the imagination into which the viewer's fantasies can flow. Giacometti was adept at seeking out ways of creating just such spaces in his sculptures, where external and internal reality could mingle.

He had already achieved this effect with the Cages; with his models of squares he opened up yet another category of Surrealist sculpture.[50] The idea of a model implies a double reality: on the one hand it is a factual object that can be manipulated, and on the other hand it stands for something that is present in the imagination. Further ambiguity results from the fact that a model refers both to the intended content of the work, the mental process, and to the small scale—as opposed to its life-size realization. Significantly, the only project to be realized full-size, *Figure in a Garden* (plate 45), changed considerably in the process: an ensemble of figures turned into a single statuelike figure, with a very different relationship to the viewer, no longer "symbolic" but with an immediate physical appeal, like conventional sculptures of human figures.

The *Figure in a Garden* was commissioned by the Vicomte de Noailles, who already owned *Gazing Head,* for the garden of his villa in Hyères, France, in early 1930.[51] During that summer Giacometti made a group of three narrow, upright flat figures in Maloja.[52] In September the Vicomte described these as "mysterious figures," a characterization that is all the more appropriate for the final version, a single figure, completed as a maquette in December. In 1931 Diego made the first rough stone cuts for it in a quarry in Burgundy, and the brothers worked on it together in spring 1931 and in 1932 in Hyères. It seems impossible to deny the connection between this tall, rigorously self-contained stone figure—growing upward like the Hera of Samos or a tree forming a curve with the ground— and much admired prehistoric megalithic steles. Yet Hohl's allusion to Arnold Böcklin's *Odysseus und Kalypso* perhaps did greater justice to the inner unease and unresolved tension of this work. Its perplexing nature, which evolved from the primary forms of a draped figure, becomes apparent to viewers as they walk around it: at every step they imagine they will come to the front of the figure, but again and again they are greeted with a side view.[53] Just as unstable are the indications of the figure's gender, and its monumental impenetrability contradicts the almost dancelike, dynamic swing of the hips.[54] As in *Gazing Head*, undeniable presence combines with an intangible elusiveness.[55]

The work on the Hyères commission may well also mark the beginning of the models of squares; perhaps the *Model for a Square* (plate 43) was the first idea on this subject.[56] There is then a certain appropriateness about Hohl's appealing interpretation of this as a Garden of Eden with the Tree of Knowledge and the serpent.[57] But it is also possible that the notion of a sculpture as a quasi-spatial architectural or landscape model emerged in conjunction with the *Project for a Passageway* (plate 44). Its theme is a recumbent woman, and as such it is the horizontal counterpart to the standing figure in Hyères, with a similar outline, the same swing in the hips, and a square head.[58] The conventional theme of the *Project for a Passageway* is combined with Surrealism's fascination with the female body and sexual activity,[59] first suggested by Marcel Duchamp.[60]

The idea of equating a reclining figure with a landscape is varied by Giacometti in *Landscape—Reclining Head* (plate 48). The switch from head to landscape is an old metaphor for the correspondence between microcosm and macrocosm. Giacometti cannot have been unaware of Dalí's rotating a horizontal photograph of an African village to reveal a vertical image of a head.[61] In terms of the evolution of Giacometti's work, *Landscape—Reclining Head* clearly derives from the *Disagreeable Object, To Be Thrown Away* (plate 41). As has been noted, one eye bulges markedly, emphasizing the active nature of the gaze fixed on the viewer.[62] The work reads predominantly as a landscape; when it was first published its caption read "Falling Body on a Graph." The idea of the body perhaps more obviously applies to the equally idiosyncratic sculpture *Caresse (Despite Hands)* (plate 49), whose abrupt steps are already inscribed with the motif of falling. The rounded side, however, as pure as in any sculpture by Brancusi, is generally interpreted as a pregnant stomach, over which a man's hands are incised, detracting attention from the abstract beauty of the object. The body is flattened in a manner similar to that seen in *The Artist's Mother* (plate 24), although not sideways but front to back, as will be seen again in the later *Large Head of Diego* of 1954 (plate 140).[63]

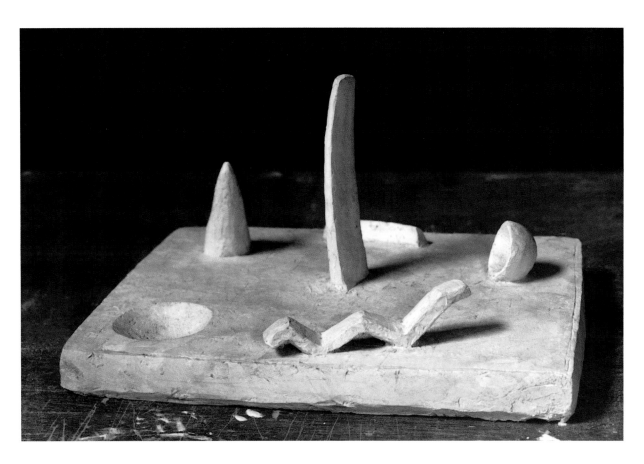

43. Model for a Square. 1930–31

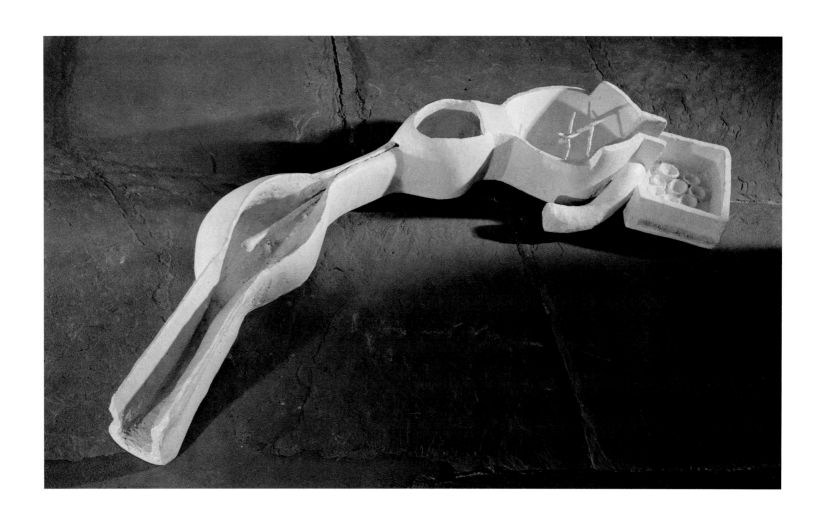

44. Project for a Passageway. 1930

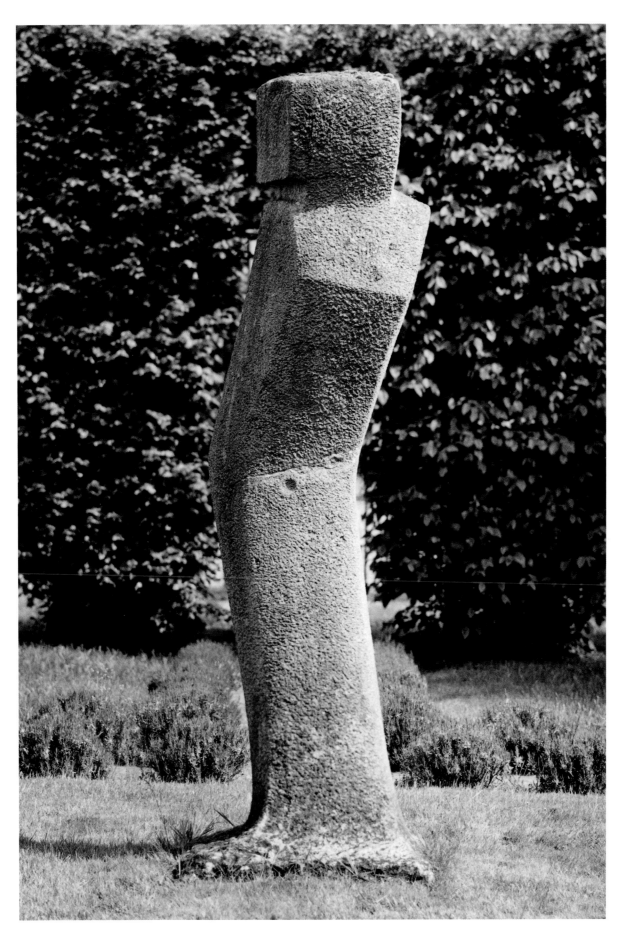

45. Figure in a Garden. 1930-32

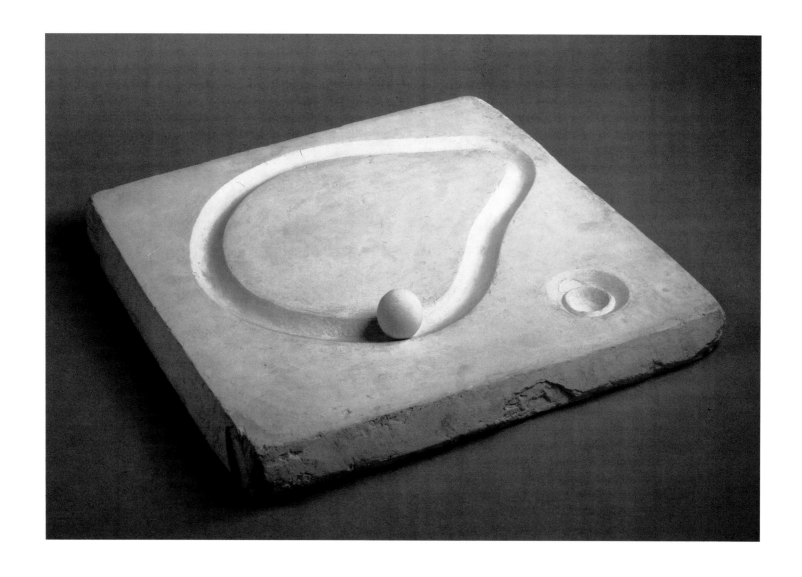

46. Circuit. 1931

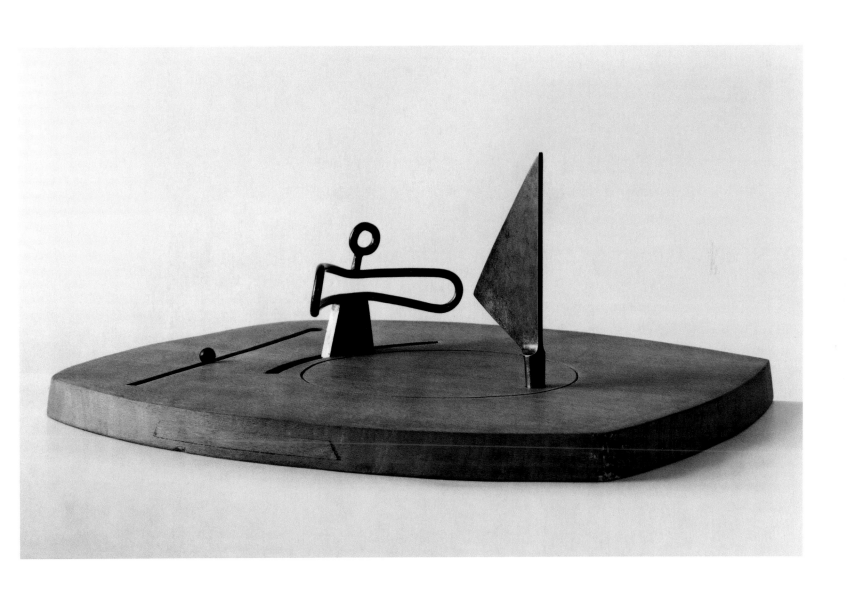

47. Man, Woman, Child. 1931

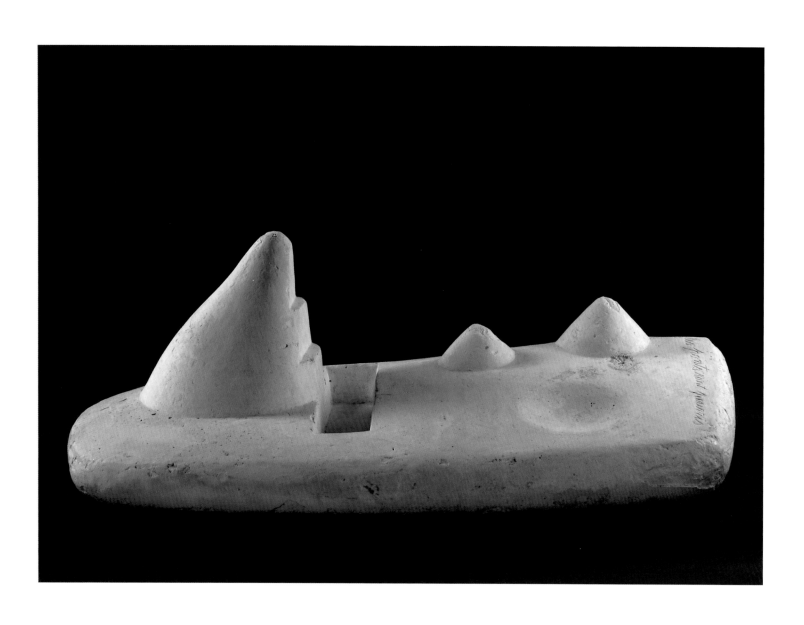

48. Landscape—Reclining Head. 1932

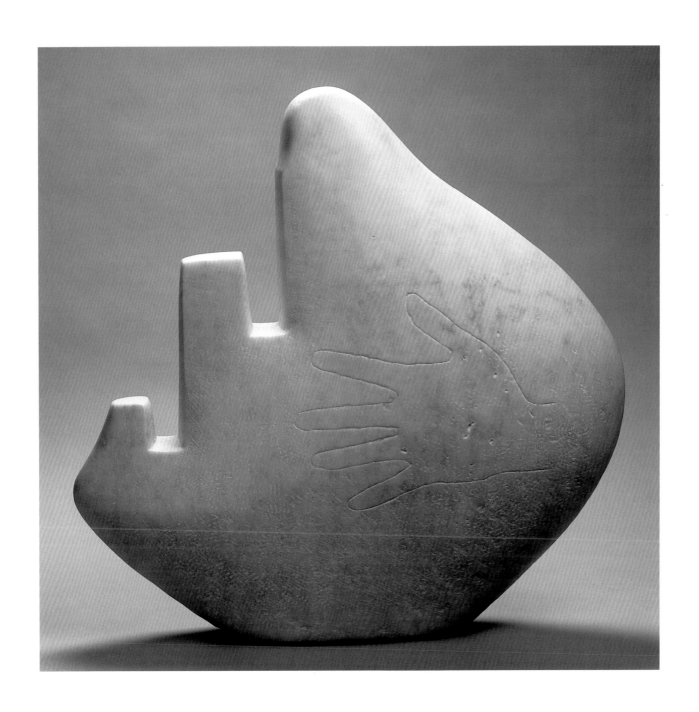

49. Caress (Despite Hands). 1932

Private Obsessions: *The Palace at 4 A.M.*

The most magical Surrealist object made by Giacometti is *The Palace at 4 A.M.* (plate 50), which was bought by Alfred H. Barr, Jr., for The Museum of Modern Art in 1936, only four years after its execution. A viewing of the *Palace* raises the question: Is this still an object, a thing? Almost an immaterial drawing in space, the *Palace* barely steps across the threshold between the imagination and external space. In a short text for *Minotaure* Giacometti described his working method by drawing on the example of the *Palace*, the idea of which gradually took on its final, succinct form in the late summer of 1932. He said that the work appeared in its finished form before his inner eye and that it was then quickly realized.[64] It was only in the finished sculpture that he found—albeit altered—images, impressions, and experiences that had deeply affected him, a working method typical of the Surrealists. According to the artist the *Palace* reflects a past time when he and a woman attempted obsessively to build a palace out of matchsticks, which always collapsed at the slightest movement. Giacometti attributes the spinal column to the woman; the standing figure to the left he identified as his mother as she appeared to him as a child; and the artist saw himself in the object in the unfinished or ruined tower. Everything seems noncorporeal, transparent, individual, and at the same time general: the timeless temple facade with three doors and the hieratically unapproachable, self-contained figure of the mother, opposite her Giacometti's lover at the mercy of time and thus of death, and the fragile glass walkway that links the two spheres and crosses over the symbol of masculinity, itself half eye, half sexual organ, ambiguously rising or falling.

The piece seems like the model of a stage with a constellation of figures from a psychodrama. It has only one main viewing angle and, as Hohl has remarked, bears a relationship to Böcklin's visionary painting *Isle of the Dead*.[65] By contrast the signlike reduction points forward to a diagram that Giacometti later used in his most complex autobiographical text, "Le Rêve, le sphinx et la mort de T." (The Dream, the Sphinx and the Death of T.) of 1946, as a way of demonstrating the tangled simultaneity of events in our memories.[66] Here events do not come to Giacometti chronologically but are linked by themes and all at once: perception and cognition are actuated in a web of spatial interconnections. That accounts for the thematic and formal plenitude of Giacometti's work and will prove the impetus for a specific, phenomenological approach in his postwar output.

Giacometti's cramped studio in the rue Hippolyte-Maindron was a similarly evocative space. It was sparse, measured barely two hundred square feet, and it was the artist's home from 1927 until his death. In the beginning it was scantily furnished, but scrubbed clean; along with his own sculptures, richly eloquent decorative pieces from his parents' house were displayed, as were a Bakota figure and the plaster cast of a Gudea head. Later, particularly after 1935, layers of sketches and working notes covered the walls. Things were no doubt at their most chaotic in the creative fervor of 1947–48, when heaps of plaster and clay, and the shards of rejected works lay about. The studio was recorded in numerous drawings; it provided the background for most of Giacometti's paintings and attracted numerous photographers. Yet nowhere does it appear so clearly, with such "metaphysical lucidity" as in two drawings of 1932 (plates 51, 52). Here, drawn with crystalline precision, *The Palace at 4 A.M.* stands in the center of the room, almost like a small model of the studio space itself; most of the works so far discussed are grouped around it. The recumbent woman of the *Project for a Passageway* (plate 44) is upright against the wall, and enlarged individual elements from the *Model for a Square* (plate 43) can also be seen. As in the drawings of the "moving and mute objects," or later in his letters to Matisse, Giacometti here, in effect, reviews his work. His progress by means of conceptual antitheses and the ensuing multifaceted nature of his works prompted him to seek such self-reassurance in his drawings as well as in his poetic autobiographical texts.[67]

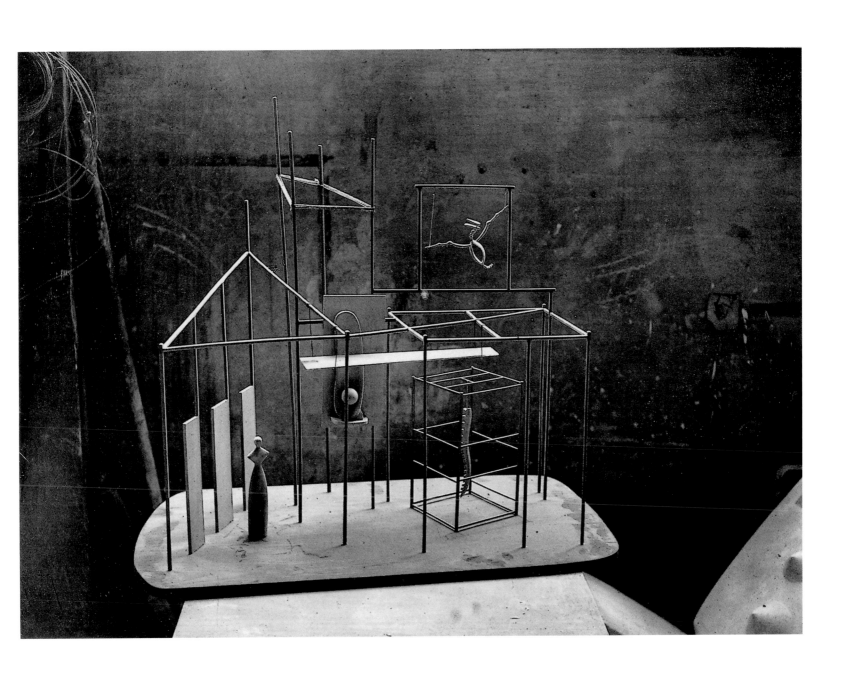

50. The Palace at 4 A.M. 1932

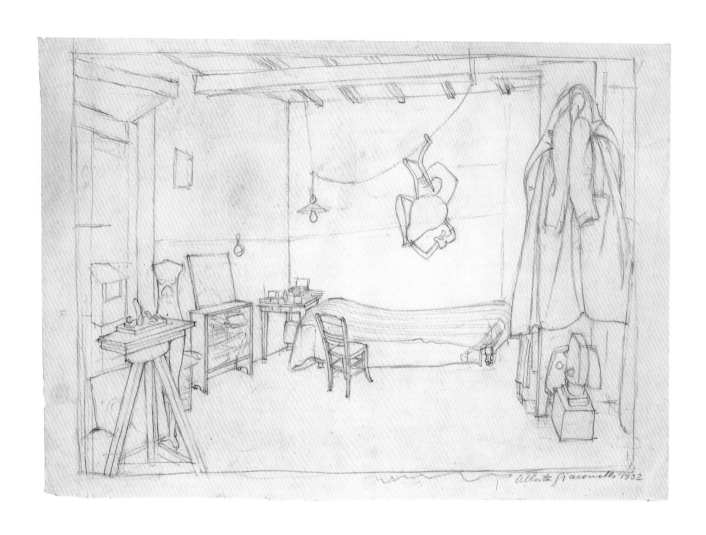

51. The Studio. 1932

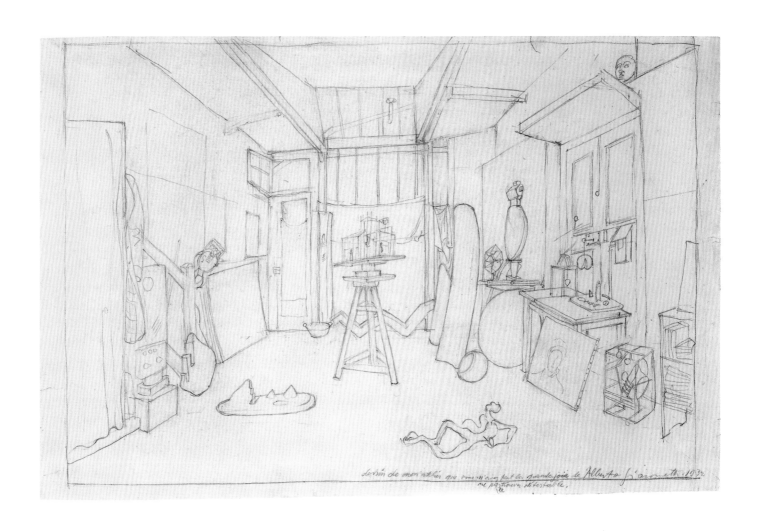

52. My Studio. 1932

"Theater of Cruelty"

The Palace at 4 A.M. (plate 50) and the two studio drawings (plates 51, 52) preceded a change in the character of Giacometti's involvement with the Surrealist movement. His succeeding works took on an increasingly somber, cruel character leading finally to objects that speak only of death, most prominently *Head—Skull* and *Cube (Nocturnal Pavilion)* (plates 62, 63). The artist had not yet found a fully satisfactory expression for the interconnectedness he saw between sexuality and violence. This theme occupied Giacometti intensely when he was drawing the studio, and is apparent in the connection between the two most noticeable sculptures in the drawings. Above the bed hangs a flat relief, a commissioned work that had evolved from *Three Figures Outdoors*.[68] This "woman in the shape of a spider" does not, however, appear to be flat against the wall, but seems to be gliding along the light cord like a giant spider, and thus it is hardly surprising that just such a creature should dominate the nightmare in "The Dream, the Sphinx and the Death of T." Lying in the foreground of the other drawing is a deformed woman with her head thrown back: a variant of the *Anguished Woman in Her Room at Night,* which Giacometti had extrapolated from Lipchitz's violent *Couple* and which he embellished with a mechanism that would be fatal to any of her imaginary partners.[69] But the Cubist stylization and model-like simplifications of these earlier works no longer satisfied him: as in the *Figure in a Garden* for Hyères he wanted to create a sculpture in the old sense of the word, a living presence that would confront the viewer instead of an object to be manipulated.

In a double metamorphosis Giacometti fused the decorative arachnid of one studio drawing with the man-killing recumbent figure in the other and came up with the *Woman with Her Throat Cut* (plate 53). As puzzling as the combination of the leaflike, jagged shell shape and its thinly extending insect limbs may be, it is compelling in the impression it gives of an animated being—terrifying either as a giant spider with energy-laden extremities or as a woman with her throat cut, writhing in death throes. It was the artist's wish that the sculpture should lie on the floor without a pedestal, not separated from the territory of the viewer. Seen from a distance, it could appear to be heading menacingly toward the viewer; seen from above, its limbs appear to be spreading apart. Although this sculpture of a fictitious creature neither conforms to the notion of spontaneous production nor to the interest in objects favored by Surrealist theory, it is nevertheless saturated with the obsessions and fixations of the Surrealists, particularly with Bataille's notions of base materialism. Giacometti's recollections of his own youthful pre-Surrealist fantasies of murder and rape appear in "Hiers, sables mouvants" (Yesterday, Quicksand).[70]

Giacometti's last Surrealist objects belong to this "theater of cruelty," and are largely without the poetic aspirations of the previous models of squares as well as the burlesque aspects of the Disagreeable Objects. Playfulness gave way to deadly seriousness. In mirror-writing on a sculpture the shape of a game board we can read its title, *No More Play* (plate 54). The central section of this piece alludes to a field of graves in a paraphrase of Fra Angelico's *Last Judgment,* as Casimiro Di Crescenzo has shown.[71] The character of the situation and the forms differ from those of earlier, similarly constructed, pieces. No longer abstract and ambiguously general, the new work is focused in real terms as sections of a board game or mechanical constructions in which directly legible figurative elements are inescapably exposed to punitive forces. In *Caught Hand* (plate 56) a mechanical crank invites the viewer to turn it, and the imagined result of the action evokes both the sadistic and the masochistic. The hand caught in the bars of the mechanism is reminiscent of prostheses or shop-window mannequins, favored fetishes of the Surrealists with their cult of compulsions and phobias concerning physical contact. As in Charlie Chaplin's movie *Modern Times,* the malicious carnality that lurks beneath the rational surface of modern technology is here brought metaphorically to light.

The most complex of these objects may well be *Point to the Eye* (plate 55), an image of combat on a Mexican ritual site with a channel for sacrificial blood. The preceding stages of this piece seem, in terms of form and content, to have a poetic lightness all their own, as in *Suspended Ball* (plate 38) and an encounter between a stork's beak and an eye-snake, sketched for "Moving and Mute Objects." The victim of the spike aiming at the eye in *Point to the Eye* appears to be death itself—always the victor in the dance of life. A web of dialectical associations is thus set up by this otherwise straightforward object. More firmly than any other it is entangled in the confusing theories and visual metaphorics of the Surrealists. This is a topic too extensive for the present essay, but mention should, nonetheless, be made of parallel ideas and imagery. Of fundamental influence in this context is Bataille's erotic

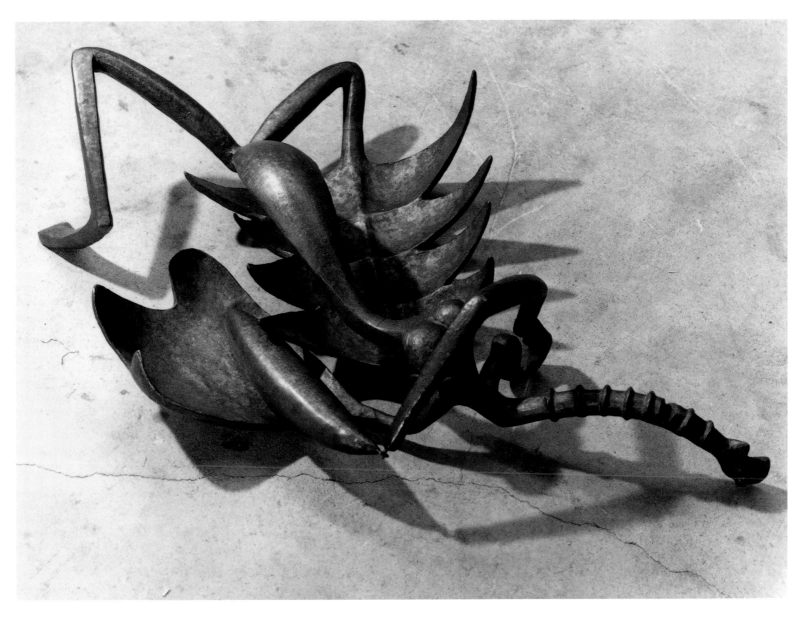

53. Woman with Her Throat Cut. 1932

novel *Histoire de l'oeil*, which virtually destroys itself with its sexually obtrusive metaphors. Almost equally important is the notorious opening scene of an eye cut through in Buñuel's and Dalí's film *Un Chien andalou* as well as Carlo Collodi's tale for children, *Pinocchio*.[72]

In *Point to the Eye*, death is threatened by the life that it is threatening; and if for Giacometti the eye and the gaze are the epitome of the living, the spike would also mean the one-ness of seeing and the seen. Metaphorically, the targeted gaze of the artist/victim turns its moving counterpart into a fixed image; he kills it like the Medusa who petrifies all those who see her. In a sense, Giacometti's late work was a search for the solution to the insoluble problem of preserving the living in a work of art.

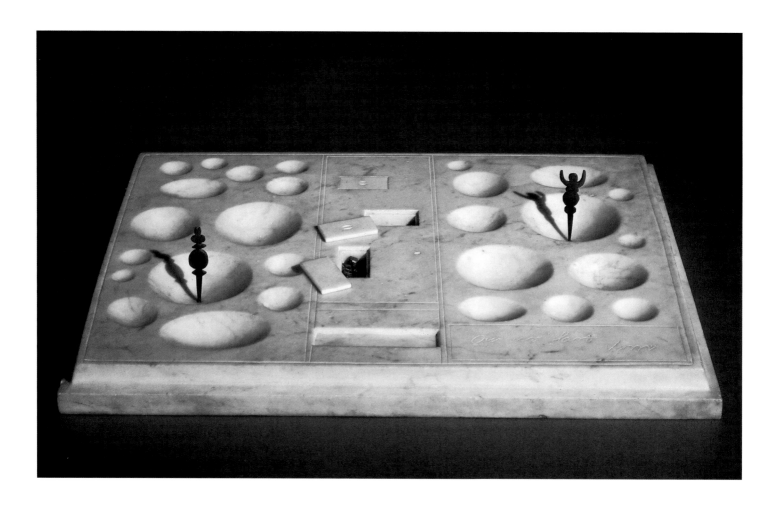

54. No More Play. 1932

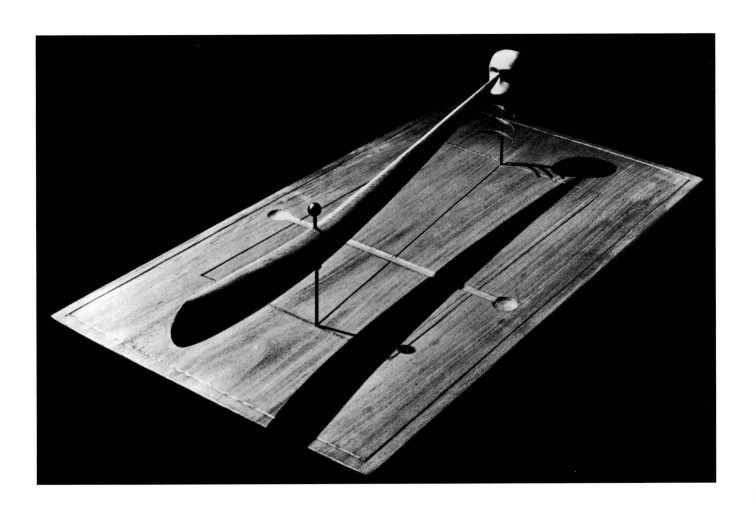

55. Point to the Eye. 1932

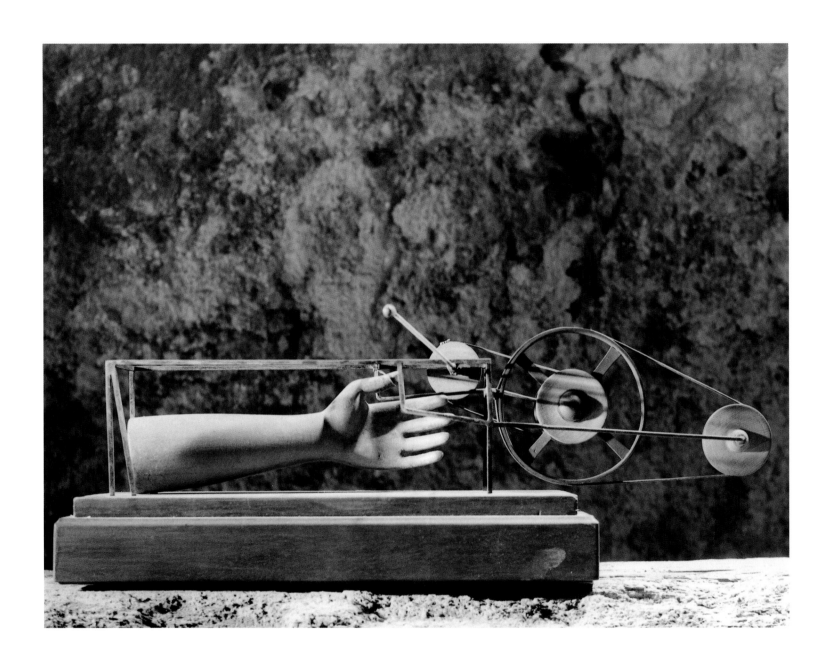

56. Caught Hand. 1932

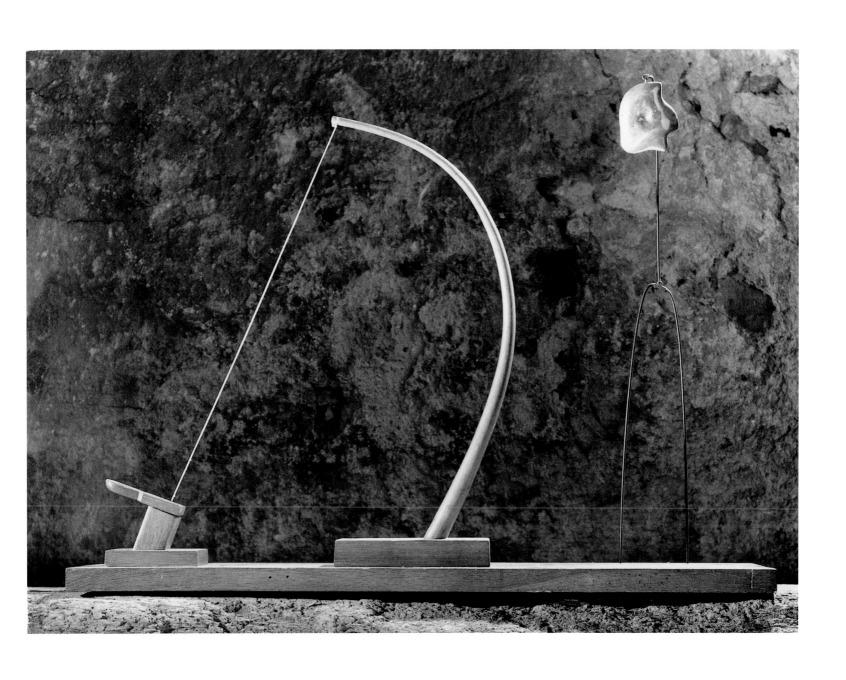

57. Flower in Danger. 1933

Maintenant le Vide (Now, the Void)

The dark tone of Giacometti's last Surrealist objects in part reflects the increasingly acute political circumstances of the time. The world economic crisis had led to an escalation of the struggle between communists and fascists. Within Surrealist circles the cry for active engagement in the social revolution created a state of high tension. Louis Aragon withdrew, and Giacometti stayed loyal to him, penning some biting caricatures for his communist journals.[73] The fact that this did not lead to a break with Breton was most probably due to Giacometti's status in this group, as the only sculptor and perceived as the most important visual artist beside Dalí. Additionally, his differences from the bourgeois Parisian literati exerted a particular fascination. After this, Breton paid special attention to Giacometti, and it was only the artist's return to making life studies from models that led to his excommunication in February 1935.

Giacometti's political partisanship was complicated by a fundamentally artistic problem. Since the late 1920s, he and Diego had earned a considerable portion of their living by making pieces for the interior decorator Jean-Michel Frank; they designed lamps, vases, and decorative items for the most expensive boutiques and exclusive clients, who included Giacometti's most important patron, the Vicomte de Noailles.[74] How could that be reconciled with his communist sympathies? In order to avoid unnecessary complications, Aragon did not publish all of Giacometti's caricatures, and even then only under a pseudonym. But the more pressing artistic problem lay in the object-character of a work of art that was demanded by the Surrealists. Giacometti was producing objects as decorative items, yet at the same time he wanted to say something meaningful with his art, express feelings, emotions, and desires, and communicate these to the viewer.

The work in which this crisis came to the fore was *The (Surrealist) Table* (compare plate 61), which was made for a group exhibition in May 1933 specially devoted to objects.[75] Its whimsical quality starts with the different legs, obviously citing René Magritte. The uncertain relationship of these legs with the overall form of the table appears formally just as clumsy as the bust of a woman with particularly incongruous drapery: the whole thing threatens to fall apart or to tip over and is far removed from the compelling formal precision of the other works of this period. The objects lying on the table divide into abstract things on the left and figurative ones on

the right, none of them of any use and claimed for the world of fashion by the perfumer's utensils in the center. The Comte de Lautréamont's "chance encounter on a table," an often-cited source of Surrealist poetry, is here unmasked as a decorative chance product.[76]

One of the studio drawings of 1932 (plate 51) evidences Giacometti's early conception of his *Walking Woman* of 1932–34 (plate 59). At the left is the figure of a slender walking woman, without head and arms, and with a shallow triangular indentation in the stomach area, much as the finished sculpture appears. A flattened, slimmed down, modernized Egyptian figure, somewhat in the style of Archipenko, *Walking Woman* stands with the left foot extended slightly forward. Beveling the base adds to the elusive, visionlike quality of the figure. It has been suggested that this sculpture represents the ghostly "Gradiva"—familiar from Freud's interpretation of her in a text which was central to the Surrealists. (Later, Giacometti turned the torso into a mannequin, thereby increasing the affinity between this elegant figure and decorative objects.[77]) Thus, almost casually, and with little apparent connection to any of his previous works, the life-size female figure steps into Giacometti's œuvre.

Although a rejection of Surrealism might be said to be present in the title *Hands Holding the Void (Invisible Object)* (plate 58), it was precisely this sculpture that so fascinated the Surrealists: instead of taking it as a critique, they regarded it as the ultimate in wit.[78] Although the stylized body of *Hands Holding the Void* derives from *Walking Woman,* the evident effort put into the design of the enthroned female figure is too great, and its radiance too intense, for it to be regarded in the same way as the more casually conceived earlier figure. Nor is it possible to take her as an ironic farewell to an outmoded position. A clue to this intentionally enigmatic piece may be the search for the meaning of *invisible* in the literature that was important to Giacometti at the time. In the first issue of *Documents* there is a ground-breaking article by Carl Einstein, who may be regarded as the person who actually discovered Giacometti, and he was certainly the critic who did the most to foster his critical acclaim.[79] Einstein's "Methodic Aphorisms" were in effect reflections on the origins and aim of art, and took on a central importance in Giacometti's view of himself. At one point Einstein wrote: "The religious work of art is, so to speak, a product of the invisible, caused by the

disappearance, the nonexistence of a being." In his view, art serves the cult of the dead and confronts death. In exotic and archaic art he found a kind of metaphysical realism, which attempted to grasp the indestructible *ká* of the Egyptians, the "shaded soul" of the dead. This is the "invisible" and, for an agnostic like Giacometti, the "void" was nevertheless a presence, an operative force, a *fantasme*, and his aim was to grasp it, to halt it, to hold it captive. These thoughts most probably derived not only from a general obsession with death, but from the actual experience of the death of his father in the summer of 1933.

His father's death made Giacometti head of the family, and as the eldest son it was his duty to provide a memorial stone. *Hands Holding the Void* is a monument to Giacometti's father: the hieratic large woman who holds the deceased's soul, the Egyptian *ká*. Bonnefoy's observation that the horizontal slitlike opening of the pedestal of *Hands Holding the Void* defines it as a grave is confirmed by a *Study for a Monument* of 1946.[80] There, on a high, coffinlike base, a female figure walks toward the viewer with its arms raised: a similar "compositional idea."[81] In *Hands Holding the Void* the dark interior of the grave is visible through the pedestal's slit: the dark, lower "void" as opposed to the upper void held in the figure's hands. The soul, or *ká*, can communicate throughout both spheres. Its presence is indicated by the hieroglyph of the soul bird, or death bird, on the side of the throne; the following year Giacometti positioned the same bird on the stone for the cemetery in Borgonovo. Later, he omitted it from some of the casts—perhaps just for the sake of the purity of the form,[82] perhaps in order not to perpetuate the explicitly funerary allusion of this work.

When questioned, Giacometti was reluctant to explain the circumstances of the work and answered evasively.[83] When Marcel Jean asked him, shortly after the work was completed, what the hands were holding, he said, "I always knew." André Masson was told that Giacometti had been inspired by a child holding a vase; for Leiris, the author of *Manhood*, it had to be a girl holding a ball, symbol of masculinity. Each account relates to the dead father.

The supposition that the void held in the figure's hands had actually once been the *Head—Skull* (plate 62) supports the relevance of the idea of *Hands Holding the Void* to the death of Giacometti's father. Furthermore, the most striking feature, the planar concentration of the face into planes divided by a

central ridge is also hinted at in the marble head of the artist's father (plate 26), while the conspicuous differentiation of the two eyes is preempted in *The Artist's Father (flat and engraved)* (plate 27). The ambivalence between death and life is very evident in the *Head—Skull*; one, the dead side, seems much stronger and livelier than the other, smooth abstract side. Correspondingly, in the enthroned female figure, the wheel of life (which needs death if it is to go on turning) is in one eye, while in the other, the ring has broken into three parts.

But what can be said about the figure itself whose *raison d'être* is to hold this void? The arms, the shoulders, and the frame are parallel; they enclose absence just as the flattened torso, the seat, the planes of the face, and the board in front of the feet do. The figure could not evoke, frame, and hold the void if it were not complicitous with it. As ephemeral as a hallucination, this sculpture also plays with "illusionism" in the pronounced foreshortening of the figure and the seat of the throne. It threatens to slip into the realm of the viewer, but its apparent slide is halted. Another passage in Einstein's article seems relevant here: "The work of art is a protection against the invisible that prowls everywhere and frightens: a barrier against the diffuse animism that threatens." Giacometti was very open to these ideas, which were also cultivated by the Surrealists. "Visions" of heads between death and life were much in evidence at the beginning of his subsequent mature period of phenomenological realism. Giacometti later recalled that he was not satisfied by the academic smoothness of the torso and the legs in *Hands Holding the Void*, and that he had therefore returned to life studies. He was searching for a different, more direct link between internal and external reality than the contrived, artificial, and literary route Surrealism had suggested.

The invisible is also an issue in the *Cube (Nocturnal Pavilion)* (plate 63), the second imposing work that Giacometti made during this period, and which—in a different way— marked the end of his engagement with the avant-garde.[84] The dissolution of the block to reveal its internal vitality, which had marked his involvement with Cubism, can be seen in the 1932 studio drawing with *The Palace at 4 A.M.* (plate 52) where on the right side there is a small polyhedron, made only of wire with a small captive male figure dancing inside it. The wholly free, organically moving figure is set against the strict stereometric construction: the living entombed in the

dead, a metaphor for the impossibility of grasping living reality by means of geometric stylization. The large stone in Albrecht Dürer's engraving *Melancholia* must have seemed to Giacometti like a prophetic emblem for this failure, with the death's head on one of its faces reading either as an indefinable reflection or as a shadow. It may not only have been the close formal correspondences between the *Head—Skull* and the *Cube* that were inspired by Dürer's work but also the very idea of making a sculpture of a many-sided figure of the size in which it appears in the engraving. Giacometti later commented that none of his sculptures was abstract, with the exception of the *Cube*, but even this was actually a head. Coming from pure form, in this work Giacometti has taken stylization to its ultimate limit: this is the "great abstract," fascinating, unapproachable, and utterly silently contained within itself like death. Life has withdrawn into the invisibility of its inner world.

Giacometti did not stop at this point. But progress was only possible "through opposition." Once he had been gripped by life studies again, in 1935, he drew a number of self-portraits that reflect the struggle between organic vitality and the power of geometric forms. He also reinterpreted his *Cube*, incising a self-portrait into the uppermost plane. This was to become the focus of Giacometti's subsequent work: capturing the encounter with one's living opposite in one's own perception.

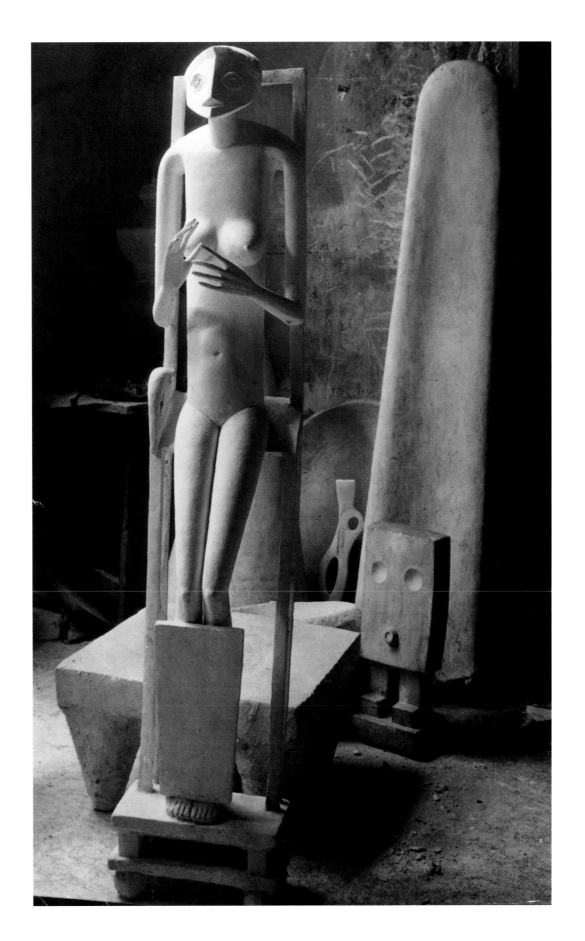

58. Hands Holding the Void (Invisible Object). 1934

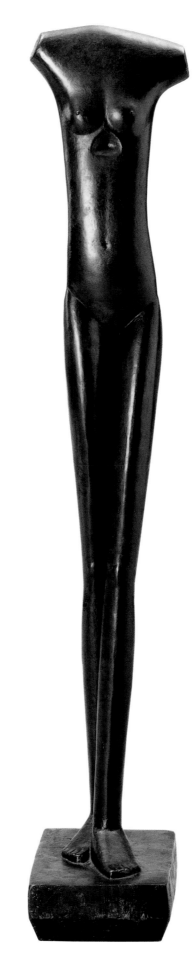

59. Walking Woman. 1932–34

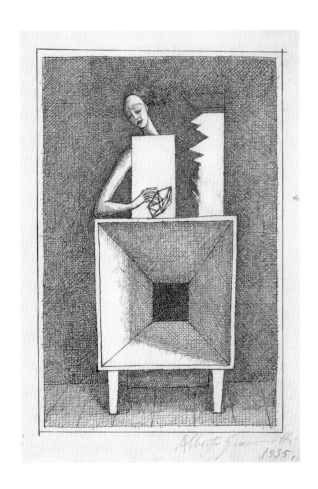

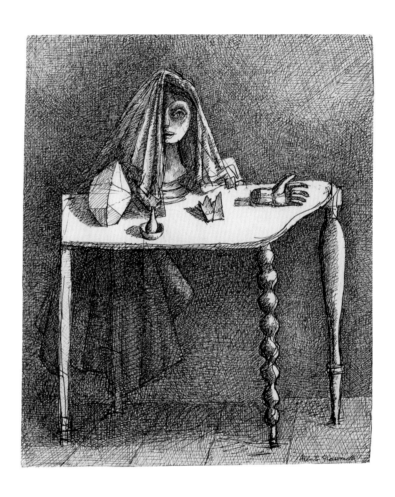

60. Figure. 1935 / **61.** The (Surrealist) Table. 1933

62. Head—Skull. 1934

63. Cube (Nocturnal Pavilion). 1934

IV. In Search of a New
Way of Seeing

Giacometti's resumption of life studies in 1934 marked a new epoch in his life and art.[85] He was not enough of a Parisian intellectual for the sectarianism and pretentiousness of the Surrealists, whose creativity was, in any case, clearly going into a decline. Giacometti was searching for an art form to express the reality of existence,[86] or, as he said, to embrace "the totality of life." The wealth of visible, palpable reality could not be achieved with the kind of metaphorical objects he had formerly made. Giacometti sensed that encounters with other people and interaction with his sitters might provide him with the means to a new expression.

Although he knew exactly what he no longer wanted, and in which direction he should pursue his search, he had little notion of how this might lead him to a solution (or that the search would last a dozen years). During this phase he intensified his experiments with stylization, which had led to *Hands Holding the Void* (plate 58). [87] His attempts of the 1920s to convey the fluidity of nature by means of cubic form were resumed but in this period supplemented by an intense attention to Egyptian art. His revived interest in Cubism is seen in *Head—Skull* (plate 62) among other things,[88] and a number of drawn self-portraits (plate 64) bear witness to his efforts to convey animated life through the use of a combination of Cubist and Egyptian derived elements. Strong as many of these drawings were, they failed to satisfy Giacometti.[89]

It is possible that a major Cézanne exhibition held in Paris and Basel in the summer of 1936 led Giacometti to make a more fundamental new beginning. His copy, *Pope Innocent X, after Velázquez* (plate 68), rendered in a more direct drawing style, buoyed up by a rhythmic microstructure, reflects characteristics of the Master of Aix, in a form that is considerably more direct. Not long after this, he finally abandons the closed forms of the Egyptian style with their tendencies toward a decorative, objectlike finish.[90] Even while returning to open Rodinesque surfaces, he was attempting a campaign of "unlearning." His aim was to banish what he considered the worn out aesthetic practices hindering him and to address the fluctuating immediacy of the living figure before him.[91] Presumably as a counterbalance to his increasingly amorphous sculptures, Giacometti confirmed his hold on compositional order in what may be considered the most impressive series of the drawings after great masterpieces he made from childhood to old age (plates 70, 71, 72).[92] Using pen rather than pencil,

he traced lines that show the power of the hieratic sculptures of Egypt and Mesopotamia, the pent-up energy of the *Three Studies of Gudea Head* (plate 72), and the transcendental crystalline lucidity of the *Study from a Head of Diedefre* (plate 70).

Since painting portraits of his father in 1932, Giacometti had made a number of other paintings without any apparent signs of a coherent style emerging. In the summer of 1937, however, he produced three canvases that lay the foundations for a later style that would not be fully in place until 1949. In these works he responds as a sculptor to Cézanne's use of color. Perceptual vibrations, which Cézanne had expressed in flecks of color, became, under Giacometti's brush, lines and light-dark contrasts. *The Artist's Mother* (plate 65) recalls the only earlier painting of similar intensity, the *Self-Portrait* of 1923 (plate 11). It has the same frontality and rigor, accentuated by the horizontals and verticals in the background, and the same monumentalization of the figure and concentration in the face. But instead of a multifaceted application of color, dark and light lines build up the forms, a framework of energy lines compellingly evoke reality yet have no mass. In *Apple on the Sideboard* (plate 67) Giacometti focused even more precisely. Concentrating on a single apple placed at the exact center of his field of vision, he expressed the decreasing exactitude toward the edges of that field in the summary execution of the painting. As though conducting a phenomenological exploration, Giacometti did not naively seek to transfer reality directly onto the canvas, but to realize the picture of reality held within his inner perception. The internal frame that began to emerge in both of these paintings became an important feature of this reflective realism. Thus, as in Surrealism, an inner picture is shown, the difference being that this is no longer a dreamlike fiction but the artist's perception of reality.

These two paintings (plates 65, 67) bespeak intense work and were certainly not quickly finished, as may be seen from the unresolved treatment of the internal frames. Giacometti went on to paint a smaller version of the still life with apple (plate 66): in the first version he outlined in black what seemed to him—after completing the work—to be the correct size.[93] Despite this (and entirely without preparatory studies), these paintings are astonishingly successful. It is quite possible that the artistic principles Giacometti sketched out here were

as yet not fully articulated in his own mind. Looking back at this intermediate period, Giacometti later often made remarks that, in effect, obscured his intentions of the time. Whatever the case, it was much easier to conduct a phenomenological study of this kind in the illusionistic medium of painting than in sculpture, which is always about real objects in real space. In fact, this was the moment when Giacometti made his first attempts to sculpt a figure seen in the distance one evening on the boulevard Saint-Michel. He later commented that in those days he had not yet understood that such things could only be painted.[94]

Behind Giacometti's idea of depicting a figure in the distance was his observation—a common experience—that one can recognize a familiar figure from a great distance and be affected by its live presence, directly, even before being able to recognize details and actually identify the person. Giacometti particularly remarked that in this situation the person is very small in comparison to one's field of vision; with that, the main focus of his artistic endeavors shifted to questions of scale and distance.[95] While the perceived distance of viewer to figure in a painting can be fixed by the painted illusion of space, sculpture does not offer this possibility. Making ever smaller figures, Giacometti tried to impart the lived experience of distance (plates 78, 79). In order to distinguish his tiny figures from miniaturized close-ups, he retained their sketchy forms and placed them on over-sized pedestals, thereby defining the relationship of motif and field of vision, as in a picture frame.[96]

The fact that this aesthetic impossibility was to mesmerize Giacometti until well after the war is due to yet another dilemma. Once again he was interrogating himself about how a figure was to be formed in its correct proportions. The old difficulties from his time at the Académie had reemerged, and with that the attempt to render the whole figure was once more immediately abandoned. But even in sculpting the head, his old nemesis, the "Sahara Desert" problem[97] opened up to plague him. Busts modeled around 1939 appeared uncertainly diffuse, although not without a certain air of vitality. Finally, miniaturization seemed to simplify matters;[98] the heads became just as small as the previous little figures and, like these, were placed on large pedestals (plate 77). Here, too, the goal was that, as in real space, the face should appear at a stroke and in its totality.

Like a relic from a lost culture, one sculpture in particular stands out from Giacometti's twelve-year quest and his numerous experiments, many of which barely survived their beginnings: Giacometti modeled one relatively large full-length figure in Maloja. A bewildering form, it can only be properly understood in the light, immaterial white of the plaster original, the *Woman with Chariot* (plate 81). Giacometti constructed this sculpture, not as he normally did in clay over a wire armature, but with plaster applied directly to a straw core.[99] Thus this plainly formed body has something of the amorphous quality of a rag doll: elongated, rounded in its cross sections, the individual shapes as unformed as those of a young child. Volume and surface, accordingly, seem to be floating, no longer sustained by basic geometric forms or permeated with vital, organic impulse. With this piece it seemed that the artist had reached the point he had been striving for since the reawakening of his interest in external appearance; he had reached the goal of unlearning conventions that were obstructing his course, of penetration of the filter of all that is known, preformed, and handed down from the past. Yet this undefined, as it were, still embryonic delicacy was to be a new starting point, and was not to form the basis of artistic work of real weight.

In essence, the Maloja figure acquires its radiance from the painted eyes and large, arched eyebrows of the face. Thus the gaze dominates the frontal view, a gaze that is wondering and open, which holds together the appearance of the whole piece. The small head possesses a presence that brings to mind the apple in the still lifes of 1937, and contrasts with the heavy cube of the pedestal, standing, for its part, on a small cart. This toy was in the studio in Maloja and no doubt initially only served to move the sculpture more easily into the light or to one side.[100] But soon Giacometti came to view it as an integral part of the work: it demonstrates metaphorically that the sculpture and the viewer are in the same space; at the same time it removes the sculpture to a realm where things are unfixed, unattainable—a vision that approaches only to roll away again.

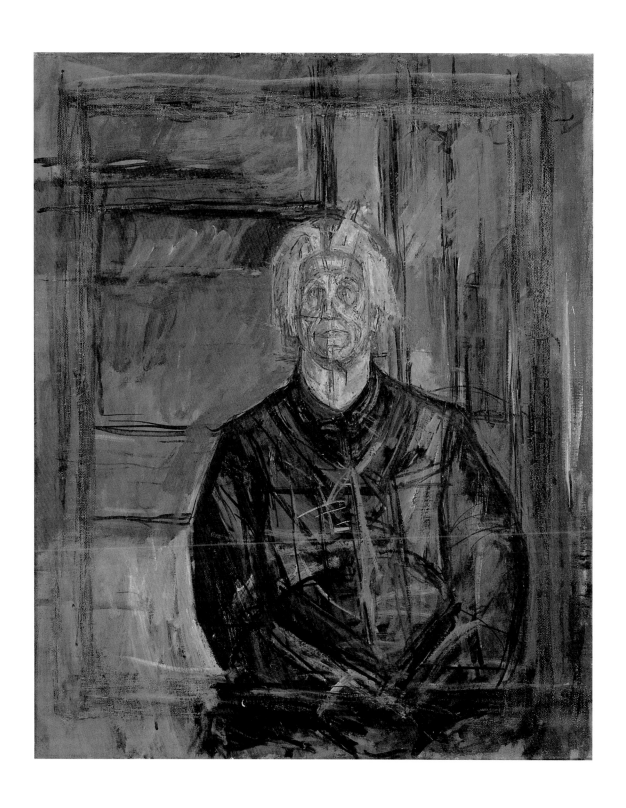

64. Self-Portrait. 1935 / **65.** The Artist's Mother. 1937

66. Apple on a Sideboard. 1937

67. Apple on the Sideboard. 1937

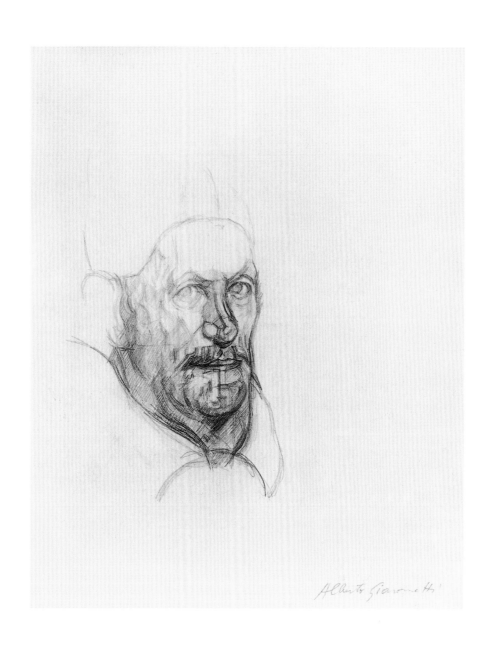

68. Pope Innocent X, after Velázquez. c. 1936 (dated 1942)

69. Head Studies. c. 1937

70. Study from a Head of Diedefre. c.1937 / **71.** Study from an Egyptian Relief. c.1937 (dated 1942)

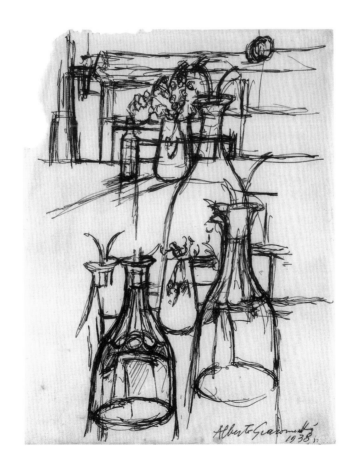

72. Three Studies of Gudea Head. c.1937 (dated 1935) / **73.** Vases and Flowers. 1938

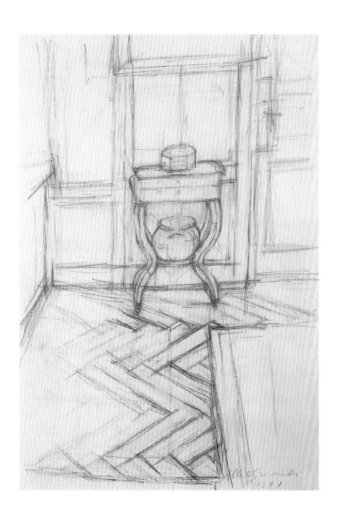

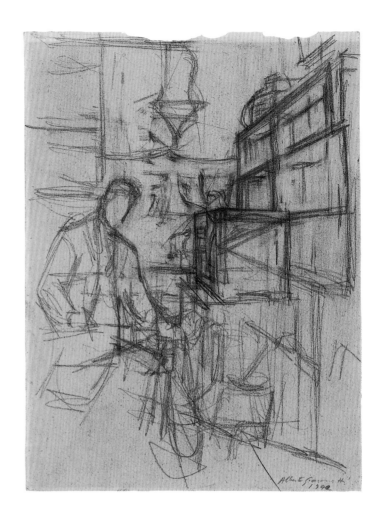

74. The Chiffonier. c. 1941 / **75.** Interior. 1942 (dated 1940)

76. "Automatic Drawing." 1943

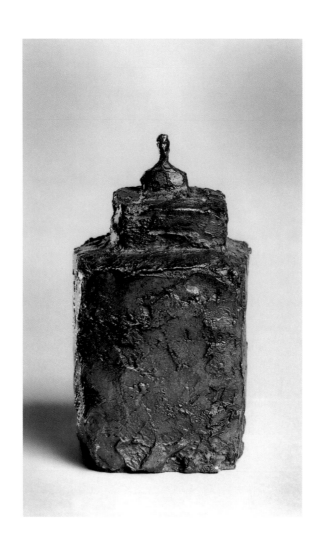

77. Small Bust on a Double Pedestal. 1940–45

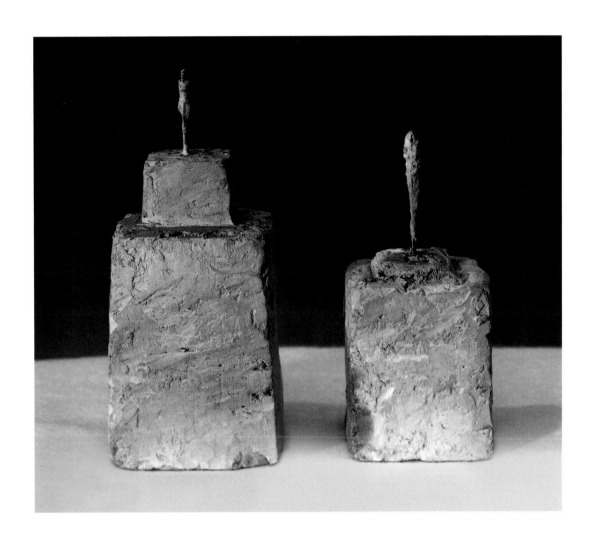

78. Small Figure on a Pedestal. 1940–45 / **79.** Small Figure on a Pedestal. 1940–45

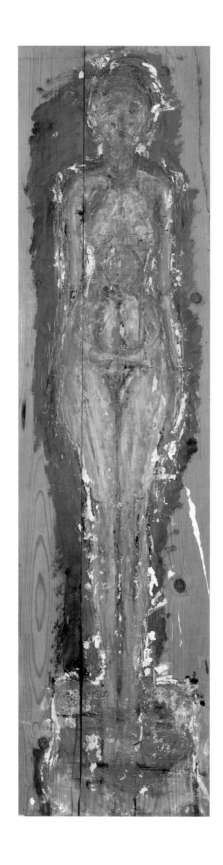

80. Nude. 1942–43

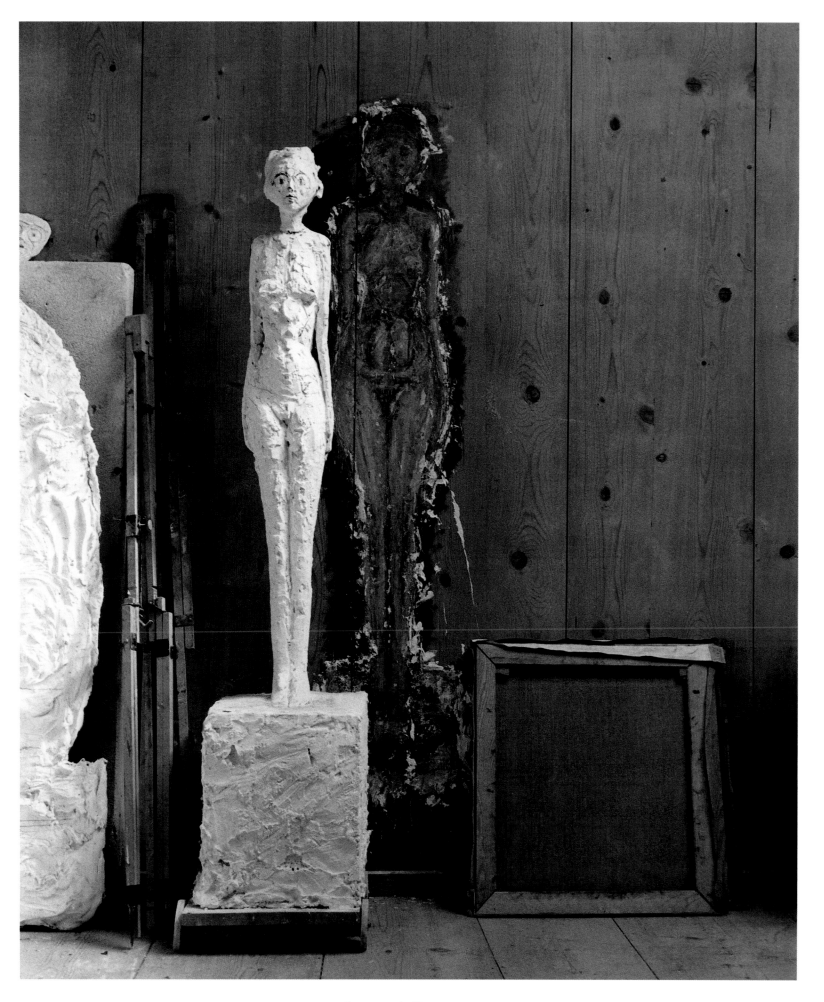

81. Woman with Chariot. 1942–43

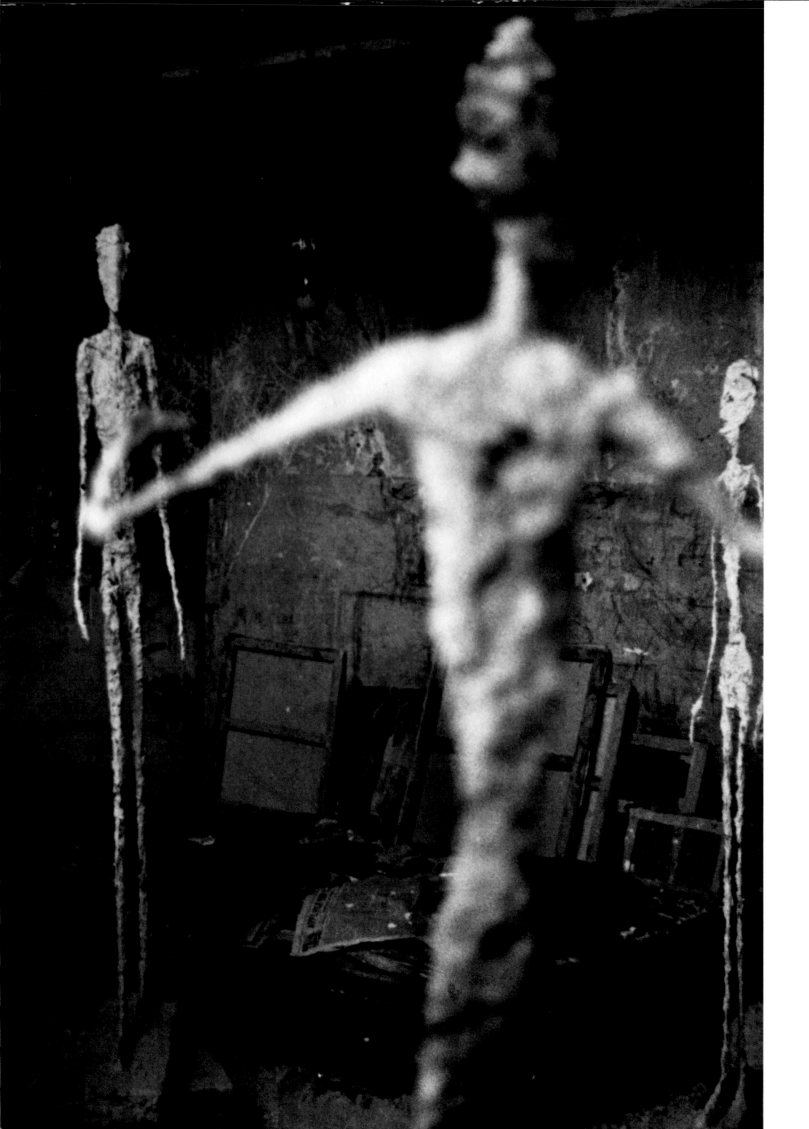

V. The Mature Style

Return to Postwar Paris

After the cease-fire in 1945, when Giacometti returned to the studio in the rue Hippolyte-Maindron, which had been maintained by his brother Diego, he brought with him six matchboxes containing a number of tiny figures he had made in Geneva that were to occupy him for another year. Featured in *Cahiers d'art*,[101] they were soon regarded as the ultimate expression of the sparsity of the era and of indefatigable, self-imposed, lonely striving for the impossible.

His return from the small bourgeois city of Geneva to the vitality and anonymity of the French metropolis had a liberating effect. Here he was reunited with friends from his Surrealist days, among them Leiris, Bataille,[102] and Aragon.[103] Among his old colleagues were the ailing Francis Gruber, Picasso, the art critic Christian Zervos, and various dealers, including Pierre Loeb,[104] who exhibited a number of his works. There was also a newer circle around Simone de Beauvoir and Jean-Paul Sartre, in which Giacometti participated in philosophical discussions. These conversations were highly productive for all concerned and led to the two texts by Sartre that became so important in the reception of Giacometti's work. In July 1946 the young Annette Arm left her parents' home in Geneva to share Giacometti's meager existence in Montparnasse; she became his most important model besides Diego, and in 1949 she and Alberto were married.

Although World War II was over, life was still difficult: people heard of the many who had been killed or maimed, and the survivors returned from concentration camps; unsavory acts of retribution were rife among former resistance fighters and collaborators alike. Tension between the communists and democrats ominously prefigured the Cold War. The supply of even basic commodities was precarious, and the winter of 1946-47 was particularly hard. Giacometti was obliged to rely on friends to cover his living expenses, and as long as he was under the spell of his tiny figures, there was scant hope of an income from his work. He probably survived because of his already modest standard of living and his unshakable faith in his vocation, which endowed every circumstance of his life, even misfortunes, with special meaning.

Then certain events occurred that were crucial to his psychic development. He later remembered being suddenly overcome in a cinema in February 1946 by a moment marked by an intense heightening and shifting of his perception of reality during which the image on the screen disintegrated into a mist of dots. His neighbor in the auditorium unaccountably seemed "wonderful" to him as, on his emerging from the building, did the whole boulevard—as though in a fairytale. At other times such visionary episodes had taken on strange dimensions: for example, when he perceived the head of a waiter suddenly transfixed above him, the living face petrified into a death's head. In July the concierge at the buildings containing the artist's studio died. That night, as Giacometti walked past the room in which the corpse lay, it seemed to him that the dead man was everywhere, and he felt that a hand touched his arm. In the autumn, after describing a particularly disturbing nightmare about spiders, he was asked by the publisher Albert Skira to record the dream for his journal *Labyrinthe*. This produced Giacometti's most important text, "Le Rêve, le sphinx et la mort de T.," in which he aired key obsessions and was able, for the first time, to describe his youthful experience of the death of van Meurs some twenty-five years earlier.

These hallucinatory experiences gradually began to release his artistic fixations. The heads and figures became slightly larger; his design for a memorial to Gabriel Péri includes his first walking man, whose immateriality may be related to the character of the model. Decisive progress is evident in his draftsmanship. When he was still in Switzerland, the rigid forms of the late 1930s were already starting to loosen somewhat, and the space around them was acquiring a certain transparency.[105] In 1946 this process accelerated noticeably: the three studies of Pierre Loeb (plate 83) are reminiscent of similarly constructed heads from around 1938, whereas the nudes produced only a little later (plates 94, 95) and the *Homage to Balzac* (plate 86) already showed that floating, chimerical quality crucial to his mature style that clearly derived from his recent visionary experiences.

82. Studio Interior. c. 1940

83. Three Portraits of Pierre Loeb. 1946 / **84.** Apples. 1946

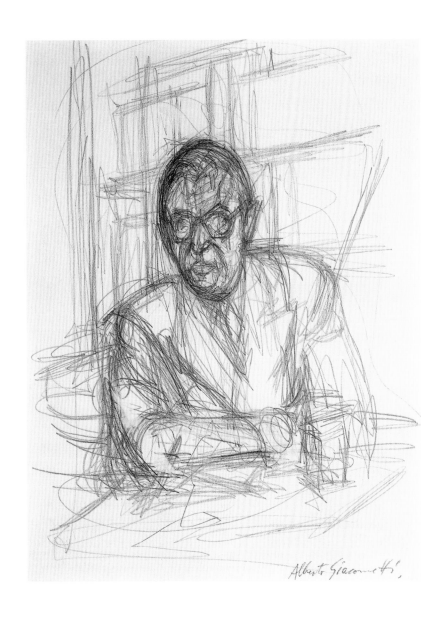

85. Jean-Paul Sartre. 1946

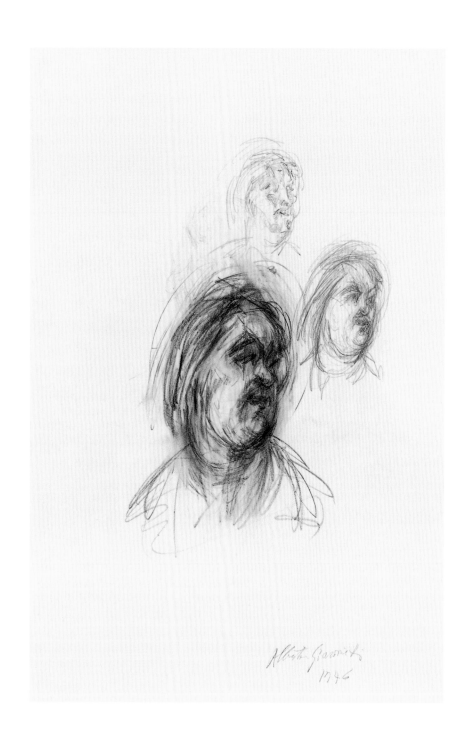

86. Homage to Balzac. 1946

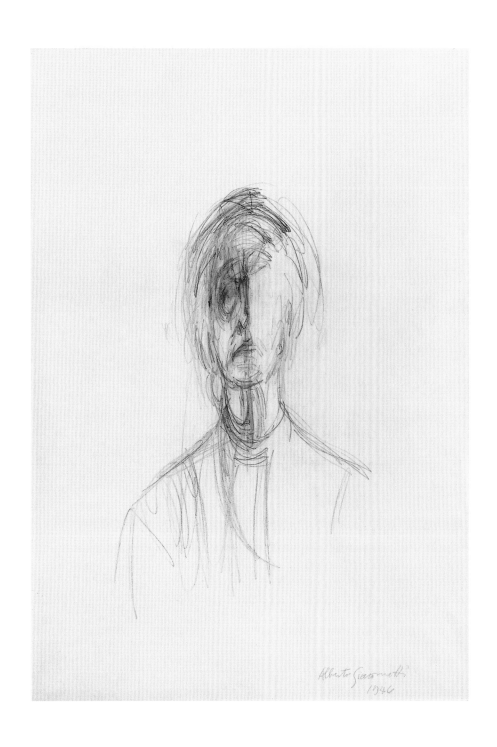

87. The Artist's Mother. 1946

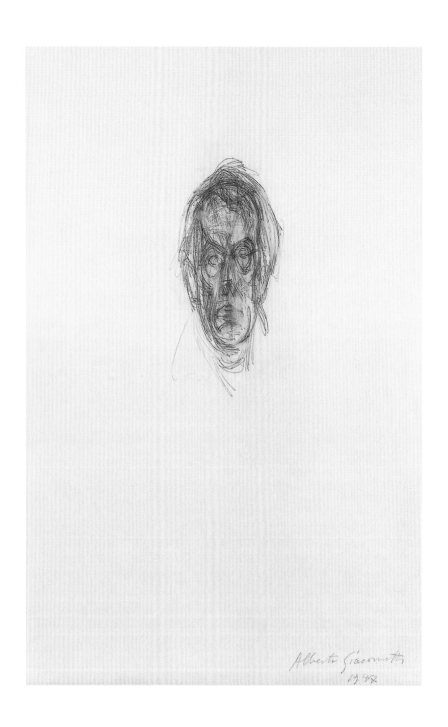

88. Head of Diego. 1947

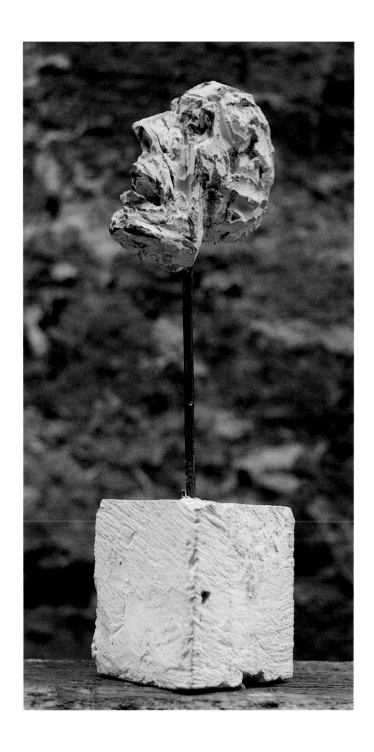

89. Head on a Rod. 1947

Body Fragments

Giacometti's late style, first exemplified in 1947 in the ethereal, weightless figures of his *Tall Figure* (plate 97) and *Walking Man* (plate 101), was heralded by three sculptures of the same year: *The Hand* (plate 92), *Head on a Rod* (plate 89) and *The Nose* (plate 90).[106] As a student at the Académie, Giacometti had found it easier to form individual parts than whole figures, and acting on that inclination in his first works in many years to approach life-size, he opted for the fragmentary. In his text "Le Rêve, le sphinx et la mort de T." there is a point of reference for each of his new sculptures: the ghostly hand that brushes Giacometti as he walks past the concierge's deathbed; the corpse's head lolling backward with, as Giacometti described it, a fly disappearing into its open mouth; and finally the elongated nose he observed as van Meurs lay dying. And, like this text, the three works deal primarily with the effect of traumatizing experiences in the artist's life, such as the death of van Meurs in 1921 and the death witnessed in 1946. His vivid recollections of the bombing of Moulins in 1940 are also implicated in these sculptures. There, Giacometti found himself in the midst of a maelstrom of people fleeing Paris as German troops advanced on the city, and he was stunned by the sight of an arm torn from a mutilated body.

However, these three sculptures also recall Surrealist works and interpret their themes anew. The clearest contrast lies in a comparison of *Head—Skull* and *Head on a Rod* (plates 62, 89). In the latter, the stylized language of symbols is operative, and in the former the immediacy of experience. The opposing states of "alive" and "dead" are indicated in *Head—Skull* by the different treatment of the two sides of the head, a meaning that has to be reconstructed by a considered analysis of the forms. In *Head on a Rod,* however, the viewer is immediately assailed by the presence of an impaled head that seems alarmingly alive.

This mingling of the lifelike and the rigid had a particular meaning for Giacometti: by turning the head of his model into an enduring, immutable (though animated) form, he in effect petrified the life of it.[107] The unfathomable connection between the gaze and death had already occupied Giacometti in *Point to the Eye* (plate 55). *The Nose* shifts the opposed elements presented in the Surrealist sculpture to include the viewer whose gaze, confronted by the thrusting, aggressive blade of *The Nose,* is met by that of Death, breaking out of its sphere.

Giacometti's reassessment of what sculpture is, what art is, and thereby what a human being and his or her life mean, is perhaps seen at its most acute in the contrast between *The Hand* (plate 92) and its Surrealist forerunners.[108] The mannequin's hand used to decorate fashion shop windows has become an admonitory memorial, a severed and eerie mutilated limb. By contrast to this evocation of the cruelty of war, the threat to the hand in *Caught Hand* (plate 56) remains in the realm of the teasingly metaphorical. The smoothly polished surface of the earlier prop yields to the perplexing, rough, pithy finish of the later one. In Giacometti's work, the "lumps and holes"[109] that Rodin pronounced sculpture to be give way to the sense of an overwhelming space or voids weighing on the figures. The thematic content of *The Hand, Head on a Rod,* and *The Nose* worked to incite Giacometti to the three-dimensional sculptural style he had first found in their elaboration and persuaded him of the expressive potential of this line of development for forming life-size figures.

To this group of works conceived in 1947 a fourth sculpture, *The Leg* (plate 91), not realized until 1958, may be added. On October 18, 1938, as Giacometti was returning home late one night, he was hit by a car in the place des Pyramides. His foot was broken, and he used a walking stick for many years afterward. He constructed a story of this misadventure, which he often recounted and which was so important to him that he fell out with Sartre when the philosopher misreported events twenty-five years later in *Les mots.*[110] *The Leg* most likely had sources in this accident of 1938 as well as in Giacometti's obsessive interest in feet.[111] This piece touches on Bataille's notions of base materialism, his penchant for the lowly, the rejected, and the reviled.[112] Like *Head on a Rod* and *The Hand,* Giacometti's *The Leg* has a severed, mutilated aspect.[113] In contrast to Bataille, however, whose privileged territory was the lowest and whose intent was to devalue the elevated and the ideal, Giacometti sought to raise what was low: a foot is lifted out of the dust and placed on a pedestal, and a leg becomes a memorial.

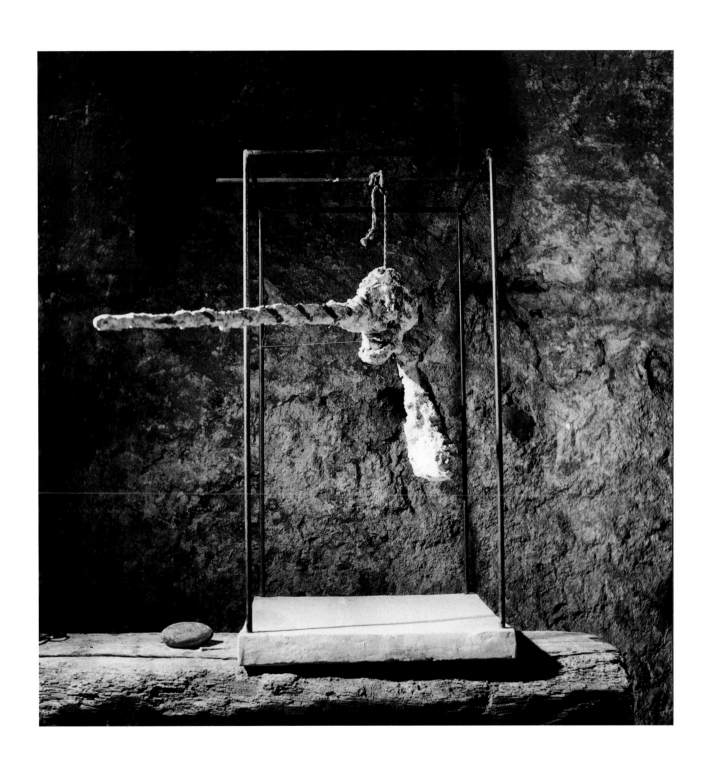

90. The Nose. 1947

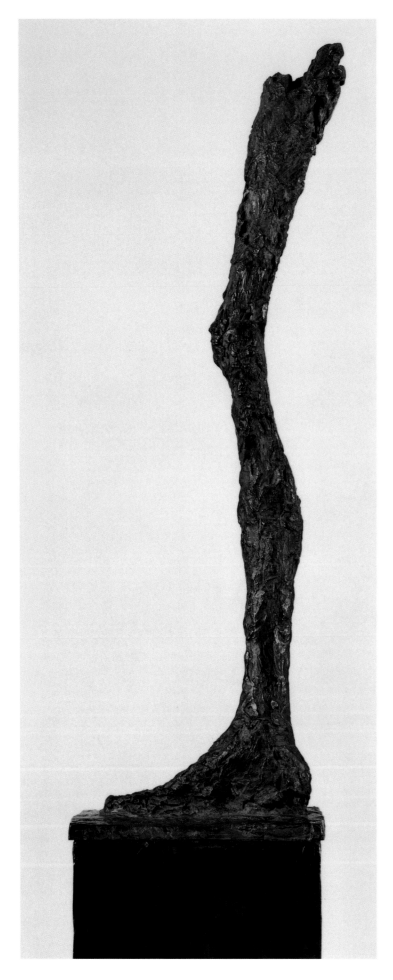

91. The Leg. 1958

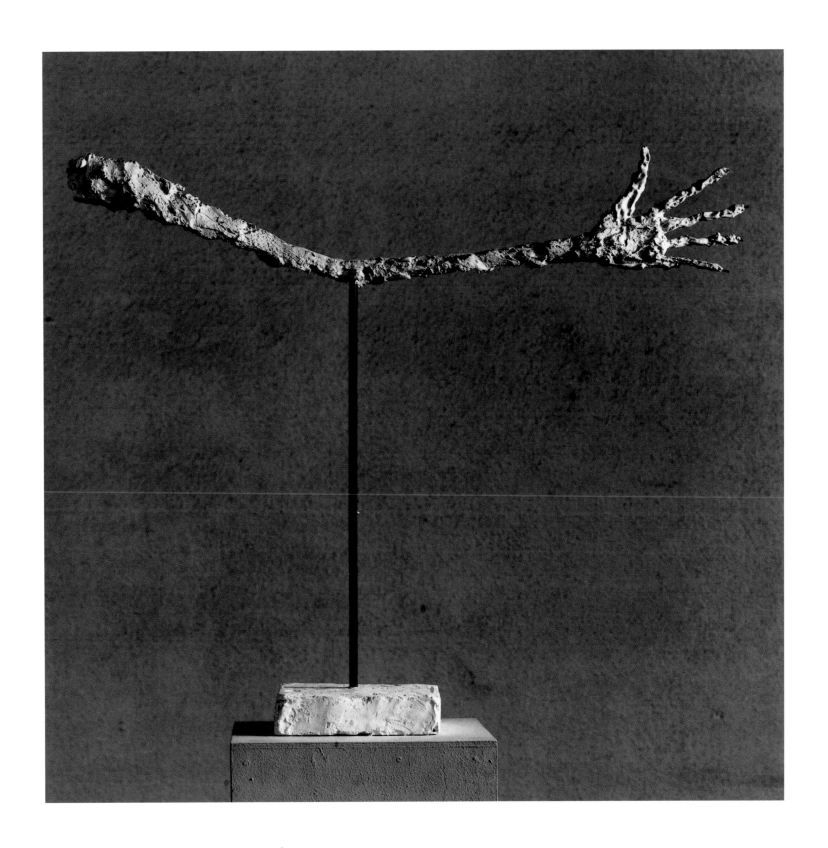

92. The Hand. 1947

Classic Figures:
Standing Woman and *Walking Man*

Giacometti's sculptures of body parts may owe some of their power to the force of the effort the artist exerted to overcome the miniature format that had obsessed him for so long. Their effectiveness and the extent to which they successfully dealt with old traumas freed Giacometti for larger projects, in which he was further encouraged by Pierre Matisse's offer of an exhibition in 1947. The sculptural treatments developed in these fragments allowed Giacometti to create large figures, without losing the visionary character of the earlier pieces: their ability to convey energy and radiant presence. The amorphousness and formlessness that filled him with terror during his days as a student at the Académie became a primary principle of experience: "The form undid itself; it was little more than specks moving in a deep black void."[114] It is the time-worn artistic problem that came to the fore in late Antiquity and again in the High Renaissance: the contradiction between an exact formal likeness and the desire to capture an animated life that resists any form of constraint. (Tintoretto's figures, which had fascinated Giacometti with their dissolution of mass into space and light, also exemplified an extreme elongation of proportion that compensated for a loss of physicality by their innate tension.)

The adoption of a method of dissolving forms implies a painterly, illusionistic approach: the figure lives, detached in its own space. The gleamingly smooth finish of Egyptian statues and the shimmering gold of medieval reliquary figures in effect achieve the same dematerialization and correspondingly evoke a similarly hieratic appearance. But unlike those timeless materials, Giacometti's roughly cracked figures were made of clay. Despite their otherworldliness they are still precariously beholden to the transient and the lowly, the everyday realm of earthbound humanity.

If Giacometti's figures insist on the amorphous materiality of their being, their postures belong to the highest reaches of rhetoric. Their stance first emerged in drawings, in notes made in the street or sketches of groups of figures, reduced to bundles of lines (plate 93), above all in the frontal female figures that rise from the ground like visions and are fixed to the paper with almost convulsive intensity (plates 94, 95). Next to a reproduction of the Venus of the Esquilin found in one of his books, the artist drew his own new, yet primeval, notion of a woman.[115]

The hieratic frontality of the characteristic female posture is countered in the *Walking Man* (plate 101) by the figure's striding, forward movement. Giacometti's self-image as an artist, always searching, striving to move forward is here exemplified. The pace of *Walking Man,* the first large figure of its kind—and for a long time the only one—is closer to the solemnity of Egyptian statues than to the dramatic striding of Rodin's own *Walking Man.* Giacometti's figure moves forward tentatively, as though making a first-ever attempt at walking. Like the subsequent female figures, the Walking Men became yet slimmer, signs rising into the space that they are pacing out and that is evoked by large bases or "squares."[116]

With these weightless elongated figures, Giacometti extended an age-old tradition of imaging man and woman as symbolic representations of the elemental. The work limited to the core of human existence is symptomatic of a postwar era that was seeking out grounds for a new start, however minimal these might be. The lofty verticality of Giacometti's figures, combined with their exquisite fragility, creates a tension with the base materiality of their composition that works to reflect the human condition caught between dignity, vulnerability, and ultimate fallibility.

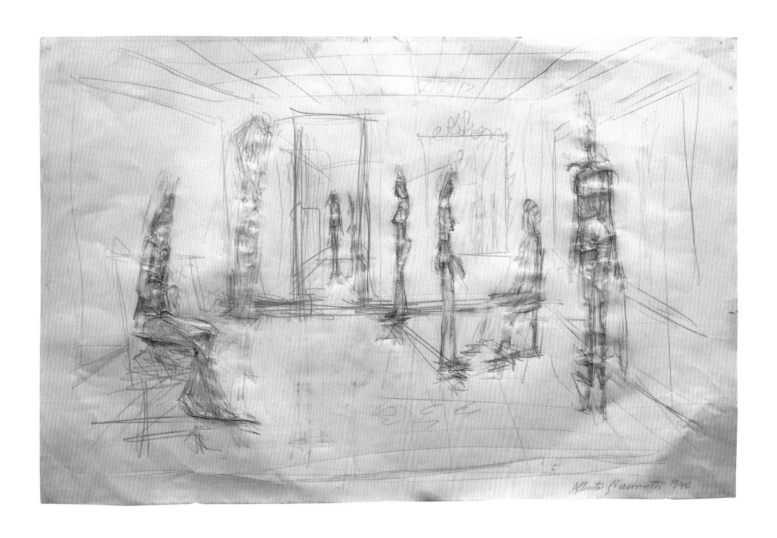

93. Figures in an Interior. 1946

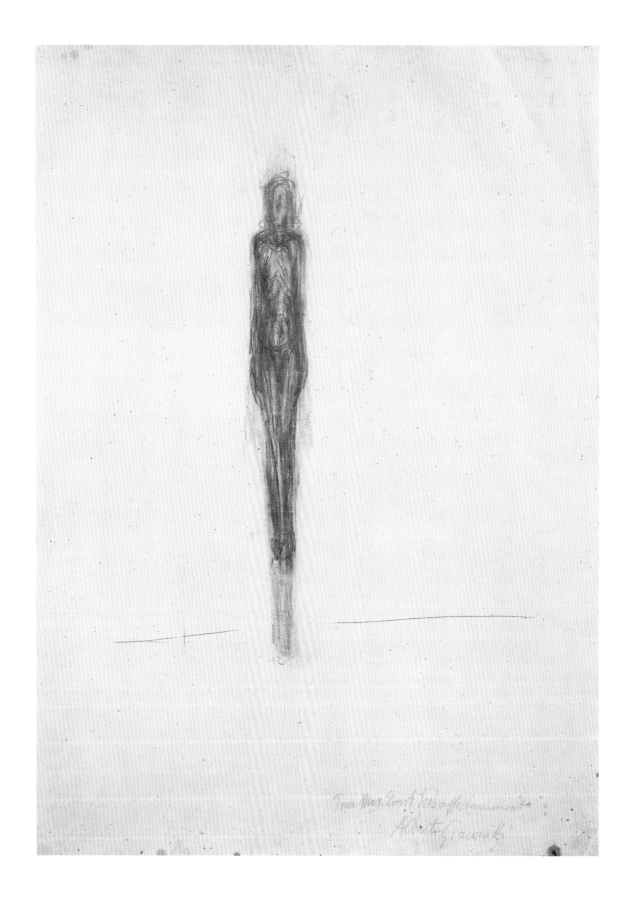

94. Standing Woman. c. 1947

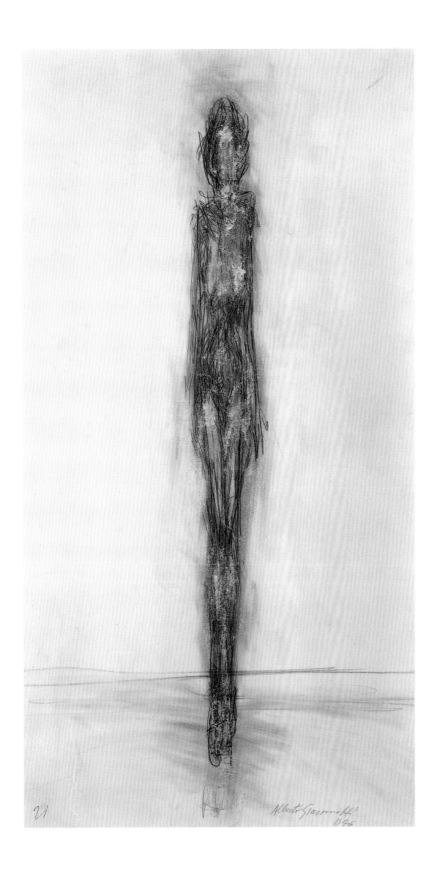

95. Standing Woman. 1946

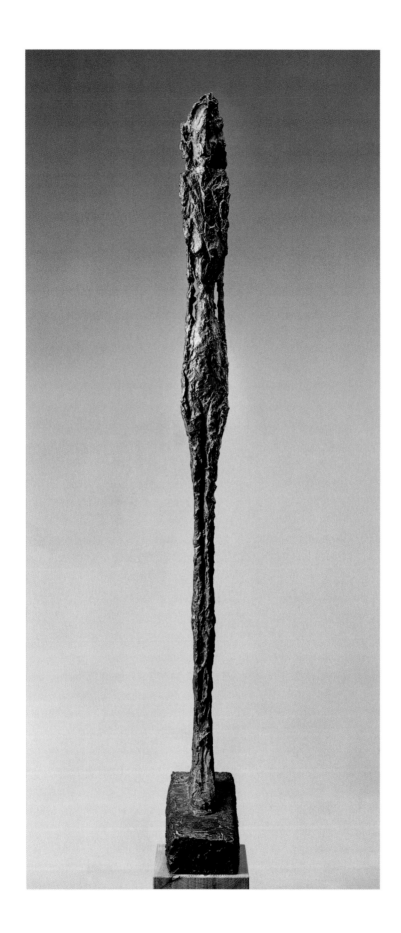

96. Femme Leonie. 1947

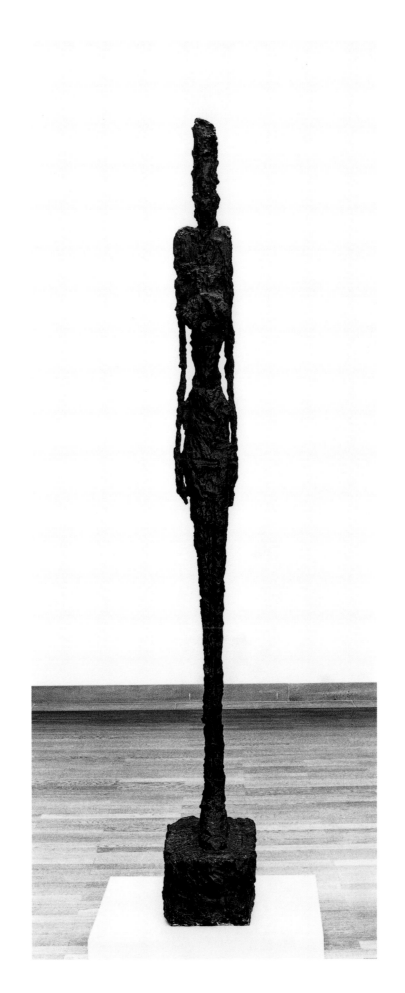

97. Tall Figure. 1947

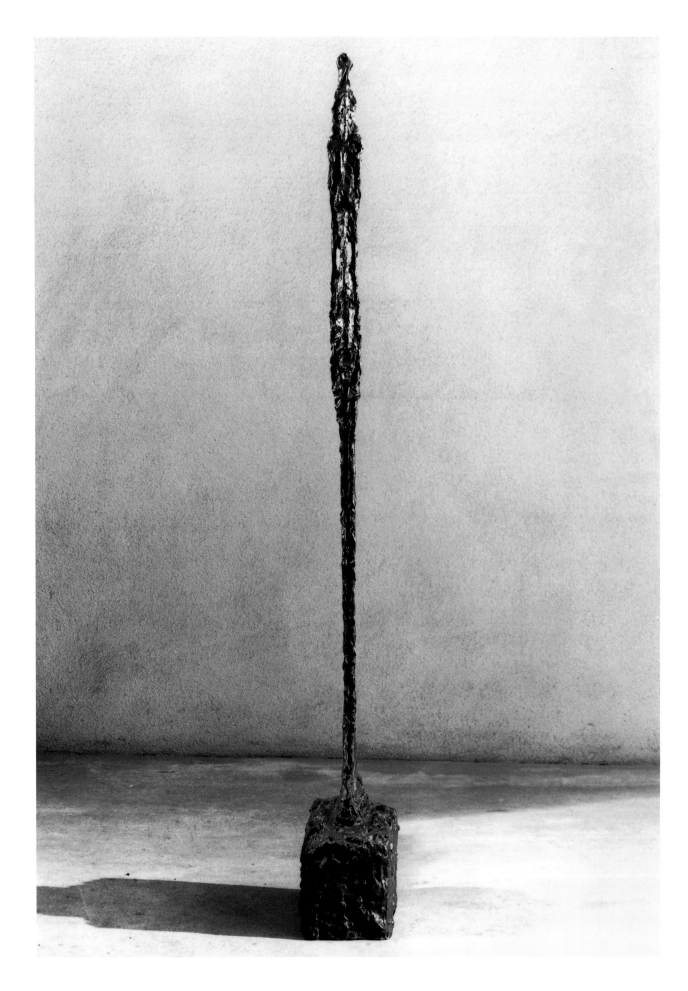

98. Standing Woman. 1948

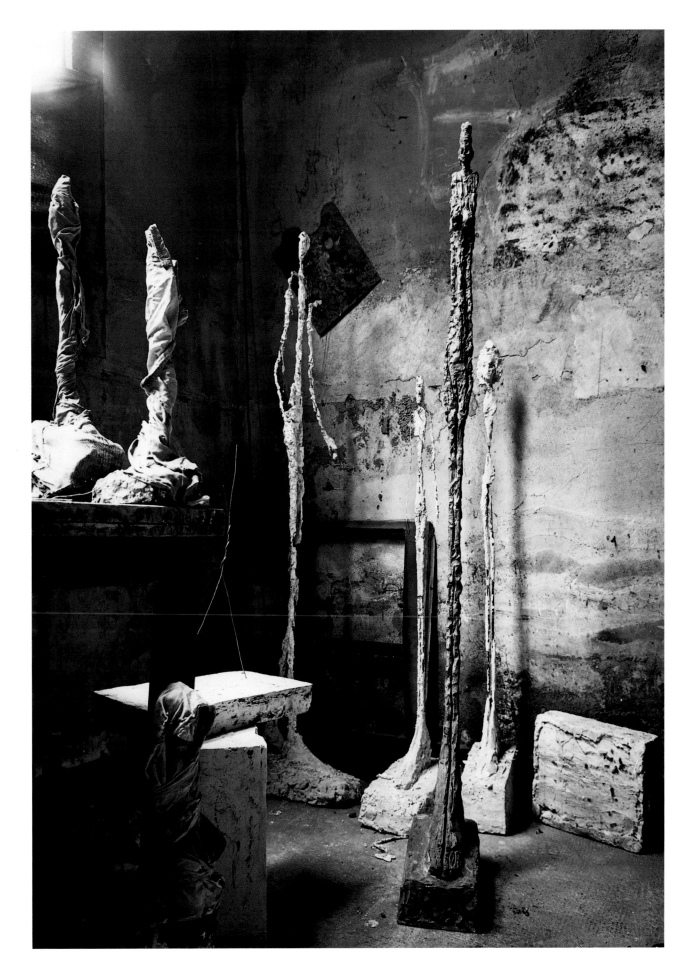

99. Standing Woman. 1948

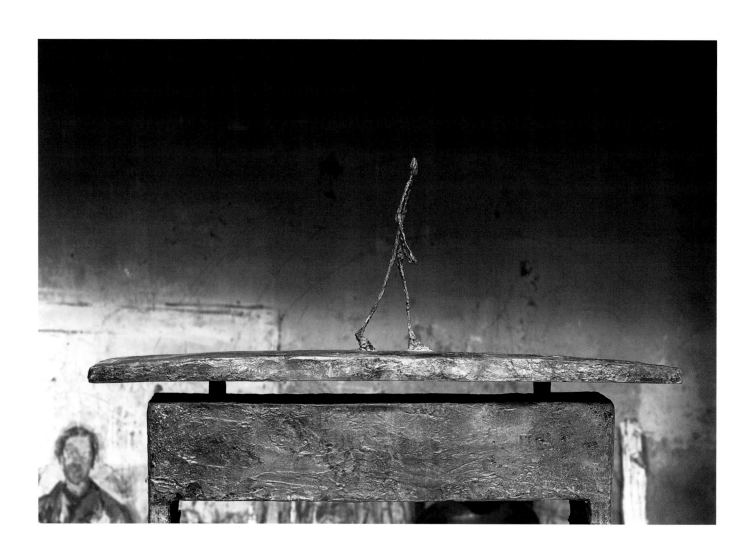

100. Man Walking in the Rain. 1948

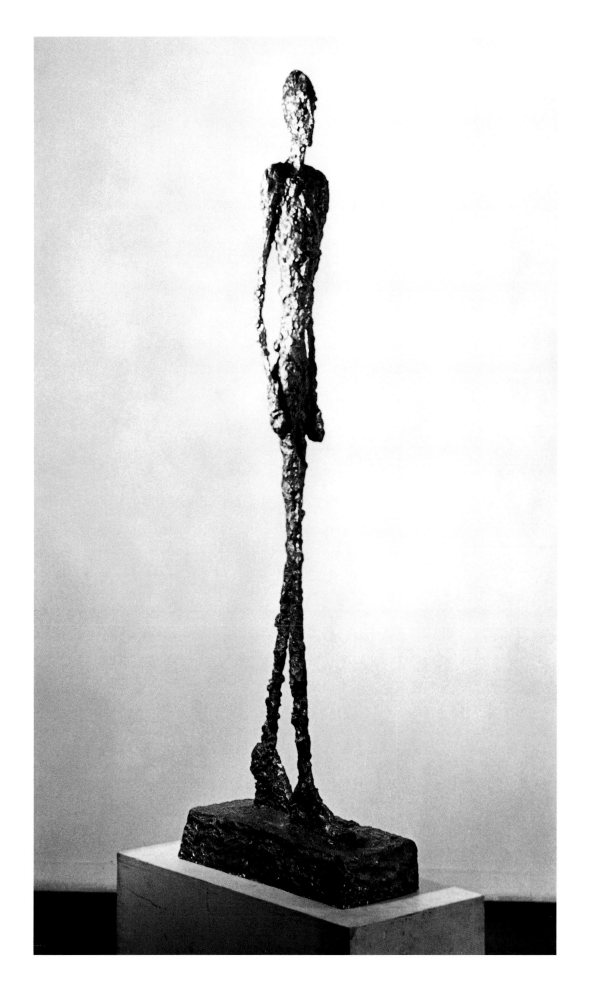

101. Walking Man. 1947

Encounters

The tall female figures and the *Walking Man* embody attitudes of their maker. The sculpted woman is constituted to appear as unattainable counterpart; the man's tentative gait identifies him with Giacometti himself. In a note on *Man Walking in the Rain* (plate 100), Giacometti remarked that he *was* this figure, and it was this work that inspired Henri Cartier-Bresson to make a famous photograph of Giacometti crossing the rue d'Alésia in the rain.

While the frontal female figures could only be taken to greater extremes—more precipitous proportions, more specific pedestals, and more concentrated heads—*Walking Man* allowed numerous variations, especially because his movements seemed to require that space around him be defined. Memories of his Surrealist models for squares, his sketching outside in the streets, and his newly developed figures combined to open a way for Giacometti to depict the appearance of a person seen from a distance in a street or a boulevard, which he had so long tried to achieve with his previous tiny figures. His men have become passersby who walk past each other without meeting. Their life is in the city, with all its ever-changing chance configurations, just as it had forcibly struck the artist, who had come from a mountain village where everyone knew everyone and no one passed by without greeting each other.[117] Critics have often focused on the loneliness of these figures; and perhaps Giacometti was already responding to comments of this kind when in his second version of *City Square*, he slightly enlarged the figures and more obviously directed the foremost man toward the woman.[118]

For Giacometti, encounters between people were an essential part of human existence. Having dealt with this as a theme in his sculpture, he soon realized it in his resumption of work with the model in 1949, which became indispensable to him and gripped him with increasing intensity until the end of his life. The interchange of artist and sitter, the almost living presence of the represented figure facing one, is what the sensitive viewer of his works should perceive. Rather than emblems of Sartre's Existentialism, where a totally self-centered ego is threatened by the other, these sculptures embody the dialogue between the self (anchored in the body) and the world, as described in the phenomenology of Maurice Merleau-Ponty, who visited Giacometti in his studio at this time and wrote about his art in his essay "L'Oeil et l'esprit." To simplify Merleau-Ponty's terms, *The Cage (Woman and Head)*

(plate 103) can be understood as a representation of this dialogue, in the sense that the head, growing out of the block (self-awareness), assimilates and integrates the image of impinging, perceived reality (the statuette) within the realm of the imagination (the bars of the cage). In a first version, Giacometti had depicted perceived reality in the shape of a figure with outstretched arms, swinging through the bars to the inside of the cage, an active intrusion in contrast to the small contemplative figure in the final version.[119] This Cage—unlike the work of the same name made in 1930 or the *Suspended Ball* (plates 37, 38)—does not symbolize problematic gender relations but deals with the realm of human consciousness, closer in spirit to the *Cube (Nocturnal Pavilion)* (plate 63), with its incised self-portrait.

This absorption of the outside world into the self is initiated by the gaze—perception—sweeping out into that world. In the pair of sculptures *Four Women on a Base* and *Four Figurines on a Stand* (plates 104, 105), Giacometti endeavored to exemplify these related mental events in the contrast of two opposite situations. In the latter work the outward gaze beholds four female figures appearing as small shapes in the distance, on a stand mimicking the gleaming, recessive orthogonals of a wood floor; in the former the internalized figures stand on a blocklike stage, threateningly close. The theme is the visual and affective relationship of the artist or viewer to perceived reality, defined by the form of the pedestal.

The highpoint of this series of works is *The Chariot* (plate 107). The process of perception, the tension between the self-revealing approach and the elusive retreat of an ultimately unfathomable other is perfectly expressed in visual terms through the metaphor of the chariot. Its base—at once practical and floating—marks a division between the sphere of the figure and that of the viewer, as ambivalent as the curtain before Raphael's Sistine *Madonna* elevating an archetypal woman into epiphanic realms.

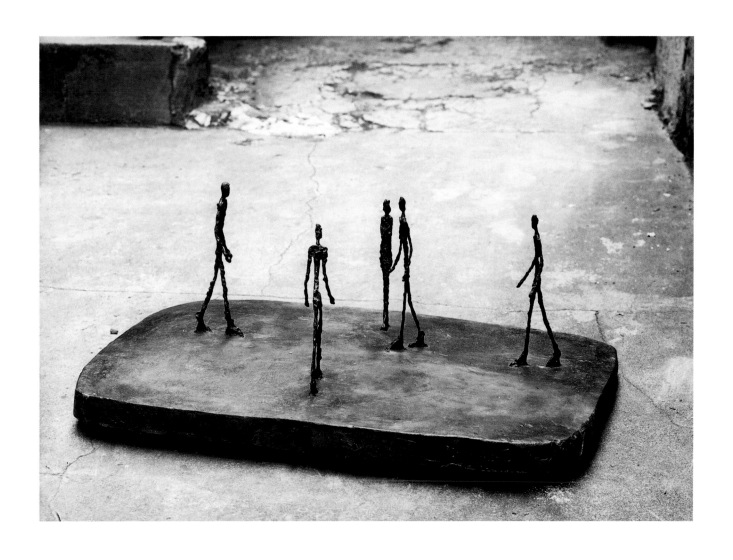

102. City Square. 1948

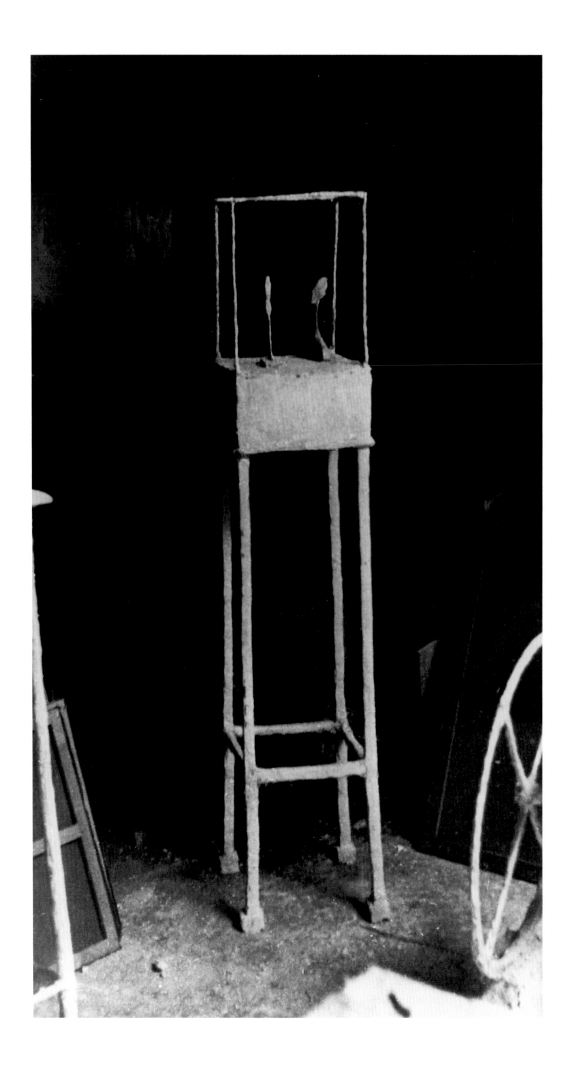

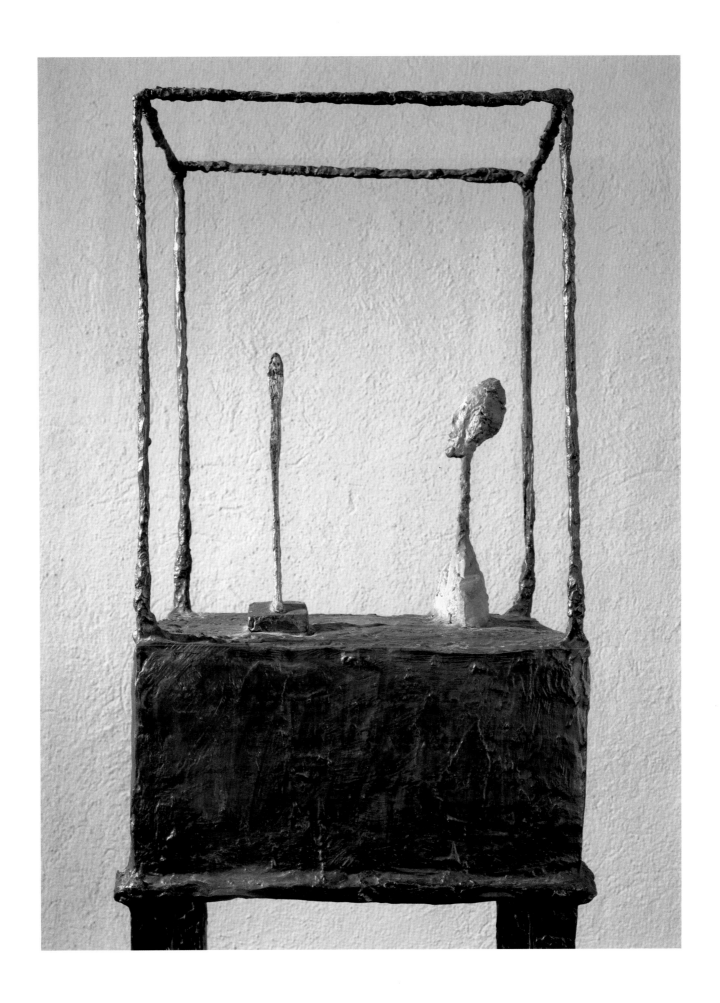

103. The Cage (Woman and Head). 1950 / The Cage, detail

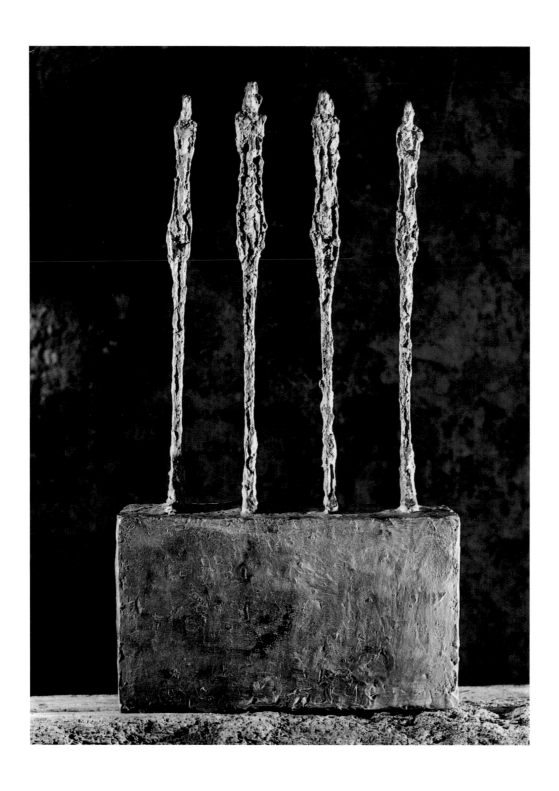

104. Four Women on a Base. 1950

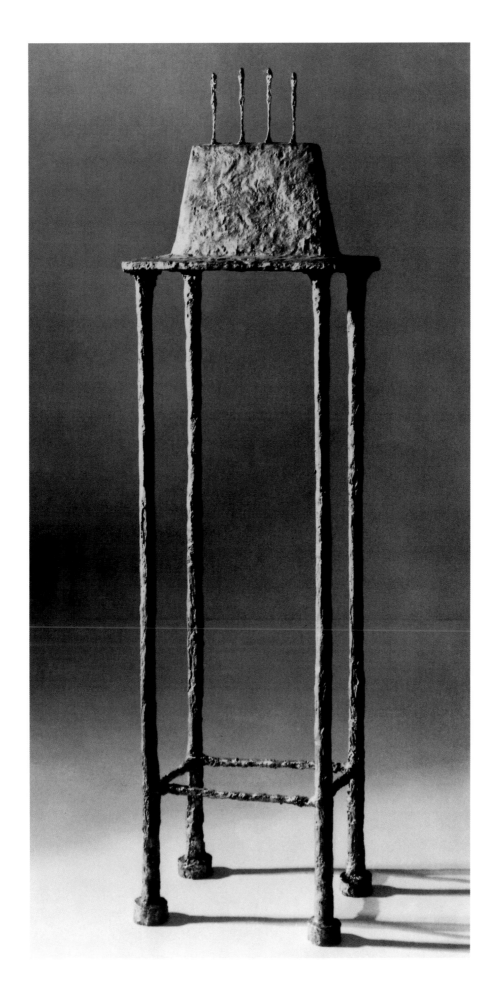

105. Four Figurines on a Stand. 1950

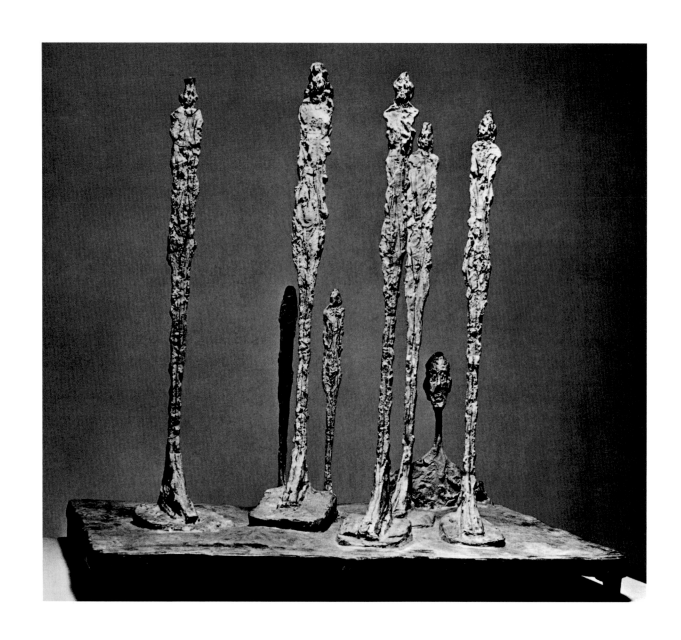

106. The Forest. 1950

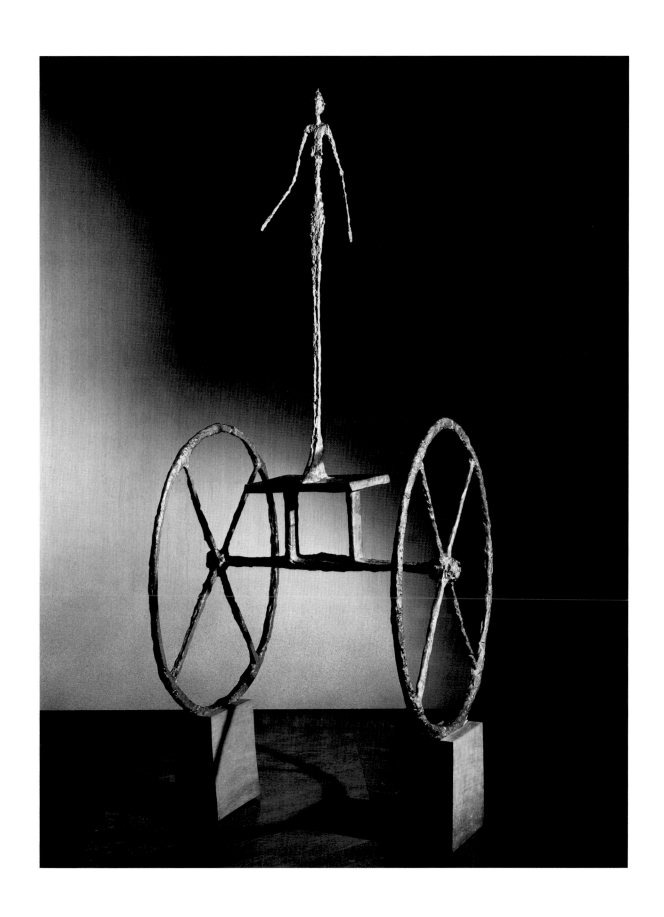

107. The Chariot. 1950

The Figure in Space: Paintings, 1949–53

While Giacometti was still working, from memory, on three-dimensional compositions in the late 1940s, he returned to painted life studies, which he had not systematically pursued since the start of the decade. He had of course continued to draw from nature; and he did make a few paintings, mostly portraits, in a variety of styles.[120] It was not until he had his "visions" that a new beginning emerged in his painting in the form of ethereally insubstantial heads with large eyes floating in space. Painted fluently and quickly, they are precursors of the many Black Heads that he painted repeatedly until the end of his life.[121] In the only one of these canvases to be painted in a large format, a huge head rapidly disappears under a number of small heads, which turn into ever smaller energy spots; beside them there is room for a standing woman, whose volume similarly decreases.[122]

Drawing seems to have helped the artist move forward. The white of the paper provided a neutral space for the imagination, but this was difficult to repeat in painting. His various experiments in painting with white grounds and large, sketchy full-length figures did not satisfy him. Presumably, he felt the lack of pictorial impact and density of surface expected from a painting. Whatever the case, in a *Portrait of Diego* of 1947–48 he structured the pictorial field with rectangles of the kind he regularly used in drawings as rudimentary indications of space and compositional elements. Here, however, they are used to form a compact lattice system.[123] Although this was to remain an isolated experiment, it nevertheless took him a step closer to his solution, which was to create a picture surface composed, on the one hand, of a dense but transparent net of fine white and black lines defining the subject and, on the other hand, of areas of earthy color applied with a broad brush, fluently, and almost like a glaze. Giacometti thus transformed and dematerialized the subject, yet preserved the realistic image made after a model. His experience of "visions" and his phenomenological deliberations had equipped him to create an inner image of what he sees in reality.[124]

The open spatiality of these pictures, with drawings of people and things, perspectives of the studio in Paris or the living room in Stampa, brings to mind thoughts of abstract spatial constructs, like those of Marie Vieira da Silva for one, or of indefinably unfathomable, aquatic psychogenic landscapes such as those painted by Matta, and which often—taking the lead from Yves Tanguy—appeared as an intermediate stage between Surrealism and the *Informel*.[125] Unlike most realistic paintings of the postwar era, such as those by Balthus, for instance, which are stylistically in the same category as the Nabis, Giacometti's paintings seem "modern." They are not stylized "likenesses" but inner "visions"[126] and thus follow in the tradition of Symbolism, which Giacometti knew from Gustave Moreau and the Italian divisionists.

Cézanne's enduring influence as Giacometti's most important mentor[127] is not, however, seen in the appearance of his paintings. Instead of colors and flecks of paint and Cézanne's sense of a "harmony parallel to nature," Giacometti used gray tones and numerous lines. The affinity between the two is not one of style but on the level of stubbornly persistent phenomenological research. Each artist had relentlessly explored the same motifs, tirelessly attempted to perceive visible nature by studying the model, and strove to transfer what had been perceived into the lasting reality of the picture, so that finally the living multiplicity of what is seen and felt might be preserved. The main means by which Giacometti achieved this consisted in the replication of the movements of the eye by the pencil or the brush, restlessly honing in on the forms, dissolving their outlines into a zone that lives and breathes and energizes their centers.

In his last, lucid essay "L'Oeil et l'esprit," Merleau-Ponty concluded that the task of painting alone is to attempt to show palpable reality in all its sensual plenitude.[128] Giacometti was most successful in this respect in the paintings he made in the early 1950s of relatives and friends in his studio, still lifes, and landscapes. Valerie Fletcher has pointed out that through the creative outburst of 1947–50, when Giacometti's most important sculptures came in a constant flow, his confidence in himself steadily increased. Through his love for Annette and unshakable friendship with Diego, his mental stability improved and allowed him to cultivate his creative energies to their fullest. In her forthcoming monograph on Giacometti's paintings, Fletcher analyzes in detail how he continued to pursue his phenomenological investigations by placing his sitters closer or farther away, by taking account of the angle, the light conditions, the bend of the canvas, and often working on specific aspects in pairs of pictures or in groups of three.

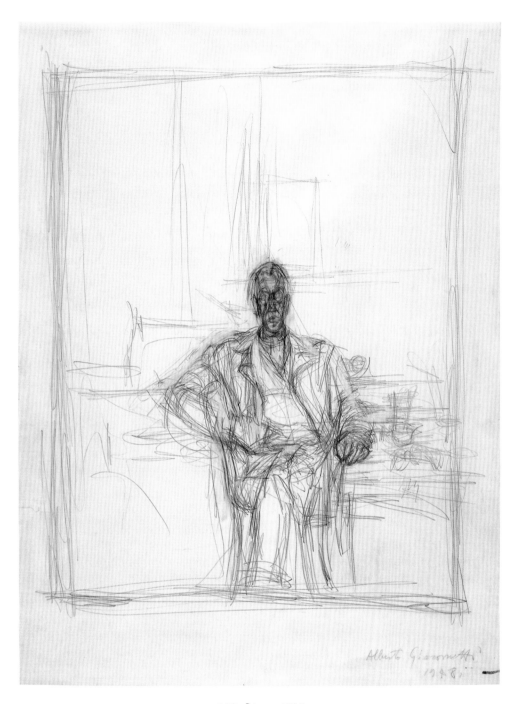

108. Diego. 1948

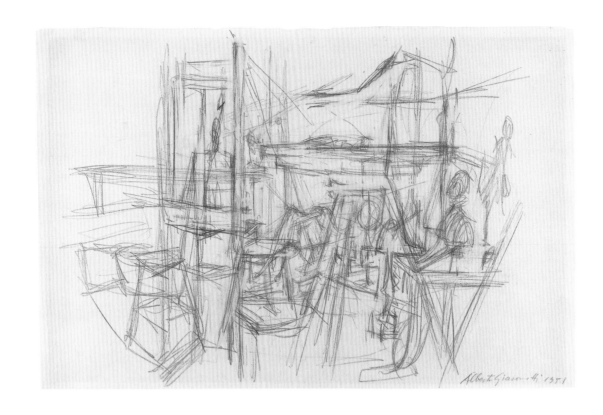

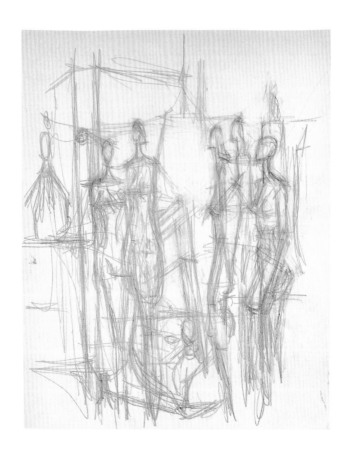

109. The Studio. 1951 / **110.** The Studio with Sculptures. 1953-56

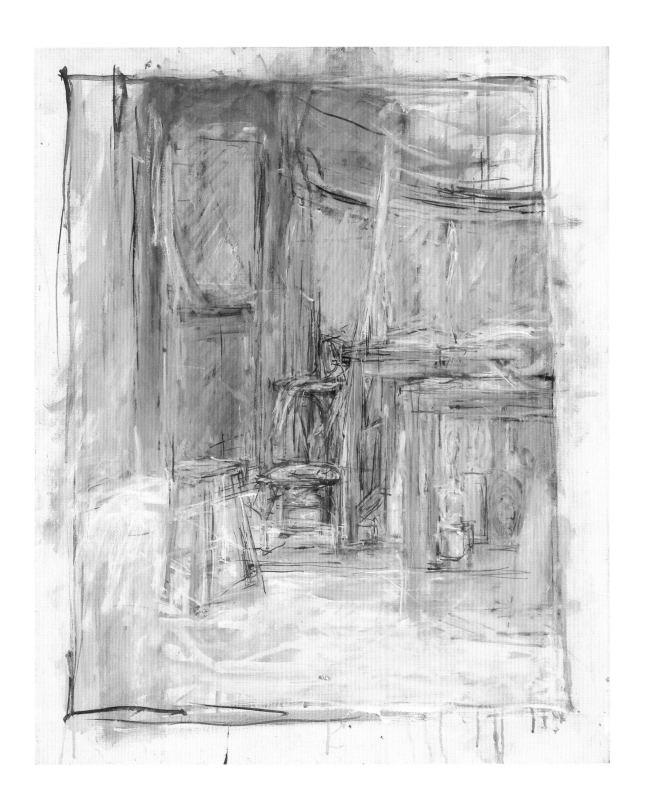

III. Interior. 1949

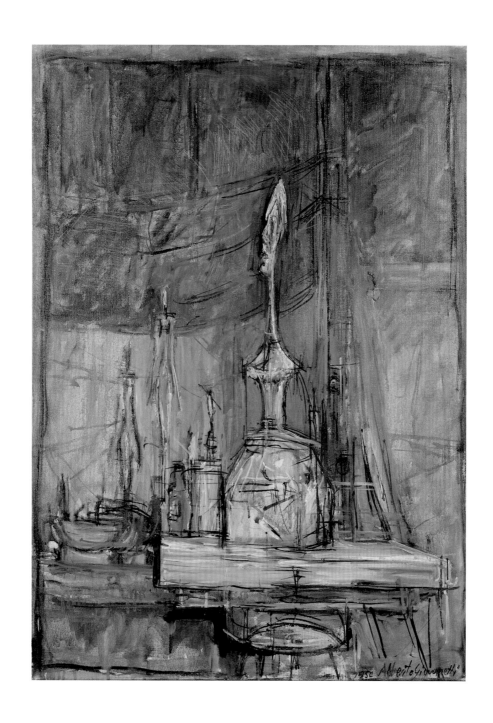

112. The Studio (Still Life). 1950

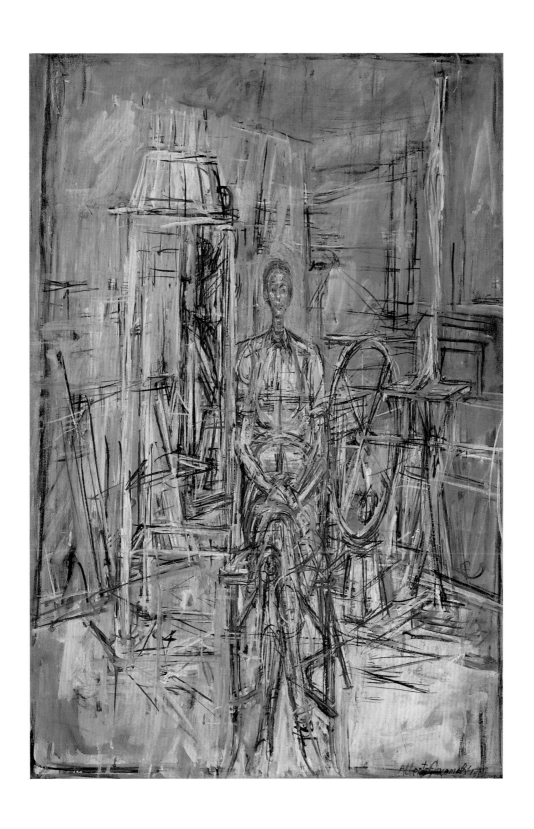

113. Annette with Chariot. 1950

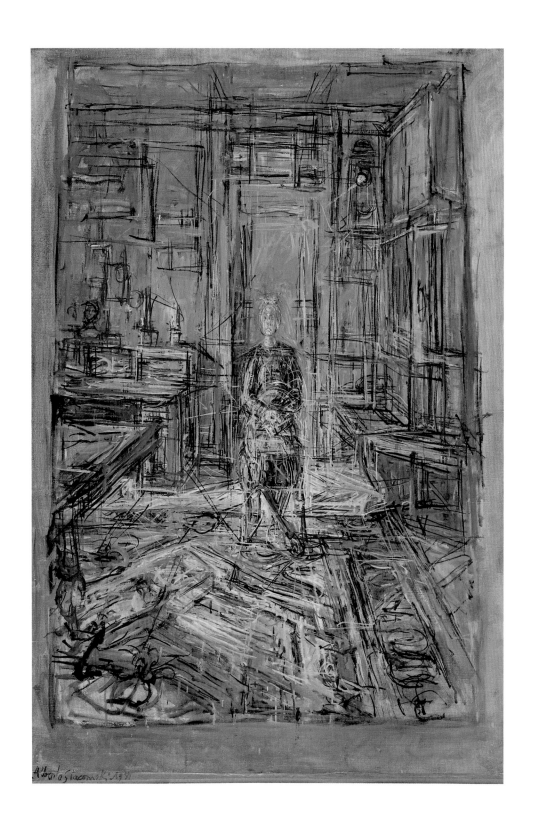

114. The Artist's Mother. 1950

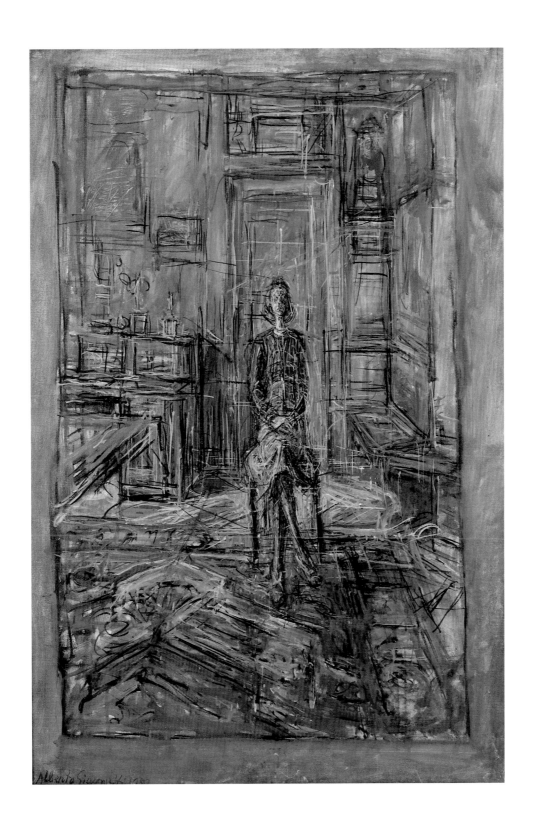

115. Annette at Stampa. 1950

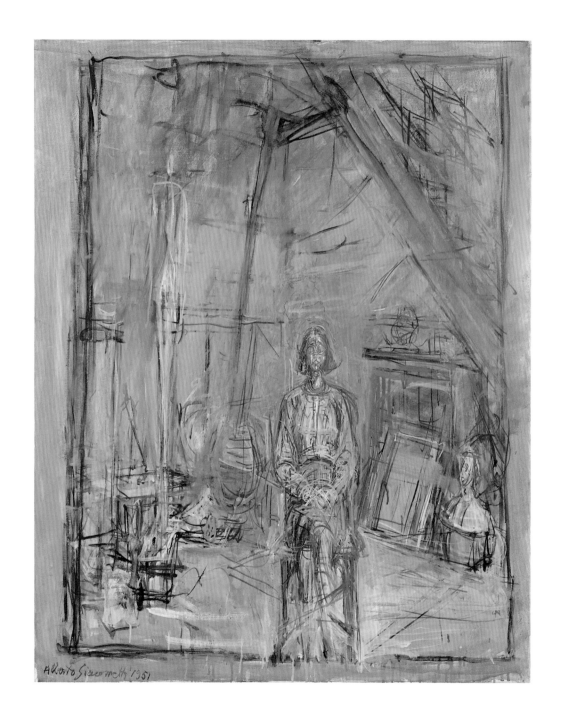

116. Annette. 1951

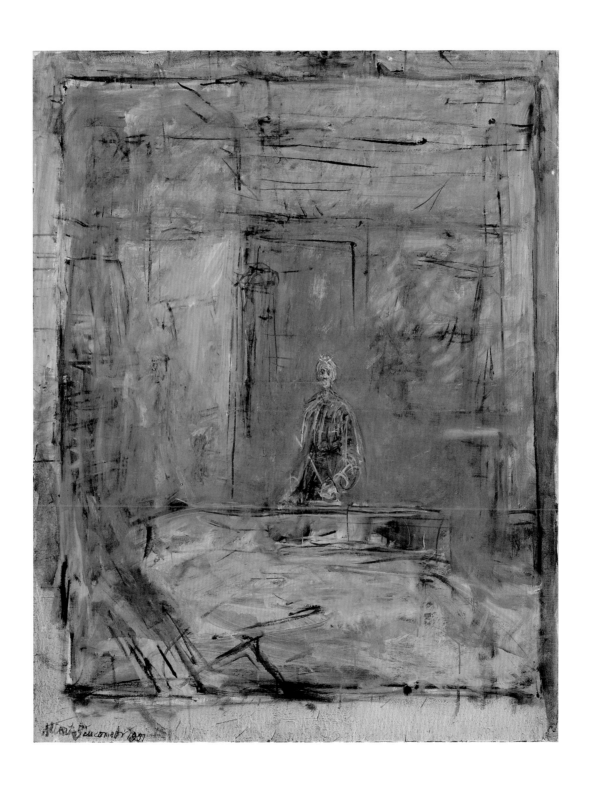

117. The Artist's Mother. 1951

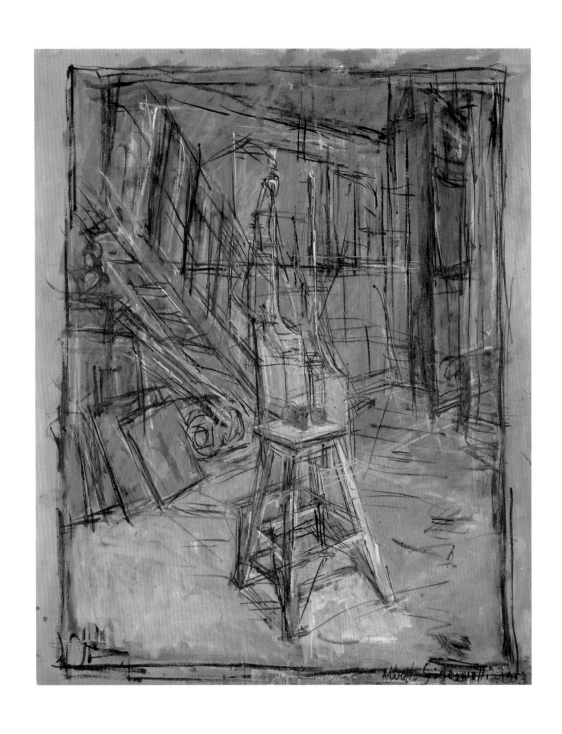

118. Apples in the Studio. 1953

119. Study of Apples. 1952 / **120.** Still Life, Three Apples. 1959

121. Sideboard at Stampa. 1955

122. Interior with a Table. 1959

123. Vase of Flowers. 1952

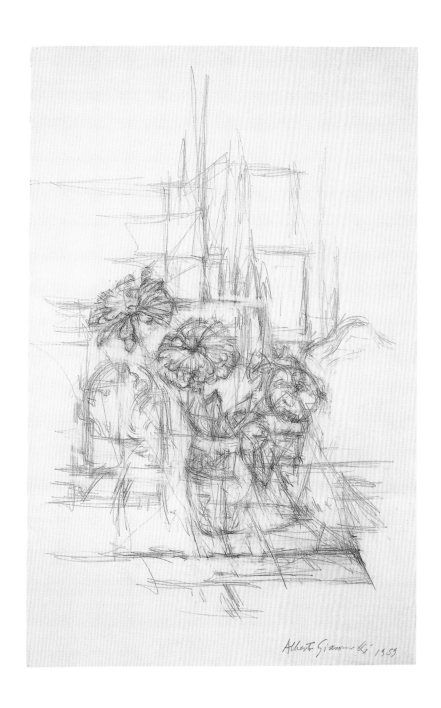

124. A Vase of Zinnias. 1959

"Existential" Figures

In the postwar period, when many were seeking to retrieve basic human values, either remembering the horrors they had survived or in the light of the atomic era, there was much discussion of the human condition. However, the humanist or existentialist mood of many came up against an abstraction almost devoid of content in the visual arts. By contrast, Giacometti's figures, reduced to the ultimate core of their being, appeared very much embodiments of the lonely and vulnerable human condition, as seen by the Existentialists. Such interpretations are peripheral to Giacometti's attitude and do not take into account the actual phenomenological intention of his works: nevertheless, from the standpoint of the viewer, these ideas do elucidate aspects of these archetypal figures, as can be seen in such writings as Sartre's early essay on Giacometti (1948), and have largely dominated the literature up until Hohl's definitive art-historical monograph (1971).

Giacometti's *Man Falling* (plate 126) was in fact to become a central icon in the Existentialist view of his work. This sculpture, one of his slenderest, most fragile figures, seems about to topple from its small, cylindrical pedestal. Yet it holds its position by throwing the head back ecstatically; it seems to emerge straight out of Sartre's *Nausea* or Camus's *The Stranger* in an extreme moment when the ground seems to open to the choice of life or death. *Man Falling* is a human being in precisely the extreme situation in which his transcendental destiny becomes apparent.[129]

In a certain sense there is a counterpart to this endangered male figure; a completely contained figure entombed in glass, the *Figure in a Box between Two Boxes which are Houses* (plate 128). This is the last of the Walking Women, with overtones of the cult of the dead, who first emerged in 1932.[130] The only other work in which Giacometti used glass was *The Palace at 4 A.M.* (plate 50). A white female figure in a glass box also inevitably recalls Snow White in her glass coffin, one of the artist's earliest obsessions. This work has been interpreted as depicting a person caught on the pathway of life, walking from her mother's womb to her grave.[131] Rather than looking at the work this way or accepting its anecdotal interpretation as Annette between Paris and Stampa, it is perhaps preferable to focus on the generality of such succinct images. The charisma of such sculptures arises from an ability to stimulate the private associations of individual viewers.

Man Pointing (plate 125) was originally intended to have a companion piece, but the other figure was never definitively realized.[132] Had it come into being, the viewer would, Giacometti felt, have been faced with a closed dialogue between two figures, whereas he wanted above all to create an immediate link between viewer and figure.[133] Begun in 1947, even before Giacometti had established his "classic" style, this figure demonstrates that any mode of forming, any style, can limit the expressive reach of a work—especially if that style already conveys a strong and distinct expressive content in its own right. *Seated Woman* (plate 127) of 1950 is another such experiment, and is similarly interesting in terms of form and content.[134] It can be regarded as an alternative project to the hieratic female figures like the *Tall Figure* (plate 97), *The Chariot* (plate 107), or as one of Giacometti's new interpretations of such Surrealist figuration as *Hands Holding the Void (Invisible Object)* (plate 58).

The masterless *Dog* (plate 129) of 1951 is another piece that lends itself to existential interpretation. As such, however, it can be seen as an image of a miserable life; it can also be a symbol of autonomous self-fulfillment. One of Giacometti's favorite anecdotes was that, after having thought about the *Dog* for a long time, while returning one night to the rue Hippolyte-Maindron, he suddenly imagined he had turned into a dog and began sniffing and seeing like one. As he recounted the experience, at the same moment, in his mind's eye, he visualized the finished bronze, which he began that night.[135]

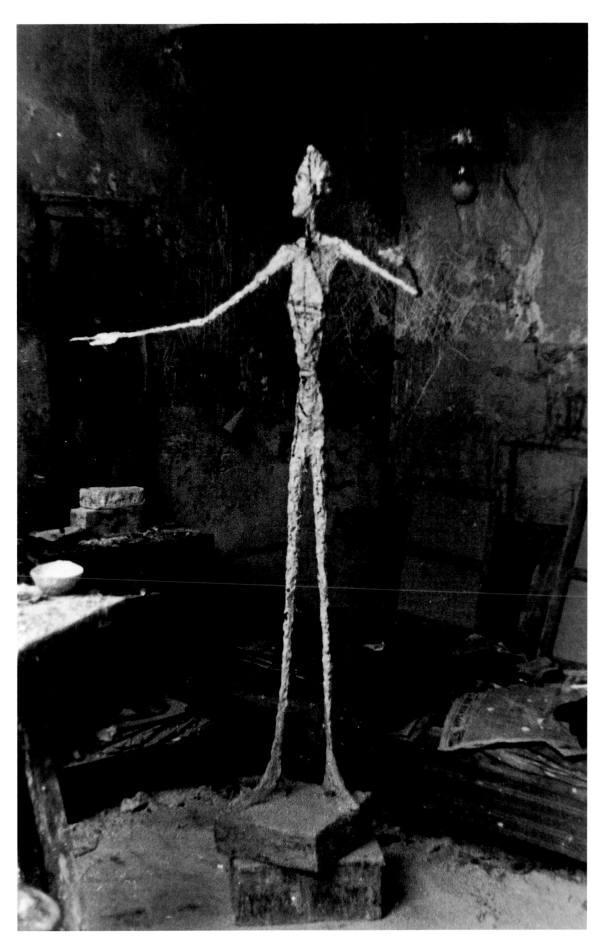

125. Man Pointing. 1947

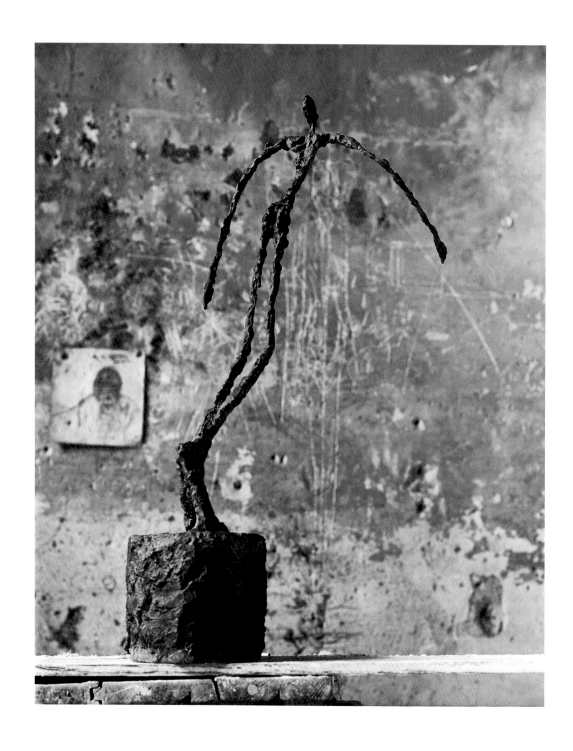

126. Man Falling. 1950

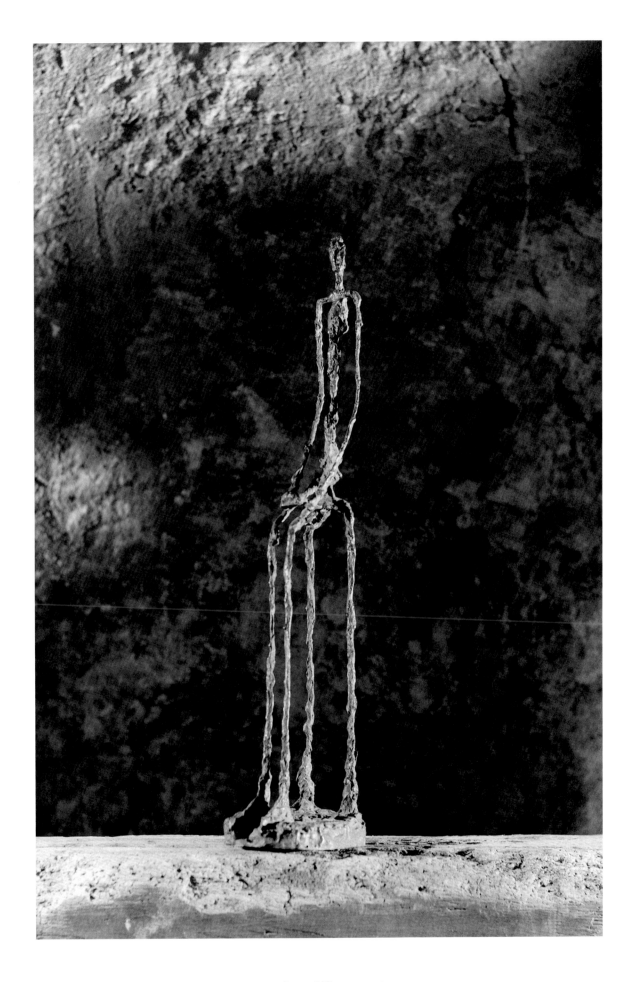

127. Seated Woman. 1950

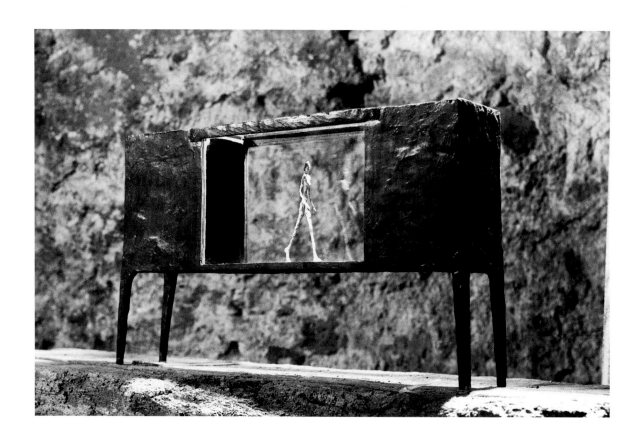

128. Figure in a Box between Two Boxes which are Houses. 1950

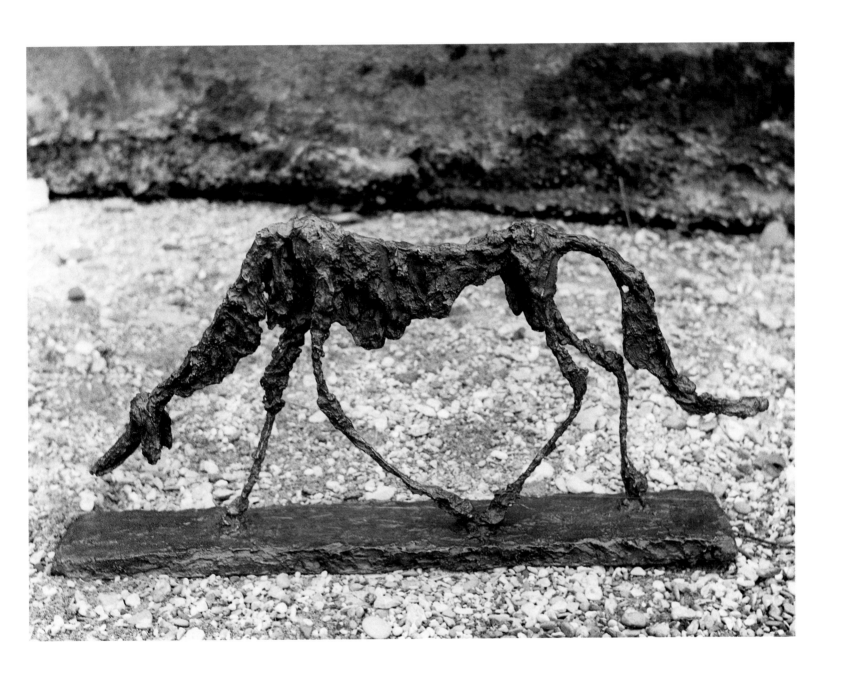

129. Dog. 1951

Landscapes

The pull of a certain location, such as the familiar territory of the rue Hippolyte-Maindron, is perfectly expressed in Giacometti's Parisian cityscape, *The Street* (plate 130), which shows a street rapidly receding into the distance, just as the artist saw it when he left his studio. In the equally large, horizontal *Landscape at Stampa* (plate 135), painted about the same time, his parent's home appears at the right in the picture; the viewer's gaze travels from the garden of his grandparents' house up the valley toward Maloja.[136] The "spectral" *Landscape, Maloja* (plate 134), however, shows the view from the family's summer house past the flat threshold of the pass to the mountains above Stampa.

In general terms, Giacometti's landscapes match the three interiors in which he lived and painted: it was not, however, until 1952, when he was in full command of the interiors that he turned his attention to landscapes.[137] Two subjects in Paris and Maloja, and three in Stampa were all he needed, but he had to be utterly familiar with them. He was freer in his drawings; he felt confident of his ability as a draftsman almost everywhere. Indeed, in his lithographs for *Paris sans fin* (*Paris without End*) he portrayed the whole range of his life, from his studio, the cafés, and the boulevards in Montparnasse to his publisher's office, the Jardin des Plantes, and the printers' workshop on the outskirts of the city.

The motif that first gripped him in 1952[138] and that stood at the center of his interest in landscape until the late 1950s was the orchard outside his father's studio, as in *The Garden at Stampa* (plate 133)—it was almost a part of the interior; he only needed to open the window or to draw the curtains back to look straight into the crowns of the trees, the crooked telegraph pole, the slope of the hills, his grandparents' hotel to the right, animal sheds, and other outbuildings to the left. In the evenings, he used to leaf through art books; catholic in his tastes, he found nothing to surpass landscapes by Jan van Eyck, Egyptian reliefs, and Chinese ink drawings. These were the objective, graphic forms that he searched for in his own imagination. In his drawings, the linear rhythms of branches may recall Analytic Cubism or an early phase in Piet Mondrian's work, but they are, in fact, an attempt to reinvigorate the structural system of the plantlike forms devised by the ancient Egyptians and to graft onto them an atmosphere borrowed from drawings by Chinese sages. Representational and spatial indicators are virtually subsumed into the movement of lines and colors, making it clearer than in almost any other of his works, that Giacometti was working at the same time as the artists of the *Informel*.[139]

Giacometti's landscape paintings evince an adherence to order and a strong existential anchor, as demonstrated by the internal frame, which is treated very differently in the various painted landscapes. *The Street*, for example, shows by its method of depicting the essentials of this specific scene that this street is intended to stand for the prototype of the genre, the ultimate street.[140] The motif is surrounded by a distinct internal frame, effectively emphasized by its dark color and double line. Critics have therefore written of it in terms of a view from a window; quite apart from the fact that this is factually impossible, it seems to miss the point. In terms of Giacometti's phenomenological research this marginal zone relates to the inner, psychic realm of the imagination: it marks out internal, not external distance. *The Garden at Stampa* of 1954, on the other hand, opens up: the frames recede in five progressive stages, until finally the atmospheric light floods over even the furthest line. Energy initially concentrated in the center of this large canvas radiates outward increasingly strongly. It invigorates the movement of the gaze alternating between focusing and opening up to the whole pictorial field, which is particularly characteristic of the way one views actual landscapes that are open on all sides. The dynamic activation of the internal frame has a function here in terms of the aesthetics of perception, comparable to the dissolution of the contours into bundles of lines which, in turn, correspond to the viewer's eye movements. Georges Seurat's painted frames were intended to fulfill a similar function but only with respect to color perception. In Giacometti's approach, considerations regarding the aesthetics of the process of making the work were just as important. Indeed, for him production methods became a creative tool: defining the pictorial field on the sheet of white paper led him to delimit the oil study on the canvas, as for instance in a small *Self-Portrait* of 1921.[141] We have seen in the paintings of apples on a sideboard of 1937 (plates 66, 67) and the experimental *Portrait of Diego* of 1947–48 how this is combined with the search for the correct dimensions for the motif. In the internal frame, we see a parallel to the aesthetic function of the pedestal in sculpture.

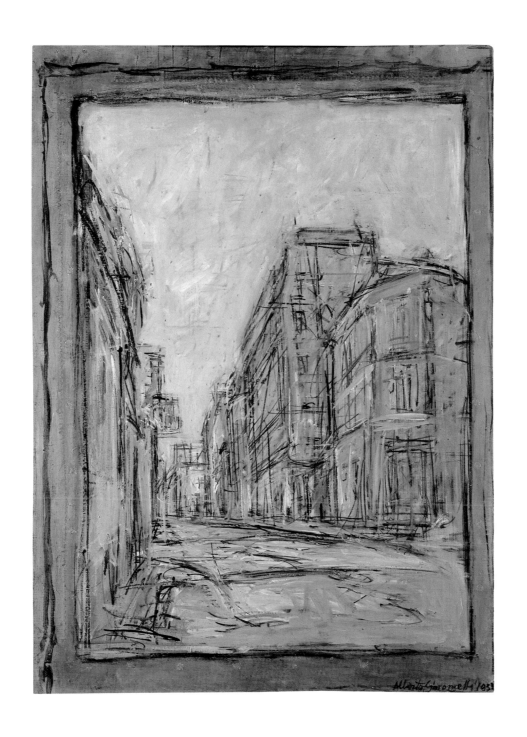

130. The Street. 1952

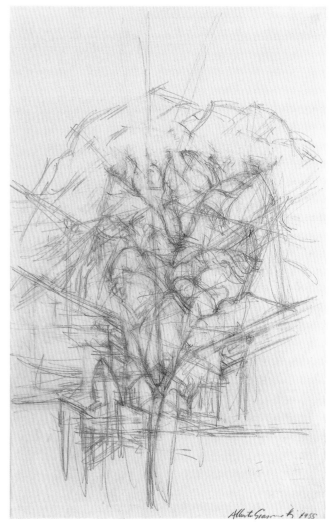

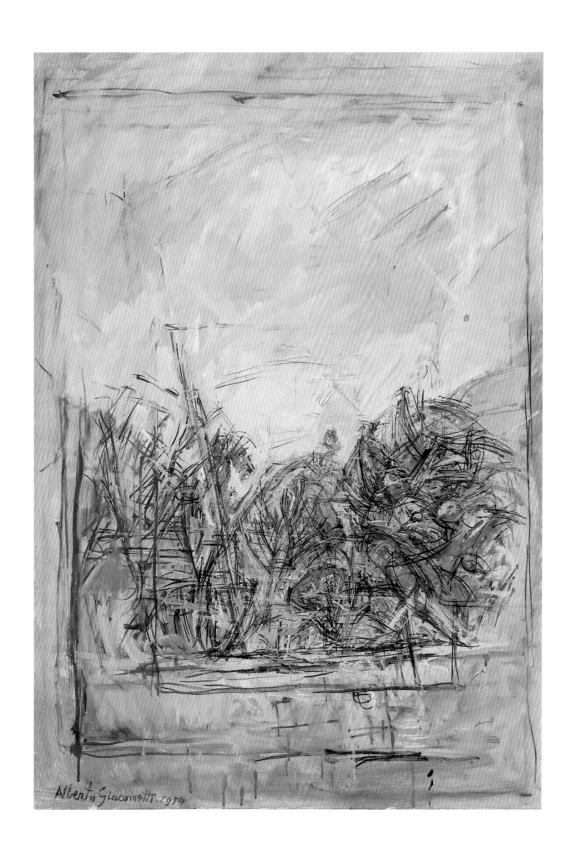

131. Mountain at Stampa. 1955 / 132. Tree at Stampa. 1955 / 133. The Garden at Stampa. 1954

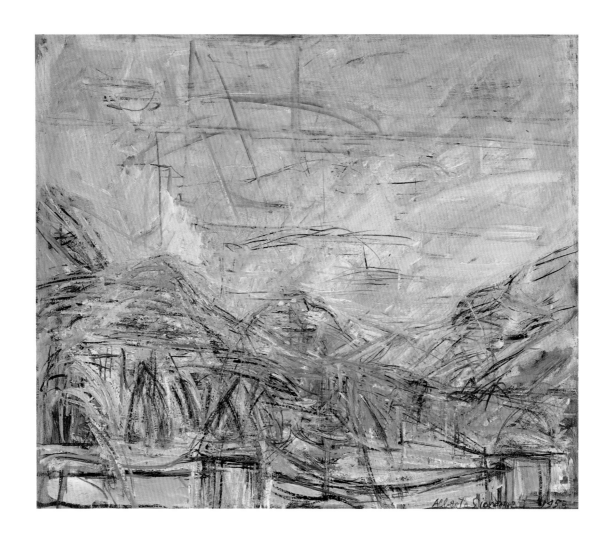

134. Landscape, Maloja. 1953

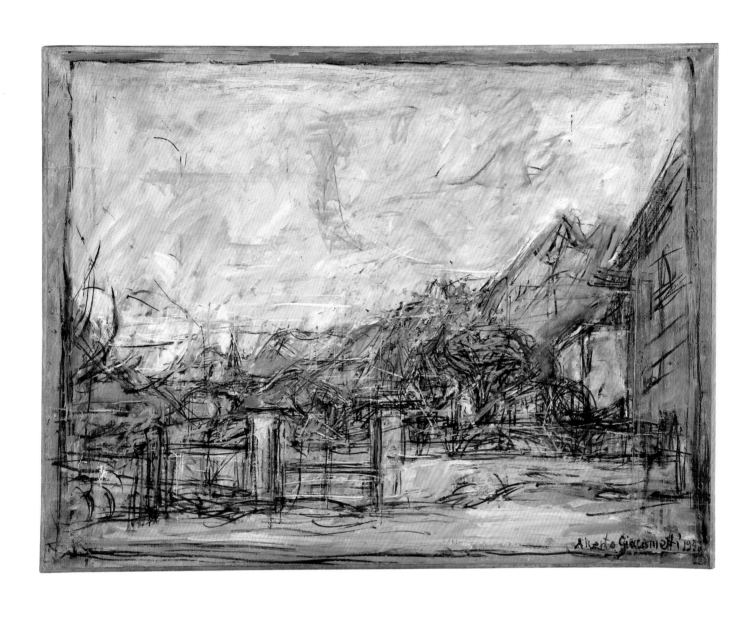

135. Landscape at Stampa. 1952

136. Landscape. 1957

137. Maloja, View toward Margna. 1957

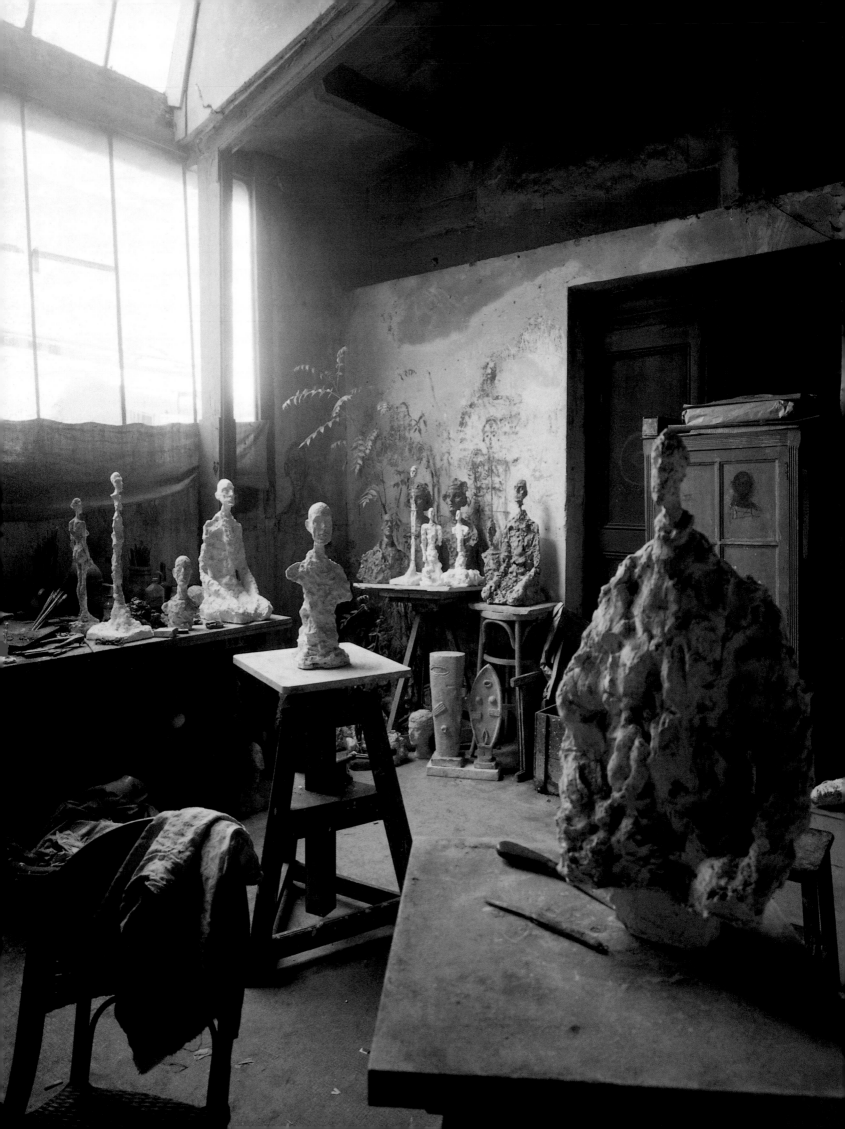

VI. Reclaiming Real Space

Heads of Diego, 1951–54

Nineteen-fifty was an extraordinarily productive year for Giacometti; most of the compositions in the weightless style that he had arrived at in 1947 date from this time. By late December, when he wrote to his American dealer Pierre Matisse he had come to the conclusion that many of the titles he had recently given his latest works were unclear, and he wanted to decide on others as replacements.[142] The letter seems to indicate that the productive possibilities of his latest "visionary" style are close to exhaustion. The last works in this vein are, as we have seen, the *Dog* (plate 129) and *Cat* both of 1951, and later *The Leg* of 1958 (plate 91). Thus, for the most part, after 1950 painting came more to the fore, bearing evidence of Giacometti's life studies, a practice he subsequently extended to his work in sculpture. In 1951 he began a systematic program of sculpting busts of Diego. From this point onward his creative output very rarely results from anything other than his encounters with the model.

From 1947 to 1950 full-length figures had dominated his work; the particular plastic form he was working on during this period could have only come into its own in a full-length figure. Although studio still lifes[143] show some busts, their character is closer to his contemporaneous paintings of visionary heads than to sculptures. A first attempt to go beyond this, to translate the effects of his new paintings into sculpture may be seen in a head made in 1950 (plate 139); although already modeled more clearly and painted in a detailed manner influenced by the oil paintings, its use of color noticeably limits its plastic presence.[144]

In order to find a new starting point for creating sculpture from life, Giacometti seems to have set aside his "visionary" forms and to have made some markedly sculptural heads conforming to classical traditions of the medium. They are distinctly reminiscent of the strangely immediate, modern-seeming terracotta portraits made by the Etruscans in the fourth and third centuries B.C. A close affinity to these is apparent in the taut proportions of the painted plaster *Bust of Diego* of 1951 (plate 138). Although this plaster is an impressive sculpture it would seem that it was too conventional for the artist himself.[145]

In the search for forms of his own, which would embody his latest discoveries about the process of perception, Giacometti returned to certain ventures from the past. A relatively early idea had been the flattening of the head and bust crossways to form a plane parallel to the viewer. Bourdelle's *Madeleine Charnaux* had offered him a preliminary precedent and may have influenced Giacometti's *The Artist's Mother* of 1927 (plate 24) and his *Gazing Head* (plate 31). In his more recent work, there is one example among the miniature sculptures (plate 77), and he had of course also used a concept of this type in *The Cage* (plate 103). The most extreme example is *Amenophis*, a delicate, insubstantial bust on a comparatively heavy, block-shaped pedestal, which—like the mostly pale paint of the finish—emphasizes the work's illusionistic character. Seen from the front, the head appears almost as a line, recalling the artist's overly slender figures.[146]

For his large weightier figures of about 1954 Giacometti abandoned the distancing pedestal and transferred its formal and weight-bearing functions to the upper torso, which took on new solidity in combination with more traditionally modeled heads. To relieve the inert qualities he found in the more conventional heads, he began to break up the surface even more determinedly than he had in the past. This added new drama to an aesthetic device that had initially suggested a sense of impending death and decay, for example, in *The Hand* (plate 92) and *Head on a Rod* (plate 89), and had had a more broadly dematerializing effect in the slender figures made from 1947 to 1950. His manipulation of the surface would go on changing until the last sculptures, the busts of Elie Lotar (plates 195, 196). At this point Giacometti used the technique to visualize processes of perception, to convey the physical energy of the bodies and yet leave them in an ephemeral realm. The gaze cannot cling to the torso, but is led to the head and to the eyes.

Through the relation of the head to the body and distortions of widths and depths Giacometti found the means to activate specific modes of perception. The first group of works to incorporate these ploys was inspired by observations made while painting. In close-up views and those from below, the painted figure appears in perspectival retreat and diminution. Transferred to sculpture, this principle is at its most succinct in *Diego in a Sweater* (plate 141), where, due to the retreat and diminution of the head, all the energy is concentrated in this intense core, which dominates everything around it. The contrast of a tiny head and massive pedestal developed in the miniature sculptures created a tension that takes on an exponentially heightened power in *Diego in a Sweater*.

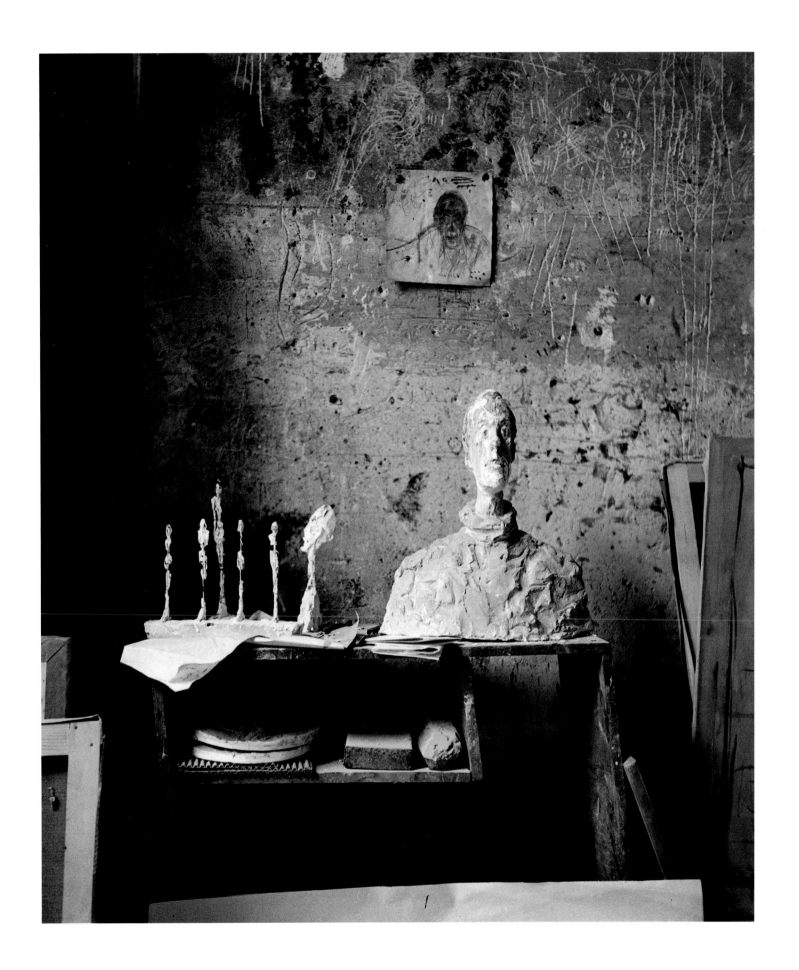

138. Bust of Diego. 1951

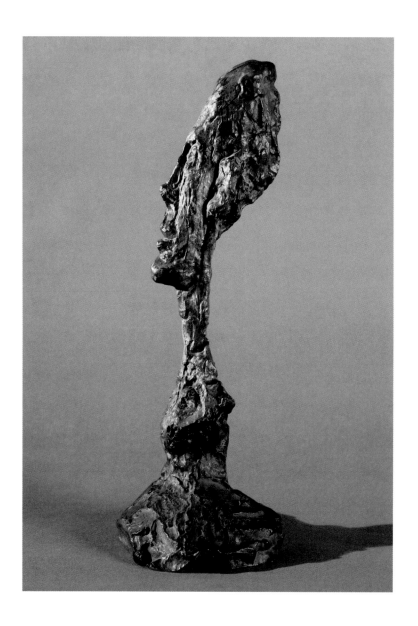

Another group of works has its high point in the *Large Head of Diego* (plate 140), where two aspects are combined: on the one hand the artist brings out, by means of sharp differentiation, the particular capacity of the head to display two different faces, which are ultimately irreconcilable in their psychological expressivity. Since the front view is naturally dominant, the profile was given more weight, which was achieved by flattening. Death, often associated with the profile in Giacometti's art, is here implied in the half-open mouth and the sharp nose. By contrast, a very carefully differentiated flattening serves to animate the front view of the face. Because of distances within the face, from the chin and the nose close at hand past the eyes to the distant ears, the viewer must constantly refocus his or her gaze. Thus perception of the head engages the viewer in a mental animation comparable to the physical incident of the work's surface. By contrast, the nonrhetorical, self-contained torso endows the narrow front view with security and weight, and links the very unequal faces to form one harmonious whole.

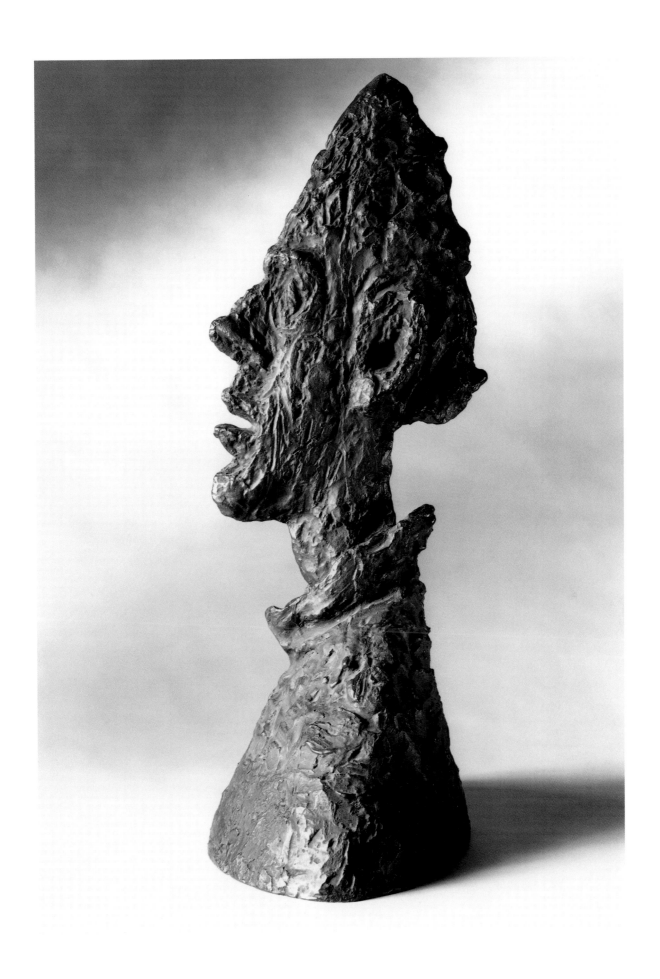

139. Bust of Diego. 1950 / **140.** Large Head of Diego. 1954

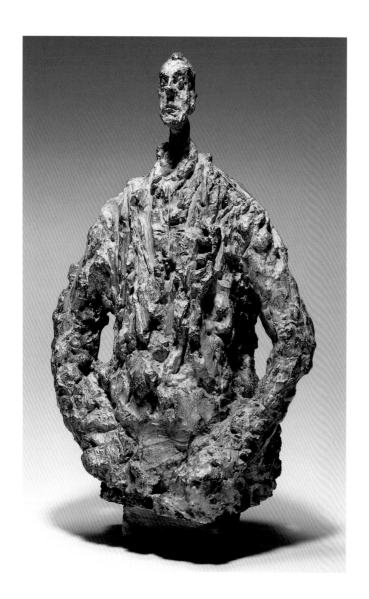

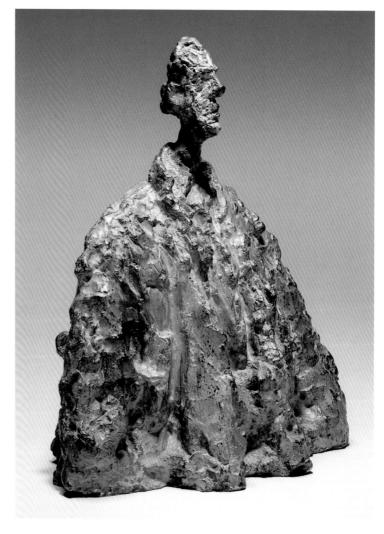

141. Diego in a Sweater. 1953 / **142.** Diego in a Cloak. 1954

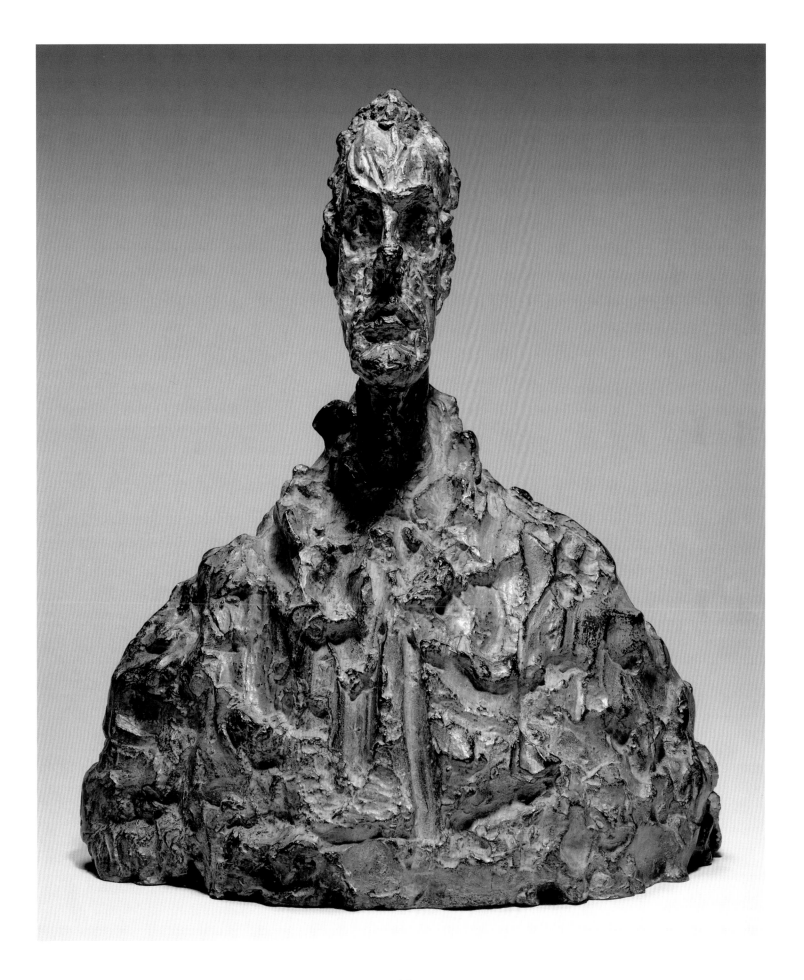

143. Bust of Diego. 1954

Portraits: Paintings and Drawings, 1954–60

In 1954 the return of a certain corporeality to the sculptures led to a solidification of the figure in the paintings as well. This is first seen in a painted portrait of Annette, where her face emerges at close quarters, rendered in considerable detail, unlike Giacometti's previous images of single heads that had the schematic generality of "visions."[147] In another painting of Annette from 1954 (plate 176), she appears in the immediate foreground, as a three-quarter-length nude with a sensually rounded body, an image unlike any encountered elsewhere in Giacometti's work. *Diego in a Plaid Shirt* (plate 144), with its complex posture and meticulously painted face, uniquely reveals the character of Giacometti's brother, the artist's model, assistant, and crucial support throughout his life.

In larger pictures, Giacometti began to readjust the pictorial balance of figure and ground. Prior to 1954, the figure had appeared contained within a defined interior structure, but with this picture and thereafter the figure came to dominate, and the ground increasingly functioned as a resonant space around it. Hohl has described this as the "evocation of reality in imaginary space," and regards the internal frame that was particularly prevalent at that time as functioning like the frame of a mirror image, reserving an imaginary space for virtual realities.[148] The fluctuation of the sitter's gaze was still conveyed by a fractured delineation, but additionally and more strongly by ambivalent indications of scale and by the brushwork flowing fluidly over the canvas. As though in a reflection, spatial depths remain oddly indeterminate behind the effects of floating light-and-dark surfaces. While perspectival indicators retreat in the surroundings, within the figures they are very evident: the tip of Diego's nose leaps toward the viewer just as it did, more literally, in the *Large Head of Diego* (plate 140). In the three-quarter figures of Jean Genet and G. David Thompson (plates 146, 147) an aggressive reduction of proportions, from the knees to the head, produces an optically disturbing pull into the depths and causes the figures to appear close and distant at one and the same time.[149]

With their increased attention to the figure, these paintings seem more like portraits of particular individuals than had previous paintings. Giacometti was, however, still as uninterested in physiognomic exactitude as in close psychological interpretations of his sitters; his concern was what he conceived of as an individual's essence as a whole. *Portrait of Jean Genet* (plate 146) is styled after an Egyptian figure of a seated writer in the Louvre. The painting in its entirety conveys a strong sense of internal flux, while the head seems to float alone, turned in on itself. The person shown here is aptly described by a pivotal sentence in Genet's essay on Giacometti: "Solitude, as I understand it, doesn't signify a miserable condition but, rather, a secret royalty, deep incommunicability but more or less obscure knowledge of an inviolable singularity." In contrast, the steel magnate and collector Thompson is portrayed as a man of obvious will and ego whose person extends threateningly forward from his tiny, densely corelike head to his hands grasping his thighs like mighty claws (plate 147).

While Giacometti had previously restricted himself to sitters who were close family members, he later turned, in the 1950s, to include a few others who had a close relationship to him, above all writers and critics who had written about his art. Beside Genet, there were Peter Watson and Isaku Yanaihara, and, later on, David Sylvester (plate 148) and James Lord,[150] who published a detailed account of the slow-moving production of these portraits. He undertook, as well, portraits of the sympathetic art dealer Marguerite Maeght and the photographer Ernst Scheidegger, whose camera had sensitively captured the artist, his work, and his surroundings since 1943, and who also documented his working methods in a film.[151]

A considerably larger circle of acquaintances looks out at us from his drawings, notably his most important dealers: Pierre Matisse, Louis Clayeux, Aimé Maeght, and Eberhard W. Kornfeld (plate 154); and writers such as Jacques Dupin, who later wrote the first monograph on the artist, Giorgio Soavi, and Douglas Cooper, among others. In 1954 Giacometti was commissioned to design a medallion with a head of Henri Matisse, for which he made numerous life studies of the painter (plate 152), who died a few months later in Nice. Many of these sheets can be counted among the most intense works Giacometti produced.

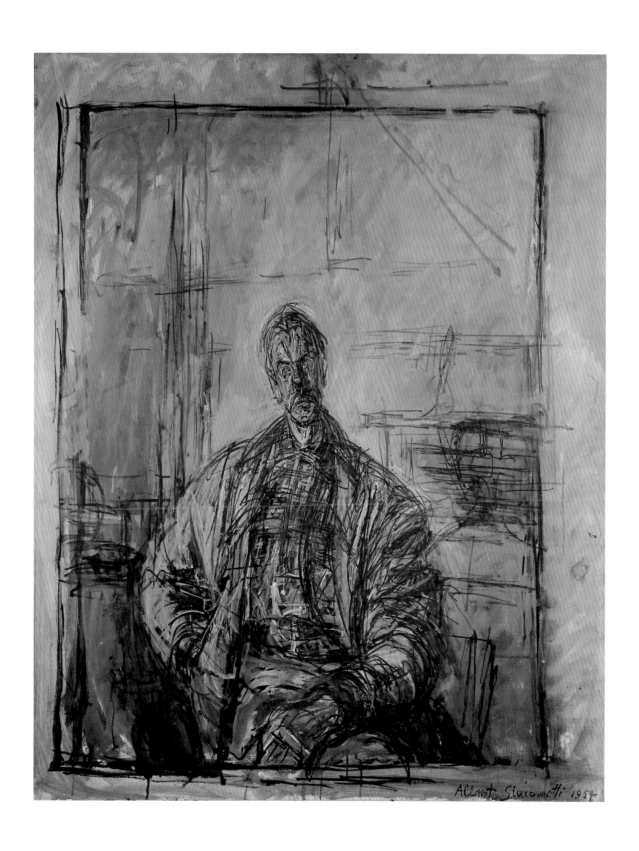

144. Diego in a Plaid Shirt. 1954

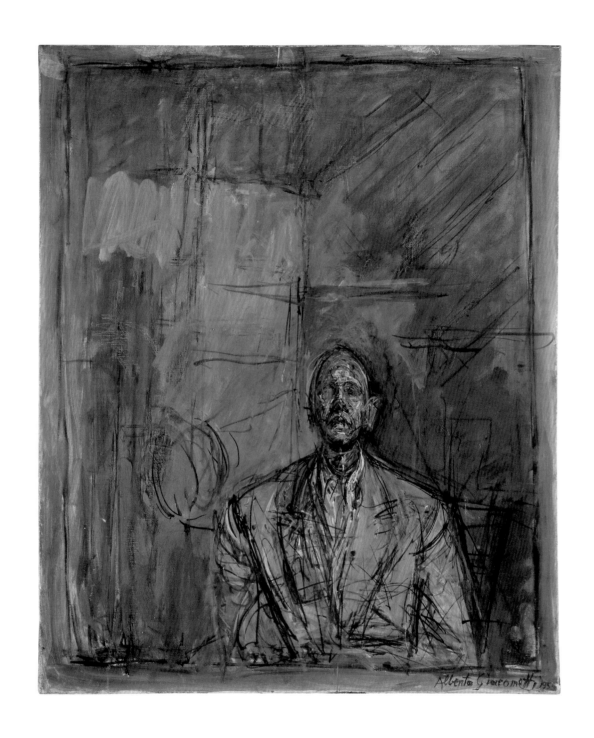

145. Jean Genet. 1954–55

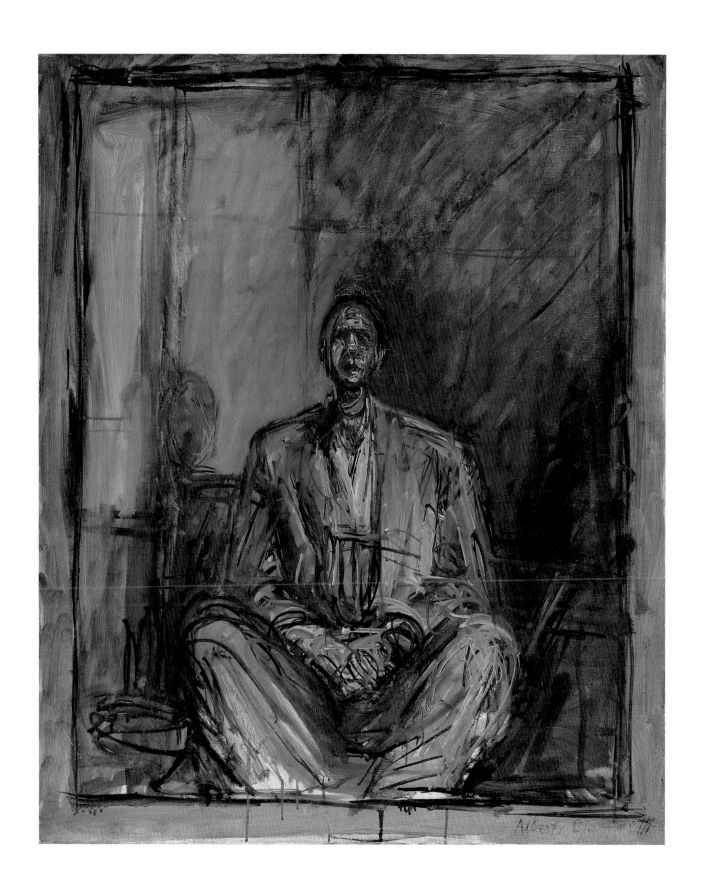

146. Portrait of Jean Genet. 1954-55

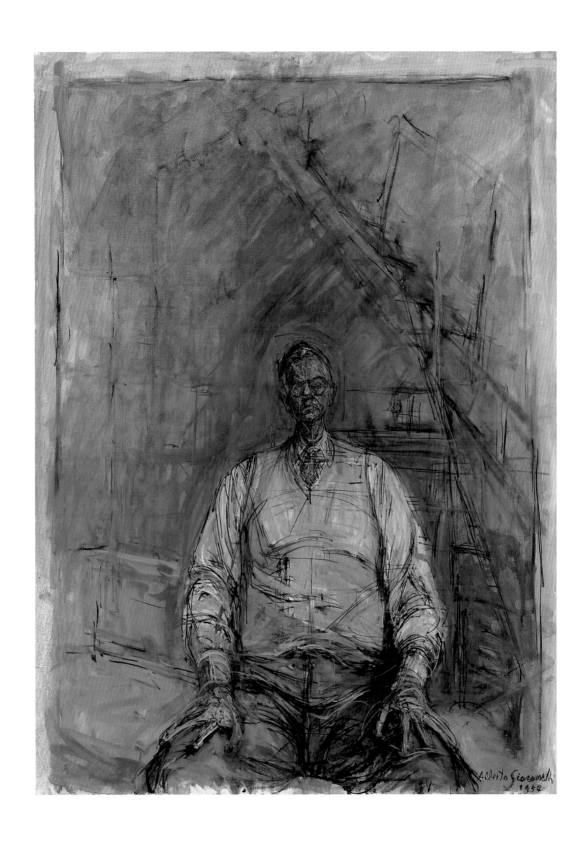

147. Portrait of G. David Thompson. 1957

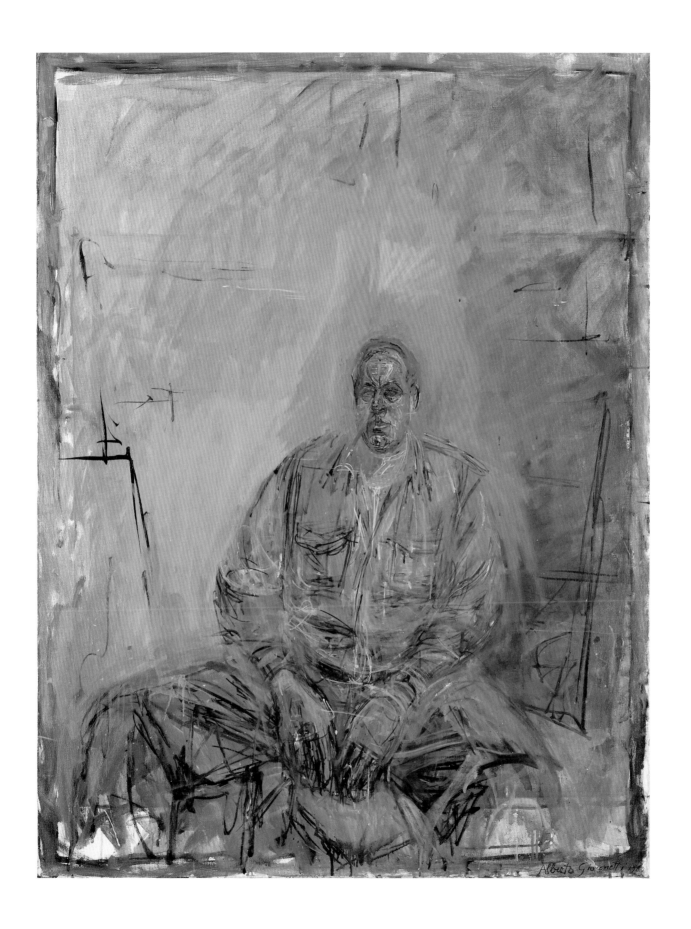

148. Portrait of David Sylvester. 1960

149. Jean Genet. 1954

150. Annette. 1954

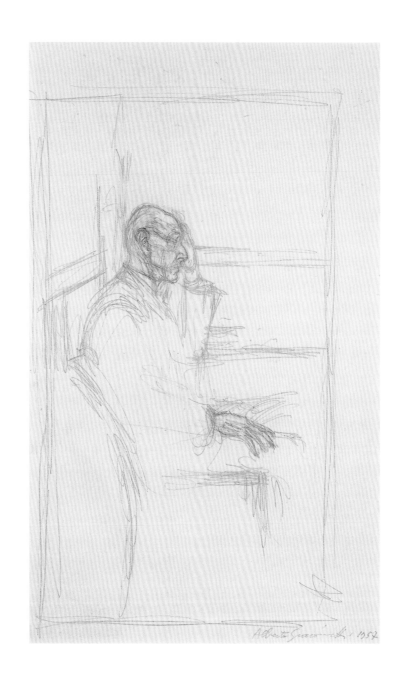

151. Igor Stravinsky. 1957

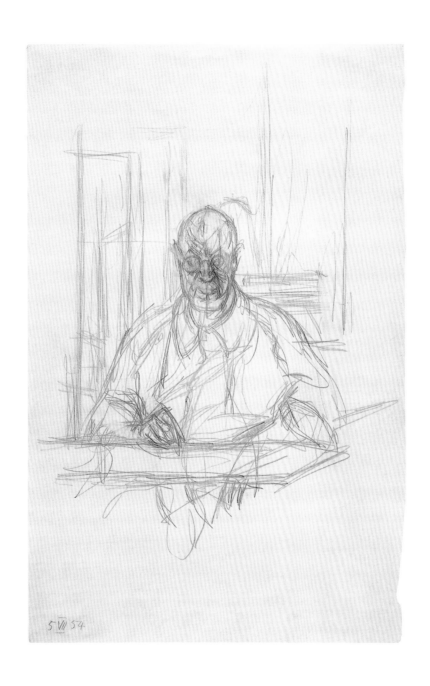

152. Henri Matisse. 1954

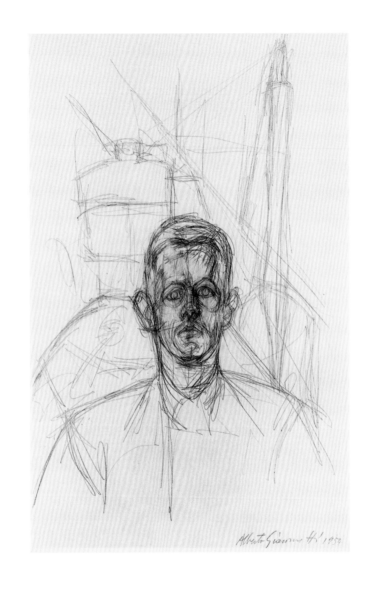

153. James Lord. 1954

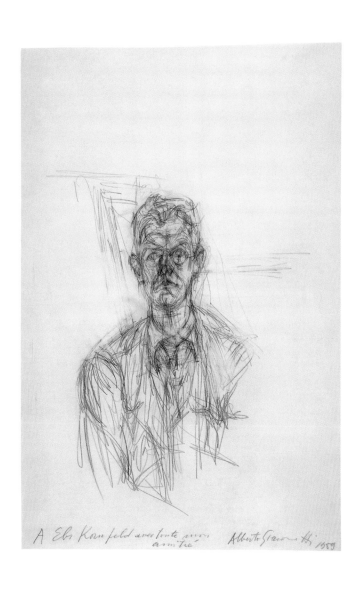

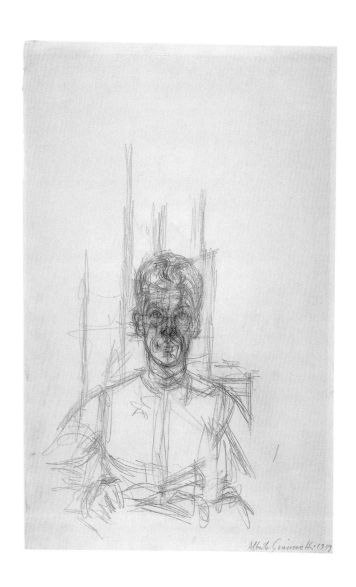

154. Eberhard W. Kornfeld. 1959 / **155.** Silvio Berthoud. 1959

The Women of Venice

In 1953, some time after Giacometti had returned to life studies in sculpture, he began to model standing nudes of Annette. They differ radically from the threadlike "visionary" figures made from 1947 to 1950: only the calm, frontal posture remains. As in the busts of Diego, this new departure started with a period of experimentation, which, however, had less to do with problems of phenomenology than with questions of lifelike accuracy and expressivity. This in itself shows the different meanings of these central subject areas in Giacometti's work: on the one hand, his primarily reflexive relationship to the head concentrating on the encounter via the gaze, and on the other hand, to the either hieratically distant or too close and threatening woman. For Giacometti, these mirror the two fundamental types of relationships to one's fellow human beings, and the range of his figures extends from relatively normally proportioned life studies to the extremely wide, deformed "little monsters" and disturbingly fragmented figures.[152]

When Giacometti resumed work on the standing female figure, with an eye to his participation in the Venice Biennale of 1956, he strove for a synthesis of his experiments from life and his previous visionary figures. Despite their strictly limited subject, the nine bronze casts of the Women of Venice divide easily into four types, each of which adheres to different formal traditions. First, I and IV form a pair by virtue of their expressive affinity to life studies. The second group takes up the extremely slender forms of earlier works, with arms close to their bodies and the head and the body linked by long hair; of these, VI is the most extreme in its proportions, and appears to be a conscious synthesis of the "visionary" type with certain life studies, characterized by fuller breasts and prominent pelvises. In the third type, VII and VIII (plate 160) are wider than their sisters, and in VIII, Giacometti once again attains a hieratic sense of closure without losing the corporeality of the broader body.[153] In their own ways, II (plate 159) and V (plate 161) also tend in this direction, and II has less volume, as the arms and the body come together (a possible consequence of the frontality that Giacometti had tried out in a Plaque sculpture in 1929). At the same time, the experience gained from making the heads of Diego is most evident here: the lateral flattening of the torso is countered by the front-to-back flattening of the head and feet. The tension Giacometti often set between a heavy pedestal, sloping toward the front, and a tiny head is at its most distinct here, endowing the

pieces with that sense of the visionary the artist favored. By contrast, in the last type, exemplified by V, Giacometti modeled a more rounded shape within a strict overall form, with the bowlike containment of the torso by the arms and shoulder recalling *Hands Holding the Void* (plate 58), just as it anticipates the *Tall Woman II* of 1960 (plate 172) and the autonomous, cultlike status of the group to which it belongs.

As in the case of the heads of Diego, this analysis by experiment shows Giacometti's systematic development and combination of certain principles of form and composition to have been a wholly conscious procedure, as had previously been the case in the evolution "through opposition" of the Surrealist works. In published interviews Giacometti regularly pronounced his art to have failed; in his notebooks and letters to his family, however, he regularly identified progress: in one comment he talked of his oeuvre as a strict sequence moving from one day to the next, from one work to the next.[154] When it came to making the Women of Venice series, it is reported that Giacometti spent the weeks between January and May 1956 working with the same clay over the same wire frame; as soon as the result satisfied him, he had Diego make a plaster cast.[155] By this method he produced around fifteen figures, of which several were seen in Venice and in the concurrent retrospective in Bern; nine were later cast in bronze. This account, emphasizing the importance of process in his working method, corresponds to descriptions of his method when he was painting, the only difference being that while one layer of paint disappears under the next, in sculpture the successive stages can be preserved. A rotating sequence of states, each representing a stage in the search for unattainable perfection, simulates the constant changing of all living things.

The Women of Venice mark the halfway point in Giacometti's mature work; they bring together the different characteristics of his figures. The evocative name, which binds the individual figures into one group despite their differences, had an enhancing effect: as the figures became legendary, they came to be regarded as the epitome of his art. The extremely small, distant heads and the innovatively sloping pedestals, from which the over-size feet grow,[156] still make them seem like revelatory, illusionistic visions. Their marked three-dimensionality heightens the erotic quality of the breasts and pelvis, whose curves are accentuated by the hands on either side of it.[157] At the same time, the extreme plasticity brings out the morbid,

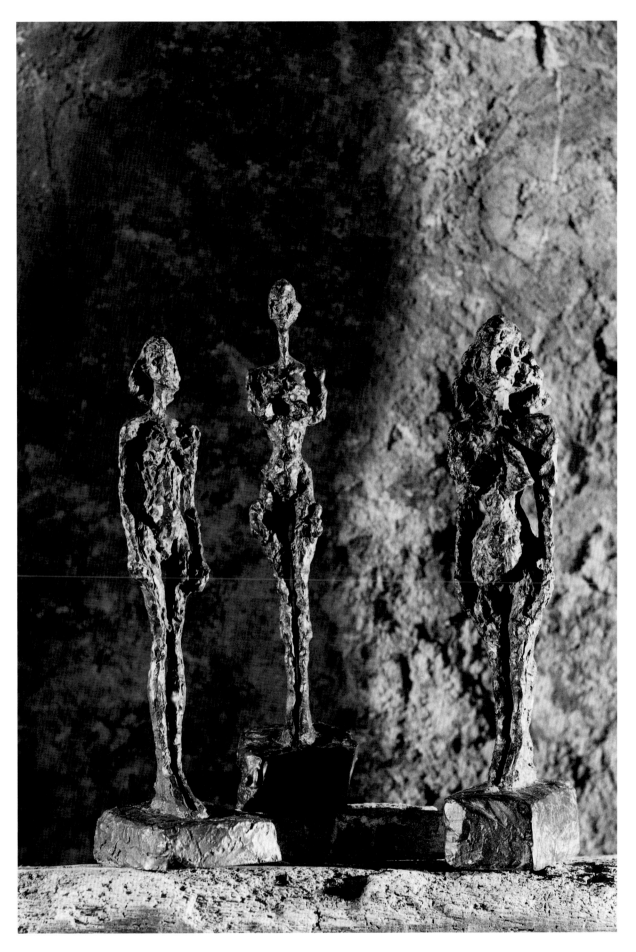

156. Nude, after Nature. 1954 / **157.** Standing Nude without Arms. 1954 / **158.** Standing Nude III. 1953

decaying nature of the amorphously fissured surfaces. The tension in the mingling of goddess and concubine, of Egyptian cult image and decomposing corpse, is seen nowhere as vividly as in this group, in which now one, now another aspect moves into focus. Genet's widely read text, "L'Atelier de Giacometti" (Giacometti's Studio), which had great influence on the perception of the work, was written during this period and particularly discusses the Women of Venice. Giacometti's sensibility—in accord with the spirit of the time—emphasized the link between the eternal "imaginary museum" and "base materialism," and is most clearly given form in the leitmotif of "sculpture for the dead."

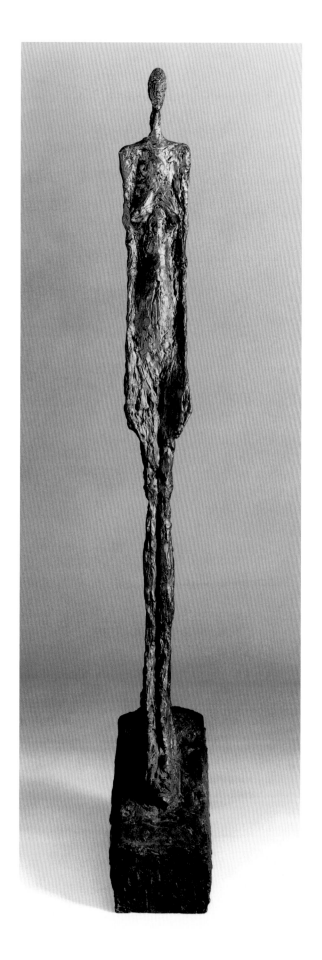

159. Woman of Venice II. 1956

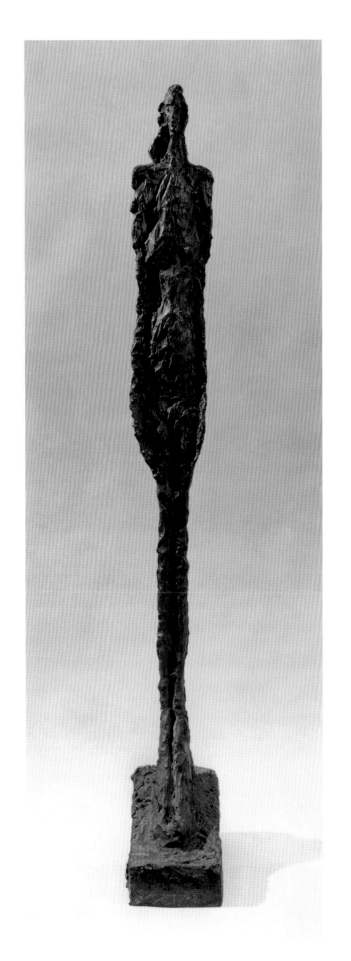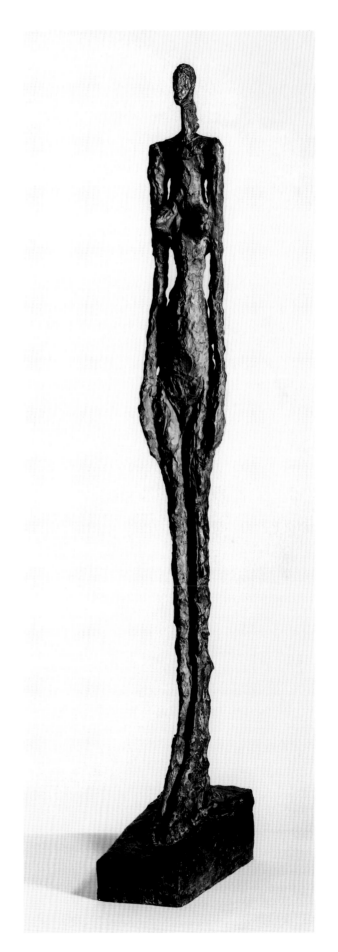

160. Woman of Venice VIII. 1956 / **161.** Woman of Venice V. 1956

The Yanaihara "Crisis"

Giacometti was not an artist blessed with a constant flow of significant production. Although he always worked with great intensity, his oeuvre is relatively sparse. The two very fruitful four-year stretches, from 1929 to 1932 and from 1947 to 1950, are outweighed by long periods when he was barely able to produce anything to his satisfaction: from 1921 to 1925 and again from 1935 to 1946. In 1957 his productivity went into decline again and after a last flowering around 1962, it gradually ebbed away. It was only his drawings that continued to flow in abundance and in high quality, typically for him in times of crisis. Even during his most productive phases after the war, he rejected the greater part of what he made. Countless versions of clay figures disappeared in his hands as he strove for improvement. In his paintings ever new layers of the same face hid earlier attempts, which, to those who saw them, had seemed final and successful. Indeed, it often seemed that an external reason interrupting his work, such as the departure of a sitter or an exhibition deadline determined a final version.[158] Thus his working process followed a pattern that seems characteristic for modernity, comparable to the endless circling of the object by the subject in phenomenology and the replacement of narration by description, or the insistent naming of items in poetry.[159]

The visionary quality that Giacometti wanted to convey is not that of the fleeting impression, snatched in a chance second of Baudelaire's "Le peintre de la vie moderne" (The Painter of Modern Life). He was not searching to capture the fluidly indistinct, evocative nature of the momentary. Rather, for Giacometti it was the essential presence of the human being, as it appears to the artist, that he sought to grasp—the ceaseless dialogue between seeing and the seen, eye and hand, in which the form continuously grows and dissolves. And this he wanted to capture as a momentary experience, as in an epiphany: "The goal is to create a complete whole all at once."[160] The demand that the aesthetics of the sublime makes on the impact of a work is applied by Giacometti to his own production, albeit reversing the customary model of empathy between artist and viewer. The more profound reason for Giacometti's obsessive compulsion to rework pieces was his will to go ever deeper—making him mistrust the quick success that came with his level of virtuosity—the will to approach ever closer to the living presence of his sitter. And at the same time it is the process of Giacometti's own life—the discovery of himself in his engagement with the sitter and the creative act—which rates the creative act above the end result.[161]

Giacometti's drive to endow the pictorial experience of encounter with the same life as it had in reality led to the last major crisis in his work. Primarily rooted in the dynamic of the development of his work, it occured to him in the autumn of 1956 when he was working on a portrait of a Japanese professor of philosophy, Isaku Yanaihara. We have already seen how Giacometti turned to ethereal schemas of heads after his "visions" of 1946, and thereafter returned to making life studies in 1949, which, in turn, led to an increasingly dense internal imagery in the figures, which after 1954 gained ever greater weight and presence compared to the space around them. Gathering momentum, this tendency produced pictures in 1956 where increasingly indistinct outlines of shapes in the studio multiply and splinter apart. The gray mist, licking like a flame around the *Diego* of 1956 (plate 162), reads as an almost desperate blow for freedom from the space that refuses to be reconciled with the figure.[162]

With *Diego,* a critical point was reached: whereas Giacometti earlier sought to make "illusionistic sculptures," he later tried to achieve the opposite, namely, to entice tangibly three-dimensional figures on the canvas into the three-dimensional reality of the viewer. The first visible result of this difficult reversal, *Yanaihara* (plate 163) may look like the fragile expression of a crisis, but one that provokes a new impulse to create. The sequence of portraits of Yanaihara reveals the long and vexatious path that finally culminated in the paintings of Caroline in 1962.

In the 1956 painting of Yanaihara the perspectival indicators in the background have largely disappeared; significantly, the trapezoid on the right reads rather as a brace supporting the figure within the rectangle of the picture. The pale yellowish and grayish floating surfaces are reminiscent of the portrait of Genet, but here the source of these effects of light seem unimportant; all that remains is a wholly indefinable spatial mist or color plane, like an internal frame. The actual year of the crisis was 1957,[163] with paintings like that of the matchstick man lost in a wide, empty pictorial field,[164] and the so-called *Sketch* in Zurich, in which a head of Annette can barely hold its own against a flood of thick gray impasto, itself witness to the tortuously protracted work on the piece.[165] That year also marked the first of the Black Heads of Diego, which

recall the "visionary" ethereal heads from the postwar years and which Giacometti continued to make until his death. With their staring eyes in often shockingly amorphous, dark faces, lost against a somber ground, they so closely matched the existentialist mood of the time that they long influenced the public perception of Giacometti's painting. An example here is the life-size, stunningly monumental *Large Black Head* of 1961 (plate 191).

A large nude of Annette also of 1957 (plate 167) conveys a similarly somber and gray mood. Yet the more securely rendered figure detached itself somewhat from the misty space, and seems to indicate a way out of the crisis. Instead of sinking into the depths, the figure seems to be floating forward, an effect that is reinforced by the narrow vertical format and the dynamic opening of the internal frame at the top and especially below. It is possible to follow how this figure came into being; in its final version, the figure is without internal perspectival indications, as initially it was smaller.[166] Variations in the size and hence in the distance of the figures had played an important part in Giacometti's phenomenological research since the 1930s, as we have seen, and are often interpreted in the literature with psychological overtones.[167] Evidence that the "crisis" had been overcome by 1959 at the latest may be found in the vigorous coloration of *Aïka* (plate 168), inspired by the charm of Giacometti's tailor's fifteen-year-old daughter. She sat for the painting close to a window and only during the day. (The somber gray of some other pictures is partly a result of Giacometti's manic habit of working all night.) The large *Portrait of Isaku Yanaihara* of the same year (plate 164) and, above all, the picture of 1961 (plate 165), made when Yanaihara visited Paris for the last time, show how much the figure and particularly the head have gained in terms of substance and presence. What was previously a confining studio space dissolves into a lively painterly treatment of the canvas, which is increasingly left unpainted. The whole effect is almost that of the figure being projected forward into real space.

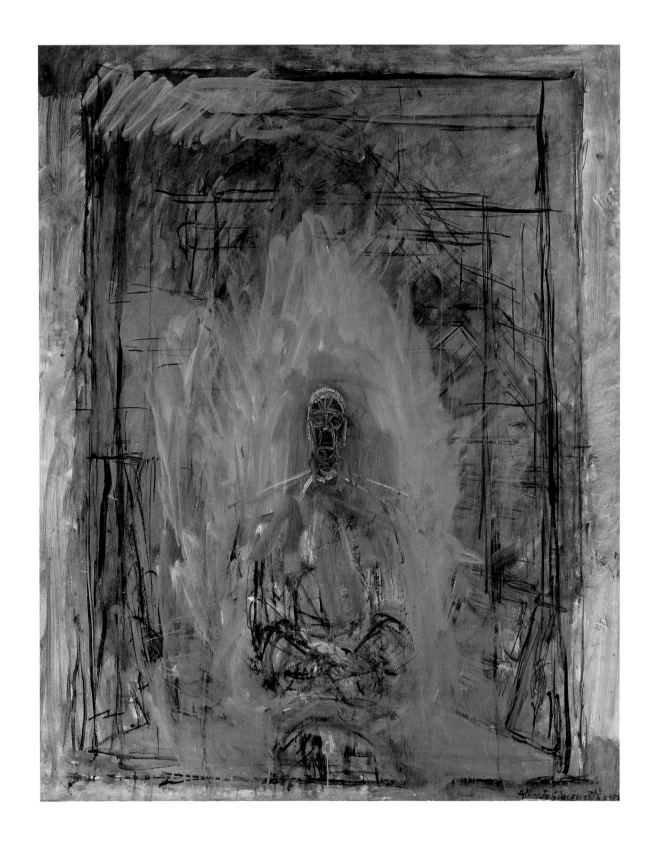

162. Diego. 1956

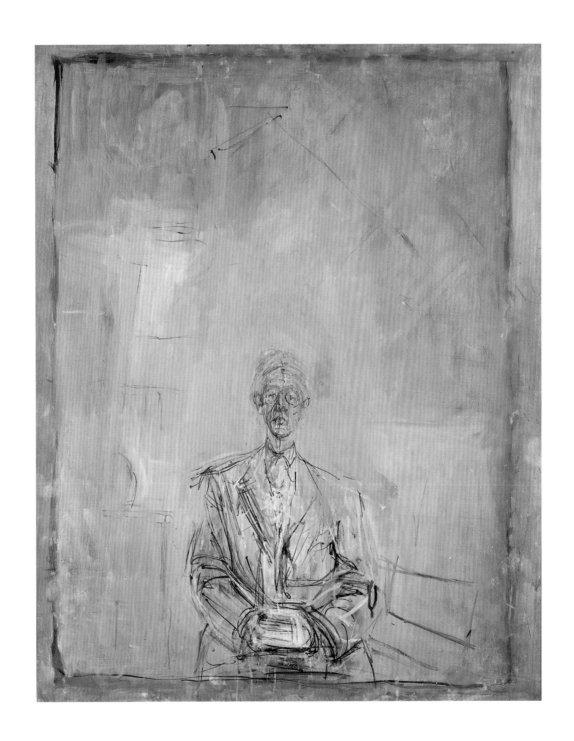

163. Yanaihara. 1956

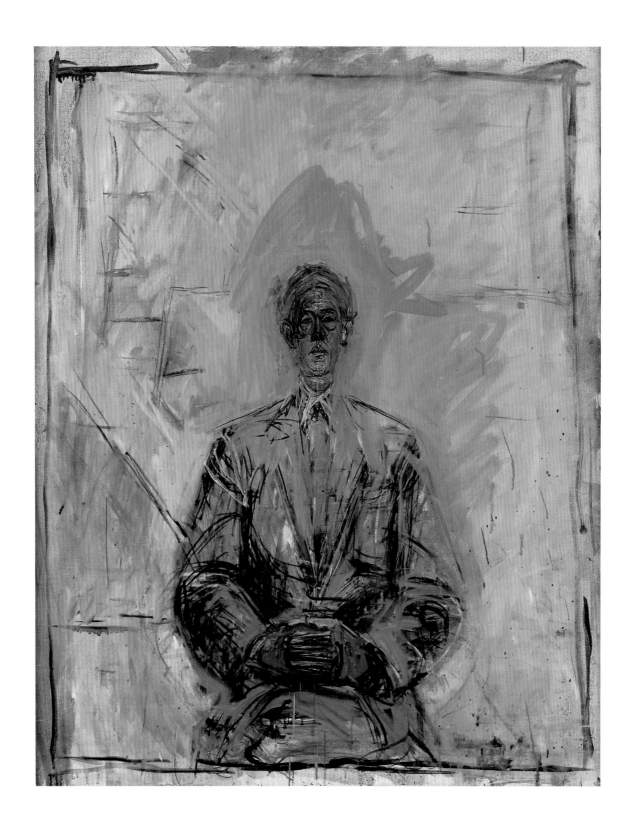

164. Portrait of Isaku Yanaihara. 1959

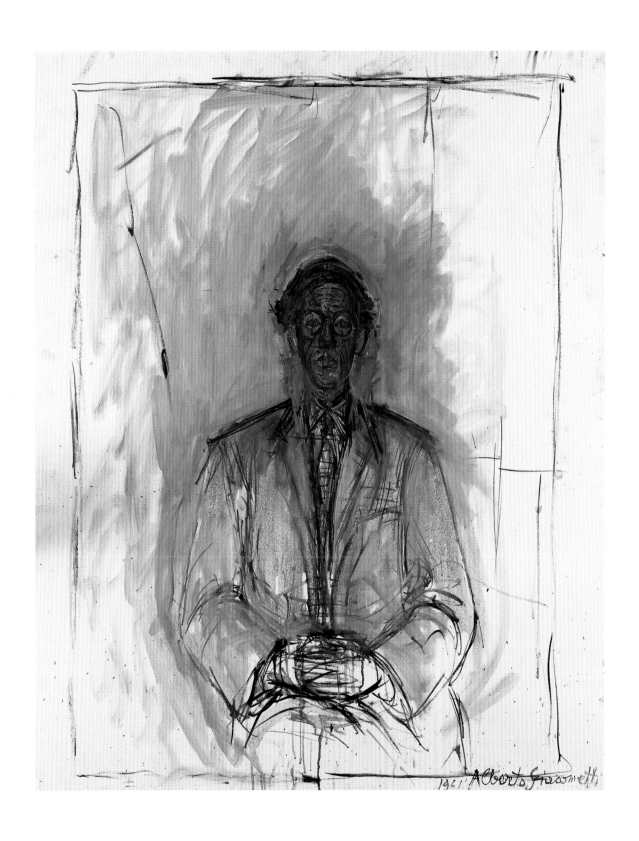

165. Isaku Yanaihara. 1961

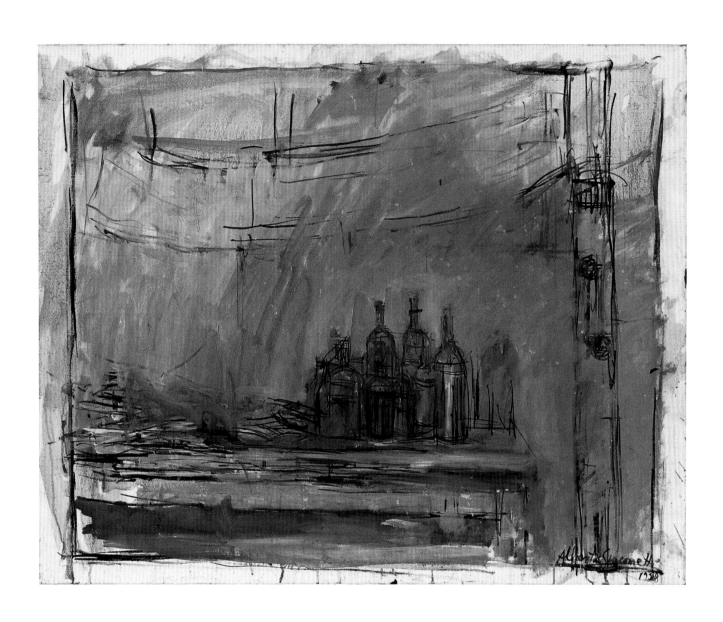

166. Still Life with Bottles. 1958

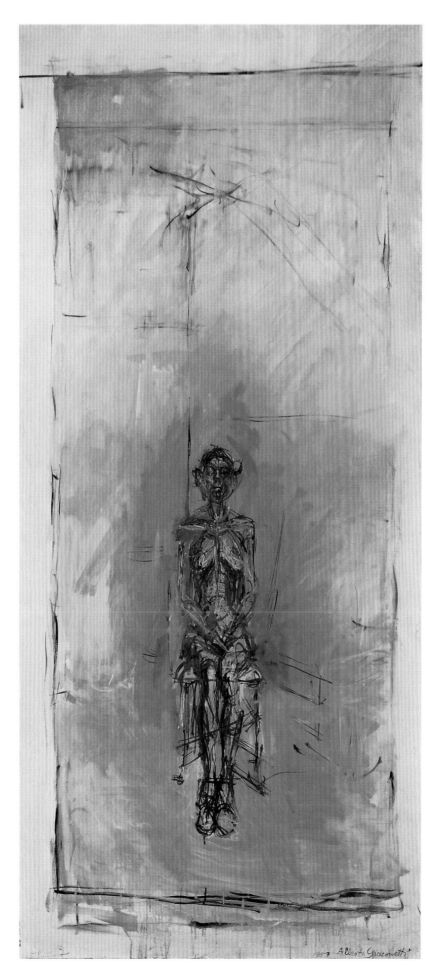

167. Tall Seated Nude. 1957

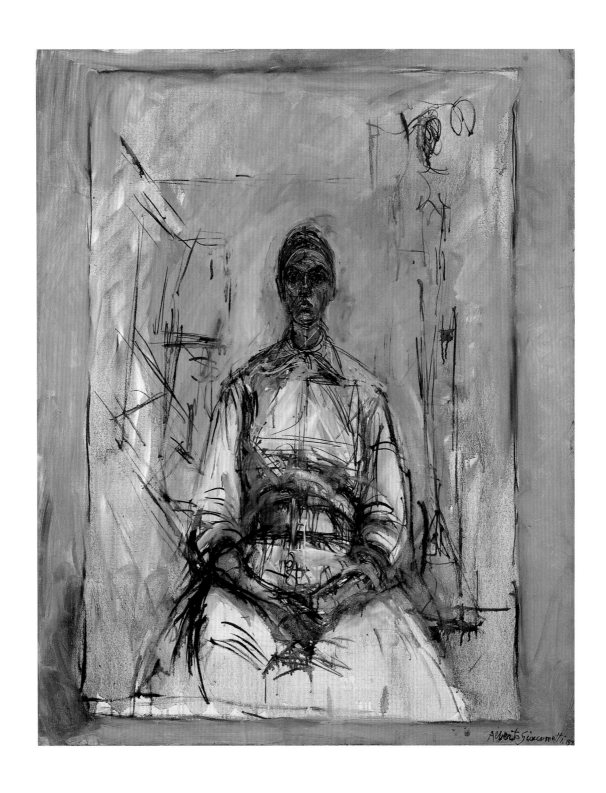

168. Aïka. 1959

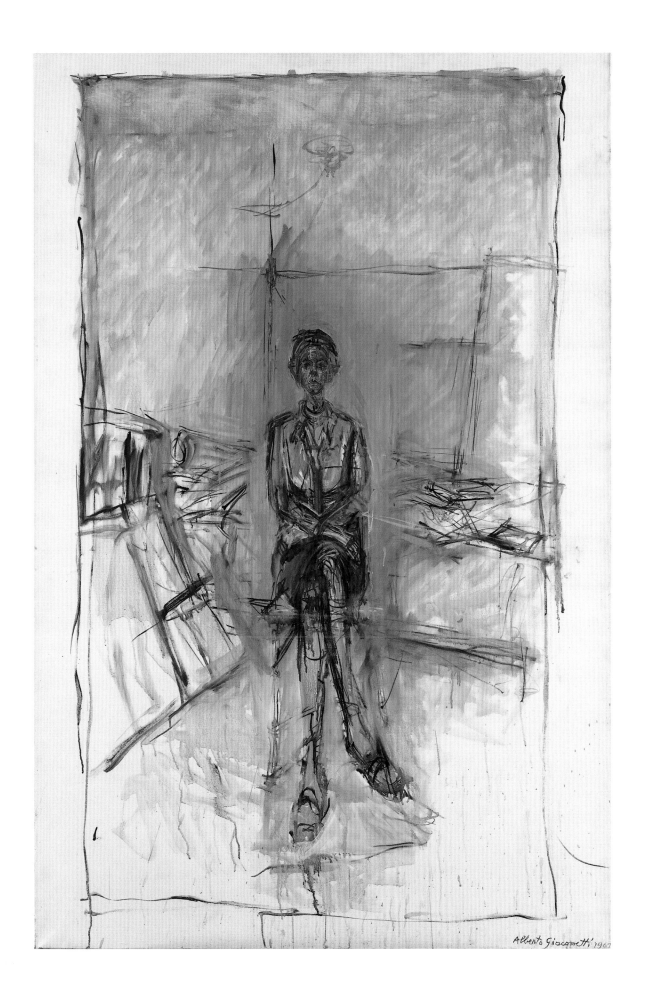

169. Annette in the Studio. 1961

Figures for Chase Manhattan Plaza

In 1956 Gordon Bunshaft, the architect of the headquarters of the Chase Manhattan Bank, invited Giacometti to design a group of sculpted figures for the plaza on Pine Street in New York City. His suggestion that the *Three Walking Men* of 1949 could be enlarged to a height of nearly sixty feet was hardly likely to find favor with an artist for whom questions of dimension were a central issue.[168] But after lengthy deliberations Giacometti proposed a group of larger-than-life-size sculptures: a standing woman, a walking man, and a head on a pedestal, representing the three major themes that almost exclusively occupied him in his mature sculptural work. He made tiny models and started, in his cramped studio, to work on a number of variants for the large figures. In 1960 a head, four different women, and two variants of the Walking Men were cast, albeit without ever arriving at their ultimate destination.[169]

The idea of grouping a number of sculptural forms in a public plaza goes back to the *Model for a Square* of 1930-31 (plate 43). In keeping with Surrealist notions of the integration of art and everyday life, these objectlike pieces were to stand directly on the ground so that viewers could move freely among them. Important to this direct contact is the activation of the space between the figures, which thereby forms a continuum with the surroundings. In *City Square* of 1948 (plate 102), Giacometti took this concept a stage further; the relation of the individual figures to their surroundings corresponds to the situation of people in a street. But in this case the work is not a model for life-size sculptures but consists of filigree figures inside an imaginary space.

Having reclaimed real space in the 1950s with sculptures that display a new three-dimensional solidity, Giacometti was in a position to form larger-than-life, freestanding figures and thus to realize both concepts by merging them. By their dimensions alone the figures rise above the everyday—although they are anchored in it by being placed in a particular position—touching on the sphere typical of traditional cult figures. Not part of the transcendental realms of religion and myth, they nevertheless point to past time—the walking man as the epitome of human striving, the head as a symbol of seeing consciousness. The tradition of the cult image is seen at its clearest in the motionless, tall standing woman. Its form required the most concentrated stylization for the autonomous sculptural quality of the figure to have an epiphanic effect on the viewer. Giacometti was looking back to the *Woman of*

Venice V (plate 161), the curve of whose arms and shoulders recall the idol-like figure in *Hands Holding the Void* (plate 58). It seems logical that in its last phase, the project concentrated on this one figure. When Giacometti traveled to New York in the autumn of 1965 for his retrospective at The Museum of Modern Art, he visited the Chase Manhattan Plaza. In view of the huge height of the surrounding buildings he decided to make his standing woman twenty-five feet tall. But it was not to be; shortly after his return to Europe he died, and his last project for a square was never realized.

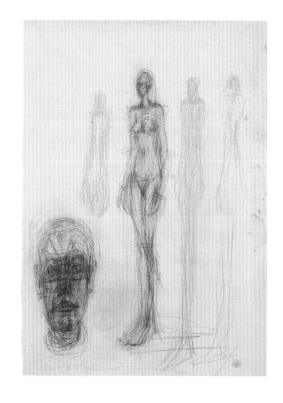

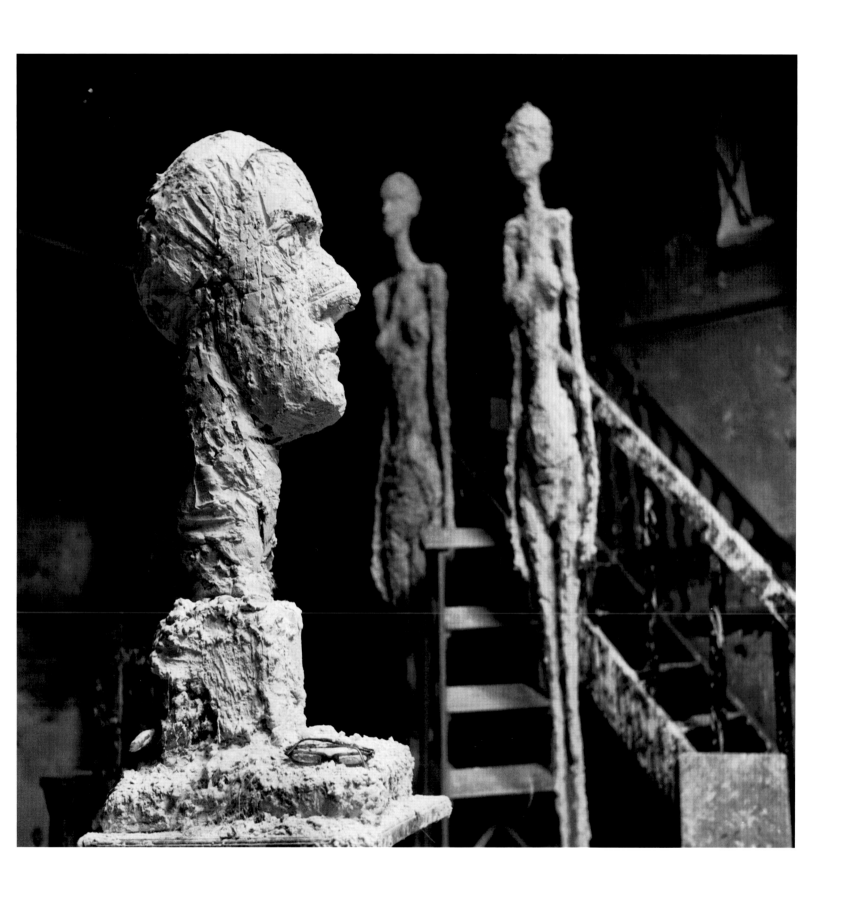

170. Four Figures and a Head. 1960 / **171.** Monumental Head. 1960 233

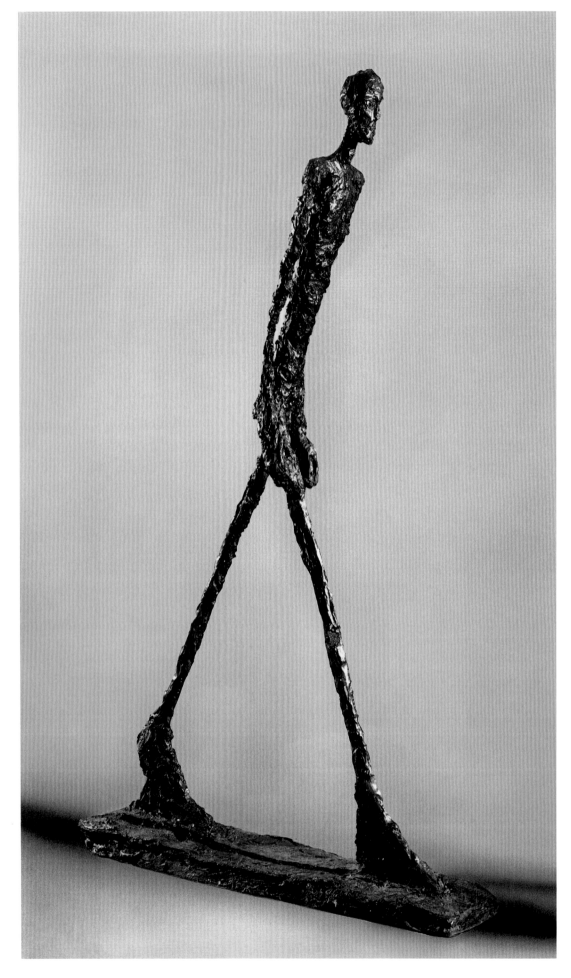

172. Walking Man II. 1960

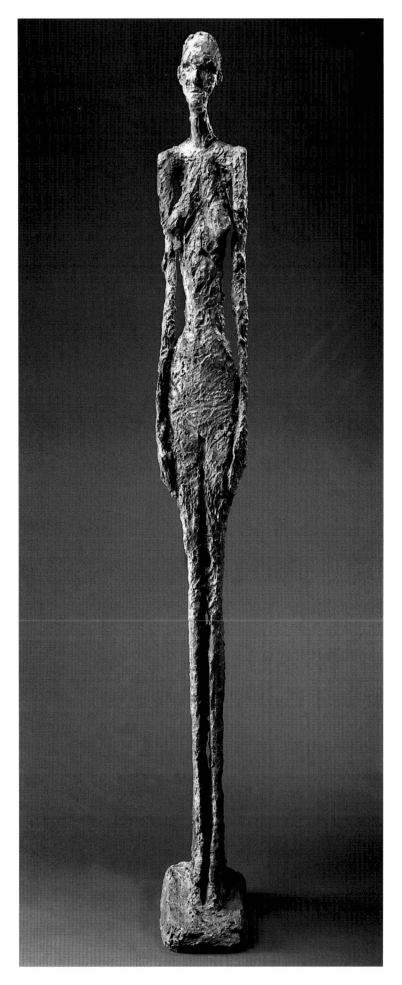

173. Tall Woman II. 1960

Late Images of Annette: Drawing, Painting, Modeling

Drawing or, more precisely, capturing reality by drawing had been Giacometti's primary creative drive since childhood, precociously creating his own work by combining the model set by his father with ideas gleaned from historical examples. When he came up against his first crisis during the transition from his self-confident youth to life as a professional artist, it was drawing that helped him to move on again. When modeling and painting seemed impossible, he could always draw. In fact, in times of crisis he produced many of his most intense drawings, such as the crystalline life drawings from his time at the Académie, the analytical copies of the late 1930s, the works on paper that show his search to progress beyond miniature figures, certain portrait drawings during the Yanaihara crisis, and finally the series depicting his mother produced in 1963 in Stampa. Only while he made purely imaginative avant-garde works, from 1925 to 1934, did he draw less, limiting drawing to his stays in the Bregaglia valley and to depictions of objects that came to him in his imagination.[170]

The mutual influence of the different genres of drawing, painting, and sculpture always revolves around issues of seeing, perceiving, and capturing reality: Giacometti's basic phenomenological aim was simply to show the process of "seeing." His drawings offer the best proof of this. The complex of lines, bundled together by living energies, corresponds to the restless movements of the eye that circle around objects, link them to other things, measure their spatial dimensions, distinguish the important from the unimportant. Just as Cézanne established the appearance of reality on his canvas with floating tensions among flecks of color, so Giacometti used lines to record on paper his dialogue with the existence of things.[171]

Giacometti pursued the same phenomenological aims on canvas as in clay. Admittedly, it was the white of the paper that opened up the inner mental space, that neutral ground on which the traces of seeing could leave their mark and which is not a given in other mediums. Thus the themes of Giacometti's work ranged most widely in his drawings and similar graphic works; in the paintings he portrayed familiar landscapes and still lifes as well as people he knew; but the sculptures were restricted to the head, the standing woman, and the walking man. Similarly, the range of his sitters became increasingly narrow.[172] Thus there are only a few moments when the same motif is treated in all three genres. The most intense interchange of this kind may perhaps be seen in the portraits of Annette made in the early 1960s.[173] There Giacometti searched in all mediums for a new, more rigorous evocation of the ephemeral living model. The drawings (plates 177, 178), with the purity of their delineation, vividly demonstrate a canon of proportions that would seem to have been devised for eternity—and where Giacometti came ever closer to achieving the effect of Egyptian art. In painting, too, the lines that give the face and gaze their vibrancy achieved a new clarity.[174] In sculpture, an immediately striking feature of the heads is the artist's renewed interest in the pedestal and the very different forms it can take. Here, again, Giacometti sought to combine a moment of elevation and withdrawal with the impact of a living, breathing presence.

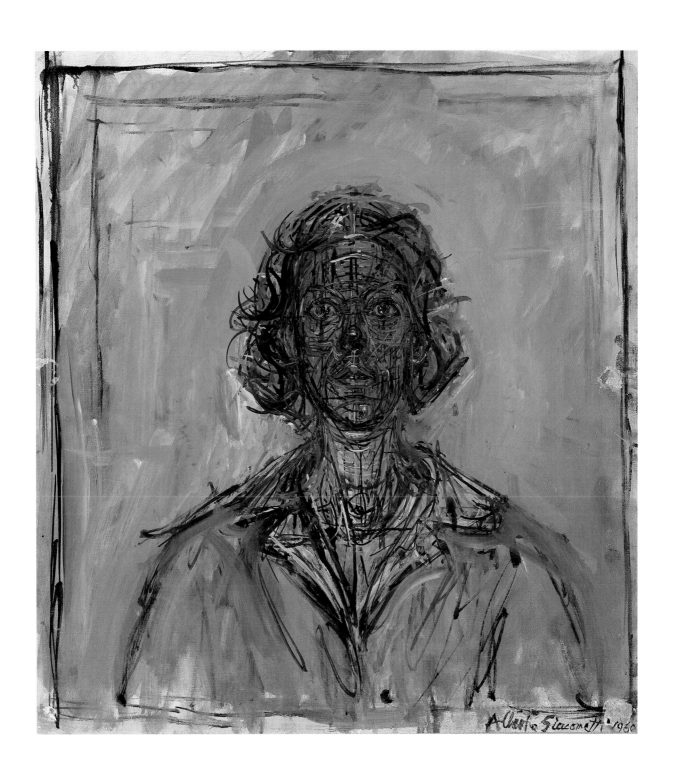

174. Annette. 1960

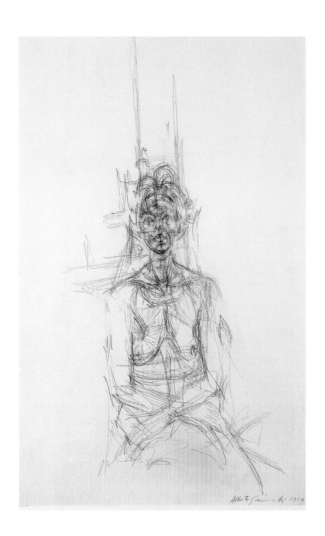
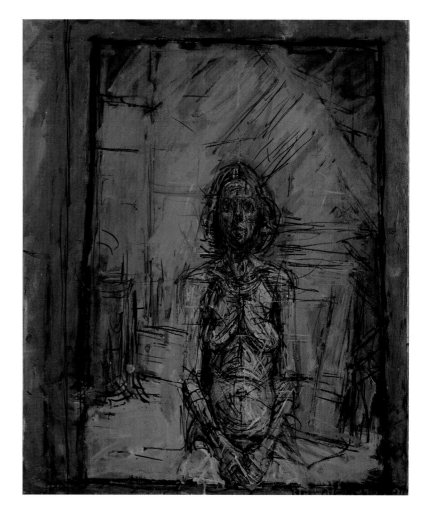

175. Annette. 1959 / **176.** Annette. 1954

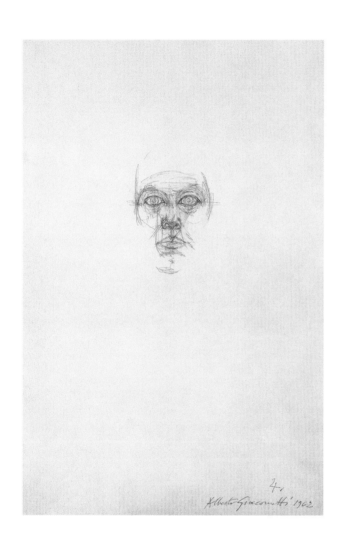

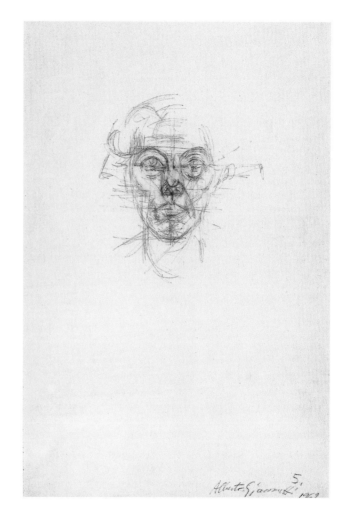

177. Annette IV. 1962 / **178.** Annette V. 1962

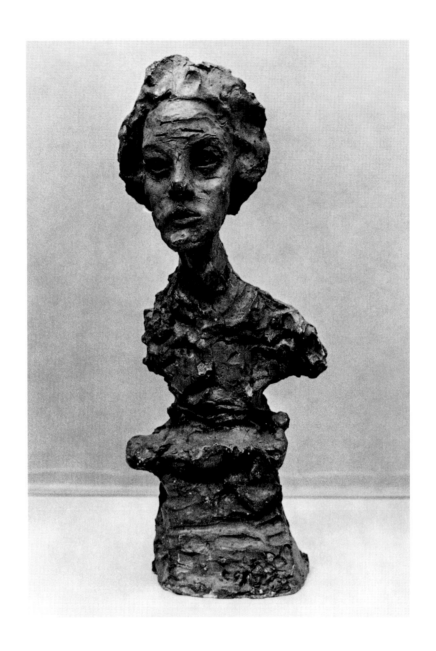

179. Annette IV. 1962

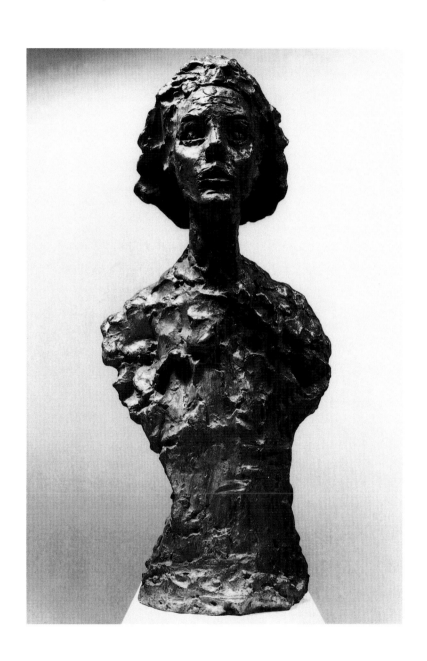

180. Annette VIII. 1962

Caroline

In the paintings that Giacometti made of Caroline, he arrived at the highpoint of his ambition to capture the living reality of a human being. At first this was only possible by his sketching a ghostly figure a considerable distance away; in 1947 these became dematerialized pictures born in the artist's imagination. Through the phenomenological experiments of the 1950s and the Yanaihara crisis his work attained a new substantiality and immediacy. In the autumn of 1959 he met Caroline, a twenty-one-year-old prostitute;[175] in the spring of 1961 he made a first sequence of memorable pictures, which he was able to surpass the following year, owing to his concurrent systematic exploration of strict formal structures in his work with Annette.[176]

One's meeting with the other significantly determines the relationship to reality and, consequently, the sense of self. This everyday occurrence is generally accepted, but it can take on an elemental force. Grasping the perplexing presence of a human being and forming it was the goal of Giacometti's lifelong search. It was behind Giacometti's persistent engagement with Caroline, his by no means indifferent sitter, who had to withstand his intense gaze. The encounter with the vivid young woman seems to have heightened his creative powers.[177]

This kind of intensity can hardly apply to the whole figure: it has to be concentrated in the face, on the mirror of the living personality, as Giacometti repeatedly stressed. The viewer's power of seeing has to be stimulated so that a life can emerge from the dormant configuration of shapes confronting him or her. Cubism's attempt to achieve this caused the depicted object to disintegrate in the process. Giacometti, however, by a canny concentration of the energy lines of his own restless "seeing" managed the pictorial counterpart of the daily experience of encounter, when human beings face us as closed bodies yet as openly responsive life.

In *Caroline II* (plate 182) the radiance of the figure's personality fills the whole picture. Toward the outside edges of the picture, bare canvas and trails of color clearly made of binding agent and pigment confirm the reified facture of the painting. Lost hints of an internal frame and oscillating veils of color surround the head and open up a space around the figure. The body, treated in a nearly Abstract Expressionist manner, activates the viewer's attention on a psychic level by its posture and on a visual level by its facture. Inexorably the torso leads the viewer to the head, which curves toward the viewer with sculptural force; here, it would seem that all the evocative, illusionistic power of realistic painting as Giacometti knew it has imploded. The conventional notion that the successful resolution of a painting lies in the adhesion of its forms to a coherent whole that presents another, clarified reality is here refuted. The genesis of the work takes place openly before the eyes of the viewer.

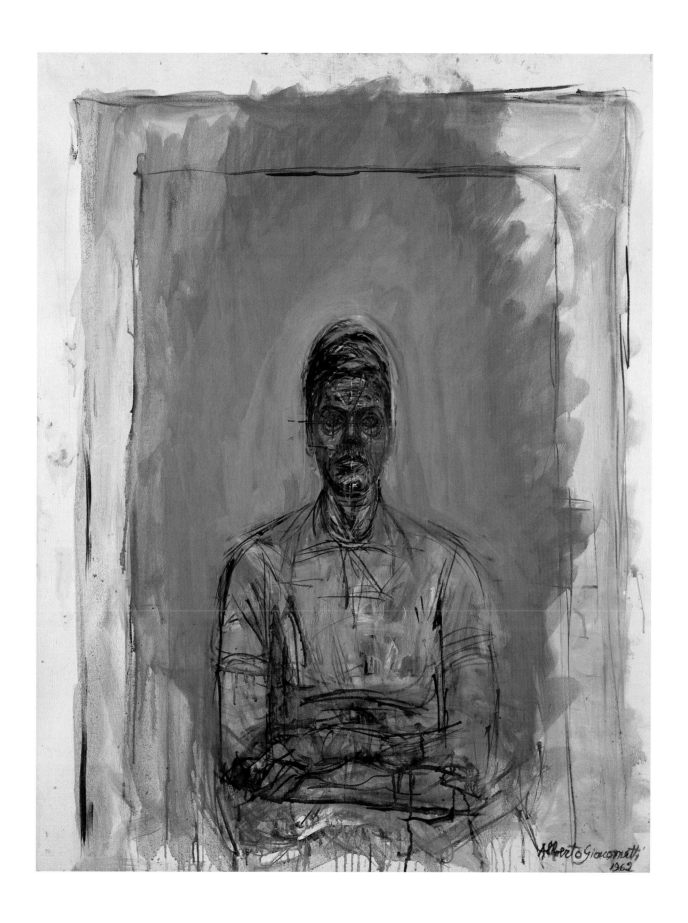

181. Caroline. 1962

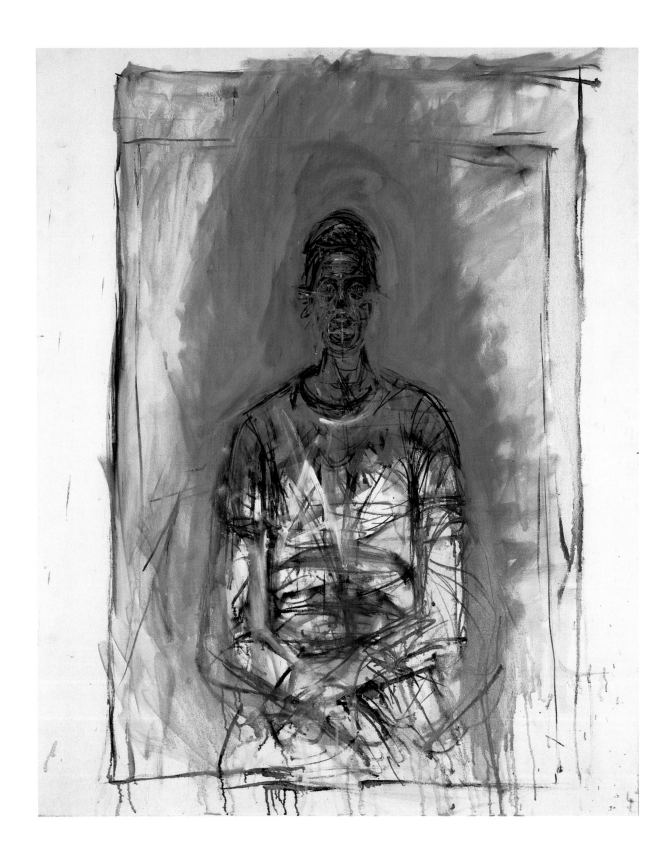

182. Caroline II. 1962

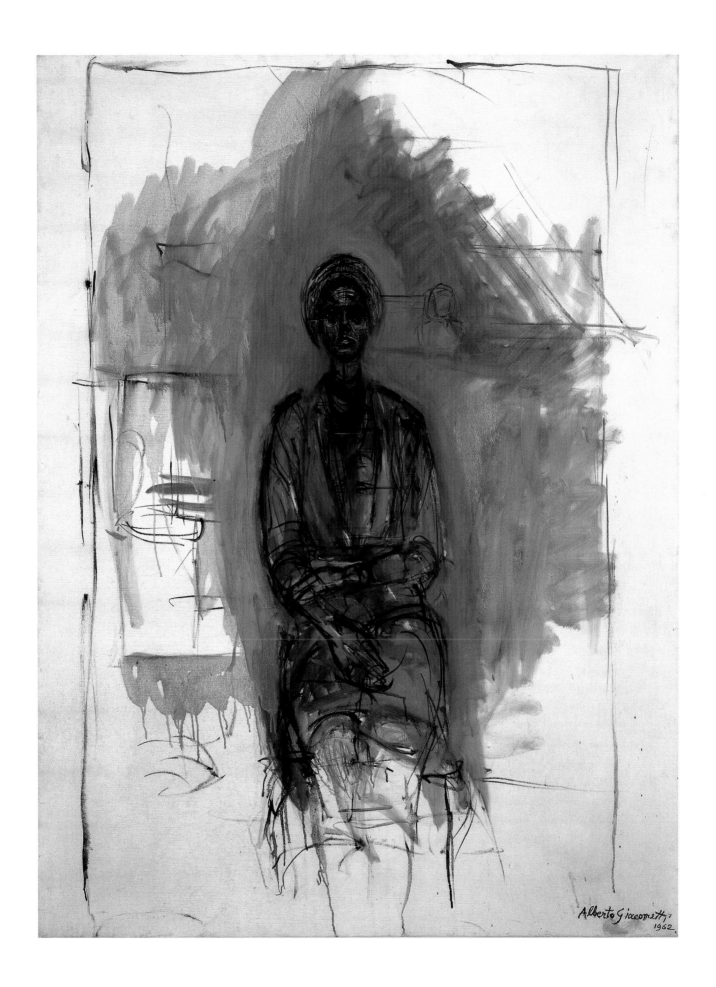

183. Caroline. 1962

The Final Years

Giacometti aged prematurely. A manic worker, never without a cigarette, he found it harder than ever to tear himself away from his creative work after the difficulties with Yanaihara. After Annette had modeled for him during the day, Caroline would come in the evening and sit before the easel until midnight; then after a break in the bars of Montparnasse, Giacometti would return to the studio and go on working until morning. Early the next day Diego would look into the studio, but it was increasingly seldom that he found a finished sculpture to cast, while the demand for the furniture he himself was designing grew steadily. In these years he only rarely sat as a model, but his features still define the heads made from memory. He disliked Caroline, and his friendship with Annette had been clouded. There were terrible scenes between the two women.

Giacometti's health was becoming a matter of concern; a physician from Grisons persuaded him to have a thorough medical examination. On February 6, 1963, he underwent stomach surgery. As soon as Giacometti was fit to travel again, he went to Stampa to convalesce. He stayed for some time because his ninety-two-year-old mother was also ailing (she died in January 1964). In contrast to Paris and his hectic life there, at Stampa everything was as it had been in his youth. His mother read or sewed; Alberto sat opposite her and drew her. He still felt too weak for anything else. He captured her likeness from several angles.[178] A series of lithographs shows his mother, the rooms, and the landscape in Stampa (a counterpart to the series *Paris sans fin*).[179]

Giacometti was at last one of the most famous living artists. In 1962 he was awarded the Grand Prize for Sculpture at the Venice Biennale. Honors were bestowed on him from all sides. Comprehensive retrospectives of his work were mounted in major museums: 1962 in the Kunsthaus Zürich, 1965 in the Tate Gallery and The Museum of Modern Art. His sculptures had a central position in the Fondation Maeght, which his Paris art dealer opened in Saint-Paul-de-Vence in 1964. Through the efforts of the Basel art dealer Ernst Beyeler, and following wide-ranging public discussions, the most important collection of his works formed the basis of the Alberto Giacometti Foundation in Zürich.[180] Giacometti began traveling a great deal, repeatedly to London, to the south of France, and in October 1965 to New York and Copenhagen. In December, in a state of complete exhaustion, he returned to the Cantonal

Hospital in Chur for a postoperative check-up; although the cancer was not in evidence, his general state of health had visibly declined: on January 11 he died of heart failure.

Giacometti had become a legend, known far beyond the narrow confines of the followers of avant-garde art. Untouched by the honors and riches that came his way, he clung to his meager lifestyle. He continued to live in his makeshift home in the rue Hippolyte-Maindron, where he pursued his labors in his shabby studio, striving to capture the essence of the human presence; he continued to go to the corner café, to eat hard boiled eggs, and talk to anyone. His appearance, his unruly hair and weather-beaten features, his idiosyncratic language reminded Parisians of a shepherd from the mountains region or a Cynic philosopher of antiquity. In their minds, his unforgettable sculptures—shrouded in the mists of contemporary Existentialism—were of a piece with their creator. Giacometti himself became the Man Walking in the Rain in the famous photograph by Henri Cartier-Bresson.[181] More than a little of this may be accounted for by Giacometti's own self-stylization in the numerous interviews he gave, which elucidated central aspects of his art but which also alluded to his failures, his modesty, and his quest for truth.[182]

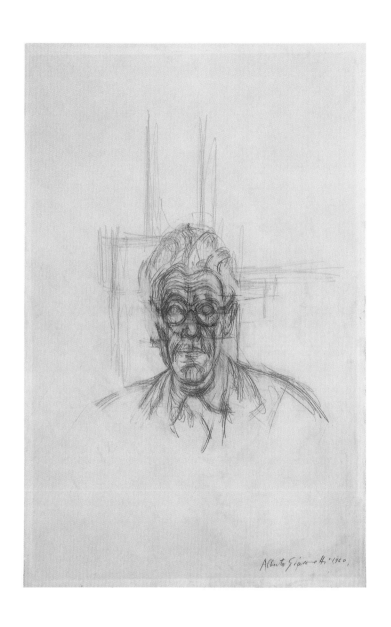

184. Self-Portrait. 1960

185. The Mother, Reading (frontal view). 1963 / **186.** The Mother, Reading (in profile). 1963

187. Interior at Stampa. 1959 / **188.** Ceiling Lamp. 1963

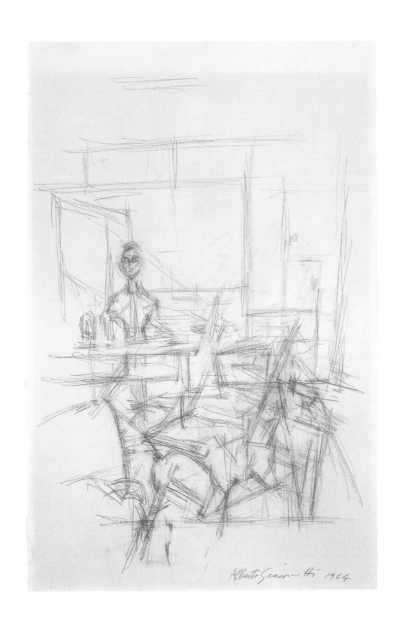

189. The Studio at Stampa. 1964

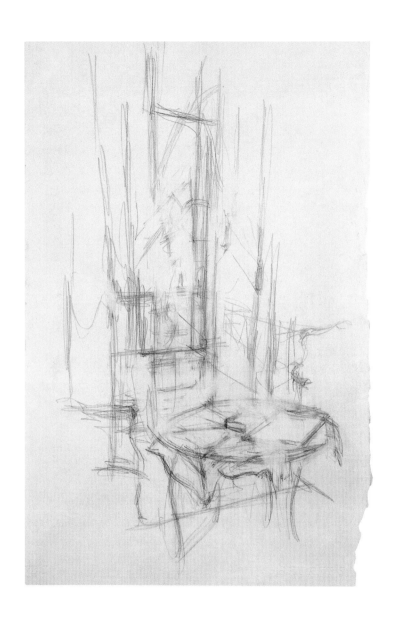

190. Hotel Room III. c. 1963

Last Works

Until the very end Giacometti kept the issues of *Documents* that Bataille had published in 1929–30, which included the first article devoted to his work. Written by Leiris, it had initially established his reputation as an artist. This was also where he could read the already much-quoted article by Carl Einstein who identified the origins of art in the will to overcome death. His dying mother, the ominous tensions among those closest to him, the tumult of outward success, the signs of his own impending death—all these both magnified the old contradictions and heightened his will to forcibly reconcile oppositions in his works. While the evocation of a living human presence reached its last highpoint in the portraits of Caroline (plates 181, 182, 183), the visionary face emerging from the inner darkness in *Large Black Head* (plate 191) achieves a singular, monumental form. After the interruption caused by Giacometti's illness and operation, Caroline became noticeably less radiant; somber thoughts pass over her features.[183] In two of the last paintings Giacometti attempted to combine the two major themes from the past: the nude and the head. Directly above a bust he painted a seemingly floating female figure, both figurations are contained within superimposed internal frames.[184] In one of these two pictures the face seems to appear through the female torso, in the other the head appears on the surface again, above the nude, its features a strange mingling of those of Diego and Caroline (plate 193).

In a number of large nudes (plate 192) the process of making a work—as opposed to its completion—was given a new emphasis. The last indications of external space had disappeared, as had, on occasion, signs of the rectangular frame. In the clothed figures, the less-important torso carried a dominating head, but in the nudes the head and body of necessity formed one whole. It is no longer the living gaze but the total human being that is the theme. The skeletal legs, the lower reaches of the body that seem to dissolve in the fluid brushwork spoke of the being of the person depicted: as much part of death as of life. The failure that is demonstrated here and which Giacometti insisted on not only alludes to the incompatibility of imagination and realization, to the fundamental impossibility of truly breathing life into a work of art, but also to the fact that the human being is forever beholden to death and that human existence is a matter of constant becoming and fading away.

Giacometti's last sitter was an old acquaintance from his Surrealist years, the photographer Elie Lotar. The busts of Lotar (plates 195, 196), especially the second, with its worn, eroded shoulders, are locked into an amorphousness that suggests Bataille's theories of base materialism and the ineluctibility of the earthbound. Yet the head on those shoulders possesses a stubborn radiance seldom seen in Giacometti's work. The gaze is directed higher, recalling a seated Egyptian figure; the whole is elevated into the sublime, where time ceases to exist, and the paradoxes of death and life, density of form and absence of form, are subsumed in the sheer crystalline view of the aesthetic presence.

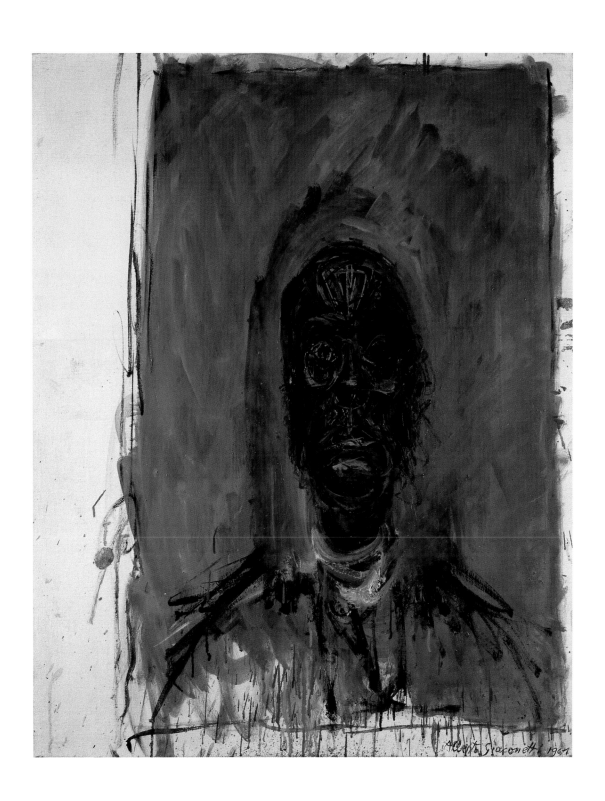

191. Large Black Head. 1961

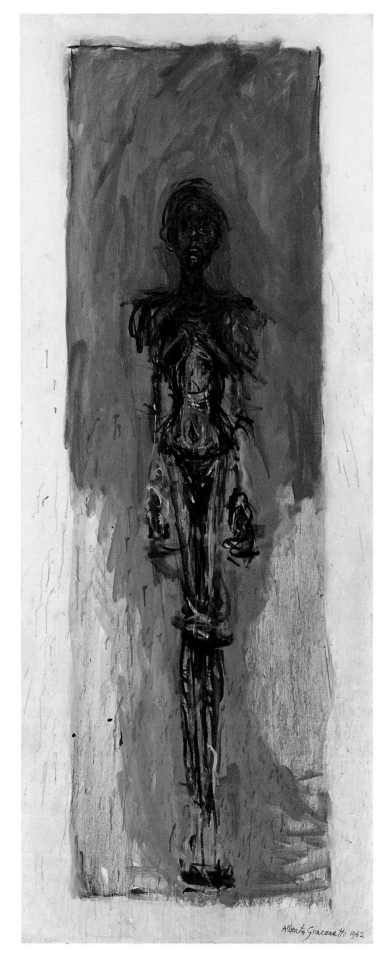

192. Large Nude. 1962

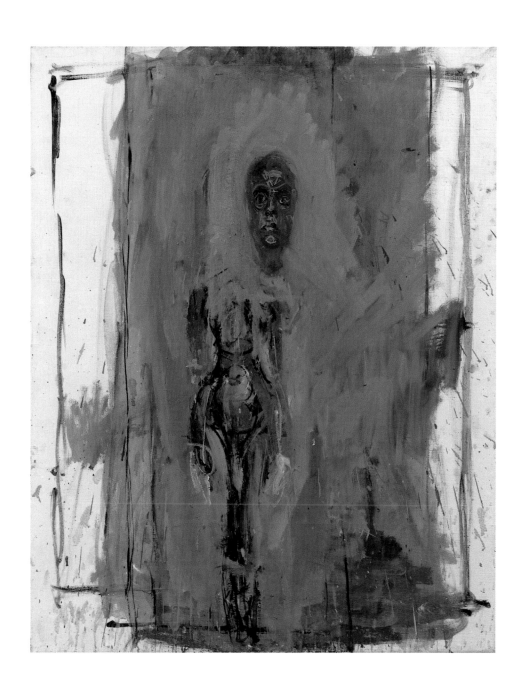

193. Woman and Head. 1965

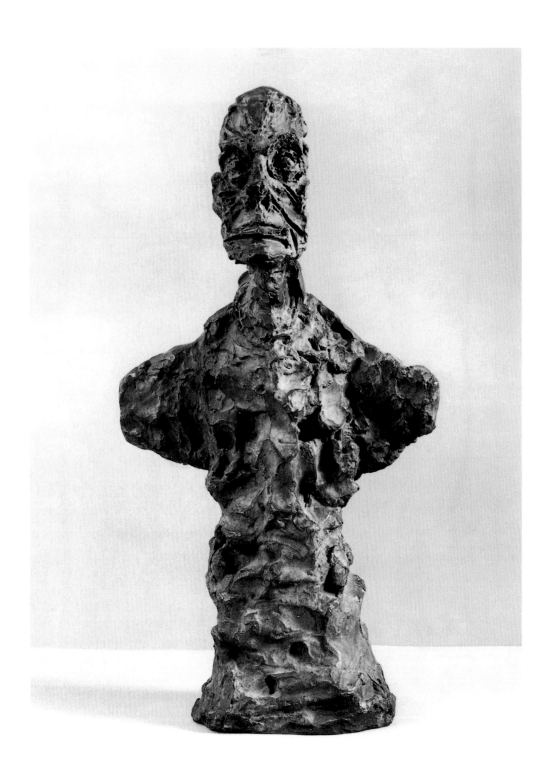

194. New York Bust I. 1965

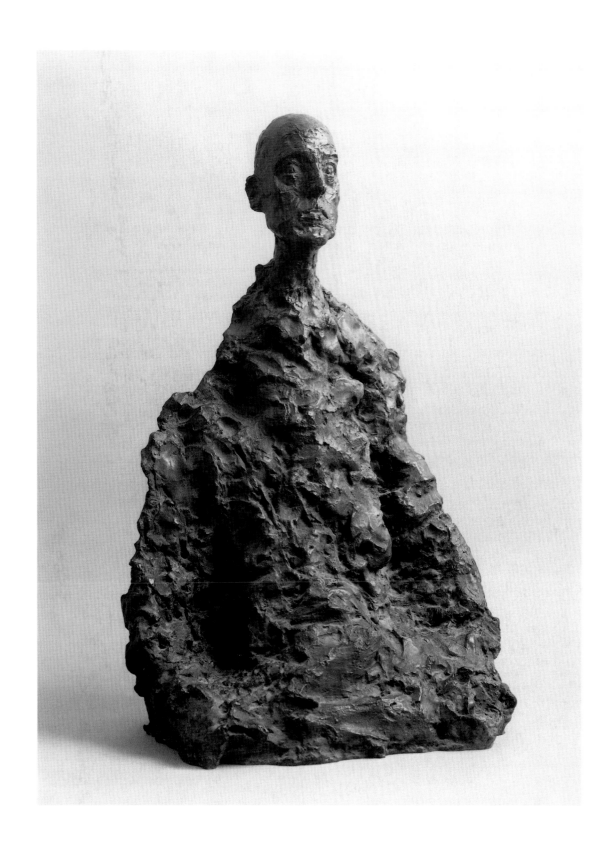

195. Lotar II. 1965

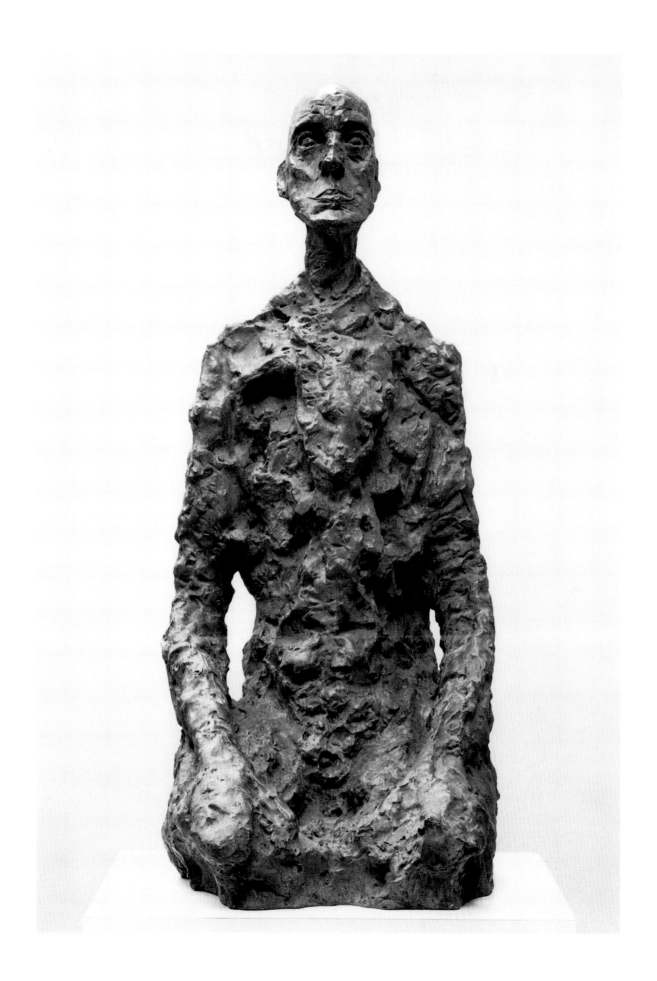

196. Lotar III. 1965

This essay has been translated from the German by Fiona Elliott and edited for the English edition. It is indebted to the groundbreaking study of Giacometti's work by Reinhold Hohl (1971) and to the major biography of his life by James Lord (1985). For the surrealist period, it refers to ideas from Bonnefoy (1991), von Maur (1987), Brenson (1974), and Krauss (1984); it also draws on Dufrène (1994), Meyer (1968), Sylvester (1994), Fletcher (1998), and Dupin (1962). For the period 1925–34, facts are largely based on Casimiro Di Crescenzo (1994), Brenson, and the catalogue overseen by Agnès de la Beaumelle at the Musée national d'art moderne (1999). These and other sources appear in the following notes and in full in the Selected Bibliography. Sources for individual works are cited in the Checklist of the Exhibition.

I.

1. Pietro Bellasi attempts to make a fruitful connection between landscape and his interpretation of Giacometti's work; see Pietro Bellasi, "Il sogno che urla e comanda: Metafore di una valle delle Alpi," in *I Giacometti: La Valle, il mondo* (Milan: Fondazione Antonio Mazzotta, 2000): 15–44.

2. Not in 1903; see James Lord, *Alberto Giacometti: A Biography* (New York: Farrar, Straus, Giroux, 1985): 8.

3. For more on portraits of Annetta by Giovanni and Alberto, see Christian Klemm, *La Mamma a Stampa: Annetta—gesehen von Giovanni und Alberto Giacometti* (Zürich: Kunsthaus, 1990). Yves Bonnefoy bases his ideas of Alberto's psyche on the hypothesis of an overly close relationship between mother and son. The problematic nature of such constructs is evident in his questionable assessment of Annetta's influence on Alberto's art; see Yves Bonnefoy, *Alberto Giacometti: Biographie d'une oeuvre* (Paris: Flammarion, 1991).

4. See Dieter Schwarz with Paul Müller and Viola Maria Radlach-Pries, *Giovanni Giacometti 1868–1933.* Vol. 1: *Leben und Werk* (Zürich: 1996); Vol. 2: *Werkkatalog der Gemälde* (Zürich: 1997).

5. See Alberto Giacometti, "Le Rêve, le sphinx et la mort de T." and "Mai 1920," in *Écrits / Alberto Giacometti,* ed. Michel Leiris and Jacques Dupin (Paris: Hermann, 1990): 27–35, 71–73.

6. *Écrits* (1990): 38; Reinhold Hohl, *Alberto Giacometti* (Stuttgart: Hatje, 1971; English edition 1972): 77, on "crises": 191 f.; Bonnefoy, *Biographie* (1991): 101.

7. For more on this period, see Hohl, *Alberto Giacometti* (1971): 77, on linguistic assimilation: 78; Casimiro Di Crescenzo, "Alberto Giacometti: Early Works in Paris, 1922-1930," in *Alberto Giacometti* (New York: Yoshii Gallery, 1994).

8. Otto Charles Bänninger's *Head of Alberto* is in the Giacometti Foundation; see Christian Klemm, *Die Sammlung der Alberto Giacometti-Siftung* (Zürich: Zürcher Kunstgesellschaft, 1990): 182. Giacometti's close contact with Bänninger and his wife, Germaine Richier, has been confirmed by Bruno Giacometti to the author. For more on Richier's postwar art, see Angela Lammert, ed., *Raum und Körper in den Künsten der Nachkriegszeit* (Amsterdam: 1998). The strangely flat, caricature-like head that Giacometti made of Flora was first illustrated in *Alberto Giacometti* (Basel: Galerie Beyeler, 1990): no. 4; the connection was identified and described in Lord, *Biography* (1985): 87 ff.

9. Later played down, if anything, by Giacometti, in *Écrits* (1990): 271, the relevant details have so far been subjected to no more than preliminary examination. For more on their fundamental affinity, see Hohl, *Alberto Giacometti* (1971): 24, 29; Thierry Dufrène, *Alberto Giacometti: Les Dimensions de la réalité* (Geneva: Albert Skira, 1994): 17 f.; and Casimiro Di Crescenzo and Simone Soldini, eds. *Alberto Giacometti: Dialoghi con l'arte* (Mendrisio: Museo d'arte Mendrisio, 2000): 65. In a letter to his parents of December 20, 1923, Alberto describes a lesson; see Klemm, *Sammlung* (1990): 38.

10. The sketchbooks, some of which have only recently come into the possession of the Giacometti Foundation as a gift from Bruno Giacometti (although most are still in the Giacometti Estate in Paris), will provide a more detailed picture of the artist's development from 1920 to 1927; see *Zürcher Künstgesellschaft: Jahresbericht 2000* (Zürich: Kunsthaus, 2000).

11. Already mentioned in a letter to Lucas Lichtenhan of May 29, 1918; see Klemm, *La Mamma* (1990): 95.

12. *Écrits* (1990): 245 f. The painting of *The Skull* also dates to winter 1923–24; it was formerly owned by Jacques Lacan; see Jacques Dupin, *Alberto Giacometti* (Paris: Maeght Editeur, 1962): 96, and Bonnefoy, *Biographie* (1991): 112.

II.

13. An important source of information on these was the journal *Cahiers d'art,* founded by Christian Zervos in 1926; see Dufrène, *Dimensions* (1994): 29 f.

14. Karin von Maur has provided the clearest overview; see Karin von Maur, "Giacometti und die Pariser Avantgarde bis 1935," in *Alberto Giacometti* (Berlin: Nationalgalerie, 1987). This period is described in most depth and with new information in Di Crescenzo, "Early Works in Paris" (1994).

15. Dufrène, *Dimensions* (1994): 27 f. For more on the preparatory drawings, see Agnès de la Beaumelle, ed., *Alberto Giacometti: Le Dessin à l'oeuvre* (Paris: Musée national d'art moderne, Centre Georges Pompidou and Gallimard, 2001): no. 32 f.

16. First illustrated in Beyeler, *Giacometti* (1990): no. 2. The plaster, in the Estate of Annette Giacometti, was previously owned by Diego. A cast, 26³/₁₆ × 17¹⁵/₁₆ × 15³/₄″ (66.5 × 45.5 × 40 cm), is in Zürich (fig. 1); see Christian Klemm, "Überraschendes von Alberto Giacometti," *Zürcher Kunstgesellschaft: Jahresbericht 1991* (Zürich: Kunsthaus, 1991).

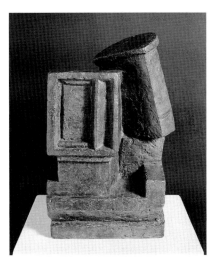

1. *Cubist Composition: Two Heads*

17. Giacometti did not have a cast made of a similar sculpture; see illus. in Dupin, *Giacometti* (1962): 194; Ernst Scheidegger, *Spuren einer Freundschaft: Alberto Giacometti* (Zürich: Ernst Scheidegger, 1990): 26 f.

18. Giacometti noted these principles in his first letter to Pierre Matisse: "Mais tout ceci alternait, se contredisait et continuait par contraste. Désir aussi de trouver une solution entre les choses pleines et calmes et aiguës et violentes"; see *Écrits* (1990): 38–42.

19. Di Crescenzo has conducted research providing new, accurate details; he rejects the interpretations by Rosalind Krauss, putting considerable emphasis on Bataille's ideas, who accuses Giacometti of pursuing a decorative "art nègre"; see Di Crescenzo, "Early Works in Paris" (1994): 46–52; and Rosalind Krauss, "Giacometti," in William Rubin, ed., *Primitivism in 20th Century Art* (New York: The Museum of Modern Art, 1984): vol. 2, 502–533. For inspiration from prehistoric times, see Stephanie Poley, "Alberto Giacomettis Umsetzung archaischer Gestaltungsformen in seinem Werk zwischen 1925 und 1935," *Jahrbuch der Hamburger Kunstsammlungen* 22 (1977): 175–186; on rock drawings in the Bregaglia valley, see Dufrène, *Dimensions* (1994): 31; see also Urs Schwyler, *Schalen-und Zeichensteine in der Schweiz* (Basel: 1992).

20. Di Crescenzo rightly comments that what may easily seem banal in the present liberal sexual climate would have been perceived very differently in 1926, although the formal rigor of sexual symbols

would, for that very reason, hardly have seemed "provocative"; see Di Crescenzo, "Early Works in Paris" (1994): 48 ff.

21. In the large female figures with hands on their upper thighs, Giacometti often evokes a concave saucerlike shape in the pelvic area. In 1954, in a portrait drawing of James Lord, he placed the sitter between an early female figure and a late one (plate 153), thus once and for all making this connection clear.

22. Sketched in a letter to Matisse; see *Écrits* (1990): 39, 45; see fig. p. 58.

23. Marble, 14³/₈″ (36.5 cm) high, first published in Sotheby's sale catalogue, New York, November 8, 1995, and acquired by the Kunstmuseum Basel in 1999 (fig. 2).

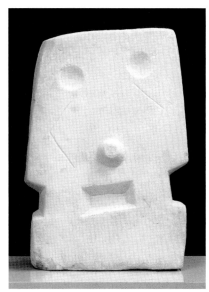

2. *Man*

24. The plaster was in Maloja; see Scheidegger, *Spuren einer Freundschaft* (1990): 26. The usual suggestion that this figure derives from Congolese crouching figures—with a similar, somewhat unusual posture—is not convincing, even less so the interpretation of these as "grave steles for childless, unmarried men," which Giacometti is supposed to have taken over from Leiris; but he only met Leiris two years later.

25. These are the *Self-Portrait* of 1921 (plate 6) and the self-portrait on a "naïve" painting for his parents' silver wedding anniversary in 1925; see Klemm, *La Mamma a Stampa* (1990): illus. 122 f.; Bonnefoy, *Biographie* (1991): illus. 63. A tendency to prettify self-portraits is evident if one compares the drawn self-portraits of 1918 (plates 2, 4) with pictures that his father made of him around the same time.

26. He had already responded to this in a granite head of 1925; see Scheidegger, *Spuren einer Freundschaft* (1990): 110.

27. See *Alberto Giacometti* (Berlin: Nationalgalerie;

Munich: Prestel, 1987): no. 21 (plaster), no. 22 (granite). On the relationship between Alberto and Giovanni, see Schwarz, *Leben und Werk* (1996): 178; for the exhibition of Giovanni's paintings of September 22, 1927, Galerie Aktuaryus, Zürich, which included sculpted heads by Alberto, see 184. The order in which the sculptures were made is not documented; the dates are also only partially confirmed.

28. The *Head of the Artist's Mother* has left its mark on the roughly flattened *Head of Flora Mayo*; see Beyeler, *Giacometti* (1990): no. 4.

29. Interview with Charbonnier, *Écrits* (1990): 243 ff.: the preliminary stage referred to here, which did not satisfy Giacometti, may possibly be the *Man* which was never cast, and which was reduced to a general outline and five indentations (plaster); see *Alberto Giacometti: La Collection du Centre Georges Pompidou, Musée national d'art moderne* (Paris: Éditions du Centre Pompidou et Réunion des Musées Nationaux, 1999): no. 5. Presumably, there is also an echo in the *Gazing Head* of Hodler's concept of "parallelism," with its emphasis on the expressive qualities of the two basic directions.

30. For the derivation and the model-like preliminary stage, see Klemm, *Sammlung* (1990): no. 13.

31. Initially, as in the little Men, where the figure and the sculpture are identical, with "legs": an example is in the Hirshhorn Museum and Sculpture Garden, Smithsonian Institution, Washington, D.C. A further Woman hides the *Spoon Woman* behind a diaphanous membrane (plaster, The Museum of Modern Art, New York; bronze, Kunsthaus Zürich); see Klemm, *Sammlung* (1990): no. 18. See also the figure in attitudes of dance, in ibid., no. 19; *Giacometti: La Collection* (1999): no. 6 f. The multiplication of the type, in conjunction with decreasing stringency, soon started to disturb Giacometti, who for the first time was faced with a descent into artist-craftsmanlike object production; see Reinhold Hohl, ed., *Giacometti: A Biography in Pictures* (Ostfildern-Ruit: G. Hatje, 1998): 61, 80.

32. Illustrations of the precursors can be found in von Maur, "Pariser Avantgarde" (1987): 58 f.

III.

33. Presumably this is *Man*; see *Alberto Giacometti: La Collection* (1999): no. 5.

34. The Surrealist work was first structured by Hohl, *Alberto Giacometti* (1971); besides factual detail and original interpretations, Michael Brenson, "The Early Work of Alberto Giacometti: 1925–1935," Ph.D. diss. (Baltimore: Johns Hopkins University, 1974), also presented a first attempt at a catalogue of works from 1925 to 1935, which will be superseded by the forthcoming catalogue by Casimiro Di Crescenzo. Special mention should also be made of the work of Jean Clair, *Le Nez de*

Giacometti (Paris: Gallimard, 1992); Georges Didi-Huberman, *Le Cube et le visage* (Paris: Éditions Macula, 1993); Krauss, "Giacometti" (1984), and idem, "Sept notes concernant le contexte de 'Boule suspendue,'" in *Alberto Giacometti: Sculptures, Peintures, Dessins* (Paris: Musée d'art moderne de la ville de Paris, 1991).

35. Brenson, "Early Work" (1974): 70, n. 30 (according to information from Masson). Carl Einstein should be recognized as the actual discoverer, as letters in the Estate of Michel Leiris confirm; see Hohl, *Biography in Pictures* (1998): 60.

36. As cited in Werner Haftmann, *Malerei im 20. Jahrhundert,* 4th ed. (Munich: 1965): 218.

37. A sketch of the sculpture and a copy of the Venus of Laussel hints at the move into the third dimension; see Luigi Carluccio, *Alberto Giacometti: Le copie del passato* (Turin: 1967): illus. 2.

38. Lost, recorded in a photograph by Marc Vaux (fig. 3); see Dupin, *Giacometti* (1962): 204; *Giacometti: La Collection* (1999): 95.

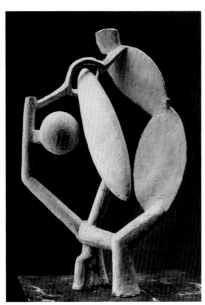

3. *Woman, Head, Tree*

39. On the Cages, see particularly Siegfried Salzmann, "Käfig und Kasten im Werk von Alberto Giacometti," in *Alberto Giacometti: Plastiken, Gemälde, Zeichnungen* (Duisburg: Wilhelm-Lehmbruck Museum, 1977), who makes special reference to Duchamp and Ernst; see also Dufrêne, *Dimensions* (1994): 55 f. An inspiration for the concept no doubt came from the Surrealists' fascination with female praying mantises, kept in cages, who destroy the male during extended copulation.

40. On Bataille's affection for Giacometti and also for an illuminating critique of Bataille with regard to Bonnefoy's interpretation of Giacometti, see Bonnefoy, *Biographie* (1991): 169, 189.

41. Yves Bonnefoy, "Giacometti: Le Problème des deux époques," *Connaissance des Arts,* no. 478 (December 1991): 60–77.

42. This appeared in *Le Surréalisme au service de la révolution* (December 1931): 16–17 f.; see *Écrits* (1990): 2 f.

43. Bataille's influence is particularly emphasized by Krauss, "Giacometti" (1984). Bonnefoy, *Biographie* (1991): 169 ff., criticizes Bataille's position regarding Giacometti. Of particular interest to Giacometti may have been Bataille's article on Celtic coins; see Georges Bataille, "Le Cheval académique," *Documents* 1 (April 1929): 27–31.

44. On Ipoustegui, see Angelica Zander Rudenstine, *The Peggy Guggenheim Collection, Venice: The Solomon R. Guggenheim Foundation* (New York: 1985): 329 f. Despite the "direct carving" movement, in sculpture it was still the norm to have works executed by *practiciens* (specialists).

45. See Hohl, *Alberto Giacometti* (1971): 22, for the various preliminary stages: a Dada object, not recorded visually, made by Augusto Giacometti in 1916; and for experiments by Russian Constructivists.

46. For numerous ambivalences see Krauss, "Giacometti" (1984): 512 f., and idem, "Sept notes" (1991), who perhaps makes too much of the sexual transgressions.

47. In 1929 the Abstraction-Création group was founded in Paris; its members, unlike the Surrealists, wanted to pursue the formal, geometric-abstract avant-garde.

48. The main version, made in iron by Bastianelli, reproduced in *Le Surréalisme au service de la révolution,* no. 6 (1933), has been lost; the painted plaster model, formerly owned by Diego, came up for auction at Sotheby's in London, July 2, 1975 (no. 100), and was acquired by the Tate Gallery. For an interpretation, see, among others, Krauss, "Giacometti" (1984): 512. André Breton repeatedly, and erroneously, presented *Suspended Ball* under the title *L'Heure des Traces;* see Brenson, "Early Work" (1974): 235.

49. See Dalí's article in *Le Surréalisme au service de la révolution* (December 1931): 16–17 f. Breton acquired the wood version; it became the centerpiece of his collection of exotic and Surrealist "fetishes," and he showed it at numerous exhibitions of Surrealist work.

50. For "visual models," see Hohl, *Alberto Giacometti* (1971): 81. Krauss suggests a connection to Luquet's "intellectual realism" and regards the move toward the horizontal, whereby a sculpture becomes the base, as Giacometti's most important innovation; see Krauss, "Giacometti" (1984): 514, 521.

51. This sculpture, exhibited for the first time in Zürich, is well documented in Giacometti's correspondence with the Vicomte; Giacometti always referred to it as a "statue." It was scarcely taken into account before Brenson, "Early Work" (1974), and was published with a number of photographs in

Friedrich Teja Bach, "Giacomettis 'Grande Figure Abstraite' und seine Platz-Projekte," *Pantheon* 38, no. 3 (July–September 1980): 269-280.

52. Placed in such a way that they still deeply impressed Max Ernst in 1935; documented in only one photograph, first published in *Minotaure,* nos. 3–4 (December 1933): 40.

53. Bach, "Grande Figure Abstraite" (1980), goes into more detail on this, and sees this figure as part of the sequence of large female figures that dominated sculpture in the early 20th century.

54. In his extensive analysis, Brenson, "Early Works" (1974), sees one side as male, the other as female, and the figuration as a whole as preadamite.

55. Hohl, "Odysseus und Kalypso. Der Mythus der existentiellen Impotenz bei Arnold Böcklin und Alberto Giacometti," in *Arnold Böcklin, 1827–1901* (Basel: Kunstmuseum, 1977), interprets this in psychological, ontological terms as frustration and impotence.

56. On its first publication in *Cahiers d'art* (1932), the date was given as 1930–31; the date 1931 presumably applies to the wood version (plate 43). In a schematic sketch, *Progetti per cose grandi all'aperto,* ink on paper, 4¾ x 4⅛" (12 x 10.4 cm), Collection Eberhand W. Kornfeld, Bern (fig. 4), Giacometti clarified his ideas on the relationship of the viewer to the large, realized sculptures. The matchstick men, in an alert, latently active posture, are either identified with or are confronted by elements in the projects; see Bach, "Grande Figure Abstraite" (1980). Giacometti realized the individual elements of the *Model for a Square* on a larger scale, but only the cone has survived; see *Giacometti: La Collection* (1999): no. 19.

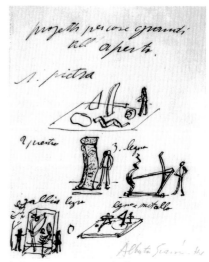

4. *Progetti per cose grandi all'aperto*

57. This is the view put forward by Hohl, "Odysseus und Kalypso" (1977), who even sees the realized large statue as a synthesis of the more important elements of the *Model for a Square.*

58. See the schematic drawing in Bach, "Grande

Figure Abstraite" (1980) and the studio drawing (plate 52) in which the *Project for a Passageway* is standing upright on the left.

59. Note also Max Ernst's *Die Anatomie als Braut,* which provides a thematic parallel to Giacometti's leaning to open plastic forms and at the same time also serves his sexual obsessions. The surprising, forward-looking quality of this piece comes from the rendition of the picture as an abstract sculpture with a reified character: pictures of African villages merge with childhood experiences of space and widely used bodily metaphors, and result in the concept of an architectural model. The detail of the piece is influenced by Aragon's psychological slant on a house passage in his *Paysan de Paris* and by the search for ways of portraying movement; in concrete terms it concerns the "rites of passage" known from ethnographic studies and the notion of the journey of life.

60. *The Passage from Virgin to Bride,* 1912, The Museum of Modern Art, New York. For a detailed account, see Antje von Graevenitz, "De bedreiging van het oog: Obsessionele zinnebeelden van Giacometti," *Archis,* no. 3 (1986).

61. Illustrated immediately after the *Suspended Ball* in *Le Surréalisme au service de la révolution,* no. 3 (December 1931).

62. Noticeably accentuated in the drawing made of the finished piece (in Basel); on this, see Jean Clair, "Alberto Giacometti: La pointe à l'oeil," *Cahiers du Musée national d'art moderne,* no. 11 (1983): 62–99.

63. This interpretation of *Caress (Despite Hands)* is supported by the original inscription on *Landscape—Reclining Head*: "Si la vie continue." A fine line passes across the three raised shapes, marking out the course of continuity, although it is questioned by the grave behind the pregnant figure and by the conditional form of the inscription. The individual life-journey of *Project for a Passageway* is extended here to take in the span from one generation to the next. Later (after the death of Ottilia in 1937?) Giacometti wrote, "Mais les ponts sont pourris," above the text.

64. *Minotaure,* nos. 3–4 (December 1933): 46; *Écrits* (1990): 17 f.

65. Hohl, *Alberto Giacometti* (1971): 84; in addition, Hohl refers to pictures by André Lurçat (illus. p. 294), which draw inspiration from the same source: Böcklin, particularly for his *Isle of the Dead,* which was one of the most important reference points for the Surrealists; see *Arnold Böcklin— Giorgio de Chirico— Max Ernst: Eine Reise ins Ungewisse* (Zürich: Kunsthaus, 1998).

66. *Labyrinthe,* nos. 22–23 (1946): 12 f.; *Écrits* (1990): 27–35.

67. See Hohl, *Alberto Giacometti* (1971): 188.

68. For more on this group of works and on connections to Antonin Artaud's "Theater of Cruelty," see

Bonnefoy, *Biographie* (1991): 178 ff.; for more on *Woman with Her Throat Cut,* see *Giacometti: La Collection* (1999): no. 22 f., which illustrates the preliminary stages and preparatory drawings. The relief of David-Weill has been lost, as has a more decorative preliminary stage for Georges-Henri Rivière.

69. The sculpture by Lipchitz was illustrated in *Documents,* no. 7 (1929): 39; Giacometti's sculpture, which has not survived, was illustrated in *Cahiers d'art* (1932): 239. In connection with this, Zervos noted that Giacometti, still unsatisfied, wanted to exclude everything that conveyed "un air d'artifice"; instead, he wanted to create a "caractère d'enigme." This striving for the enigmatic and perplexing was notable among the ideas that de Chirico adopted from the Surrealists; see *Écrits* (1990): 12.

70. *Écrits* (1990): 7–9.

71. See Casimiro Di Crescenzo, "On ne joue plus, 1932, di Alberto Giacometti," *Venezia Arti,* no. 6 (1992): 134–138.

72. See Clair, "La pointe à l'oeil" (1983), and idem, *Le Nez de Giacometti* (1992); Bataille's novel of 1926; and the article "Oeil" in *Documents,* no. 4 (1929): 215 ff.

73. Aragon withdrew in 1931, and during 1932 Giacometti did not go to meetings for a time; see Bonnefoy, *Biographie* (1991): 234 f. The designs for caricatures, only some of which were used, are now in Paris; see *Giacometti: La Collection* (1999): nos. 32–36, and Casimiro Di Crescenzo, "Giacometti: Künstler und Revolutionär," in Toni Stooss, Patrick Elliott, and Christoph Doswald, eds., *Alberto Giacometti: 1901–1966* (Vienna: Kunsthalle, 1996).

74. See Léopold Diego Sanchez, *Jean-Michel Frank, Adolphe Chanaux* (Paris: 1980); *Alberto Giacometti: Retour à la figuration, 1934–1947* (Geneva: Musée Rath, 1986): 31 ff.; and *Giacometti: La Collection* (1999): no. 37–45.

75. *Exposition surréaliste,* Galerie Pierre Colle, Paris, May 1933. This was bought by the Vicomte de Noailles, placed decoratively at the end of a corridor, and donated in 1951 to the Musée national d'art moderne; see *Giacometti: La Collection* (1999): no. 25.

76. The connection to Lautréamont is seen explicitly in a vignette; see *Giacometti: La Collection* (1999): no. 24. The close connection to a fireplace design for Frank is shown in Brenson, "Early Work" (1974): 173. The first extended interpretation, taking an "anti-modernist" view, is in Gérard Regnier, "Orangerie des Tuileries: Alberto Giacometti," *La Revue du Louvre et des Musées de France,* 19, nos. 4–5 (1969): 287–296. Bonnefoy also regards this piece primarily as an ironic response to the Lautréamont source; see Bonnefoy, *Biographie* (1991): 220 f. Hohl, *Alberto Giacometti* (1971): 101 f., points to Magritte's *The Difficult Passage*

and to a picture by Léger (illus. p. 294).

77. In the *Exposition surréaliste,* Galerie Pierre Colle, May 1933; see *Giacometti: La Collection* (1999): 98, and Brenson, "Early Work" (1974): 168 ff.

78. This sculpture brings out the fixed ideas of those interpreting it. In his erotic surrealist text, "Equation de l'objet trouvé," [in *Documents,* no. 1 (1934): 17–24; *L'Amour fou* (Paris: 1937): 40–57], André Breton recounts that Giacometti had trouble forming the head; they found the solution in a flea market, a face mask from World War I. It was only later that he suspected the connection to death, albeit misunderstanding it as a yearning for death. In 1955 Giacometti rejected this account; see interview with Alain Jouffroy, "Portrait d'un artiste: Giacometti," *Arts, lettres et spectacles,* no. 545 (December 1955): 9. Bonnefoy, *Biographie* (1991): 226–241, is duly critical of Breton, and from his own notion of Alberto's close relationship to his mother, arrives at an extreme interpretation: the "image archétypale qui résume sa condition" is his mother in the shape of a "madonne de l'absence," who has given him laws instead of life and who, accordingly, holds nothingness, or a death's head, instead of a child. Krauss, "Giacometti" (1984): 514–520, regards the figure as "acéphale" in the sense used by Bataille; she also views a plaster work in the artist's estate as a first, rejected version of the head.

79. Carl Einstein, "Aphorismes méthodiques," *Documents,* no. 1 (1929): 32–34; see also his article about Miró, ibid.: 263 ff., in which he defines "le vide" as "identique et contraire au néant," in short, as "l'absolu."

80. See Bonnefoy, *Biographie* (1991): 226 ff.; *Cahiers d'art* (1946): 258 (as *Étude pour un monument*); and *Alberto Giacometti: Exhibition of Sculptures, Paintings, Drawings* (New York: Pierre Matisse Gallery, 1948): 40 (as *Night*). Only the pedestal for this sculpture has survived in the artist's estate. A drawing of c. 1943 links the two sculptures; see Hohl, *Alberto Giacometti* (1971): 296, illus. 67; *Le Dessin à l'oeuvre* (2001): no.76.

81. Hohl proposes that the "composition" and the "totality of life" are a synthesis of Gauguin's *Where Do We Come from … ;* see Hohl, *Alberto Giacometti* (1971): 104.

82. Giacometti similarly removed the indications of arms from *Spoon Woman.*

83. See Brenson, "Early Works" (1974): 186.

84. Didi-Huberman has written a whole book on the numerous implications of this piece; see Georges Didi-Huberman, *Le Cube et le visage* (Paris: 1993). See also Klemm, *Sammlung* (1990): no. 32, and *Giacometti: La Collection* (1999): 29.

IV.

85. This return to figuration is, in fact, part of a broad movement that started much earlier: once

again we see a generational shift in Giacometti's work. For more on this topic in general, see the studies by Jean Clair and *Canto d'Amore: Klassizistische Moderne in Musik und bildender Kunst* (Basel: 1996); for particular reference to Giacometti, see Musée Rath, *Retour à la figuration* (1986), which deals with the subject in a strangely tangential manner; for more detail, see Bonnefoy, *Biographie* (1991): 243-285.

86. To quote the title of the monograph by Franz Meyer of 1968.

87. Seen most vividly in a bust of Isabel. It was not by chance that he called this *L'Égyptienne;* see Hohl, *Alberto Giacometti* (1971): 290, illus. 17.

88. The main section of a destroyed study of a head is shown in ibid.: 73.

89. A further self-portrait, dated 1935, is illustrated in ibid.: 88

90. Besides this marked difference from later copies, the particular formation of the nose also points to a date during this period and not, as in a later note by Giacometti, to 1942.

91. Giacometti himself spoke of this later, particularly in conversation with Parinaud; see *Écrits* (1990): 272 f.

92. Di Crescenzo puts forward the interesting suggestion that this group of drawings, on paper of the same size and color, was originally planned for an issue of *Verve;* see Di Crescenzo and Soldini, *Dialoghi con l'arte* (2000): 110. They were mostly post-dated, and only the "1937" can have been marked at the time; see Carluccio, *Le copie del passato* (1967): no. 106. For more on the copies, see ibid., with a text by Giacometti; *Écrits* (1990): 95-98; *Le Dessin à l'oeuvre* (2001): nos. 174 ff.; Reinhold Hohl and Dieter Koepplin, *Alberto Giacometti: Zeichnungen und Drückgraphik* (Tübingen: Kunsthalle, 1981): 79-88; and Di Crescenzo and Soldini, *Dialoghi con l'arte* (2000); a publication on this topic by Casimiro Di Crescenzo is in preparation.

93. According to an observation made by Valerie Fletcher, whose dissertation on the paintings ("Alberto Giacometti: The Paintings," Ph.D. diss., Columbia University, New York, 1994) will shortly be published.

94. Interview with Pierre Dumayet; see *Écrits* (1990): 281.

95. Hans Holländer, "Das Problem des Alberto Giacometti," in *Wallraf-Richartz Jahrbuch,* vol. 33 (1971): 259-284, has put this problem very clearly; Dufrène, *Dimensions* (1994), takes this as the main argument of his book. Giacometti himself, if anything, mystified this simple situation by referring to it as part of his phenomenological studies; another example of this would be the episode in his father's studio when the pears he was drawing grew ever smaller. Of particular interest in this connection is the interview with Sylvester in 1964; see *Écrits*

(1990): 288 f. Carlo Huber, *Alberto Giacometti* (Zürich/Lausanne: 1970): 5 f., makes reference to an essay that Giacometti cannot have missed, published by the renowned Basel sculptor Carl Burckhardt in 1920, "Rodin und das plastische Problem," in which the author discussed the problem of the relationship between close and distant forms.

96. In conversation with Sylvester, Diego Giacometti said that these pedestals were originally intended for larger figures and that they remained the same size, whereas the figures themselves grew ever smaller; see David Sylvester, *Looking at Giacometti* (London: Chatto & Windus, 1994): 143.

97. Letter to Matisse, [1947]; see *Écrits* (1990): 39.

98. The smallest example, the *Head of Diego,* only 3 ⅛" (8 cm) high, was the most radiant of all. See Dupin, *Giacometti* (1962): 224-230 (series of heads from this period), 231 (*Head of Diego*).

99. The exact makeup of the core can only be guessed at from small holes in the surface. As Bruno Giacometti reports, he sometimes took small packets of modeling clay from Zürich to Maloja; it would have been difficult to make large clay sculptures, particularly during the war.

100. Information from Bruno Giacometti.

V.

101. *Cahiers d'art* (1946), pp. 253-268.

102. He made a portrait of the author for Bataille's *Histoire des rats;* see Herbert C. Lust, *Giacometti: The Complete Graphics and 15 Drawings* (New York: 1970): nos. 81-83; see also sketch in Hohl, *Biography in Pictures* (1998): 125. He also modeled a bust of Diane Bataille and one of Marie-Laure de Noailles; see *Giacometti: La Collection* (1999): no. 54.

103. Casimiro Di Crescenzo in *Alberto Giacometti: Sculture, dipinti, disegni* (Milan: Palazzo Reale, 1995): nos. 28 f.; idem, "Künstler und Revolutionär" (1996): 48 ff. See also Aragon's obituary of Giacometti in *Les Lettres françaises,* no. 1114 (1966): 1; no. 1115 (1996): 16 f.; in German in Axel Matthes, ed., *Louis Aragon mit anderen: Wege zu Giacometti* (Munich: 1987): 21-31.

104. Pierre Loeb, Giacometti's first dealer in 1929-30, planned an exhibition with the artist for autumn 1946, which, however, did not come to fruition. But Giacometti made numerous drawings of Loeb, in 1946 and subsequently; see *Giacometti: La Collection* (1999): no. 49.

105. In a letter to Isabel, written in the hospital in 1938, Alberto describes his observations or visions of "threads of dust" wafting through space: these may well be the beginnings of the characteristic spatial lines, cited in Sylvester, *Looking at Giacometti* (1994): 142.

106. This group of works has been thoroughly researched in Gottlieb Leinz, "'Das Bein' von Alberto Giacometti: Erinnerungen an den Tod," *Pantheon* 55 (1997): 172-188.

107. In effect, he achieves what is known in French as *méduser,* after the petrifying properties of the gaze of Medusa. For more on this, see Clair, *Le Nez de Giacometti* (1992). The distaste for solid, dead forms—intrinsic to all sculptures—is related to this; see Sylvester, *Looking at Giacometti* (1994): 130 f.

108. These include the mannequin hand modeled for Elsa Schiaparelli, the *Caught Hand* (plate 56), and the hand on *The (Surrealist) Table* (plate 61); see Victor I. Stoichita, "Die Hand," in Matthes, *Wege Zu Giacometti* (1987).

109. See Eduard Trier, *Bildhauertheorien im 20. Jahrhundert* (Berlin: 1971): 58, in the context of his discussion of the breaking up of the sculptural block.

110. Aptly analyzed in Leinz, "Das Bein" (1997): 176 ff.

111. Such a personal piece may have seemed too trivial to execute in 1947 in view of the massive suffering inflicted by war. A further difficulty may have been the weightless style: this sculpture was scarcely possible without the plasticity that was not to return to his work until the mid-1950s.

112. Bataille put this most succinctly in his essay on the big toe (in *Documents,* no. 6 [1929]: 297-302) Severed limbs and impaled heads are among the impure things thrown into the dirt; see Georges Bataille in *Documents,* no. 6 (1929): 328-330 (with photographs by Eli Lotar made in a slaughterhouse).

113. Rodin is credited with having reintroduced individual limbs as a theme in sculpture, inspired by the torso of Belvedere; see also Alberto Giacometti, "A propos de Jacques Callot" (1945), in *Écrits* (1990): 25 f., with its reference to still lifes of parts of corpses by Goya and Géricault.

114. [*Le forme se défait, ce n'est plus que des grains qui bougent sur un vide noir et profond.*]: letter to Matisse, [1947,] in *Écrits* (1990): 39.

115. In Carl Emil von Lorck, *Nacktheit als Lebensausdruck in der bildenden Kunst* (Berlin: n.d.): 177 (Alberto Giacometti Stiftung. Zürich, GS 188); see Christian Klemm, "27 Bücher mit Zeichnungen von Alberto Giacometti," in *Zürcher Kunstgesellschaft Jahresbericht 1998* (Zürich: Kunsthaus, 1998): illus. 8.

116. Sylvester, *Looking at Giacometti* (1994): 148 f., puts forward the convincing suggestion that Giacometti took the proportions to even greater extremes as a result of having seen the aesthetic effect of the bronzes. In retrospect, it would seem that above all the first Tall Woman of 1947 was still a transitional work in this respect and in the forming of the large head.

117. For more on the principle of decay, which was already important in Surrealism and which Giacometti presumably encountered primarily in the work of Hans Arp, see Bonnefoy, *Biographie* (1991): 349 ff.

118. After a time that had seen dictatorships and war, this "negative" freedom was perceived as a positive value, as a necessary condition for self-determination, and interpreted as such in Jean Genet, "L'Atelier d'Alberto Giacometti" (Paris: 1958), among others.

119. The plaster cast in the artist's estate in Paris was first published in Beyeler, *Giacometti* (1990): no. 17 (a new bronze version), and no. 64 (a sheet of nine studies). In a letter to Matisse in autumn 1950, Giacometti mentions this version and comments, "cela devient vite insupportable"; see *Écrits* (1990): 54.

120. In Geneva Giacometti made two commissioned portraits of Mme Cole Dupont, dark drawings against a white ground, in a manner related to the "hard style" of the copies and, for the first time, with a noticeable internal frame (Musée Rath, *Retour à la figuration* [1986]: 24; Bonnefoy, *Biographie* [1991]: 262); for two portraits of Tériade of February–March 1946, colored again almost like the self-portraits and the full-length portrait of Diego from the early 1920s, see Bonnefoy, *Biographie* (1991): 362, pl. 334; *Alberto Giacometti: Sculture, dipinti, disegni* (1995): nos. 94 f.; *Le Dessin à l'oeuvre* (2001): no. 93.

121. Here and in what follows the author acknowledges his debt to the groundbreaking, as yet unpublished, study of Giacometti's paintings by Valerie Fletcher. Some of her findings may already be seen in Valerie J. Fletcher, *Alberto Giacometti: 1901–1966* (Washington, D.C.: Hirshhorn Museum and Sculpture Garden, 1988), and in idem, "Giacomettis Gemälde," in Stoss, Elliott, and Doswald, *Giacometti* (1996): 53–59.

122. Kunsthaus Zürich, on loan from the Paul Büchi-Stiftung; an earlier state of the canvas may be seen in Pierre Matisse, *Giacometti* (1948): 1, 15, 42; see also *Alberto Giacometti* (Basel: Galerie Beyeler, 1963): no. 64, and Klemm, *Jahresbericht 1991*.

123. See Steven Hooper, ed., *Robert and Lisa Sainsbury Collection* (New Haven, London, Norwich: Yale University Press, 1997): no 23.

124. Giacometti lucidly described it in an interview with Parinaud in 1962 as the "résidu d'une vision"; see *Écrits* (1990): 273.

125. For more on the postwar artistic situation, see Bernard Cesson in *L'Écriture griffée* (St. Etienne: Musée d'art moderne, 1993): 11 ff.; Sarah Wilson, "Paris Post War: In Search of the Absolute," in *Paris Post War Art and Existentialism, 1945–55* (London: Tate Gallery, 1993): 25–52; *L'art en Europe: Les Années décisives 1945–1953* (St.

Etienne, Geneva: 1987). For more on the studio as a specific theme, especially in the paintings of Francis Gruber, see "Francis Gruber," in *Paris Post War Art and Existentialism* (1993).

126. See Tobia Bezzola, "Phenomenon and Imagination," in this volume.

127. Most recently referred to by Max Reithmann in *Giacometti: La Collection* (1999): 13 ff.; see also Sylvester, *Looking at Giacometti* (1994): 139.

128. First published in *Art de France* (1961): 187–208; see *Série folio/essais* (Paris: Gallimard, 1985): 13–15.

129. The "perdre pied" Giacometti mentioned in descriptions of his accident in 1938 was also important for *The Leg*; see Leintz, "Das Bein" (1997): 176 ff.

130. Like the lost, Egyptian-style *Night* of 1946. See above, note 80, and Klemm, *Sammlung* (1990): no. 51.

131. Hohl, in *Alberto Giacometti: A Retrospective Exhibition* (New York: Solomon R. Guggenheim Museum, 1974): 26; perhaps it is his sister Ottilia, who died in childbirth.

132. A rejected version may be seen in photographs of the studio taken in 1947–48; see Scheidegger, *Spuren einer Freundschaft* (1990): 70 f. For a last attempt made for a 1951 exhibition at the Galerie Maeght, see Fletcher, *Giacometti* (1988): 130; see also *Giacometti: La Collection* (1999): no. 51.

133. As we have seen in the description of the fragment sculptures, in contrast to the situation in the early Surrealist works, the two poles merge into one in the postwar work: Giacometti's aim was no longer to create "playing boards" but confrontational sculptures.

134. See the thorough analysis and backup for the dating given by Agnès de la Beaumelle in *Giacometti: La Collection* (1999): no. 55. The earlier accepted date of 1956 refers to the cast; the date 1946, recently issued by the office of the Association Annette et Alberto Giacometti seems stylistically improbable; were that date correct one would expect to see the work in shots of the studio taken in 1947–48.

135. The style of the narrative and of the genesis of the work are still very much in the Surrealist tradition; recounted in Genet, "L'Atelier" (1958); *Alberto Giacometti: Einige Aufsätze von Professor Dr. Gotthard Jedlicka* (Zürich: 1965): 23–25; and James Lord, *A Giacometti Portrait* (New York: The Museum of Modern Art, 1965): 21. Together with *Cat* and the later destroyed *Horses*, these are more or less the last "imagined" sculptures in the "weightless" illusionistic style.

136. This painting, filled with so many familiar memories, is related in its composition to Romantic landscapes in the tradition of Caspar David Friedrich, which Giacometti certainly knew of from

the graveyard scene by Segantini, *Il dolore confortato dalla fede (Glaubenstrost)*, now in Hamburg.

137. The study with the tree behind the kitchen in Stampa may go right back to 1950: see Hooper, *Sainsbury* (1997): no. 25, but the draftsmanship here still comes very much to the fore; the painting is really more of a pen drawing.

138. See Giacometti's text from around 1952 on landscape painting in *Écrits* (1990): 202–205.

139. The only landscape with a different motif, an almost too beautiful, strangely ethereal picture with the rectangles of two white houses floating in sky blue, instantly call to mind de Staël's search for the Archimedean point between abstraction and landscape or still life; see *Alberto Giacometti: Sculptures, peintures, dessins* (Paris: Musée d'art moderne de la ville de Paris, 1991): no. 131.

140. Just once he went a step further and painted a symbolically abbreviated landscape consisting only of mountain, tree, and person; he frequently drew a man under a tree or a head in profile in front of the sun; see ibid.: nos. 130, 134.

141. See Stooss, Elliott, and Doswald, *Giacometti* (1996): no. 26 and portrait drawings of 1918, (plates 2–5); in the printed works such defining lines are the rule.

VI.

142. See *Écrits* (1990): 51 f. and 53–63 for sketches of the works with the titles and commentaries that were reproduced in the catalogue of the second Giacometti exhibition in the Pierre Matisse Gallery, New York, in November 1950.

143. This is seen even more clearly in the still life of 1949 in Zürich, which Giacometti marked as "1947" at some point after 1962; see Klemm, *Sammlung* (1990): no. 70.

144. In autumn 1950 Giacometti started painting his newer sculptures for the exhibition at the Pierre Matisse Gallery; there is another, intensely painted, *Diego* of 1950; see Stooss, Elliott, and Doswald, *Giacometti* (1996): no. 144, "2/6." In the interview with Sylvester in 1964 Giacometti talked extensively about painting sculptures, which he had already been doing in his youth and during his Surrealist period; see Sylvester, *Looking at Giacometti* (1994): 214–218.

145. According to Eberhard W. Kornfeld, Giacometti took it back to the studio after the second cast and started to rework it. The first cast, which formerly belonged to the Maeght collection, is painted; see Stooss, Elliott, and Doswald, *Giacometti* (1996): no. 195.

146. See *Alberto Giacometti: Sculptures, Peintures, Dessins* (1991): nos. 206 f.

147. See *Alberto Giacometti* (Berlin: Nationalgalerie, 1987): no. 132.

148. Hohl, *Alberto Giacometti* (1971): 144.

149. First described by Sartre in his second text

on Giacometti, written for the second exhibition in the Galerie Maeght in 1954, where paintings dominated sculptures for the first time.

150. Lord, *Portrait* (1965), with an illustration of a number of states.

151. Scheidegger, *Spuren einer Freundschaft* (1990): frontispiece. See interview with Scheidegger in Stooss, Elliott, and Doswald, *Giacometti* (1996): 375–379. Mention should also be made of Maurice Lefèbre-Foinet, who supplied his paint materials, and Nelda Negrini, an acquaintance in Stampa (both in the collection of the Giacometti Foundation), and Dr. Serafino Corbetta in Chiavenna (1961); see Di Crescenzo and Soldini, *Dialoghi con l'arte* (2000): no. 123

152. See Stooss, Elliott, and Doswald, *Giacometti* (1996): no. 213, for *Petit Monstre II* and for two of the disturbingly naturalistically painted small nudes of 1953. Due to their size and the minimally worked pedestals, these sculptures look much like studies.

153. Variants of the same approach may be seen in III, with shorter hair, and IX, with extremely large feet.

154. Note written February 18, 1963; see *Écrits* (1990): 219.

155. See summary in *Giacometti: La Collection* (1999): no. 68; plaster versions shown in Venice and Bern were heightened with color. In 1957 Maeght and Giacometti selected nine versions to be cast in bronze.

156. Alberto took this opportunity to give *Femme Leonie* (plate 96) a pedestal in the new style.

157. In his study of Giacometti's early work Brenson, "Early Works" (1974): 1 ff., undertakes a detailed comparison of *Spoon Woman* and *Woman of Venice VII*.

158. See Fletcher, "Alberto Giacometti: The Paintings" (1994): 342 ff., to whom I am also grateful in the following.

159. See, for instance, Francis Ponge or Gertrude Stein. But Giacometti also wanted the eternity of the Ancients and hence tried to integrate the splintered perspective back into his work.

160. Lord, *Portrait* (1965): 59; Hohl, *Alberto Giacometti* (1971): 174.

161. For more on the artist's relationship to the model, see Bonnefoy, *Biographie* (1991): 372 ff.

162. See ibid.: 420, on the related picture in the Solomon R. Guggenheim Museum, New York.

163. Alberto was evidently also able to control the "crisis" to a certain extent: witness the masterly picture of Thompson from the same year (plate 147).

164. Collection Klewan; Stooss, Elliott, and Doswald, *Giacometti* (1996): no. 193.

165. Kunsthaus Zürich, Inv. no. 1958/8; see Nationalgalerie, *Giacometti* (1987): no. 204.

166. This observation was made in Fletcher, "Paintings" (1994): 348. It may well be that the

memory of a similarly composed painting of 1951 played a part in the production of these two pictures; see Dupin, *Giacometti* (1962): 104, and Di Crescenzo and Soldini, *Dialoghi con l'arte* (2000): no. 118.

167. Valerie Fletcher makes this point with the necessary differentiation.

168. These facts have been reported by Lord, *Biography* (1985), and Sylvester, *Looking at Giacometti* (1994): 227–230; summarized in *Giacometti: La Collection* (1999): no. 74.

169. They were shown at the Venice Biennale in 1962; see Huber, *Giacometti* (1970): 86. They also made a great impression in the central courtyard of the Fondation Maeght in Saint-Paul-de-Vence, which opened in 1964.

170. See the comprehensive volumes with good reproductions of the drawings published by the Galerie Maeght in 1969 and Lord in 1971; the usually neglected "philological" work is taken up in Beaumelle, *Le Dessin à l'oeuvre* (2001). For more on the drawings, see Hohl, in Stooss, Elliott, and Doswald, *Giacometti* (1996): 61–69.

171. Compare the approach in Dupin, *Giacometti* (1962): 29 f.

172. Even the sculptures of Yanaihara and Caroline are isolated and, if anything, unsatisfactory attempts; he does not model his mother any more after 1927.

173. For more detail on this see Bonnefoy, *Biographie* (1991): 503 ff.; see also Gottfried Boehm, "Alberto, porträtierend," in Klemm, *La Mamma a Stampa* (1990): 132–135.

174. One is reminded here of the false doors in Egyptian burial chambers and the rectangular nimbuses in early medieval art; see Bonnefoy, *Biographie* (1991): 392 f., for his assumption of a mystical component. Frequent mention has been made of the similarity to icons. Giacometti's particular interest in Byzantine art is well known; see Hohl, in Nationalgalerie, *Giacometti* (1987): 142–144.

175. This was, in fact, Yvonne Marguerite Poiraudeau, born 1938; see Lord, *Biography* (1985).

176. It is not certain when Giacometti started to paint Caroline. Whatever the case, the exhibition at the Galerie Maeght in May 1961 included five pictures of her. A particularly memorable example is now in the possession of the Fondation Beyeler.

177. Giacometti always stressed the importance of the sitter; see the early letter to his parents of December 29, 1923, about the classes he was taking with Bourdelle; see Klemm, *Sammlung* (1990): 38..

178. There are numerous examples in Klemm, *La Mamma a Stampa* (1990).

179. A counterpart to the series *Paris sans fin,* it was started in 1959, with breaks from autumn 1962

to 1963, and finished in 1965. This appeared posthumously with a text by Giacometti; see Casimiro Di Crescenzo, "Giacometti e Tériade," in Marilena Pasquali, ed., *Alberto Giacometti: Disegni, sculture e opere grafiche* (Bologna: Museo Morandi, 1999): 31–47.

180. For more on this, see Bettina von Mayenburg-Campbell and Dagmar Hnikova, eds., *Die Sammlung der Alberto Giacometti-Stiftung* (Zürich: 1971), and Klemm, *Sammlung* (1990); Willy Rotzler, *Die Geschichte der Alberto Giacometti-Stiftung* (Bern: 1982), provides a documentation of the discussions at the time. The decisive roles of Ernst Beyeler and Hans Grether are correctly reported in *Fondation Beyeler* (Reihen: Fondation Beyeler; Munich: Prestel, 1997): 27–29.

181. For an extensive documentation of the unusually numerous and high quality photographs that show Giacometti and his world, see *Von Photographen gesehen: Alberto Giacometti* (Chur: Bündner Kunstmuseum, 1986); Scheidegger, *Spuren und Freundschaft* (1990); and Hohl, *Giacometti: A Biography in Pictures* (1998).

182. The more important of these are collected in *Écrits* (1990); the interview with Sylvester in 1964 is only reprinted in full in Sylvester, *Looking at Giacometti* (1994). "Art interests me very much, but truth interests me infinitely more": reported in James Lord, *Alberto Giacometti Drawings* (Lausanne: Paul Bianchini, 1971): 26. For more on this question, see the final section in Hohl, *Alberto Giacometti* (1971): 185 ff.

183. See the two pictures in the artist's estate, *Giacometti: Sculptures, peintures, dessins* (1991): no. 168 f.

184. These two pictures are illustrated in ibid.: no. 280 f.; in early copies the illustrations have been inadvertently confused.

This listing follows the numbering of the plates, which begin on page 45. For the sculptures, paintings, and drawings catalogued here, the following are given: title in English; title in French in brackets from 1925 on; date (original conception of the work); medium; dimensions, in inches and centimeters, height before width before depth; inscriptions or other markings; and owner or custodian of the work. This may be followed by abbreviated references on the individual work, keyed to the Selected Bibliography; and by remarks on title, dates, and alternate versions. An illustration accompanying an entry shows a version exhibited in New York that differs in medium from that illustrated in the plates or an alternate view.

1. Head of Bruno. 1919
Plaster, 14¾ × 8 1/16 × 9⁷/16"
(37.5 × 20.5 × 24 cm)
Signed and dated on base, right: "Alberto Giacometti 1919"
Alberto Giacometti-Stiftung, Zürich. GS 136

REFERENCES: Hohl 1972, p. 289, illus. no. 7; Martigny 1986, p. 137; Zürich (coll. cat.) 1990, no. 1; Vienna 1996, no. 17.

REMARKS: Signed and dated after 1919; nonetheless, the inscribed date is probably correct, as seen by comparing this plaster with a 1918 drawing in which Bruno appears to be younger (Vienna 1996, no. 11).

2. Self-Portrait. 1918
Ink on paper, 14⁹/16 × 10 1/16"
(37 × 25.5 cm)
Dated lower right: "I. 1918."
Private collection

REFERENCES: Basel 1966, no. 137; Lord 1972, no. 6; Zürich 1990, pp. 104 f.; Paris 1991, no. 4 (ref.); Vienna 1996, no. 4 (ref.); Soldini 1998, pp. 27 ff.

3. The Artist's Mother. 1918
Ink on paper, 13³/8 × 9⁷/8" (34 × 25 cm)
Dated lower right: "5 Agosto 1918"
Private collection, Switzerland

REFERENCES: Zürich 1990, pp. 104 f., no. 60; Vienna 1996, no. 5.

4. Self-Portrait. 1918
Ink on paper, 14³/8 × 9¹⁵/16"
(36.5 × 25.3 cm)
Signed lower right: "Alberto Giacometti"; dated lower left: "1918"
Öffentliche Kunstsammlung Basel, Kupferstichkabinett

REFERENCES: Basel 1966, no. 146; Tübingen 1981, [no.] Z 6 (ref.); Berlin 1987, no. 1; Zürich 1990, pp. 104 f., no. 56; Madrid 1990, no. 2 (ref.);

Bonnefoy 1991, pp. 80 ff.; Paris 1991, no. 5 (ref.); Vienna 1996, pp. 53 f., no. 10 (ref.); Paris 2001, no. 5 (ref.).

5. Portrait of the Mother. 1918
Ink on paper, 10 × 7¹³/16"
(25.4 × 19.9 cm)
Signed and dated lower right: "Alberto Giacometti, 1918"
Alberto Giacometti-Stiftung, Zürich. GS 157

REFERENCES: Hannover 1966, no. 6; Tübingen 1981, p. 32; Basel 1981, p. 32, no. A13; Berlin 1987, no. 2; Zürich 1990, pp. 104 f., no. 58; Zürich (coll. cat.) 1990, no. 105; Bonnefoy 1991, illus. p. 21; Paris 1991, no. 6 (ref.); Vienna 1996, pp. 53 f., no. 9 (ref.); Paris 2001, no. 9 (ref.).

6. Self-Portrait. 1921
Oil on canvas, 32½ × 28³/8"
(82.5 × 72 cm)
Signed lower right: "Alberto Giacometti"
Alberto Giacometti-Stiftung, Zürich. GS 62

REFERENCES: Basel 1963, no. 62; Huber 1970, p. 98; Zürich (coll. cat.) 1971, p. 182; Berlin 1987, pp. 116 ff.; Washington 1988, no. 1; Zürich (coll. cat.) 1990, no. 68 (ref.); Bonnefoy 1991, p. 101; New York 1994, pp. 29 ff.; Vienna 1996, p. 54.

7. Mountain at Stampa. c. 1923
Pencil on paper, 19⁵/16 × 12"
(49 × 30.5 cm)
Signed lower right: "Alberto Giacometti"
Musée national d'art moderne, Centre Georges Pompidou, Paris. Inv. AM 1987-1159

REFERENCES: Saint-Paul 1978, no. 202; Saint-Etienne 1999, no. 2 (ref.); Paris 2001, no. 18 (ref.).

8. Three Nudes. 1923-24
Pencil on paper, 17½ × 11"
(44.5 × 28 cm)
Signed and dated lower right: "Alberto Giacometti 1923-24"
Alberto Giacometti-Stiftung, Zürich. GS 95

REFERENCES: Basel 1963, no. 97; Zürich (coll. cat.) 1971, p. 227 (ref.); Tübingen 1981, [no.] Z 25 (ref.); Berlin 1987, no. 7; Zürich (coll. cat.) 1990, no. 115; Bonnefoy 1991, pp. 116 ff.; Soldini 1998, p. 29, no. 16; Paris 2001, no. 27 (ref.).

9. Self-Portrait. 1923-24
Pencil on paper, 19 1/8 × 12³/8"
(48.5 × 31.5 cm)
Signed and dated lower right: "Alberto Giacometti / autoportrait 1923-24."
Alberto Giacometti-Stiftung, Zürich. GS 93

REFERENCES: Basel 1963, no. 94; Zürich (coll. cat.) 1971, p. 225; Duisburg 1977,

no. 84; Tübingen 1981, [no.] Z 29; Berlin 1987, no. 8; Zürich (coll. cat.) 1990, no. 125; Soldini 1998, p. 28; Paris 2001, no. 16 (ref.).

10. The Skull. 1923
Pencil on paper, 9 1/16 × 8⁷/16"
(23 × 21.5 cm)
Signed and dated lower right: "Alberto Giacometti / 1923"
Robert and Lisa Sainsbury Collection, University of East Anglia, Norwich

REFERENCES: London 1955, no. 54; Berlin 1987, no. 10; Bonnefoy 1991, pp. 121 ff.; Didi-Huberman 1993, p. 86; Norwich (coll. cat.) 1997, no. 26; Paris 2001, no. 29 (ref.).

REMARKS: Shown in Zürich only.

11. Self-Portrait. 1923
Oil on canvas, 21⁵/8 × 12⁵/8"
(55 × 32 cm)
Kunsthaus Zürich. Inv. 2000/1

REFERENCES: Washington 1988, no. 2; Madrid 1990, p. 70; Paris 1991, no. 1 (ref.); Vienna 1996, p. 54, no. 31 (ref.); Soldini 1998, p. 28.

12. Self-Portrait. 1925
Plaster, 16 1/8 × 8¼ × 11" (41 × 21 × 28 cm)
Signed on base, left: "Giacometti"
Alberto Giacometti-Stiftung, Zürich. GS 180

REFERENCES: Hohl 1972, illus. p. 36; Brenson 1974, no. 1; Klemm 1993; New York 1994, pp. 29 ff.

13. Torso [Torse]. 1925
Plaster, 22¹³/16 × 9¹³/16 × 9⁷/16"
(58 × 25 × 24 cm)
Signed on base, right: "Alberto Giacometti"
Alberto Giacometti-Stiftung, Zürich. GS 1

REFERENCES: Paris 1925, no. 648 (Torse); "Tentative catalogue of early works" 1948, New York 1948, no. 1; Meyer 1968, pp. 46 f.; Huber 1970, pp. 7 ff.; Zürich (coll. cat.) 1971, pp. 56, 58 (ref.); Hohl 1972, pp. 30, 78; Brenson 1974, pp. 34, 53 f., nos. 2, 19; Lamarche-Vadel 1984, p. 32; Lord 1985, p. 287; Berlin 1987, pp. 55 ff.; Madrid 1990, p. 51; Zürich (coll. cat.) 1990, no. 4 (ref.); Bonnefoy 1991, p. 137; Paris 1991, no. 19 (ref.); Didi-Huberman 1993, p. 19; Dufrêne 1994, pp. 19 ff.; New York 1994, no. 1 (ref.); Milan 1995, pp. 8 ff., no. 4 (ref.); Vienna 1996, no. 38 (ref.); Soldini 1998, p. 30.

REMARKS: In 1971, Serge Brignoni asserted (in contrast to Brenson) that Giacometti reworked Torso after the Paris 1925 exhibition (see Brenson 1974, p. 219, no. 2). The sculpture was preceded by several drawings (Paris 2001, nos. 32 f.).

14. Studio with Sculptor's Turntable
[Atelier à la sellette] 1931 (?)
Pencil on paper, 19⁵⁄₁₆ × 14⁹⁄₁₆"
(49 × 37 cm)
Signed and dated lower right: "Alberto Giacometti / 1931"
Alberto Giacometti-Stiftung, Zürich. GS 167

REFERENCES: Bern 1956, no. 71; Lord 1971, no. 17; Brenson 1974, no. 83; Zürich (coll. cat.) 1990, no. 131; Bonnefoy 1991, illus. p. 18; Paris 1991, no. 54 (ref.); Vienna 1996, no. 73 (ref.); Paris 2001, no. 41 (ref.).

REMARKS: Signature and date were added later.

15. Still Life with Gudea Head
[Nature morte à la tête de Gudea]. 1927
Pencil on paper, 19⁵⁄₁₆ × 12⁵⁄₈"
(49 × 32 cm)
Graphische Sammlung der Eidgenössische Technische Hochschule, Zürich

REFERENCES: Lugano 1990, no. 25; Hohl 1991; New York 1994, no. 13 (ref.); Basel 1995, pp. 19 ff.; Vienna 1996, p. 63, no. 54 (ref.); Mendrisio 2000, p. 21; Paris 2001, no. 38 (ref.).

REMARKS: According to Hohl (1991), the sculpture next to the Sumerian head (c. 2150–2100 B.C.) is a self-portrait, now in the Jeanne Bucher Collection, Paris (Milan 1995, no. 7).

16. Cubist Composition: Man
[Composition cubiste: Homme]. 1926–27
Bronze, 25 × 10⁵⁄₈ × 7⁷⁄₈"
(63.5 × 27 × 20 cm)
Inscribed on base: "3/6 Alberto Giacometti"; "C. Valsuani Cire perdue"
Collection Gustav Zumsteg, Zürich

REFERENCES: Basel 1966, no. 9; Hohl 1972, p. 79; Brenson 1974, no. 21 (ref.); Berlin 1987, p. 56; Madrid 1990, no. 150; Bonnefoy 1991, p. 140; Paris 1991, no. 26 (ref.); New York 1994, pp. 44 f.; Dufrène 1994, p. 34; Milan 1995, p. 9, no. 6 (ref.); Vienna 1996, no. 46 (ref.).

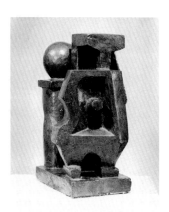

17. Figures [Personnages]. 1926–27
Bronze, 10¼ × 7⅞ × 5⅞" (26 × 20 × 15 cm)
Foundry mark back of base, left: "CIRE / C VALSUANI / PERDUE"
Alberto Giacometti-Stiftung, Zürich. GS 6

REFERENCES: Bucarelli 1962, illus. no. 7; Zürich (coll. cat.) 1971, p. 66 (ref.); Brenson 1974, no. 17; Lamarche-Vadel 1984, p. 37; Lord 1985, pp. 98 f.; Zürich (coll. cat.) 1990, no. 9; Paris 1991, no. 25 (ref.); Bonnefoy 1991, p. 130; New York 1994, pp. 25, 43 f.; Dufrène 1994, pp. 23, 34; Milan 1995, p. 9; Vienna 1996, no. 43 (ref.); Soldini 1998, pp. 31 ff.

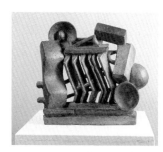

18. Composition: (Reclining) Couple [Composition: Le Couple (couché)]. 1927
Bronze, 15½ × 18⅛ × 5⅞" (39.3 × 46 × 15 cm)
Signed back of base: "Alberto Giacometti E1"; "Cire / Pastori / Perdue"
Private collection

REFERENCES: Dupin 1962, illus. p. 196; Hohl 1972, p. 79; Brenson 1974, no. 35; Duisburg 1977, p. 56; Washington 1988, p. 26, no. 6; Chur (coll. cat.) 1989, p. 187 (ref.); Bonnefoy 1991, p. 144; Paris 1991, no. 28 (ref.); New York 1994, p. 45; Vienna 1996, no. 44 (ref.); Frankfurt 1998, p. 15; Bern (coll. cat./Kornfeld) 1998, no. 111; Soldini 1998, pp. 35 ff.; Mendrisio 2000, p. 22, no. 98 (ref.).

REMARKS: Lost plaster version shown on page 61.

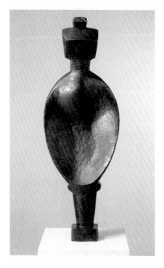

19. Spoon Woman [Femme-cuillère]. 1926–27
Bronze, 57 × 20¼ × 8¼" (144.8 × 51.4 × 21 cm)
Signed back of base, right: "Alberto Giacometti 0/6"; and left: "Susse Fondeur Paris"
The Museum of Modern Art, New York. Acquired through the Mrs. Rita Silver Fund in honor of her husband Leo Silver and in memory of her son Stanley R. Silver, and the Mr. and Mrs. Walter Hochschild Fund, 1986

REFERENCES: Paris 1927 (Sculpture); "[First] Letter to Pierre Matisse" 1948, "Tentative catalogue of early works" 1948 (Femme grande); Dupin 1962, pp. 39 f.; Meyer 1968, pp. 48 ff., 126; Huber 1970, pp. 13 ff.; Hohl 1972, pp. 78 f.; Brenson 1974, pp. 1 ff., 56 f., no. 24; Duisburg 1977, pp. 43 ff., 79 f.; Poley 1977, pp. 178 ff.; Tübingen 1981, pp. 43 ff.; Lamarche-Vadel 1984, p. 34; Krauss 1984, pp. 504 ff.; Lord 1985, pp. 93 f.; Berlin 1987, p. 58 f.; Dallas 1987, no. 27 (ref.); Washington 1988, pp. 23 f., no. 4; Zürich (coll. cat.) 1990, no. 8 (ref.); Madrid 1990, no. 148; Bonnefoy 1991, pp. 140 ff.; Paris 1991, no. 24 (ref.); New York 1994, pp. 25, 50 ff.; Dufrène 1994, pp. 20 ff.; Milan 1995, no. 5 (ref.); Vienna 1996, no. 41 (ref.); Sylvester 1997, pp. 31 ff.; Soldini 1998, pp. 31 ff.

REMARKS: For the original state, see Hohl (1972, illus. p. 39). In Zürich bronze cast "1/6" from Alberto Giacometti-Stiftung, Zürich, GS 4, is shown. Plaster version, with simplifications, before casting in 1954 shown on page 63.

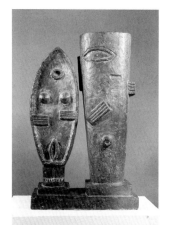

20. The Couple [Le Couple]. 1926
Bronze, 23½ × 15 × 14⅝" (59.6 × 38 × 37.1 cm)
Signed verso, right corner: "A. Giacometti 3/6"; left corner: "Susse Fondeur Paris"
The Museum of Modern Art, New York. Blanchette Rockefeller Fund, 1982

REFERENCES: Paris 1926, no. 865 (Sculpture); Paris 1928 (Figures);

"[First] Letter to Pierre Matisse" 1948, "Tentative catalogue of early works" 1948 (Homme et femme); Dupin 1962, p. 39 f.; Meyer 1968, pp. 50 ff.; Huber 1970, pp. 14, 22, 47; Hohl 1972, p. 79; Zürich (coll. cat.) 1971, p. 64 (ref.); Brenson 1974, pp. 35 f., no. 15; Duisburg 1977, pp. 79 f., no. 2; Poley 1977, pp. 176 ff.; Lamarche-Vadel 1984, p. 37; Krauss 1984, pp. 506 f.; Lord 1985, p. 94; Berlin 1987, no. 14, pp. 57 f.; Washington 1988, p. 23 f., no. 3; Zürich (coll. cat.) 1990, no. 7 (ref.); Madrid 1990, p. 53, no. 149; Bonnefoy 1991, pp. 135 ff.; Paris 1991, no. 22 (ref.); Dufrène 1994, pp. 21 ff., 36; New York 1994, pp. 40 ff.; Milan 1995, pp. 9 ff.; Vienna 1996, pp. 32 f., no. 40 (ref.); Soldini 1998, pp. 31 ff.

REMARKS: In Zürich bronze cast "1/6" from Alberto Giacometti-Stiftung, Zürich, GS 5, is shown. Plaster version shown on page 64.

21. Dancers [Danseurs]. 1927
Terra-cotta, painted, 9¼ × 6⁵⁄₁₆ × 5⅛" (23.5 × 16 × 13 cm)
Inscribed and dated on bottom: "2/V / A927 / AG"
Musée national d'art moderne, Centre Georges Pompidou, Paris. AM 1981-511

REFERENCES: Paris 1928, no. 35; Brenson 1974, pp. 41 ff., 58, 227, nos. 29, 30; Lamarche-Vadel 1984, p. 37; New York 1994, p. 41; Saint-Etienne 1999, no. 4 (ref.).

22. Head [Tête]. 1926
Plaster, 11⁵⁄₁₆ × 11¹³⁄₁₆ × 3⅜" (28.8 × 30 × 8.5 cm)
Musée national d'art moderne, Centre Georges Pompidou, Paris. AM 1981-509

REFERENCES: Lamarche-Vadel 1984, p. 43; Krauss 1984, p. 512; Paris 1991, no. 20; New York 1994, pp. 29 f.; Saint-Etienne 1999, no. 3 (ref.).

23. Small Crouching Man [Petit homme accroupi]. 1926
Bronze, 11¼ × 6⅞ × 3¹⁵⁄₁₆" (28.5 × 17.5 × 10 cm)
Signed and dated on base, left: "A. Giacometti"; on front: "1926"; foundry mark on back: "CIRE/M PASTORI/ PERDUE"
Alberto Giacometti-Stiftung, Zürich. GS 3

REFERENCES: Basel 1966, no. 8; Brenson 1974, pp. 25 ff., no. 11; Huber 1970, p. 88; Hohl 1972, pp. 79, 191; Lamarche-Vadel 1984, p. 37; Krauss 1984, p. 512; Zürich (coll. cat.) 1990, no. 6; Paris 1991, no. 21 (ref.); Didi-Huberman 1993, p. 193; New York 1994, pp. 46 f., no. 2 (ref.); Milan 1995, pp. 9ff; Soldini 1998, pp. 31 ff.; Mendrisio 2000, no. 96 (ref.).

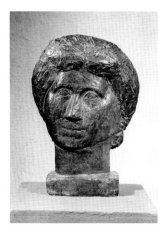

24. The Artist's Mother

[La Mère de l'artiste]. 1927
Bronze, 12¹³⁄₁₆ × 9¹⁄₁₆ × 4⁵⁄₁₆" (32.5 ×
23 × 11 cm)
Signed and dated on base, front:
"1927"; on back: "Alberto Giacometti";
foundry mark on left: "CIRE / M
PASTORI / PERDUE"
Alberto Giacometti-Stiftung, Zürich.
On permanent loan to the
Kunstmuseum Basel. GS 7

REFERENCES: Dupin 1962, illus. p. 191;
Meyer 1968, pp. 52 f., 182; Huber
1970, pp. 18 f.; Zürich (coll. cat.)
1971, p. 68 (ref.); Hohl 1972, p. 80;
Brenson 1974, no. 31; Lamarche-Vadel
1984, p. 40; Berlin 1987, p. 138;
Washington 1988, no. 7; Zürich (coll.
cat.) 1990, no. 12 (ref.); Zürich 1990,
p. 126; Paris 1991, no. 34 (ref.); New
York 1994, p. 37; Dufrène 1994,
pp. 25, 39; Vienna 1996, no. 51 (ref.);

REMARKS: Plaster version shown on page
69.

25. The Artist's Father

[Le Père de l'artiste]. 1927
Bronze, 11 × 8⁷⁄₁₆ × 9¹⁄₁₆" (28 ×
21.5 × 23 cm)
Foundry mark on back, left: "CIRE / M
PASTORI / PERDUE"
Alberto Giacometti-Stiftung, Zürich.
GS 8

REFERENCES: London 1965, no. 6;
Meyer 1968, p. 51 f.; Huber 1970,
pp. 17 f.; Zürich (coll. cat.) 1971,
p. 70 (ref.); Brenson 1974, p. 40,
no. 33; Lamarche-Vadel 1984, p. 40;
Zürich (coll. cat.) 1990, no. 10;
Bonnefoy 1991, p. 146; Paris 1991,
no. 30 (ref.); Madrid 1990, p. 145;
Didi-Huberman 1993, p. 105 ff.; New
York 1994, pp. 27 ff.; Dufrène 1994,
pp. 25, 39; Vienna 1996, no. 49

26. The Artist's Father

[Le Père de l'artiste]. 1927
Marble, 11¹³⁄₁₆ × 9¹⁄₁₆ × 8¼" (30 ×
23 × 21 cm)
Private collection, Switzerland

REFERENCES: Saint-Paul 1978, no. 5;
Madrid 1990, no. 146; Paris 1991,
no. 29 (ref.); Didi-Huberman 1993,
pp. 105 ff.; Dufrène 1994, pp. 25, 39;
Vienna 1996, no. 48 (ref.); Soldini
1998, p. 31.

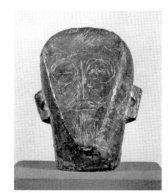

27. The Artist's Father (flat and engraved)

[Le Père de l'artiste (plat
et gravé)]. 1927
Bronze, 10¹³⁄₁₆ × 8¼ × 5½" (27.5 ×
21 × 14 cm)
Foundry mark on back, left: "CIRE / M
PASTORI / PERDUE"
Alberto Giacometti-Stiftung, Zürich.
GS 9

REFERENCES: Basel 1964, no. 8a; Meyer
1968, pp. 52 f.; Huber 1970, p. 18;
Zürich (coll. cat.) 1971, p. 72 (ref.);
Hohl 1972, p. 80; Brenson 1974,
pp. 40 f., no. 34; Lamarche-Vadel 1984,
p. 40; Washington 1988, no. 8; Zürich
(coll. cat.) 1990, no. 11 (ref.);
Bonnefoy 1991, pp. 156 f.; Paris 1991,
no. 31 (ref.); Didi-Huberman 1993,
pp. 106 f.; New York 1994, pp. 27 ff.;
Dufrène 1994, pp. 25, 39; Vienna
1996, no. 50 (ref.); Soldini 1998,
p. 34.

REMARKS: Original plaster version shown
on page 72.

28. The Artist's Father

[Le Père de l'artiste]. c. 1932
Oil on canvas, 18⅛ × 14¹⁵⁄₁₆" (46 ×
38 cm)
Kunsthaus Zürich. Inv. 1963/42

REFERENCES: Zürich 1962, no. 104;
Lamarche-Vadel 1984, pp. 40 f.; Berlin
1987, p. 116; Paris 1991, no. 33;
Vienna 1996, p. 54, no. 53.

REMARKS: This painting, like a somewhat
larger frontal portrait in the Kunsthaus
Zürich (Zürich [coll. cat.] 1990, p. 90),
is a preliminary study for the version
owned by the Giacometti family and
traditionally dated 1932 (Vienna 1996,
no. 52). The portrait of Renato Stampa
(Vienna 1996, no. 96), similar to this
group of paintings, is signed and dated
1932.

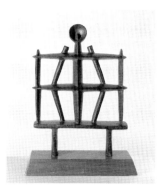

29. Man (Apollo)

[Homme (Apollon)]. 1929
Bronze, 15¾ × 12 × 3⅜" (40 × 30.5 ×
8.5 cm)
Signed and dated back, lower left:
"3/6 Alberto Giacometti 1929"
Hirshhorn Museum and Sculpture
Garden, Smithsonian Institution,
Washington, D.C. Gift of Robert H.
Hirshhorn, 1966

REFERENCES: Leiris 1929, illus. p. 214;
"[First] Letter to Pierre Matisse" 1948,
"Tentative catalogue of early works"
1948 (Homme); Dupin 1962, p. 40
(Apollon); Meyer 1968, pp. 60 f.;
Huber 1970, pp. 22, 31 f.; Zürich (coll.
cat.) 1971, p. 90 (ref.); Hohl 1972,
p. 79; Brenson 1974, pp. 45 ff., 117,
no. 52; Washington (coll. cat.) 1974,
p. 695 (ref.), illus. 342; Lamarche-Vadel
1984, pp. 43 f.; Berlin 1987, pp. 59 f.;
Washington 1988, pp. 26, 40, no. 11;
Zürich (coll. cat.) 1990, no. 22 (ref.);
Madrid 1990, p. 54, no. 156; Bonnefoy
1991, p. 163; Paris 1991, no. 44 (ref.);
Dufrène 1994, pp. 24 ff.; Milan 1995,
p. 12; Vienna 1996, no. 65 (ref.);
Soldini 1998, pp. 39, 238.

REMARKS: On the question of the title
Apollo, first found in Dupin 1962, see
Brenson 1974. In Zürich bronze cast
"2/6" from Alberto Giacometti-
Stiftung, Zürich, GS 18, on permanent
loan to the Kunstmuseum Basel, is
shown. Plaster version shown on
page 75.

30. Woman

[Femme]. 1928–29
Marble, 13⁵⁄₁₆ × 12³⁄₁₆ × 3⁹⁄₁₆" (33.5 ×
31 × 9 cm)
Signed on base, left: "A. Giacometti"
(the A., added later, is in a different
hand)
Alberto Giacometti-Stiftung, Zürich.
GS 13

REFERENCES: Leiris 1929, illus. pp. 212 f.;
"[First] Letter to Pierre Matisse" 1948;
Dupin 1962, pp. 34 f.; Meyer 1968,
pp. 53 ff.; Zürich (coll. cat.) 1971, p. 80;
Hohl 1972, p. 80; Brenson 1974,
pp. 42 f., nos. 41, 42; Tübingen 1981,
pp. 45 f.; Lamarche-Vadel 1984, p. 44;
Zürich (coll. cat.) 1990, no. 17 (ref.);
Paris 1991, no. 41 (ref.); Bonnefoy
1991, p. 163; New York 1994, pp. 52 ff.;
Milan 1995, pp. 11 ff.; Dufrène 1994,

pp. 37 f.; Vienna 1996, no. 61 (ref.);
Soldini 1998, p. 36.

REMARKS: Marble version executed by
Diego; original plaster reproduced in
Dupin 1962, illus. p. 199; a first version
with "tiny legs," is represented by a
bronze cast dated 1929, in the Hirsh-
horn Museum and Sculpture Garden,
Smithsonian Institution, Washington, D.C.

31. Gazing Head [Tête qui regarde].
1928
Plaster, 15³⁄₈ × 14⁹⁄₁₆ × 2³⁄₁₆" (39 ×
37 × 5.5 cm)
Signed and dated on base, back
(brush): "Alberto Giacometti 19 . . ,"
the last two digits scraped off and
replaced in pencil "27"; also in pencil,
above the old signature: "Alberto
Giacometti 1927"
Alberto Giacometti-Stiftung, Zürich.
GS 10

REFERENCES: Leiris 1929, illus. p. 211;
"[First] letter to Pierre Matisse" 1948,
"Tentative catalogue of early works"
1948 (Tête, 1928); Charbonnier
1951, pp. 22 f.; Dupin 1962, pp. 34 f.;
Meyer 1968, pp. 53 ff.; Huber 1970,
pp. 19, 88; Zürich (coll. cat.) 1971, p.
76; Hohl 1972, pp. 80, 170, 246;
Brenson 1974, pp. 41 f., no. 38; Poley
1977, pp. 180 f.; Tübingen 1981, pp.
44 f.; Lamarche-Vadel 1984, pp. 43 f.;
Lord 1985, pp. 110, 153; Berlin 1987,
pp. 18, 60, 138; Washington 1988, p. 24,
no. 9; Madrid 1990, p. 56, no. 152;
Zürich (coll. cat.) 1990, no. 14 (ref.);
Zürich 1990, p. 126; Bonnefoy 1991,
pp. 149 ff.; Paris 1991, no. 37 (ref.);
Didi-Huberman 1993, pp. 126 ff.; New
York 1994, pp. 52 ff., no. 5 (ref.);
Dufrène 1994, pp. 25, 37 ff., 108;
Milan 1995, pp. 10ff., no. 8 (ref.);
Vienna 1996, no. 57 (ref.); Sylvester
1997, pp. 31, 42, 52, 115 f.; Soldini
1998, p. 39.

REMARKS: First exhibited at the Galerie
Jeanne Bucher, Paris, May 1929.

32. Reclining Woman

[Femme couchée]. 1929
Plaster, 11 × 17½ × 6½" (28 × 44.5 ×
16.5 cm)
Signed on base, back: "Plâtre original";
"Alberto Giacometti" (brush)
Alberto Giacometti-Stiftung, Zürich.
GS 15

REFERENCES: New York 1948, no. 3;
Meyer 1968, p. 61; Huber 1970, p. 26;
Zürich (coll. cat.) 1971, pp. 84 ff.
(ref.); Hohl 1972, p. 79; Brenson 1974,
p. 43, no. 51; Lamarche-Vadel 1984,
p. 39; Lord 1985, p. 115 f.; Berlin 1987,
p. 59; Zürich (coll. cat) 1990, nos. 20,
21 (ref.); Madrid 1990, pp. 54, 82;
Paris 1991, no. 42 (ref.); Bonnefoy
1991, p. 165; New York 1994, p. 58;
Milan 1995, pp. 12 f., no. 10 (ref.);
Vienna 1996, no. 62 (ref.); Soldini
1998, pp. 35 ff.

33. Reclining Woman Who Dreams

[Femme couchée qui rêve]. 1929
Bronze, painted white, 9⁷/₁₆ × 16¹⁵/₁₆ × 5⁵/₁₆" (24 × 43 × 13.5 cm)
Signed on base, back left (brush): "Alberto Giacometti 0/6"; on the bronze exposed between the name and number, the stamp "0/6"
Alberto Giacometti-Stiftung, Zürich. GS17

REFERENCES: Leiris 1929, illus. pp. 213 f. (*Femme couchée*); "[First] Letter to Pierre Matisse" 1948, "Tentative catalogue of early works" 1948 (*Femme couchée*); Dupin 1962, p. 40; Metzger 1966; Meyer 1968, pp. 60 ff., 96 f.; Huber 1970, pp. 26, 31 f.; Zürich (coll. cat.) 1971, p. 88 (ref.); Hohl 1972, p. 79; Brenson 1974, pp. 46 f., no. 53; Washington (coll. cat.) 1974, p. 695 (ref.), illus. 401; Hall 1980, p. 10; Lamarche-Vadel 1984, p. 39; Lord 1985, pp. 115 f.; Berlin 1987, p. 59; Washington 1988, pp. 24 ff., no. 13; Zürich (coll. cat.) 1990, no. 23 (ref.); Madrid 1990, p. 54; Paris 1991, no. 43 (ref.); Bonnefoy 1991, p. 163 ff.; New York 1994, pp. 58 f.; Dufrêne 1994, pp. 24, 31 ff.; Milan 1995, pp. 12 ff.; Vienna 1996, nos. 63, 64 (ref.); Soldini 1998, pp. 35 ff.

34. Man and Woman

[Homme et femme]. 1929
Bronze, 15³/₄ × 15³/₄ × 6¹/₂" (40 × 40 × 16.5 cm)
Musée national d'art moderne, Centre Georges Pompidou, Paris. AM 1984-355

REFERENCES: Leiris 1929, illus. pp. 210, 212 (*Homme et femme*); "[First] Letter to Pierre Matisse" 1948, "Tentative catalogue of early works" 1948; Dupin 1962, pp. 17 f., 40; Meyer 1968, pp. 59 f; Huber 1970, pp. 14, 20, 31; Hohl 1972, pp. 70 f.; Brenson 1974, pp. 43, 130 ff., no. 50; Poley 1977, p. 181; Lamarche-Vadel 1984, p. 50; Lord 1985, pp. 108, 115; Berlin 1987, p. 63, no. 30; Madrid 1990, p. 82, no. 154; Bonnefoy 1991, pp. 163 ff.; Paris 1991, no. 44 bis (ref.); Didi-Huberman 1993, p. 151; Dufrêne 1994, pp. 19 f., 29; New York 1994, pp. 52 ff.; Vienna 1996, no. 66 (ref.); Sylvester 1997, pp. 43, 60; Soldini 1998, pp. 38 ff.; Saint-Etienne 1999, no. 8 (ref.).

35. Three Figures Outdoors

[Trois personnages dehors]. 1929
Bronze, 20¹/₄ × 15³/₁₆ × 3⁹/₁₆" (51.5 × 38.5 × 9 cm)
Signed and dated on underside of base: "Alberto Giacometti / 1930"
Art Gallery of Ontario, Toronto. Purchase, 1984

REFERENCES: Leiris 1929, illus. p. 214; Paris 1929 (Bernheim); Meyer 1968, pp. 58 f.; Huber 1970, pp. 20 f.; Hohl 1972, pp. 79 f.; Brenson 1974,

pp. 61 ff., no. 54; Duisburg 1977, pp. 56 ff.; Washington 1988, pp. 24 ff., no. 12; Bonnefoy 1991, p. 178; New York 1994, p. 60; Dufrêne 1994, pp. 19, 46; Milan 1995, p. 12; Soldini 1998, p. 39.

REMARKS: Giacometti colored a photograph of the plaster version of this work and titled it *Homme, Femmes et fantómes (Spectres)* (New York 1994, no. 15). A photograph by Jacques-André Boiffard confirmed that the exhibited bronze, probably a unique cast, was executed as early as 1932 (Saint-Etienne 1999, illus. p. 56). Shown in Zürich only. Plaster version shown on page 81.

36. L'Heure des traces. 1930

Lost

REFERENCES: *Le Surrealisme au service de la révolution*, no. 6 (1933), illus.; "[First] Letter to Pierre Matisse" 1948; Hohl 1972, pp. 82, 103, 191; Brenson 1974, pp. 102 ff., no. 76; Tübingen 1981, pp. 47 f.; London (coll. cat.) 1981, pp. 275 f.; Krauss 1984, p. 512; Berlin 1987, pp. 63 f.; Madrid 1990, pp. 60 f.; Dufrêne 1994, pp. 48 ff.; Vienna 1996, pp. 34 f.; Sylvester 1997, pp. 55 ff.

REMARKS: The steel version, executed by Bastianelli, has been lost. The painted model (plaster and metal, 26¹⁵/₁₆ × 14³/₁₆ × 11¹/₄" [68.5 × 36 × 28.5 cm]) that belonged to Diego, appeared at auction in 1975 and was purchased by the Tate Gallery, London. Photograph of steel version shown on page 85.

37. Cage. 1930

Wood, 19⁵/₁₆ × 10⁷/₁₆ × 10⁷/₁₆" (49 × 26.5 × 26.5 cm)
Moderna Museet, Stockholm

REFERENCES: Giacometti 1931, illus. (line drawing), p. 18; Paris 1933 (Salon des Surindépendents) (*Oiseau-silence*); Axis no. 1 (1935), illus. p. 12 (*Palais de quatre heures III*); "[First] Letter to Pierre Matisse" 1948, "Tentative catalogue of early works" 1948 (*Cage*); Dupin 1962, pp. 18, 40 f.; Meyer 1968, p. 70; Huber 1970, pp. 26 ff.; Hohl 1972, p. 82; Brenson 1974, pp. 91 ff., no. 74; Duisburg 1977, pp. 53, 60 ff.; Tübingen 1981, pp. 48 f.; Lamarche-Vadel 1984, p. 52; Krauss 1984, p. 518; Lord 1985, pp. 127, 357; Berlin 1987, p. 64; Washington 1988, p. 28; Madrid 1990, p. 28; Bonnefoy 1991, p. 181; Didi-Hubermann 1993, pp. 52 f.; Dufrêne 1994, pp. 43, 55 ff.; Milan 1995, pp. 15, 22; Vienna 1996, pp. 34 ff.; Soldini 1998, pp. 39 ff.; Saint-Etienne 1999, pp. 23 f. (ref.).

REMARKS: A photograph by Marc Vaux documents the lost plaster original (Saint-Etienne 1999, illus. p. 58). A large version was produced for the Paris Surrealist exhibition at the Pierre Colle

Gallery in 1933, as seen in a reproduction in *Lu* (October 1933). Shown in Zürich only.

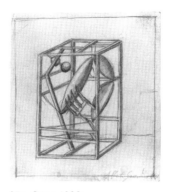

37a. Cage. 1930

Pencil on paper, 5³/₈ × 4¹³/₁₆" (13.6 × 12.2 cm)
Signed lower right: "Alberto Giacometti"
Musée national d'art moderne, Centre Georges Pompidou, Paris. Inv. AM 1975-89

REFERENCES: Giacometti 1931 illus. (line drawing), p. 18; auction catalogue Kornfeld, Bern, June 13, 1975, no. 341; Saint-Etienne 1999, no. 9 (ref.); Paris 2001, no. 43 (ref.).

REMARKS: Presumably a drawing of *Cage* (plate 37) for Giacometti's 1931 article "Objets mobiles et muets."

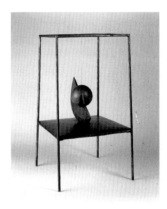

38. Suspended Ball

[Boule suspendue]. 1930
Wood, iron, and string, 23³/₄ × 14³/₈ × 13³/₈" (60.4 × 36.5 × 34 cm)
Musée national d'art moderne, Centre Georges Pompidou, Paris. Purchase, 1996

REFERENCES: Paris 1930 (Galerie Pierre); Dalí 1931, pp. 16 f.; Giacometti 1931, illus. (line drawing), p. 19; Nadeau 1945, pp. 215 f.; "[First] letter to Pierre Matisse" 1948, "Tentative catalogue of early works" 1948 (*Boule suspendue*), New York 1948, no. 4; Dupin 1962, p. 41; Meyer 1968, pp. 71 ff.; Huber 1970, pp. 26 ff.; Hohl 1972, pp. 22, 80 ff., 211, 248; Zürich (coll. cat.) 1971, p. 92 (ref.); Brenson 1974, pp. 62 ff, no. 57; Duisburg 1977, p. 62; Poley 1977, p. 182 f.; Tübingen 1981,

pp. 47 f., 56; Krauss 1984, pp. 511 ff.; Lamarche-Vadel 1984, pp. 49 f.; Lord 1985, pp. 117 f., 127, 156; Berlin 1987, pp. 62 f.; Washington 1988, pp. 26 ff.; Zürich (coll. cat.) 1990, no. 24 (ref.); Madrid 1990, pp. 19, 57 ff., no. 157; Bonnefoy 1991, pp. 195 ff.; Paris 1991, pp. 37 ff., no. 45 (ref.); Dufrêne 1994, pp. 34 ff.; New York 1994, p. 63; Milan 1995, pp. 13 f.; Vienna 1996, pp. 33 f.; Beaumelle 1997, pp. 19 f.; Sylvester 1997, pp. 44 ff., 52, 55 f., 61 f.; Soldini 1998, pp. 40 ff; Saint-Etienne 1999, pp. 23 f., no. 10 (ref.).

REMARKS: In a first version, the bars of the cage were covered with plaster and thus resembled the relatively thick bars seen in the wood version of *Cage*. The shape and position of the sphere and crescent in the first version were closer to those in the wood version executed by the Basque cabinetmaker Ipústegui (Musée national d'art moderne, Paris) and to the (probably contemporary) variant in metal and plaster (Alberto Giacometti-Stiftung, Zürich). The first version, with the plaster removed from its bars, or possibly yet another variant, can be seen in a photograph by Man Ray, next to *Hands Holding the Void* (Saint-Etienne 1999, p. 60). For the 1965 London exhibition, Alberto or Diego made a reproduction (in the artist's estate) of the work. For a detailed description of these versions, see Saint-Etienne (1999, no. 10); André Breton acquired the wood version and presented it repeatedly under the title *L'Heure des traces*, which actually belongs to a different sculpture (plate 36). In Zürich original plaster version from Alberto Giacometti-Stiftung, Zürich, GS 19, on permanent loan to the Kunstmuseum Basel, is shown. Photograph of plaster version shown on page 87.

39. Vide-poche. 1930

Plaster, 6⁷/₈ × 7¹¹/₁₆ × 11⁵/₈" (17.5 × 19.5 × 29.5 cm)
Alberto Giacometti-Stiftung, Zürich. GS165

REFERENCES: Hohl 1972, illus. p. 59 (*Sculpture*); Brenson 1974, pp. 71 f., no. 60; Geneva 1986, p. 45; Zürich (coll. cat.) 1990, no. 26; Paris 1991, no. 46 (ref.); New York 1994, p. 55, no. 9 (ref.); Milan 1995, p. 14 f., no. 11 (ref.); Dufrêne 1994, p. 35; Vienna 1996, no. 69 (ref.) Mendrisio 2000, p. 22, no. 100 (ref.).

REMARKS: In the Jeanne Bucher collection, Paris, there is a second original plaster that is signed and dated 1930 (Mendrisio 2000, no. 100). Diego Giacometti provided Brenson with the title, *Vide-poche,* around 1970.

40. Family Portrait

[Portrait de famille]. 1930
Wood, 8⁷⁄₁₆ × 6⅛ × 7½" (21.5 × 15.5 × 19 cm)
Ny Carlsberg Glyptotek, Copenhagen

REFERENCES: [Eijler] Bille, *Picasso, realisme og abstrakt kunst*, 1945, p. 77; Berlin 1987, no. 37; Madrid 1990, p. 16; Copenhagen (coll. cat.) 1994, no. 15; Milan 1995, p. 15; Soldini 1998, pp. 43 f.; Saint-Etienne 1999, p. 64 (ref.).

REMARKS: In 1945 Giacometti wrote Eijler Bille that this work was actually a family portrait, "and by no means an abstract work. At that time I was in love with a girl who had a lame sister." According to Giacometti, the three conical pegs represent this girl, her lame sister, and her little brother (from Hohl 1972, p. 101, erroneously related to the *Objet désagréable à jeter*).

41. Disagreeable Object, To Be Thrown Away

[Objet désagréable à jeter]. 1931
Bronze, 8¹¹⁄₁₆ × 8¹¹⁄₁₆ × 11⁷⁄₁₆" (22 × 22 × 29 cm)
Signed on back, at bottom: "A. Giacometti 5/6": on left edge: "PASTORI FONDEUR"
Alberto Giacometti-Stiftung, Zürich. GS 135

REFERENCES: Giacometti 1931, illus. (line drawing), p. 18; Paris 1933, no. 29 (?); Zürich 1934, no. 72 (*Objet sans base*); "[First] Letter to Pierre Matisse" 1948, "Tentative catalogue of early works" 1948 (*Objet désagréable à jeter*); London 1955, no. 5 (*Objet – tête qui marche*); Dupin 1962, p. 42; Meyer 1968, pp. 82 ff.; Huber 1970, pp. 35 ff.; Hohl 1972, pp. 79, 101; Brenson 1974, p. 119 f., no. 79; Lamarche-Vadel 1984, p. 54; Krauss 1984, pp. 522 f.; Berlin 1987, p. 67; Madrid 1990, pp. 31, 58 ff., no. 158; Zürich (coll. cat.) 1990, no. 27 (ref.); Paris 1991, no. 47 (ref.); Didi-Huberman 1993, pp. 114, 151; Sylvester 1994, p. 96; Dufrêne 1994, p. 35; Milan 1995, p. 15, no. 12 (ref.); Vienna 1996, no. 70 (ref.), 71 (wood); Soldini 1998, pp. 41, 70 ff.; Saint-Etienne 1999, no. 11 (ref.).

REMARKS: Alberto gave the original plaster to his brother Bruno as a wedding present in 1935. Bruno asserts that his brother always placed the object in such a way that the "nose" was at the top, as seen in Giacometti 1931. The wood version, executed by Ipústegui, is in the Scottish National Gallery of Modern Art in Edinburgh.

42. Disagreeable Object

[Objet désagréable]. 1931
Plaster, 4⅛ × 19⁷⁄₁₆ × 5⅞" (10.4 × 49.3 × 15 cm)
Musée national d'art moderne, Centre Georges Pompidou, Paris. Inv. AM 1987-1171

REFERENCES: Giacometti 1931, illus. (line drawing), p. 19; Paris 1933, no. 29 (?); "[First] Letter to Pierre Matisse" 1948, "Tentative catalogue of early works" 1948 (*Objet désagréable*); Meyer 1968, pp. 82 ff.; Huber 1970, pp. 32 ff.; Hohl 1972, pp. 79 ff.; Brenson 1974, pp. 117 ff., nos. 77, 78; Poley 1977, p. 182; Krauss 1984, pp. 522 f.; Berlin 1987, p. 67; Madrid 1990, p. 62; Sylvester 1994, pp. 91 ff.; Dufrêne 1994, p. 35; Vienna 1996, no. 72; Soldini 1998, pp. 42f, 69 ff.; Saint-Etienne 1999, p. 24, no. 12 (ref.).

REMARKS: For the versions in marble and wood, see Saint-Etienne 1999, nos. 12 f..

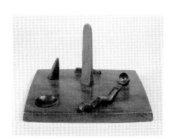

43. Model for a Square

[Projet pour une place]. 1930–31
Wood, 7⅝ × 12⅜ × 8⅝" (19.4 × 31.4 × 22.5 cm)
Peggy Guggenheim Collection, Venice (Solomon R. Guggenheim Foundation, New York)

REFERENCES: Giacometti 1931, illus. (line drawing), p. 18; Zervos 1932, illus. p. 341 (*Projet pour une place [en pierre], 1930-31*); "[First] Letter to Pierre Matisse" 1948 (*Maquette pour une grande sculpture dans un jardin*), "Tentative catalogue of early works" 1948; Meyer 1968, pp. 76 ff.; Huber 1970, pp. 31 f., 72; Hohl 1972, p. 79; Brenson 1974, pp. 65 ff., 78 f., 94 ff., no. 59; Tübingen 1981, p. 51; Krauss 1984, p. 521; Venice (coll. cat.) 1985, no. 66 (ref.); Geneva 1986, pp. 70 ff.; Berlin 1987, pp. 67, 74 ff., 139 f.; Washington 1988, no. 15; Madrid 1990, pp. 58 ff., no. 161; Dufrêne 1994, pp. 35, 57 ff., 90, 157 ff.; Venice (coll. cat.) 1995, pp. 10 ff., no. 1; Vienna 1996, pp. 17, 35; Soldini 1998, p. 101.

REMARKS: For the version in wood made by Ipústegui and subsequent changes, see the detailed discussion in Venice (coll. cat.) 1985. Photograph of the lost original plaster, page 93, represents the work with the proper position of the individual elements.

44. Project for a Passageway

[Projet pour un passage]. 1930
Plaster, 6⁵⁄₁₆ × 49⅝ × 16⁹⁄₁₆" (16 × 126 × 42 cm)
Signed on basin, front right: "Alberto Giacometti plâtre original" (pencil); back right: "Alberto Giacometti" (incised)
Alberto Giacometti-Stiftung, Zürich. GS 20

REFERENCES: "Tentative catalogue of early works" 1948 (*Projet for a Tunnel*, 1932), New York 1948, no. 7; Basel 1963, no. 17 (*Projet pour un passage*); Meyer 1968, pp. 81 f.; Huber 1970, pp. 31 f.; Zürich (coll. cat.) 1971, p. 94 (ref.); Hohl 1972, p. 81; Brenson 1974, pp. 75 ff., no. 73; Tübingen 1981, pp. 50 f.; Lamarche-Vadel 1984, p. 54; Krauss 1984, pp. 518 ff.; von Graevenitz 1986, pp. 13 f.; Berlin 1987, p. 67; Zürich (coll. cat.) 1990, no. 25 (ref.); Madrid 1990, pp. 59 ff.; Bonnefoy 1991, pp. 196 f.; Dufrêne 1994, pp. 50 ff.; Vienna 1996, p. 35.

45. Figure in a Garden

[Figure dans un jardin]. 1930–32
Burgundy stone, 94½" (240 cm) high
Private collection

REFERENCES: "Tentative catalogue of early works" 1948 (*Figure dans un jardin*); Brenson 1974, pp. 94 ff., 132, no. 72; Hohl 1977, p. 117; Bach 1980; Lord 1985, pp. 104, 130; Bonnefoy 1991, p. 540.

REMARKS: At the beginning of 1930 the Vicomte de Noailles commissioned Giacometti to create a sculpture for the garden of his villa in Hyères. The model was completed in December, and in early 1931 Diego shipped the block of stone from the train station of the quarry at Pouillenay. The brothers worked together in Hyères in March 1931 and in the early summer of 1932, adding the last touches in the early summer of 1933. The correspondence between de Noailles and Giacometti, which after the end of 1930 consistently refers to the work as a "statue," was published in Bach 1980 along with several photographs and a detailed interpretation. Shown in Zürich only.

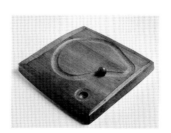

46. Circuit. 1931

Wood, 1¾ × 19⅛ × 18½" (4.5 × 48.5 × 47 cm)
Musée national d'art moderne, Centre Georges Pompidou, Paris. Inv. AM 1987-557

REFERENCES: Paris 1932 (?); *Transition* no. 21 (1932), illus. p. 146; "[First] Letter to Pierre Matisse" 1948; Bern 1956, no. 6 (*La Boule*); Dupin 1962, pp. 41 f. (*Circuit*); Meyer 1968, p. 76; Huber 1970, p. 35; Hohl 1972, pp. 83, 105; Brenson 1974, pp. 81 f., 88 f., 141, no. 80; Krauss 1984, pp. 512, 521; Berlin 1987, pp. 67, 74; Madrid 1990, no. 159; Bonnefoy 1991, pp. 204 f.; Dufrêne 1994, pp. 49 f., 92; Milan 1995, pp. 15, 62; Vienna 1996, pp. 17 f.; Soldini 1998, pp. 43, 65 ff., 85, 238; Saint-Etienne 1999, no. 17 (ref.).

REMARKS: Photograph of original plaster (Musée national d'art moderne, Paris) shown on page 96.

47. Man, Woman, Child

[Homme, femme, enfant]. 1931
Wood and metal, 16⁵⁄₁₆ × 14⁹⁄₁₆ × 6⁵⁄₁₆" (41.5 × 37 × 16 cm)
Öffentliche Kunstsammlung Basel, Kunstmuseum

REFERENCES: *Cahiers d'Art* 1936, illus. p. 61 (*Trois figures mobiles sur un plan*); "[First] Letter to Pierre Matisse" 1948, "Tentative catalogue of early works" 1948 (*Homme, femme, enfant*); Meyer 1968, pp. 75 f.; Huber 1970, pp. 35, 72; Hohl 1972, p. 84; Poley 1977, p. 184; Berlin 1987, pp. 67, 74; Washington 1988, p. 28; Madrid 1990, pp. 15, 62, 82; Dufrêne 1994, pp. 58 ff.; Milan 1995, pp. 15, 22; Vienna 1996, p. 35; Sylvester 1997, p. 53; Soldini 1998, pp. 42 f., 74 ff., 135.

REMARKS: Shown in Zürich only.

48. Landscape—Reclining Head

[Paysage—Tête couchée]. 1932
Plaster, 10¹⁄₁₆ × 26¾ × 14¾" (25.5 × 68 × 37.5 cm)
Inscribed on surface: "Mais les ponts sont pourris"; earlier (erased) inscription: "Si la vie continue"
Musée national d'art moderne, Centre Georges Pompidou, Paris. Inv. AM 1987-1154

REFERENCES: Paris 1932 (?); Zervos 1932, illus. p. 340 (*Chute d'un corps sur un graphique*, 1932); Zürich 1934, no. 73 (*Graphique d'un mouvement*); "[First] Letter to Pierre Matisse" 1948 (*Espèce de paysage—tête couchée*); Hohl 1972, pp. 83, 104; Brenson 1974, pp. 67, 120 ff., 141, no. 95; Tübingen 1981, pp. 52 f.; Krauss 1984, p. 521; Berlin 1987, pp. 75, 90; Paris 1991, no. 48 (ref.); Bonnefoy 1991, p. 539; Dufrêne 1994, pp. 43 f., 70 ff.; Vienna 1996, p. 35; Sylvester 1997, pp. 50 f.; Soldini 1998, pp. 75 f., 239; Saint-Etienne 1999, p. 18, no. 20 (ref.).

49. Caress (Despite Hands)

[Caresse (Malgré les mains)]. 1932
Marble, 18¹¹⁄₁₆ × 19½ × 6⁵⁄₁₆" (47.5 × 49.5 × 16 cm)

Musée national d'art moderne, Centre Georges Pompidou, Paris. Inv. AM 1984-310

REFERENCES: Paris 1932; Zervos 1932, p. 342, illus. p. 337 (*Malgré les mains*, 1932); Dupin 1962, illus. p. 211 (*Caresse*); Meyer 1968, p. 77; Hohl 1972, pp. 83, 301; Brenson 1974, p. 120, no. 94; Poley 1977, p. 183; Tübingen 1981, p. 53; Lamarche-Vadel 1984, p. 69; Lord 1985a; Berlin 1987, pp. 68, 90; Madrid 1990, pp. 63, 83; Paris 1991, no. 50 (ref.); Bonnefoy 1991, pp. 46, 202; Dufrêne 1994, pp. 58 ff., 70; Vienna 1996, p. 35; Sylvester 1997, p. 51; Soldini 1998, pp. 83 ff., 239; Saint-Etienne 1999, p. 18, no. 21 (ref.).

REMARKS: The original plaster, reproduced in Zervos 1932, is preserved in a private French collection; the provenance references to Zervos (Saint-Etienne 1999) relate to the plaster, not the marble, version.

50. The Palace at 4 A.M.
[Palais à quatre heures le matin]. 1932
Wood, glass, wire, and string, 25 × 28¼ × 15¾" (63.5 × 71.8 × 40 cm)
The Museum of Modern Art, New York. Purchase, 1936

REFERENCES: Zervos 1932, illus. p. 342 (*Palais de 4 heures*, 1932); Giacometti 1933, p. [46]; "[First] Letter to Pierre Matisse" 1948, "Tentative catalogue of early works" 1948 (*Palais de 4 heures*), New York 1948, no. 11; Dupin 1962, p. 42 f.; Meyer 1968, pp. 78 ff.; Huber 1969; Huber 1970, pp. 29, 39 ff.; Hohl 1972, pp. 79 ff; Brenson 1974, pp. 107 ff., no. 105; Duisburg 1977, pp. 64 ff.; Tübingen 1981, pp. 64 f.; Melis 1983, p. 24 ff.; Krauss 1984, p. 520; Lamarche-Vadel 1984, pp. 59 ff.; Lord 1985, pp. 143 f.; Berlin 1987, pp. 64 ff.; Washington 1988, pp. 28 ff.; Madrid 1990, pp. 12, 61, 84.; Zürich 1990, p. 130; Bonnefoy 1991, pp. 30 ff.; Didi-Huberman 1993, pp. 42 ff., 229 ff.; Dufrêne 1994, pp. 7 ff.; 60 ff., 125; Milan 1995, p. 15; Vienna 1996, pp. 36 f.; Sylvester 1997, pp. 58 f.; Soldini 1998, pp. 83 ff.

REMARKS: Lost plaster version photographed by Man Ray (see p. 15) and published in Zervos 1932; the wood version is believed to have been executed by Ipústegui. A 1933 Brassaï photograph (see p. 101) shows cage positioned diagonally around the spine, as is seen in Giacometti's two drawings of the *Palace* in Basel (Tübingen 1981, no. 38) and New York (Paris 2001, no. 48). Another Brassaï photograph, published in *Minotaure* 1933, shows this cage in a slightly different position (see p. 24).

51. The Studio [L'Atelier]. 1932
Pencil on paper, 12⁵⁄₁₆ × 16⁹⁄₁₆" (31.2 × 42.1 cm)
Signed and dated lower right: "Alberto Giacometti 1932"
Öffentliche Kunstsammlung Basel, Kupferstichkabinett

REFERENCES: Hohl 1972, p. 307; Brenson 1974, no. 97; Hall 1980, illus. p. 17; Tübingen 1981, pp. 38 ff., [no.] Z 41; Berlin 1987, no. 39; Washington 1988, no. 16B; Bonnefoy 1991, p. 30; Paris 1991, no. 56 (ref.); Vienna 1996, pp. 166 ff., no. 76; Paris 2001, no. 51 (ref.).

52. My Studio [Mon Atelier]. 1932
Pencil on paper, 12⁹⁄₁₆ × 18⁷⁄₁₆" (31.9 × 46.9 cm)
Inscribed lower right: "dessin de mon atelier que vous m'avez fait la grande joie de / ne pas le [sic] trouver détestable. Alberto Giacometti 1932"
Öffentliche Kunstsammlung Basel, Kupferstichkabinett

REFERENCES: Hohl 1972, p. 306 ff.; Brenson 1974, no. 96; Tübingen 1981, pp. 38 ff., [no.] Z 40; Berlin 1987, no. 40; Washington 1988, no. 16A; Bonnefoy 1991, p. 30; Paris 1991, no. 55; Vienna 1996, no. 74 (ref.); Paris 2001, no. 50 (ref.).

53. Woman with Her Throat Cut
[Femme égorgée]. 1932
Bronze, 8 × 34½ × 25" (20.3 × 87.6 × 63.5 cm)
Signed and dated below left hand: "A Giacometti / 1932 4/5"; "Alexis Rudier Fondeur Paris"
The Museum of Modern Art, New York. Purchase, 1949

REFERENCES: *Minotaure* no. 3-4 (1933), illus. p. 46; "[First] Letter to Pierre Matisse" 1948, "Tentative catalogue of early works" 1948 (*Femme égorgée*), New York 1948, no. 8; Basel 1950, no. 95 (*Figure-objet*); Dupin 1962, pp. 18, 43; Meyer 1968, p. 82; Huber 1970, pp. 35 f., 47 f; Hohl 1972, p. 82 ff.; Zürich (coll. cat.) 1971, p. 100 (ref.); Brenson 1974, pp. 121 ff., 162 ff., no. 102; Tübingen 1981, p. 46; Lamarche-Vadel 1984, p. 54; Krauss 1984, p. 521; Lord 1985, pp. 138 f., 156, 276 f.; Venice (coll. cat.) 1985, no. 68 (ref.); Berlin 1987, p. 66; Washington 1988, p. 31, no. 18; Brenson 1988; Zürich (coll. cat.) 1990, no. 30 (ref.); Madrid 1990, pp. 16 ff., 83, no. 162 (ref.); Bonnefoy 1991, pp. 32 ff., 129, 209 ff.; Paris 1991, no. 57 (ref.); Didi-Huberman 1993, p. 52 f.; Dufrêne 1994, pp. 35 ff., 61 ff.; New York 1994, p. 64; Milan 1995, p. 15 f., Wolsburg 1995, p. 68 ff., Venice (coll. cat.) 1995, p. 17 ff., no. 3; Vienna 1996, pp. 37ff, no. 78 (ref.); Sylvester 1997, pp. 59 f.; Soldini 1998, p. 57; Saint-Etienne 1999, no. 23 (ref.).

REMARKS: For preliminary stages, see p. 104; for preliminary drawings, see Paris 2001, nos. 47 f. When the first bronzes were cast in 1940 (1/5 Guggenheim Venice, and 2/5 Musée national d'art moderne, Paris), the original plaster broke apart, so that the three additional copies cast in 1949 (3/5 Alberto Giacometti-Stiftung, Zürich, 4/5 The Museum of Modern Art, New York, 5/5 Scottish National Gallery of Modern Art, Edinburgh) had to be reproduced from the Paris copy (see Venice [coll. cat.] 1985).

54. No More Play [On ne joue plus]. 1932
Marble, wood, and bronze, 1⁵⁄₈ × 22¹³⁄₁₆ × 17¾" (4.1 × 58 × 45.1 cm)
Inscribed: "On ne joue plus" (in mirror-writing)
National Gallery of Art, Washington, D.C. Gift (partial and promised) of the Patsy R. and Raymond D. Nasher Collection, Dallas, in honor of the 50th Anniversary of the National Gallery of Art

REFERENCES: Zervos 1932, illus. p. 340 (*On ne joue plus*); "[First] Letter to Pierre Matisse" 1948, "Tentative catalogue of early works" 1948, New York 1948, no. 10; Meyer 1968, pp. 78 ff.; Huber 1970, p. 35; Hohl 1972, pp. 82 f., 104; Brenson 1974, pp. 83, 88 ff., no. 91; Krauss 1984, pp. 512 ff.; Lord 1985, p. 137; Dallas (coll. cat.) 1987, no. 27A (ref.); Berlin 1987, pp. 67, 74 f.; Washington 1988, p. 28; Madrid 1990, pp. 62 f.; Bonnefoy 1991, pp. 221 f.; Di Crescenzo 1992; Didi-Huberman 1993, pp. 231 ff.; Milan 1995, pp. 15, 22; Soldini 1998, p. 83.

55. Point to the Eye [Pointe à l'œil]. 1932
Wood and iron painted black, 5⁵⁄₁₆ × 23⁷⁄₁₆ × 12³⁄₁₆" (12.7 × 58.5 × 29.5 cm).
Signed and dated on back of base: "Alberto Giacometti 1932"
Musée national d'art moderne, Centre Georges Pompidou, Paris. AM 1981-251

REFERENCES: Zervos 1932, illus. p. 341 (*Relations désagrégeantes*, 1932); "[First] Letter to Pierre Matisse" 1948 (*Pointe menaçante, l'œil d'une tête-crâne*), "Tentative catalogue of early works" 1948 (*Pointe à l'œil, 1931*), New York 1948, no. 5 (*Drive to the Eye*); Dupin 1962, pp. 18, 41; Meyer 1968, pp. 73 f., 95 f.; Huber 1970, p. 47; Zürich (coll. cat.) 1971, p. 96 (ref.); Hohl 1972, pp. 82, 103, 138; Brenson 1974, pp. 83 ff., no. 81; Tübingen 1981, p. 66; Clair 1983; Lamarche-Vadel 1984, pp. 69 ff.; Krauss 1984, p. 512; Lord 1985, pp. 137 ff.; Graevenitz 1986, pp. 11 ff.; Berlin 1987, pp. 66 f.; Washington 1988, p. 37; Zürich (coll. cat.) 1990, no. 28 (ref.); Madrid 1990, p. 62; Bonnefoy 1991, pp. 31 ff.,

193 ff.; Paris 1991, no. 52 (ref.); Clair 1992, p. 20; Dufrêne 1994, pp. 31, 51.; Vienna 1996, pp. 35 f.; Dufrêne 1997, pp. 38 ff.; Soldini 1998, pp. 37 ff., 68 ff., 237 ff.; Saint-Etienne 1999, no. 15 (ref.)

REMARKS: In Zürich, original plaster from Alberto Giacometti-Stiftung, Zürich, GS 21, is shown.

56. Caught Hand [Main prise]. 1932
Wood and metal, 7⁷⁄₈ × 23⁷⁄₁₆ × 10⁵⁄₈" (20 × 59.5 × 27 cm)
Signed and dated on back, left: "Alberto Giacometti 1932" (pencil)
Alberto Giacometti-Stiftung, Zürich. GS 22

REFERENCES: Zervos 1932, illus. p. 338 (*Courrounou U-Animal*, 1932); "[First] Letter to Pierre Matisse" 1948 (*Main prise au doigt*), "Tentative catalogue of early works" 1948 (*Doigt pris*); Dupin 1962, p. 42; Basel 1963, no. 19 (*Main prise*); Meyer 1968, pp. 81 f.; Huber 1970, p. 36; Zürich (coll. cat.) 1971, p. 98 (ref.); Hohl 1972, pp. 82, 102; Brenson 1974, pp. 105 f., no. 93; Duisburg 1977, p. 58; Lord 1985, p. 139; Berlin 1987, pp. 66 ff., 93; Washington 1988, p. 37; Zürich (coll. cat.) 1990, no. 29 (ref.); Madrid 1990, p. 62 ff.; Bonnefoy 1991, pp. 206, 217 ff.; Dufrêne 1994, pp. 49 ff., 61; Soldini 1998, pp. 65 ff.; Saint-Etienne 1999, pp. 21 ff.

57. Flower in Danger
[Fleur en danger]. 1933
Wood, metal, and plaster, 22¹⁄₁₆ × 30¹¹⁄₁₆ × 7¹⁄₁₆" (56 × 78 × 18 cm)
Signed on base board, front right: "Alberto Giacometti" (with brush in white)
Alberto Giacometti-Stiftung, Zürich. GS 24

REFERENCES: *Minotaure*, no. 3-4, 1933, p. 47; "Tentative catalogue of early works" 1948 (*Fil tendu*, 1933), New York 1948, no. 12 (*Taut Thread*, 1933); Dupin 1962, pp. 18, 43; Bucarelli 1962, illus. 18 (*Fleur en danger*); Meyer 1968, p. 81; Huber 1970, p. 36; Zürich (coll. cat.) 1971, p. 102 (ref.); Hohl 1972, p. 83; Brenson 1974, p. 171, no. 121; Lamarche-Vadel 1984, p. 54; Berlin 1987, pp. 66 ff; Washington 1988, pp. 31, 40, no. 19; Zürich (coll. cat.) 1990, no. 31 (ref.); Paris 1991, no. 60 (ref.); Dufrêne 1994, pp. 37, 49 ff., 77; Vienna 1996, no. 80 (ref.); Soldini 1998, pp. 66 f.

REMARKS: In a photograph taken by Brassaï (see page 82), published in *Minotaure* in 1933, *Flower in Danger* is shown resting on top of a sculptor's turntable with an unpolished version of the plaster head; from 1962 to 2001 the upper part of the wire stand that supports the head was bent, so that the position of the head was incorrect.

The frequent dating of this photograph by Brassaï to 1932 is without foundation; it was, more likely, made only in the summer of 1933, judging from its publication in *Minotaure*. The defective original plaster is in the artist's estate; the wood version was executed by Ipústegui.

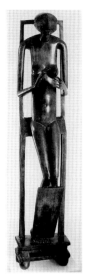

58. Hands Holding the Void (Invisible Object) [Mains tenant le vide (L'Objet invisible)]. 1934
Bronze, 59⅞ × 12⅞ × 10" (152.1 × 32.6 × 25.3 cm)
Signed and dated on back of base: "Alberto Giacometti / 1935 / 0/6"; "Susse Fondeur Paris"
The Museum of Modern Art, New York. Louise Reinhardt Smith Bequest, 1995

REFERENCES: Breton 1934; "[First] Letter to Pierre Matisse" 1948, "Tentative catalogue of early works" 1948 (*Mains tenant le vide,* 1934), New York 1948, no. 13; Dupin 1962, p. 43; Meyer 1968, pp. 85 ff.; Huber 1970, p. 45; Hohl 1972, pp. 103 f.; Brenson 1974, pp. 184ff, no. 135 (ref.); Poley 1977, p. 184; Tübingen 1981, p. 53; Lamarche-Vadel 1984, pp. 59 ff., 71; Krauss 1984, pp. 503 ff.; Lord 1985, p. 151 ff.; Berlin 1987, pp. 69 f., 88 ff., 109 f., no. 58; Washington 1988, pp. 31 ff, no. 21; Madrid 1990, pp. 64 f., 83 ff., no. 167 (ref.); Bonnefoy 1991, pp. 55 ff.; Paris 1991, no. 59 (ref.); Didi-Huberman 1993, pp. 61 ff.; Dufrêne 1994, pp. 92 ff.; Vienna 1996, no. 83 (ref.); Sylvester 1997, pp. 17 ff.; Soldini 1998, pp. 86 ff., 239 ff.; Saint-Etienne 1999, pp. 19 ff.

REMARKS: Photograph of original plaster with *Man*, 1925–26, to the right of it is shown on page 113.

59. Walking Woman
[Femme qui marche]. 1932–34
Bronze, 59⁷⁄₁₆ × 9⁷⁄₁₆ × 15¹⁄₁₆" (151 × 24 × 38.2 cm)
Signed on base behind right foot: "Alberto Giacometti IV/IV"

Museum of Fine Arts, Boston. Henry Lee Higginson and William Francis Warden Funds. Inv. 64.520

REFERENCES: Paris 1933; "Tentative catalogue of early works" 1948 (*Femme qui marche* ,1933); Meyer 1968, pp. 88 f.; Hohl 1972, pp. 103 f.; Brenson 1974, pp. 167 f., no. 104, 116, 117, 118; Tübingen 1981, pp. 53 f.; London (coll. cat.) 1981, pp. 276 f.; Lamarche-Vadel 1984, pp. 70 f.; Lord 1985, pp. 144 f., 179; Venice (coll. cat.) 1985, no. 67 (ref.); Berlin 1987, pp. 68 f., 109 f.; Washington 1988, p. 31, no. 17; Madrid 1990, pp. 64, 83 ff., no. 165; Paris 1991, no. 58 (ref.); Bonnefoy 1991, pp. 210 f., 540; Milan 1995, p. 15, no. 16 (ref.); Venice (coll. cat.) 1995, pp. 13 ff., 22 f.; Vienna 1996, no. 81 (ref.); Stuttgart 1998, pp. 26 f.; Soldini 1998, p. 69; Mendrisio 2000, p. 22, no. 101 (ref.).

REMARKS: This work (without its beveled base) is visible in Giacometti's 1932 drawing of his atelier (plate 51). For a 1933 Surrealist exhibition in Paris at the Galerie Pierre Colle, Giacometti added detachable objects as arms and a head, as documented in a photograph by Man Ray (Saint-Etienne 1999, illus. p. 98).

60. Figure. 1935
Ink on paper, 11⅛ × 7¹³⁄₁₆" (28.3 × 19.9 cm)
Signed and dated lower right: "Alberto Giacometti / 1935"
Collection Eberhard W. Kornfeld, Bern

REFERENCES: Auction catalogue Kornfeld, Bern, January 13, 1975, no. 355; Berlin 1987, no. 52; Washington 1988, no. 24; Madrid 1990, no. 19; Bonnefoy 1991, p. 541; Paris 1991, no. 62 (ref.); Vienna 1996, no. 92 (ref.); Paris 2001, no. 61 (variant in the Estate of Annette Giacometti).

61. The (Surrealist) Table
[Table (surréaliste)]. 1933
Ink on paper, 8¾ × 7¼" (22.2 × 18.4 cm)
Signed lower right: "Alberto Giacometti"
Judy and Michael Steinhardt Collection, New York

REFERENCES: Santa Cruz de Tenerife 1935, no. 40; New York 1994, p. 132; auction catalogue Christie's, New York, November 10, 1994, no. 225; Milan 1995, no. 22 (ref.); Vienna 1996, no. 88 (ref.); Paris 2001, no. 60 (ref.).

REMARKS: The plaster of *The (Surrealist) Table* is in the Musée national d'art moderne, Paris (Saint-Etienne 1999, no. 25).

62. Head—Skull [Tête-crâne]. 1934
Plaster, 7⁵⁄₁₆ × 7⅞ × 8⅞" (18.5 × 20 × 22.5 cm)
Signed bottom right: "Alberto Giacometti" (incised)

Alberto Giacometti-Stiftung, Zürich. GS 26

REFERENCES: *Minotaure* no. 5, 1934, illus. p. 42 (*Tête d'homme*); "[First] Letter to Pierre Matisse" 1948 (*Tête crâne*), "Tentative catalogue of early works" 1948 (*Tête*); Bucarelli 1962, illus. 19 (*Tête cubiste*); Dupin 1962, p. 43; Meyer 1968, pp. 90 f.; Huber 1970, pp. 44 f.; Hohl 1972, pp. 104 f.; Zürich (coll. cat.) 1971, pp. 106 ff. (ref.); Washington (coll. cat.) 1974, p. 695 (ref.), illus. 404; Brenson 1974, pp. 180 ff., no. 133; Lamarche-Vadel 1984, pp. 71 ff.; Dallas (coll. cat.) 1987, no. 28 (ref.); Washington 1988, p. 32, no. 22; Zürich (coll. cat.) 1990, no. 33 (ref.); Paris 1991, no. 61 (ref.); Bonnefoy 1991, p. 214; Didi-Huberman 1993, pp. 94 ff.; Dufrêne 1994, p. 78; Milan 1995, p. 17; Vienna 1996, no. 91 (ref.); Sylvester 1997, p. 64 f.; Soldini 1998, pp. 87 f.; Saint-Etienne 1999, no. 30 (ref.).

REMARKS: The title *Cubist Head* (which seems to have originated with Bucarelli 1962) should be avoided, as Meyer (1968) has shown. Various versions in plaster, terra-cotta, and marble survive from the time of conception; the bronzes were cast later. In the plaster in the Hirshhorn Museum and Sculpture Garden (ex-collections Man Ray, G. David Thompson; see Washington 1974), the right eye is believed to have been cut out by Max Ernst.

63. Cube (Nocturnal Pavilion)
[Cube (Pavillon nocturne)]. 1934
Bronze, 37 × 21¼ × 23¼" (94 × 54 × 59 cm)
Signed on front, bottom left: "Alberto Gicometti 1/2"; on back, bottom: "Susse Fondeur Paris"
Alberto Gicometti-Stiftung, Zürich. GS 25

REFERENCES: *Minotaure* no. 5, 1934, illus. p. 42 (*Pavillon nocturne*); Luzern 1935, no. 33 (*Partie d'une sculpture*); "[First] Letter to Pierre Matisse" 1948, "Tentative catalogue of early works" 1948 (*Cube*); Meyer 1968, pp. 89 ff.; Dupin 1962, p. 43; Huber 1970, pp. 42 ff., 88 ff; Zürich (coll. cat.) 1971, p. 104 (ref.); Hohl 1972, pp. 101 ff., 134 ff.; Brenson 1974,

pp. 174 ff., no. 124; Tübingen 1981, p. 50; Lamarche-Vadel 1984, pp. 71 ff.; Berlin 1987, p. 68; Washington 1988, p. 32, no. 23; Madrid 1990, no. 166; Zürich (coll. cat.) 1990, no. 32 (ref.); Bonnefoy 1991, pp. 212 ff.; Paris 1991, pp. 43 ff., no. 63 (ref.); Didi-Huberman 1993; Dufrêne 1994, pp. 34, 49, 92; Milan 1995, p. 17; Vienna 1996, pp. 39 ff.; Soldini 1998, pp. 85 ff., 108; Saint-Etienne 1999, no. 29 (ref.).

REMARKS: At least two original plasters (Musée national d'art moderne, Paris, and the artist's estate) exist. Neither includes the engraved images from c. 1936, seen on the bronze in the Giacometti-Stiftung, Zürich. A plaster, displayed with its original base in Giacometti's atelier, is shown on page 117. A retouched print of this image was reproduced in *Minotaure* in 1934.

64. Self-Portrait [Autoportrait]. 1935
Pencil on paper, 14¹⁵⁄₁₆ × 12⅝" (38 × 32 cm)
Signed and dated lower right: "Alberto Giacometti 1935"
Private collection, Paris

REFERENCES: Lord 1972, no. 23; Brenson 1974, no. 147; Saint-Paul 1978, no. 207; Geneva 1986, illus. p. 19; Berlin 1987, no. 60; Bonnefoy 1991, illus. p. 191; Paris 1991, no. 65 (ref.); Didi-Huberman 1993, p. 34; Paris 2001, no. 64 (ref.).

65. The Artist's Mother
[La Mère de l'artiste]. 1937
Oil on canvas, 28¹⁄₁₆ × 24⅛" (71.2 × 61.2 cm)
Private collection

REFERENCES: New York 1948, no. 16; Meyer 1968, p. 100; Lamarche-Vadel 1984, p. 74; Lord 1985, pp. 185, 289; Berlin 1987, pp. 116 ff.; Washington 1988, no. 26; Zürich 1990, pp. 133 f.; Bonnefoy 1991, pp. 257 f.; Paris 1991, no. 64 (ref.); Dufrêne 1994, pp. 100, 106; Milan 1995, p. 19, no. 90 (ref.); Vienna 1996, p. 55; Soldini 1998, pp. 132 f.

66. Apple on a Sideboard
[Pomme sur un buffet]. 1937
Oil on canvas, 10⅝ × 10⅝" (27 × 27 cm)
Collection William Louis-Dreyfus

REFERENCES: Lord 1985, pp. 183 ff., 289; Berlin 1987, pp. 116 ff.; Washington 1988, no. 28; Paris 1991, no. 66 (ref.); Bonnefoy 1991, p. 256; Soldini 1998, p. 132.

67. Apple on the Sideboard
[La Pomme sur le buffet]. 1937
Oil on canvas, 28⅜ × 29¾" (72 × 75.5 cm)
Signed and dated lower right "Alberto Giacometti 1937"
Private collection

REFERENCES: New York 1948, no. 14; Huber 1970, p. 100; Lamarche-Vadel 1984, p. 74; Berlin 1987, pp. 116 ff.; Washington 1988, no. 27; Bonnefoy 1991, pp. 257 f.; Paris 1991, no. 67 (ref.); Dufrêne 1994, pp. 84, 100 ff.; Milan 1995, p. 19, no. 91 (ref.); Vienna 1996, p. 55, no. 97 (ref.).

68. Pope Innocent X, after Velázquez [Pape Innocent X d'après Velázquez]. c. 1936 (dated 1942)
Pencil on paper, 8¼ × 10¼"
(21 × 26 cm)
Signed and dated lower right: "Alberto Giacometti 1942"
Musée Picasso, Paris

REFERENCES: Carluccio 1967, illus. no. 101; "Picasso und seine Sammlung," Kunsthalle der Hype-Kulturstiftung, Münich 1998, no. 40.

REMARKS: This drawing, after a reproduction of a 1649 Velázquez painting in the Galleria Doria-Pamphili, Rome, was probably completed around 1936, and the signature and date added later.

69. Head Studies c. 1937
Pencil on paper, 10⅝ × 8¼"
(27 × 21 cm)
Alberto Giacometti-Stiftung, Zürich, sketchbook GS233, fol. 10v. Gift of Bruno and Odette Giacometti

REFERENCES: Klemm 2000.

70. Study from a Head of Diedefre
[Etude d'après une tête de Diedefre]. c. 1937
Ink on paper, 10⅝ × 8¼" (27 × 21 cm)
Collection Kazuhito Yoshii, New York
REFERENCES: Kiyoharu 1990, no. 5; Milan 1995, no. 18; Paris 2001, no. 185 (ref.).

REMARKS: After a head of the pharaoh Diedefre (IV Dynasty, c. 2520 B.C.).

71. Study from an Egyptian Relief
[Etude d'après un relief égyptien]. c. 1937 (dated 1942)
Ink on paper, 9⁷⁄₁₆ × 7⅜"
(24 × 18.7 cm)
Signed and dated lower right: "Alberto Giacometti 1942"
Private collection, Switzerland
REFERENCES: Zürich 1962, no. 193; Tübingen 1981, p. 86; Madrid 1990, no. 30; Paris 1991, no. 304 (ref.); Mendrisio 2000, no. 47; Paris 2001, no. 192 (ref.).

REMARKS: One of several studies after a relief in the tomb of Ipui, Thebes, XIX Dynasty (plate 6 in Ludwig Curtius, *Handbuch für Kunstwissenschaft. Die Antike Kunst II. Die klassische Kunst Griechenlands*, Potsdam, 1938).

72. Three Studies of Gudea Head
[Trois études d'après le Goudéa]. c. 1937 (dated 1935)
Ink on paper, 10⁷⁄₁₆ × 8¼"
(26.5 × 21 cm)
Signed and dated left: "Alberto Giacometti 1935"
Private collection, Paris

REFERENCES: Paris 1980, illus. p. 288; Geneva 1986, illus. p. 52; Paris 1991, no. 311.

REMARKS: Studies from a reproduction in Curtius 1938, plate 71.

73. Vases and Flowers
[Carafes et fleurs]. 1938
Ink on paper, 10⅝ × 8¼"
(27 × 20.9 cm)
Signed and dated lower right: "Alberto Giacometti 1938"
Alberto Giacometti-Stiftung, Zürich. GS 98
REFERENCES: Basel 1963, no. 100; Zürich (coll. cat.) 1971, p. 229 (ref.); Tübingen 1981, [no.] Z 44 (ref.); Zürich (coll. cat.) 1990, no. 132.

74. The Chiffonier [Le Chiffonier].
c. 1941
Pencil on paper, 15¹⁵⁄₁₆ × 12⅜"
(40.5 × 31.5 cm)
Signed and dated lower right: "Alberto Giacometti / 1941"
Collection William Louis-Dreyfus

REFERENCES: Paris (Bernard) 1969, no. 6; Paris 1969 (Orangerie), no. 223; Paris 2001, no. 72 (ref.) .

REMARKS: The drawing shows the sewing table in the living room in Stampa; to the right is the door to the large bedroom. The inscription was probably added at a later date; Alberto was not in Stampa in 1941.

75. Interior [Intérieur]. 1942 (dated 1940)
Pencil on paper, 12³⁄₁₆ × 9⁷⁄₁₆"
(31 × 24 cm)
Signed and dated lower right: "Alberto Giacometti 1940"
Private collection, courtesy Pieter Coray

REFERENCES: Hohl 1972, illus. p. 92; Geneva 1986, illus. p. 60; Berlin 1987, no. 97.

REMARKS: Inscription later, at which time, as he commonly did, Giacometti corrected the date.

76. "Automatic Drawing"
["Dessin automatique"]. 1943
Pencil on paper, 12¹³⁄₁₆ × 9⅝"
(32.5 × 24.5 cm)
Signed and dated lower right: "Alberto Giacometti 1943"
Private collection, courtesy Claude Bernard Gallery, Ltd.

REFERENCES: Geneva 1967, no. 84; Paris 2001, no. 77 (ref.).

77. Small Bust on a Double Pedestal
[Petit buste sur double socle]. 1940–45
Bronze, 4⁷⁄₁₆ × 2⅜ × 2⁵⁄₁₆"
(11.2 × 6 × 5.8 cm)
Inscribed on bottom right: "A. Giacometti"; on back, bottom: "THINO FON"
Alberto Giacometti-Stiftung, Zürich. GS184

REFERENCES: *Cahiers d'Art* 1946, pp. 253 ff.; New York 1965, no. 20; London 1965, illus. 10; Meyer 1968, pp. 105 f.; Huber 1970, p. 48; Hohl 1972, pp. 107 f.; Lamarche-Vadel 1986, pp. 78 f.; Stuttgart 1987, p. 99; Washington 1988, no. 29; Madrid 1990, no. 177; Bonnefoy 1991, pp. 269 ff.; Paris 1991, no. 75; Dufrêne 1994, pp. 115 ff.; Vienna 1996, no. 104; Mendrisio 2000, no. 106 (ref.).

REMARKS: In the literature, the miniature sculptures (including plates 78, 79) are generally discussed as a group rather than individually. It is difficult to date these works with any precision; some were probably executed as early as 1940, before Giacometti left Paris for Switzerland in 1942; others may be as late as 1945.

78. Small Figure on a Pedestal
[Petite figure sur socle]. 1940–45
Plaster and metal on plaster base, 4½ × 2 × 2⅛" (11.4 × 5.1 × 5.2 cm)
The Museum of Modern Art, New York. Gift of Mr. and Mrs. Thomas B. Hess, 1966

REFERENCES: *Cahiers d'Art* 1946, pp. 253 ff.; New York 1965, no. 20; London 1965, illus. 10; Meyer 1968, pp. 105 f.; Huber 1970, p. 48; Hohl 1972, pp. 107 f.; Lamarche-Vadel 1986, pp. 78 f.; Stuttgart 1987, p. 99; Washington 1988, p. 118; Bonnefoy 1991, pp. 269 ff.; Dufrêne 1994, pp. 115 ff.

79. Small Figure on a Pedestal
[Petite figure sur socle]. 1940–45
Plaster and metal on plaster base, 3¾ × 1¹¹⁄₁₆ × 1¾" (9.5 × 4.3 × 4.2 cm)
The Museum of Modern Art, New York. Gift of Mr. and Mrs. Thomas B. Hess, 1966

REFERENCES: *Cahiers d'Art* 1946, pp. 253 ff.; New York 1965, no. 20; London 1965, illus. 10; Meyer 1968, pp. 105 f.; Huber 1970, p. 48; Hohl 1972, pp. 107 f.; Lamarche-Vadel 1986, pp. 78 f.; Stuttgart 1987, p. 99; Washington 1988, p. 118; Bonnefoy 1991, pp. 269 ff.; Dufrêne 1994, pp. 115 ff.

80. Nude [Nu]. 1942–43
Oil on wood and plaster, 64³⁄₁₆ × 16¾" (163 × 42.5 cm)
Private collection

REFERENCES: Münich 1997, no. 34; Saint-Paul 1997, no. 163; Montreal 1998, no. 33.

REMARKS: Shown in New York only.

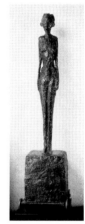

81. Woman with Chariot
[Femme au chariot]. 1942–43
Bronze, 65¾ × 15¾ × 14½" (167 × 40 × 36.8 cm)
Signed: "1/6"; "Susse Fondeur Paris"
Private collection, New York

REFERENCES: Negri 1956; Basel 1964, no. 24a (*Grande figure au chariot*); Meyer 1968, pp. 106, 173 ff.; Huber 1970, pp. 46f; Hohl 1972, pp. 133 f.; Stuttgart (coll. cat.) 1982, pp. 135 f. (ref.); Lamarche-Vadel 1984, p. 125; Lord 1985, pp. 228, 335, 357; Berlin 1987, pp. 110 f.; Washington 1988, p. 33, no. 31; Madrid 1990, pp. 87 f.; Bonnefoy 1991, p. 282; Paris 1991, no. 78 (ref.); Dufrêne 1994, p. 170; Soldini 1998, pp. 132 ff.; Stuttgart (coll. cat.) 1999, pp. 186 ff., no. 37; Saint-Etienne 1999, pp. 19 ff.

REMARKS: The painted original (now in the Wilhelm-Lehmbruck Museum, Duisburg) was built up of plaster and filling and was acquired in the 1950s by Dr. Corbetta, Giacometti's physician in Chiavenna. Giacometti later found it in Chiavenna, with part of the base and the little wagon removed. In his estate, there is a cast of this work as found in Chiavenna, set on a reconstruction of the lost portions of the base. A plaster was cast from this reconstruction and the joint was covered with plaster as in the original. This plaster corresponds to the bronze cast, exhibited here, which was probably produced at the same time (around 1962). The painted original in the atelier in Maloja is shown on page 135. Behind it, on the wall, is the painting that Giacometti made after this work (plate 80). In Zürich, bronze cast "5/6," Staatgalerie Stuttgart, is shown.

82. Studio Interior [L'Atelier]. c. 1940
Pencil on paper, 14⅛ × 9⅝" (36 × 24.5 cm)
Signed lower right: "Alberto Giacometti"
Collection William Louis-Dreyfus

REFERENCES: Geneva 1970, no. 3; Lord 1971, no. 28; Paris 2001, no. 78 (ref.).

REMARKS: There are hints that this work might be dated c. 1945. A drawing dated 1947 (Bonnefoy 1991, p. 274) shows exactly the same scene in a more fluid style. For further discussion of the dating of this work, see Paris 2001.

83. Three Portraits of Pierre Loeb
[Trois Portraits de Pierre Loeb]. 1946
Pencil on paper, 9¼ × 8⅞" (23.5 × 22.5 cm)
Private collection

REFERENCES: Paris 1969 (Orangerie), no. 235; Paris 1991, no. 150 (ref.); Saint-Etienne 1999, no. 49 (ref.); Paris 2001, no. 82 (ref.).

84. Apples [Pommes]. 1946
Pencil on paper, 14 × 13" (35.5 × 33 cm)
Signed and dated lower right: "Alberto Giacometti 1946"
Collection Allan Frumkin, New York
REFERENCES: Hohl 1972, illus. p. 96; Berlin 1987, no. 128.

85. Jean-Paul Sartre. 1946
Pencil on paper, 11¹³⁄₁₆ × 8⅝" (30 × 22 cm)
Signed lower right: "Alberto Giacometti"
Collection William Louis-Dreyfus
REFERENCES: Lord 1971, no. 40; Hohl 1972, illus. p. 100; Saint-Paul 1978, no. 213; Geneva 1986, illus. p. 115; Berlin 1987, no. 99; Washington 1988, no. 33; Paris 2001, no. 85.

86. Homage to Balzac
[Hommage à Balzac]. 1946
Pencil on paper, 15⅞ × 12" (45.4 × 30.5 cm)
Signed and dated lower right: "Alberto Giacometti 1946"
Robert and Lisa Sainsbury Collection, University of East Anglia, Norwich
REFERENCES: Lord 1971, no. 33; Geneva 1986, illus. p. 11; Berlin 1987, no. 107; Bonnefoy 1991, illus. p. 308; Norwich (coll. cat.) 1997, no. 30; Paris 2001, no. 222.

REMARKS: Like many artists, Giacometti identified with the painter Frenhofer, the hero of Balzac's novela *Le Chef d'œuvre inconnu*. Shown in Zürich only.

87. The Artist's Mother
[La Mère de l'artiste]. 1946
Pencil on paper, 19½ × 13¾" (49.5 × 35 cm)
Signed and dated lower right: "Alberto Giacometti 1946"
Private collection

REFERENCES: New York 1965, no. 109; Lord 1971, no. 35; Berlin 1987, no. 108; Washington 1988, no. 32; London (Gibson) 1989, no. 2 (ref.); Bonnefoy 1991, illus. p. 309.

REMARKS: Shown in New York only.

88. Head of Diego [Tête de Diego]. 1947
Pencil on paper, 19⅜ × 9⅝" (49.2 × 24.5 cm)
Signed and dated lower right: "Alberto Giacometti 1947"
Private collection, courtesy Claude Bernard Gallery, Ltd.
REFERENCES: New York (Bernard) 1988, no. 8; Paris 1991, no. 93; Milan 1995, no. 38.

89. Head on a Rod [Tête sur tige]. 1947
Plaster, painted reddish in spots, 19¹¹⁄₁₆ × 4¹⁵⁄₁₆ × 6¹¹⁄₁₆" (50 × 12.5 × 17 cm)
Signed on base, left: "Alberto Giacometti" (brush); right: "Alberto" (pencil)
Alberto Giacometti-Stiftung, Zürich, on permanent loan to the Kunstmuseum Basel. GS 33

REFERENCES: New York 1948, no. 28; Meyer 1968, pp. 43, 121 f., 145; Huber 1970, pp. 90 ff.; Zürich (coll. cat.) 1971, p. 120 (ref.); Hohl 1972, pp. 104, 105, 191; Tübingen 1981, p. 66; Lamarche-Vadel 1984, p. 126; Lord 1985, pp. 285, 387 f.; Berlin 1987, p. 93; Washington 1988, pp. 39 ff., no. 36; Zürich (coll. cat.) 1990, no. 37 (ref.); Bonnefoy 1991, pp. 292 ff.; Paris 1991, no. 91 (ref.); Clair 1992, pp. 9 ff.; Didi-Huberman 1993, pp. 87 ff.; Basel 1995, p. 27; Vienna 1996, no. 130 (ref.); Sylvester 1997, pp. 74, 84, 114; Leinz 1997; Soldini 1998, pp. 88, 133, 252.

REMARKS: A less expressive variant was cast in bronze (Washington 1988, no. 36).

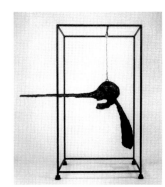

90. The Nose [Le Nez]. 1947
Bronze, wire, rope, and steel; cage 31⅞ × 15⅜ × 19" (81 × 39.1 × 48.3 cm); head 17 × 3³⁄₁₆ × 27¼" (43.2 × 8.1 × 69.2 cm)
Signed bottom: "Alberto Giacometti

5/6 Susse Fondeur Paris"
Solomon R. Guggenheim Museum, New York

REFERENCES: "[First] Letter to Pierre Matisse" 1948, New York 1948, no. 31; Dupin 1962, p. 57; Meyer 1968, pp. 43 f., 124 ff., 166 f.; Huber 1970, p. 90; Zürich (coll. cat.) 1971, p. 118 (ref.); Hohl 1972, pp. 138 f.; Washington (coll. cat.) 1974, pp. 388; Duisburg 1977, p. 68; Tübingen 1981, p. 66; Clair 1983, pp. 93 ff.; Lamarche-Vadel 1984, p. 126; Lord 1985, pp. 286 ff., 387 f.; Berlin 1987, p. 68; Washington 1988, p. 37, no. 34; Zürich (coll. cat.) 1990, no. 36 (ref.); Madrid 1990, p. 63; Bonnefoy 1991, pp. 254 ff.; Paris 1991, no. 90 (ref.); Clair 1992; Didi-Huberman 1993, p. 87; Dufrêne 1994, p. 78; Vienna 1996, no. 129 (ref.); Leinz 1997; Soldini 1998, pp. 53, 71 ff., 114; Saint-Etienne 1999, pp. 17 ff., no. 50 (ref.).

REMARKS: Painted plaster version from the Alberto Giacometti-Stiftung, Zürich, GS 36, on loan to the Kunstmuseum Basel, is shown on page 147.

91. The Leg [La Jambe]. 1958
Bronze, 86⅝ × 11¹³⁄₁₆ × 18¹⁵⁄₁₆" (220 × 30 × 46.5 cm)
Signed on base plate, left: "Alberto Giacometti 1/6"; back: "Susse Fondeur Paris"
Alberto Giacometti-Stiftung, Zürich, on permanent loan to the Kunstmuseum Basel. GS 61

REFERENCES: Venice 1962, no. 72; Meyer 1968, pp. 204 ff.; Huber 1970, pp. 92 f.; Zürich (coll. cat.) 1971, p. 176 (ref.); Duisburg 1977, pp. 103–107; Lamarche-Vadel, p. 142; Lord 1985, pp. 387 f.; 445; Zürich (coll. cat.) 1990, no. 67 (ref.); Bonnefoy 1991, p. 544; Paris 1991, no. 270; Vienna 1996, no. 223 (ref.); Leinz 1997; Saint-Etienne 1999, pp. 17 ff.

REMARKS: According to Giacometti's letter to Eduard Trier, of February 13, 1960 (Duisburg 1977, p. 105), the concept for this work dates to 1947.

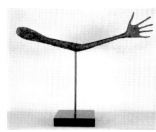

92. The Hand [La Main]. 1947
Bronze, 20⅞ × 28" (53 × 71.1 cm)
Donald L. Bryant, Jr. Family Trust
REFERENCES: New York 1948, no. 27; Dupin 1962, p. 62 f.; Meyer 1968, pp. 130 ff., 145 f., 166 f.; Huber 1970,

p. 92; Zürich (coll. cat.), 1971, pp. 110 ff. (ref.); Hohl 1972, p. 138 f.; Lamarche-Vadel 1984, p. 126; Lord 1985, p. 286 ff., 387 f.; Berlin 1987, p. 93; Stoichita 1987, pp. 75 ff.; Washington 1988, p. 37 ff., no. 35; Zürich (coll. cat.) 1990, nos. 34 and 35 (ref.); Paris 1991, no. 89 (ref.); Bonnefoy 1991, pp. 329 ff.; Clair 1992, p. 45; Dufrêne 1994, pp. 144 ff.; Vienna 1996, no. 128 (ref.); Leinz 1997; Sylvester 1997, pp. 84ff; Saint-Etienne 1999, pp. 17 ff.

REMARKS: The painted plaster from the Alberto Giacometti-Stiftung Zürich, GS 28, is shown in Zürich. Plaster shown on page 149.

93. Figures in an Interior
[Figures dans un intérieur]. 1946
Pencil on paper, 12¾ × 19⅝" (32.4 × 49.9 cm)
Signed and dated lower right "Alberto Giacometti 1946"
Morton G. Neumann Family Collection
REFERENCES: Washington 1980, no. 81.

REMARKS: Shown in New York only.

94. Standing Woman
[Femme debout]. c. 1947
Pencil on paper, 24 × 18½" (61 × 47 cm)
Inscribed lower right ; "Pour Max Ernst très affectueusement / Alberto Giacometti"
Collection Charlotte and Duncan MacGuigan, New York
REFERENCES: Lord 1971, no. 56; Berlin 1987, no. 116; Washington 1988, no. 56; Paris 1991, no. 80 (ref.); Vienna 1996, no. 112.

REMARKS: Contrary to descriptions in previous literature, the drawing is not dated. Stylistically it belongs with the drawings from 1946–47.

95. Standing Woman
[Femme debout]. 1946
Pencil on paper, 21¹⁄₁₆ × 11¼" (53.5 × 28.5 cm)
Signed and dated lower right: "Alberto Giacometti/1946"
Collection Jan and Marie-Anne Krugier-Poniatowski
REFERENCES: Bouchet 1969, illus. p. 6; Hohl 1972, p. 296, illus. 73; Madrid 1990, no. 140 (ref.); Bonnefoy 1991, illus. p. 312; Paris 1991, no. 81 (ref.); Vienna 1996, no. 109 (ref.); Berlin (coll. cat./Krugier) 1998, no. 169; Paris 2001, no. 86 (ref.).

REMARKS: Shown in Zürich only.

96. Femme Leonie. 1947
Bronze, 60 × 5¹¹⁄₁₆ × 13¹¹⁄₁₆" (153 × 14.5 × 35.5 cm)
Signed on base, right: "Alberto Giacometti / 6/6"
Private collections

REFERENCES: Bern 1955; London 1964, no. 112 (*Lion Woman*); Meyer 1968, pp. 143 ff., 169 ff.; Hohl 1972, pp. 135 ff.; Venice (coll. cat.) 1985, no. 69 (ref.); Madrid 1990, no. 191 (ref.); Paris 1991, no. 84 (ref.); Venice (coll. cat.) 1995, pp. 13 ff., no. 4; Vienna 1996, no. 114 (ref.).

REMARKS: The figure was shown in 1955 in Bern along with four Women of Venice. In a photograph of this exhibition (Saint-Etienne 1999, p. 170) the original base, later replaced by Giacometti before casting, is still visible. In 1957, Peggy Guggenheim saw the plaster in the atelier and commissioned a bronze. Giacometti titled the figure *Femme Leoni* in reference to Guggenheim's Palazzo Venier dei Leoni (Venice 1985, no. 69, note 1). At the owner's request, the work is here titled *Femme Leonie*.

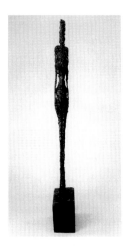

97. Tall Figure [Grande Figure]. 1947
Bronze, 79½ × 8⅜ × 16⅝" (201.2 × 21.1 × 42.2 cm).
Signed base, upper left: "1/6 Alberto Giacometti"; top corner: "Susse Fondeur Paris" (incised)
Hirshhorn Museum and Sculpture Garden, Smithsonian Institution, Washington D.C. Gift of Joseph H. Hirshhorn, 1966

REFERENCES: New York 1948, no. 21; Meyer 1968, p. 143 ff.; Huber 1970, pp. 53, 60 ff.; Zürich (coll. cat.) 1971, p. 116 (ref.); Hohl 1972, pp. 136 ff.; Washington (coll. cat.) 1974, p. 695 (ref.); Lamarche-Vadel 1984, p. 126; Berlin 1987, pp. 91 f., no. 81; Washington 1988, p. 40 ff., no. 38; Zürich (coll. cat.) 1990, no. 38 (ref.); Bonnefoy 1991, p. 332; Paris 1991, no. 83 (ref.); Dufrène 1994, p. 181; Vienna 1996, p. 23; Stuttgart 1998, no. 32 (ref.); Stuttgart (coll. cat.) 1999, pp. 38 ff., no. 38.

REMARKS: The first copies were cast with a low, irregular base measuring 7⅞" (20 cm) high; later casts by Susse have an 11" (28 cm) base as does the Hirshhorn Museum and

Sculpture Garden cast. Bronze cast "1/6" from the Staatgalerie Stuttgart, Collection Steegman, is shown in Zürich. Bronze with lower base shown on page 155.

98. Standing Woman
[Femme debout]. 1948
Bronze, 71⅞ × 8⁵⁄₁₆ × 14¾" (182.5 × 22 × 37.5 cm)
Signed on base, right: "A. Giacometti / 1/5"; back: "Alexis Rudier / Fondeur Paris"
Alberto Giacometti-Stiftung, Zürich. GS 36

REFERENCES: New York 1950, illus. p. 2; Meyer 1968, pp. 143 ff., 169 ff.; Huber 1970, pp. 66 f.; Zürich (coll. cat.) 1971, p. 126 (ref.); Hohl 1972, pp. 135 ff.; Zürich (coll. cat.) 1990, no. 42 (ref.); Dufrène 1994, pp. 137, 181.

99. Standing Woman
[Femme debout]. 1948
Bronze, painted, 65⅜ × 6½ × 13½" (166 × 16.5 × 34.2 cm)
Signed on base, upper left, and also painted on top of base, center: "3/6 Alberto Giacometti"; lower right rear of base: " [illegible] Paris "
The Museum of Modern Art, New York. James Thrall Soby Bequest, 1979

REFERENCES: New York 1950, illus. p. 2; Genet 1958; Meyer 1968, pp. 143 ff., 169 ff.; Huber 1970, p. 62; Zürich (coll. cat.) 1971, pp. 128 (ref.); Hohl 1972, p. 39 ff.; London (coll. cat.) 1981, p. 279; Washington 1988, no. 43; Zürich (coll. cat.) 1990, no. 43 (ref.); Paris 1991, no. 108 (ref.); Dufrène 1994, pp. 137, 181; Vienna 1996, no. 116 (ref.); Soldini 1998, p. 135.

REMARKS: Unpainted bronze cast "1/6" from the Alberto Giacometti-Stiftung, Zürich, GS 37, is shown in Zürich. A bronze copy in the atelier is shown on page 157.

100. Man Walking in the Rain
[Homme qui marche sous la pluie]. 1948
Bronze, 18½ × 30⁵⁄₁₆ × 5⅞" (47 × 77 × 15 cm)
Inscribed: "1/6,"; "Alexis Rudier Fondeur, Paris"
Fondation Beyeler, Riehen/Basel

REFERENCES: "[Second] Letter to Pierre Matisse "1950, pp. 5, 8 (*Moi me hâtant dans une rue sous la pluie*), New York 1950, p. (no.) 9; Meyer 1968, pp. 156 ff.; Huber 1970, pp. 65, 72 ff.; Zürich (coll. cat.) 1971, p. 124 (ref.); Zürich (coll. cat.) 1990, no. 40 (ref.); Madrid 1990, p. 91; Paris 1991, no. 96 (ref.); Dufrène 1994, pp. 144, 172; Milan 1995, p. 22, no. 41 (ref.); Vienna 1996, no. 125 (ref.); Riehen/Basel (coll. cat.) 1997, no. 42 (ref.); Vanderbeke 1997; Mendrisio 2000, p. 24, no. 107 (ref.).

101. Walking Man
[Homme qui marche]. 1947
Bronze, 66¹⁵⁄₁₆ × 9¹⁄₁₆ × 20⅞" (170 × 23 × 53 cm)
Signed and dated on back of base: "A. Giacometti 1/6 1947"; back of base, bottom: "Alexis Rudier / Fondeur Paris"
Alberto Giacometti-Stiftung, Zürich. GS 30

REFERENCES: New York 1948, no. 20; Dupin 1962, pp. 62 f.; Meyer 1968, pp. 149 ff.; Huber 1970, pp. 53 ff.; Zürich (coll. cat.) 1971, p. 114 (ref.); Lamarche-Vadel 1984, p. 126; Washington 1988, p. 135; Zürich (coll. cat.) 1990, no. 39 (ref.); Bonnefoy 1991, pp. 324 ff.; Paris 1991, no. 86 (ref.); Milan 1995, p. 23; Vienna 1996, no. 121 (ref.); Sylvester 1997, pp. 99, 114; Soldini 1998, pp. 133, 240.

102. City Square [Place]. 1948
Bronze, 8½ × 25⅜ × 17¼" (21.6 × 64.5 × 43.8 cm)
Signed on end of base: "A. Giacometti 1/6."
The Museum of Modern Art, New York. Purchase, 1949

REFERENCES: Venice 1949, no. 9; Dupin 1962, p. 63; Meyer 1968, pp. 156 ff.; Huber 1970, pp. 72 ff.; Lamarche-Vadel 1984, p. 130; Venice (coll. cat.) 1985, no. 70 (ref.); Berlin 1987, p. 60, 73 ff., 139; Washington 1988, pp. 40 ff., no. 41; Bonnefoy 1991, p. 330; Dufrène 1994, pp. 157 ff.; Milan 1995, p. 22; Venice 1995 (coll. cat.), pp. 10 ff.; Vienna 1996, no. 120 (ref.); Sylvester 1997, p. 100; Soldini 1998, pp. 133 ff., 241.

REMARKS: Giacometti made a second version of this sculpture with somewhat larger figures (Washington 1988, no. 41).

103. The Cage (Woman and Head)
[La cage (Femme et tête)]. 1950
Bronze with reddish brown patina, figures painted, 70¹⁄₁₆ × 15⁹⁄₁₆ × 15³⁄₁₆" (178 × 39.5 × 38.5 cm)
Signed on center platform, back left, above: "1/6 A. Giacometti"; below: "Alexis Rudier. / Fondeur. Paris"
Alberto Giacometti-Stiftung, Zürich. GS 42

REFERENCES: "[Second] Letter to Pierre Matisse" 1950, pp. 3, 10 f. (*Femme et tête*), New York 1950, p. (no.) 11; Meyer 1968, pp. 124 f., 175; Huber 1970, pp. 26 ff., 76 f.; Zürich (coll. cat.) 1971, p. 138 (ref.); Hohl 1972, pp. 140 ff., 169; Duisburg 1977, pp. 53, 70 ff.; Lamarche-Vadel 1984, p. 136; Berlin 1987, p. 68; Madrid 1990, p. 63, no. 208 (ref.); Zürich (coll. cat.) 1990, no. 47 (ref.); Bonnefoy 1991, pp. 341 ff.; Paris 1991, no. 135 (ref.); Dufrène 1994, p. 141; Vienna 1996, no. 132 (ref.); Sylvester 1997, p. 111 f.; Soldini 1998, p. 135; Saint-Etienne 1999, p. 196.

104. Four Women on a Base
[Quatre femmes sur socle]. 1950
Bronze, base and figures painted, 29¹⁵⁄₁₆ × 16⁵⁄₁₆ × 6¹¹⁄₁₆" (76 × 41.5 × 17 cm)
Signed on base, right: "1/6 A. Giacometti"; back: "Alexis Rudier / Fondeur Paris"
Alberto Giacometti-Stiftung, Zürich, on permanent loan to the Kunstmuseum Basel. GS 39

REFERENCES: "[Second] Letter to Pierre Matisse" 1950, pp. 3, 16, New York 1950, p. (no) 17; Meyer 1968, pp. 117 f., 170 ff.; Huber 1970, pp. 76, 170 f.; Zürich (coll. cat.) 1971, p. 132 (ref.); Hohl 1972, pp. 101, 139 f.; Lord 1985, pp. 308 f.; Berlin 1987, pp. 82 f.; Washington 1988, p. 39, no. 51; Zürich (coll. cat.) 1990, no. 45 (ref.); Bonnefoy 1991, pp. 340 ff.; Dufrène 1994, pp. 94 f., 142 ff.; Vienna 1996, no. 155 (ref.); Sylvester 1997, p. 86; Soldini 1998, p. 136; Saint-Etienne 1999, p. 17.

105. Four Figurines on a Stand
[Quatre figurines sur base]. 1950
Bronze with golden patina, figures painted, 6⅜ × 16⁵⁄₁₆ × 12⅝" (162 × 41.5 × 32 cm)
Signed on edge of base, right: "1/6 A. Giacometti"; back: "Alexis Rudier / Fondeur Paris"
Alberto Giacometti-Stiftung, Zürich. GS 40

REFERENCES: "[Second] Letter to Pierre Matisse" 1950, p. 14 (*Quatre figurines*), New York 1950, p. (no.) 15; Meyer 1968, pp. 116 ff., 170 ff.; Huber 1970, pp. 76, 170 f.; Zürich (coll. cat.) 1971, p. 134 (ref.); Hohl 1972, pp. 127, 139 f.; London (coll. cat.) 1981, p. 280; Lamarche-Vadel 1984, p. 136; Lord 1985, pp. 308 f., 335; Berlin 1987, pp. 82 f., Madrid 1990, p. 90, no. 201 (ref.); Zürich (coll. cat.) 1990, no. 46 (ref.); Bonnefoy 1991, pp. 340 ff.; Paris 1991, no. 140 (ref.); Dufrène 1994, pp. 95 f., 142 ff.; Vienna 1996, no. 157 (ref.); Sylvester 1997, p. 86; Soldini 1998, p. 154.

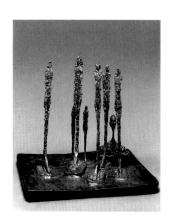

106. The Forest [La Forêt]. 1950
Bronze, painted, 22¹³/₁₆ × 24 × 19½"
(58 × 61 × 49.5 cm)
Signed on base, right edge: "A. Giaco-
metti 6/6"; rear edge: "Alexis Rudier/
Fondeur Paris"
National Gallery of Art, Washington,
D.C. Gift of Enid A. Haupt

REFERENCES: "[Second] Letter to Pierre
Matisse" 1950 (*Composition 7—figures
tête*), p. 20, New York 1950 p. (no.)
21; Dupin 1962, p. 63; Meyer 1968,
pp. 177 f.; Huber 1970, p. 83; Hohl
1972, p. 140; Duisburg 1977, pp. 90 ff.;
Lamarche-Vadel 1984, pp. 130 ff.; Lord
1985, pp. 308, 335, 357; Berlin 1987,
pp. 73 ff.; Madrid 1990, p. 91, no. 205;
Bonnefoy 1991, p. 352; Paris 1991,
no. 127 (ref.); Milan 1995, p. 22, no.
43 (ref.); Vienna 1996, no. 159 (ref.);
Soldini 1998, pp. 39, 139 f.; Saint-
Etienne 1999, pp. 16 ff.

REMARKS: Unpainted bronze shown on
page 166.

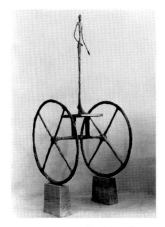

107. The Chariot [Le Chariot]. 1950
Bronze, painted, on wood base, 57 ×
26 × 26⅛" (144.8 × 65.8 × 66.2 cm);
base 9¾ × 4½ × 9¼" (24.8 × 11.5 ×
23.5 cm)
Signed on base, right: "A. Giacometti
1/6"; back of base: "Alexis Rudier. /
Fondeur. Paris."
The Museum of Modern Art, New York.
Purchase, 1951

REFERENCES: "[Second] letter to Pierre
Matisse" 1950, pp. 3, 12, New York
1950, p. (no.) 13; Dupin 1962, p. 57;
Meyer 1968, pp. 104 ff., 173 f.; Huber
1970, pp. 68 ff.; Zürich (coll. cat.)
1971, p. 142 (ref.); Hohl 1972,
pp. 133 ff.; Brenson 1974, p. 167;
Lamarche-Vadel 1984, p. 132; Lord
1985, pp. 305 ff.; Berlin 1987,
pp. 93, 111 f., no. 94; Dallas (coll.
cat.) 1987, no. 30 (ref.); Washington
1988, p. 39, no. 48; Zürich (cat. coll.)
1990, no. 50 (ref.); Bonnefoy 1991,
pp. 98, 362 ff.; Paris 1991, no. 124
(ref.); Basel 1995, p. 16; Vienna 1996,
no. 158 (ref.); Dufrêne 1994, pp. 14,
97, 170 ff.; Milan 1995, p. 21 f., Leinz

1997; Sylvester 1997, p. 99; Soldini
1998, p. 135; Saint-Etienne 1999,
pp. 21 ff.

REMARKS: Bronze cast "3/6" from the
Alberto Giacometti-Stiftung, Zürich,
GS 44, is shown in Zürich. Bronze with
light wood blocks shown on page 167.

108. Diego. 1948
Pencil on paper, 25³/₁₆ × 18¹³/₁₆"
(64 × 47.8 cm)
Signed and dated lower right: "Alberto
Giacometti 1948"
Kunstmuseum Bern

REFERENCES: Berlin 1987, no. 98;
Vienna 1996, no. 141.

109. The Studio [Atelier]. 1951
Pencil on paper, 12¹⁵/₁₆ × 19¾" (32.9 ×
50.2 cm)
Signed and dated lower right: "Alberto
Giacometti 1951"
Kunsthalle Bremen, Kupferstichkabinett

REFERENCES: Hannover 1966, no. 50;
Duisburg 1977, no. 96; Berlin 1987,
no. 140; Madrid 1990, no. 64; Vienna
1996, no. 151 (ref.); Paris 2001, no.
106 (ref.).

110. The Studio with Sculptures
[Atelier avec statues]. 1953–56
Pencil on paper, 11¼ × 10⅝" (28.5 ×
27 cm)
Private collection, Switzerland

REFERENCES: Madrid 1990, no. 135;
Vienna 1996, no. 150.

REMARKS: The figures correspond to the
preliminary stages of the Women of
Venice.

111. Interior [Intérieur]. 1949
Oil on canvas, 25⅝ × 21⅛" (65.1 ×
53.7 cm)
Signed and dated on back: "Alberto
Giacometti 1949"
Tate Gallery, London

REFERENCES: London 1955, no. 41; Lon-
don (coll. cat.) 1981, p. 279 (ref.);
Berlin 1987, no. 110.

112. The Studio (Still Life)
[L'Atelier (Nature morte)]. 1950
Oil on canvas, 25¾ × 18¼" (65.4 ×
46.4 cm)
Signed and dated lower right: "1950
Alberto Giacometti"
Private collection, Switzerland

REFERENCES: Washington 1963, no. 45;
Washington 1988, no. 54; Paris 1991,
no. 116 (ref.); Vienna 1996, no. 145 (ref.).

113. Annette with Chariot
[Annette au chariot]. 1950
Oil on canvas, 28¾ × 19¹/₁₆" (73 ×
50 cm)
Signed and dated lower right: "Alberto
Giacometti 1950"
Private collection

REFERENCES: New York 1950 , no. 29;
Zürich 1962, no. 112; Bonnefoy 1991,
p. 365; Soldini 1998, p. 250.

114. The Artist's Mother
[La Mère de l'artiste]. 1950
Oil on canvas, 35⅜ × 24" (89.9 ×
61 cm)
Signed and dated lower left: "Alberto
Giacometti 1950"
The Museum of Modern Art, New York.
Acquired through the Lillie P. Bliss
Bequest, 1953

REFERENCES: New York 1965, no. 74;
Berlin 1987, no. 112; Washington 1988,
no. 52; Zürich 1990, no. 81; Bonnefoy
1991, pp. 356, 385 f.; Paris 1991,
no. 102 (ref.); Dufrêne 1994, pp. 144 f.;
Vienna 1996, no. 139 (ref.); Soldini
1998, p. 250.

115. Annette at Stampa
[Annette à Stampa]. 1950
Oil on canvas, 35⁷/₁₆ × 24" (90 ×
61 cm)
Signed and dated lower left: "Alberto
Giacometti 1950"
Morton G. Neumann Family Collection

REFERENCES: *Derrière le miroir* 39/40
(1951), no. 4; Dupin 1962, illus. p. 101;
Washington 1988, no. 45; Bonnefoy
1991, pp. 356, 385 f.; Paris 1991,
no. 103 (ref.); Dufrêne 1994, p. 144;
Soldini 1998, p. 250.

REMARKS: Shown in New York only.

116. Annette. 1951
Oil on canvas, 31⅞ × 25⅝"
(81 × 65 cm)
Signed and dated lower left: "Alberto
Giacometti 1951"
Alberto Giacometti-Stiftung, Zürich.
GS 65

REFERENCES: *Derrière le miroir* 39/40
(1951), no. 6; Basel 1963, no. 68;
Zürich (coll. cat.) 1971, p. 188; Zürich
(coll. cat.) 1990, no. 71.

117. The Artist's Mother
[La Mère de l'artiste]. 1951
Oil on canvas, 36⅛ × 28⅝"
(91.8 × 72.7 cm)
Signed and dated lower left: "Alberto
Giacometti 1951"
Musée national d'art moderne, Centre
Georges Pompidou, Paris. Inv. AM
1982-101

REFERENCES: Ponge 1951, illus. p. 85;
Dupin 1962, repr. p. 106; Zürich 1990,
p. 135; Bonnefoy 1991, pp. 385 f.; Paris
1991, no. 104 (ref.); Milan 1995, p. 24,
no. 96 (ref.); Dufrêne 1994, pp. 144 ff.;
Saint-Etienne 1999, no. 57 (ref.); Paris
2001, no. 218 (ref.).

118. Apples in the Studio
[Pommes dans l'atelier]. 1953
Oil on canvas, 28⁹/₁₆ × 23⅝"
(72.5 × 60 cm)
Signed and dated lower right: "Alberto
Giacometti 1953"
Sprengel Museum, Hannover

REFERENCES: Dupin 1954, p. 53; Bern
1956, no. 60; Dupin 1962, illus. p. 139;
Madrid 1990, no. 304; Paris 1991,
no. 112 (ref.); Vienna 1996, p. 58,
no. 149 (ref.).

119. Study of Apples
[Etude de pommes]. 1952
Pencil on paper, 20¹/₁₆ × 13⁷/₁₆"
(51 × 34.2 cm)
Signed lower right: "Alberto
Giacometti"
Fondation Marguerite et Aimé Maeght,
Saint-Paul-de-Vence

REFERENCES: London 1955, no. 74;
Madrid 1990, no. 80 (ref.); Paris 1991,
no. 148 (ref.); Paris 2001, no. 115 (ref.).

120. Still Life, Three Apples
[Nature morte, Trois pommes]. 1959
Pencil on paper, 19¹¹/₁₆ × 12¹³/₁₆" (50 ×
32.6 cm)
Signed and dated lower right: "Alberto
Giacometti 1959"
Private collection, Zug

REFERENCES: Paris (Bernard) 1969,
no. 41; Paris 2001, no. 152 (ref.).

121. Sideboard at Stampa
[Le Buffet à Stampa]. 1955
Pencil on paper, 18⅞ × 18⅛"
(48 × 46 cm)
Signed lower right: "Alberto
Giacometti"
Private collection, Paris

REFERENCES: Lamarche-Vadel 1984,
illus. p. 157; New York 1988, no. 19.

REMARKS: This arrangement, drawn fre-
quently in detail, stood on the buffet
in Stampa.

122. Interior with a Table
[Intérieur à la table]. 1959
Pencil on paper, 19¹¹/₁₆ × 13"
(50 × 33 cm)
Signed and dated lower right: "Alberto
Giacometti 1959"
Collection William Louis-Dreyfus

REFERENCES: Lord 1971, no. 101; Saint-
Paul 1978, no. 271; New York 1988,
no. 28.

123. Vase of Flowers
[Vase de fleurs]. 1952
Pencil on paper, 18⅞ × 12⅜" (48 ×
31.5 cm)
Signed and dated lower right: "Alberto
Giacometti 1952"
Collection William Louis-Dreyfus

REFERENCES: New York 1988, no. 12.

277

124. A Vase of Zinnias
[Nature morte au bouquet de Zinnias].
1959
Pencil on paper, 19⁹/₁₆ × 12⅝" (49.7 × 32 cm)
Signed and dated lower right: "Alberto Giacometti 1959"
Private collection

REFERENCES: New York (Metropolitan) 1965, illus. p. 100; Lord 1971, no. 103; Washington 1988, no. 90; London (Gibson) 1989, no. 11 (ref.).

REMARKS: Shown in New York only.

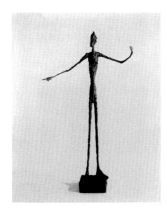

125. Man Pointing
[L'Homme au doigt]. 1947
Bronze, 70½ × 40¾ × 16⅜" (179 × 103.4 × 41.5 cm)
Signed and dated on base, bottom left: "A. Giacometti / 1/6 1947"; on back of base: "Alexis Rudier / Fondeur. Paris"
The Museum of Modern Art, New York. Gift of Mrs. John D. Rockefeller 3rd, 1954

REFERENCES: New York 1948, no. 22; Dupin 1962, p. 62 f.; Meyer 1968, pp. 146 ff.; Huber 1970, pp. 53; Hohl 1972, p. 135, 138; London (coll. cat.) 1981, p. 278 (ref.); Lamarche-Vadel 1984, p. 126; Lord 1985, pp. 284 ff., 314; Berlin 1987, p. 93; Washington 1988, no. 37; Bonnefoy 1991, pp. 325 ff.; Dufrêne 1994, pp. 137 ff.; Vienna 1996, no. 127 (ref.); Sylvester 1997, pp. 17 ff.; Soldini 1998, p. 135; Saint-Etienne 1999, no. 51 (ref.).

REMARKS: Painted plaster shown on page 185.

126. Man Falling
[Homme qui chavire]. 1950
Bronze, 23⅝ × 5½ × 8⁹/₁₆" (60 × 14 × 22 cm)
Signed on base: "Alberto Giacometti 4/6"
Kunsthaus Zürich. Vereinigung Zürcher Kunstfreunde

REFERENCES: New York 1950, p. [no.] 22; Dupin 1962, pp. 62 f.; Meyer 1968, pp. 166 ff.; Hohl 1972, illus. p. 253.; Tübingen 1981, p. 64; Berlin 1987, p. 93; Zürich (coll. cat.) 1990, p. 191; Bonnefoy 1991, p. 326; Paris 1991, no. 122 (ref.); Dufrêne 1994, p. 144;

Vienna 1996, no. 122 (ref.); Saint-Etienne 1999, p. 21.

127. Seated Woman [Femme assise].
1950
Bronze, 30⅛ × 5⅝ × 7¾" (76.4 × 14.3 × 19.7 cm)
Signed on base, right side: "Alberto Giacometti"; stamped on base, right side: "1/6"
Hirshhorn Museum and Sculpture Garden, Smithsonian Institution, Washington, D.C. Gift of Joseph H. Hirshhorn, 1966

REFERENCES: George 1951, pp. 25 ff.; Dupin 1962, illus. p. 248; Meyer 1968, p. 168; Duisburg 1977, p. 70; London 1989, no. 21 (ref.); Madrid 1990, no. 227; Bonnefoy 1991, pp. 45, 292, 377; Paris 1991, no. 79 (ref.); Dufrêne 1994, p. 55; Saint-Etienne 1999, no. 55 (ref.).

REMARKS: Bronze cast "2/6" from Fondation Beyeler, Riehen/Basel, is shown in Zürich.

128. Figure in a Box between Two Boxes which are Houses
[Figurine dans une boîte entre deux boîtes qui sont des maisons]. 1950
Bronze, glass, figure painted white, 11¹³/₁₆ × 21½ × 3 3/4" (30 × 54 × 9.5 cm)
Signed on right end: "A. Giacometti 1/6"; on back, left: "Alexis Rudier Fondeur Paris 1/6"
Alberto Giacometti-Stiftung, Zürich, on permanent loan to the Kunstmuseum, Winterthur. GS 45

REFERENCES: "[Second] Letter to Pierre Matisse" 1950, p. 24; New York 1950, [no.] 24; Dupin 1962, pp. 57 ff.; Meyer 1968, p. 161; Huber 1970, pp. 56, 65 ff.; Zürich (coll. cat.) 1971, p. 144 (ref.); Hohl 1972, pp. 225, 304; Duisburg 1977, p. 68; Berlin 1987, p. 94; Washington 1988, p. 40 f., no. 50; Madrid 1990, no. 207 (ref.); Zürich (coll. cat.) 1990, no. 51 (ref.); Bonnefoy 1991, p. 368; Paris 1991, no. 186 (ref.); Dufrêne 1994, pp. 55, 97, 170 ff.; Milan 1995, pp. 21 f.; Vienna 1996, no. 126 (ref.); Saint-Etienne 1999, no. 56 (ref.).

129. Dog [Le Chien]. 1951
Bronze, 18 × 39 × 6⅛" (45.7 × 99 × 15.5 cm)
Signed top of base: "Alberto Giacometti 4/8"; rear of base: "Susse Fondeur"
The Museum of Modern Art, New York. A. Conger Goodyear Fund, 1958

REFERENCES: Paris 1951, no. 25; Genet 1963, pp. [30/33]; Jedlicka 1965, p. 23 ff.; Lord 1965, p. 65; Meyer 1968, p. 162 f.; Zürich (coll. cat.) 1971, p. 148 (ref.); Hohl 1972, p. 303; Washington (coll. cat.) 1974, p. 695 (ref.); Duisburg 1977, p. 52; Lamarche-

Vadel 984, p. 142 f.; Lord 1985, p. 406; Berlin 1987, no. 142; Washington 1988, no. 59; Zürich (coll. cat.) 1990, no. 53 (ref.); Bonnefoy 1991, pp. 51, 332, 368; Paris 1991, no. 133 (ref.); Clair 1992, pp. 36, 47; Sylvester 1997, p. 84; Soldini 1998, p. 113.

REMARKS: Bronze cast "1/8" from the Alberto Giacometti-Stiftung, Zürich, GS 47, is shown in Zürich.

130. The Street [La Rue]. 1952
Oil on canvas, 28¾ × 21¼" (73 × 54 cm)
Signed and dated lower right: "Alberto Giacometti 1952"
Fondation Beyeler, Riehen/Basel

REFERENCES: Turin 1961, illus. (n.p.); Dupin 1962, illus. p. 113; Lamarche-Vadel 1984, p. 90; Washington 1988, no. 66; Bonnefoy 1991, pp. 472 ff.; Dufrêne 1994, p. 146; Vienna 1996, p. 55, no. 163 (ref.); Riehen/Basel (coll. cat.) 1997, no. 46 (ref.).

131. Mountain at Stampa
[La Montagne à Stampa]. 1955
Pencil on paper, 18⅞ × 12⅜" (48 × 31.5 cm)
Signed and dated lower right: "Alberto Giacometti 1955"
Collection William Louis-Dreyfus

REFERENCES: Saint-Paul 1978, no. 250; Bonnefoy 1991, illus. p. 52.

132. Tree at Stampa
[Arbre à Stampa]. 1955
Pencil on paper, 19⁹/₁₆ × 12⅝" (49 × 32 cm)
Signed and dated lower right: "Alberto Giacometti 1955"
Private collection, courtesy Art Focus gallery, Zürich

REFERENCES: London 1955, no. 86; Zürich 1999, p. 92; Paris 2001, no. 130 (ref.).

REMARKS: The tree behind the Giacomettis' house viewed from the kitchen door.

133. The Garden at Stampa
[Le Jardin à Stampa]. 1954
Oil on canvas, 35⅛/₁₆ × 28⅜" (89 × 72 cm)
Signed and dated lower left: "Alberto Giacometti 1954"
Öffentliche Kunstsammlung Basel, Kunstmuseum

REFERENCES: London 1955, no. 49; Lamarche-Vadel 1984, pp. 90 ff.; Madrid 1990, p. 71, no. 271; Bonnefoy 1991, pp. 472 ff.; Paris 1991, no. 187 (ref.); Dufrêne 1994, p. 145; Vienna 1996, p. 57, no. 165 (ref.).

134. Landscape, Maloja
[Paysage de Maloja]. 1953
Oil on canvas, 18⅛ × 21¹¹/₁₆" (46 × 55 cm)

Signed and dated lower right: "Alberto Giacometti 1953"
Private collection

REFERENCES: Dupin 1962, illus. p. 122; Lamarche-Vadel 1984, pp. 90 f.; Madrid 1990, p. 76, no. 270 (ref.); Dufrêne 1994, p. 145.

REMARKS: Shown in Zürich only.

135. Landscape at Stampa
[Paysage à Stampa]. 1952
Oil on canvas, 21¹¹/₁₆ × 28¾" (55 × 73 cm)
Signed and dated lower right: "Alberto Giacometti 1952"
Bündner Kunstmuseum, Chur

REFERENCES: Basel 1963, no. 70; Washington 1988, no. 67; Chur 1989, p. 190 (ref.); Paris 1991, no. 186 (ref.); Bonnefoy 1991, pp. 472 ff.; Dufrêne 1994, p. 145; Vienna 1996, p. 57, no. 164 (ref.).

136. Landscape [Paysage]. 1957
Pencil on paper, 19¾ × 23¾" (50 × 60.3 cm)
Solomon R. Guggenheim Museum, New York

REFERENCES: Bonnefoy 1991, illus. p. 465; Paris 2001, no. 143.

137. Maloja, View toward Margna
[Maloja, vue vers la Margna]. 1957
Pencil on paper, 19¹¹/₁₆ × 25¹³/₁₆" (50 × 65.5 cm)
Signed and dated lower right: "Alberto Giacometti 1957"
Private collection

REFERENCES: Soavi 1973, illus. [n.p.].

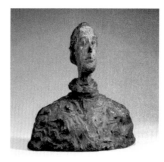

138. Bust of Diego [Buste de Diego]. 1951
Bronze, painted, 13¾ × 12 × 6⁵/₁₆" (35 × 30.5 × 16 cm)
Private collection

REFERENCES: Cahiers d'Art 1951, illus. p. 90; Basel 1966, no. 60; Lamarche-Vadel 1984, pp. 150 f.; Vienna 1996, no. 195 (ref.); Bern (Kornfeld) 1998, no. 114 (ref.).

REMARKS: Painted plaster from the collection of Eberhard W. Kornfeld, Bern, reworked by Giacometti subsequent to bronze casting, is shown in Zürich. Two bronze casts of an earlier plaster state of this bust are known to exist. An earlier plaster state is shown on page 201.

139. Bust of Diego [Buste de Diego].
1950
Bronze, painted, 11¼ × 4¹/₁₆ × 3¾"
(28.5 × 10.3 × 9.6 cm)
Signed on base: "A. Giacometti 6/6"
Collection David M. and Betty Ann
Besch Solinger

REFERENCES: New York 1950, p. [no.]
23; Madrid 1990, nos. 213, 214; Paris
1991, no. 120 (ref.); Milan 1995,
p. 24, no. 45; Vienna 1996, no. 144
(ref.); Soldini 1998, p. 136.

140. Large Head of Diego
[Grande Tête de Diego]. 1954
Bronze, 25⁹/₁₆ × 15⁹/₁₆ × 9⁵/₈" (65 ×
39.5 × 24.5 cm)
Signed on back, bottom right: "Alberto
Giacometti 4/6"; left: "Susse Fondeur
Paris"
Alberto Giacometti-Stiftung, Zürich.
GS 51

REFERENCES: London 1955, no, 35
(*Grande tête tranchante*); Dupin 1962,
illus. pp. 268 f. (*Grande tête*); Meyer
1968, pp. 181 f.; Huber 1970, pp. 92 ff.;
Zürich (coll. cat.) 1971, p. 156 (ref.);
Hohl 1972, p. 169; Martigny 1986,
pp. 135 ff.; Washington 1988, p. 44,
no. 70; London 1989 (Gibson), no. 20
(ref.); Zürich (coll. cat.) 1990, no. 58
(ref.); Bonnefoy 1991, p. 432; Paris
1991, no. 205 (ref.); Dufrêne 1994,
p. 162; Milan 1995, p. 24, no. 48
(ref.); Vienna 1996, no. 199 (ref.);
Soldini 1998, p. 136.

141. Diego in a Sweater
[Diego au chandail]. 1953
Bronze, painted, 19⁹/₁₆ × 11 × 8⁷/₈"
(49 × 28 × 22.5 cm)
Marked: "6/6"
The Patsy R. and Raymond D. Nasher
Collection, Dallas

REFERENCES: London 1955, no. 32;
Meyer 1968, pp. 181 f.; Zürich (coll.
cat.) 1971, p. 162 (ref.); Hohl 1972,
p. 169; Dallas (coll. cat.) 1987, no. 33
(ref.); London 1989 (Gibson), no. 19
(ref.); Madrid 1990, no. 240 (ref.);
Zürich (coll. cat.) 1990, no. 56 (ref.);
Bonnefoy 1991, pp. 436 ff.; Paris
1991, no. 204 (ref.); Dufrêne 1994,
p. 161; Soldini 1998, p. 139.

142. Diego in a Cloak
[Diego au manteau]. 1954
Bronze, painted, 19⁵/₁₆ × 13½ × 8¾"
(38.5 × 34.3 × 22.2 cm)
Marked: "6/6"
The Patsy R. and Raymond D. Nasher
Collection, Dallas

REFERENCES: Huber 1970, illus. no. 22;
Saint-Paul 1978, no. 79; Dallas (coll.
cat.) 1987, no. 32 (ref.).

143. Bust of Diego [Buste de Diego].
1954
Bronze, painted, 15¼ × 13¼ × 8"
(38.7 × 33.6 × 20.3 cm)
Marked: "0/6"
The Patsy R. and Raymond D. Nasher
Collection, Dallas

REFERENCES: Saint-Etienne 1960,
pp. 136 f.; Dupin 1962, illus. p. 273;
Washington (coll. cat.) 1974, p. 695,
illus. 677; Dallas (coll. cat.) 1987,
no. 31 (ref.); Washington 1988, p. 44,
no. 71; Paris 1991, no. 203 (ref.);
Milan 1995, p. 24, no. 46 (ref.); Saint-
Etienne 1999, no. 63 (ref.).

144. Diego in a Plaid Shirt
[Diego à la chemise écossaise]. 1954
Oil on canvas, 31⁷/₈ × 25³/₈" (81 ×
65.4 cm)
Signed and dated lower right:
"Alberto Giacometti 1954"
Private collection, New York

REFERENCES: *Derrière le miroir* 65
(1954), illus.; London 1955, no. 47;
Lamarche-Vadel 1984, pp. 96 f.; Wash-
ington 1988, no. 72; Bonnefoy 1991,
pp. 420 ff.; Paris 1991, no. 198 (ref.).

145. Jean Genet. 1954–55
Oil on canvas, 25¹¹/₁₆ × 21³/₈" (65.3 ×
54.3 cm)
Signed and dated lower right: "Alberto
Giacometti 1954"
Tate Gallery, London

REFERENCES: Dupin 1962, illus. p. 142;
Dufrêne 1994, p. 161; Vienna 1996,
p. 58, no. 176.

146. Portrait of Jean Genet.
1954–55
Oil on canvas, 28¾ × 23⁵/₈"
(73 × 60 cm)
Signed lower right: "Alberto Giacometti"
Musée national d'art moderne, Centre
Georges Pompidou, Paris. Inv. AM
1980-35

REFERENCES: Bern 1956, no. 67; Paris
1981, p. 46; Lamarche-Vadel 1984,
pp. 101 f.; Bonnefoy 1991, p. 393;
Paris 1991, no. 165 (ref.); Dufrêne
1994, pp. 97, 161; Saint-Etienne 1999,
no. 66 (ref.); Paris 2001, no. 219.

**147. Portrait of G. David
Thompson.** 1957
Oil on canvas, 39³/₈ × 28¾"
(100 × 73 cm)

Signed and dated lower right: "Alberto
Giacometti/1957"
Alberto Giacometti-Stiftung, Zürich.
GS 67

REFERENCES: Bucarelli 1962, pl. 85;
Basel 1963, no. 74; Zürich (coll. cat.)
1971, p. 192; Hohl 1972, p. 144; Lord
1985, pp. 379 f.; Zürich (coll. cat.)
1990, no. 73 (ref.); Bonnefoy 1991,
p. 390; Paris 1991, no. 199 (ref.);
Vienna 1996, no. 191 (ref.).

148. Portrait of David Sylvester.
1960
Oil on canvas, 45¹¹/₁₆ × 35¹/₁₆"
(116 × 89 cm)
Private collection

REFERENCES: Venice 1962, no. 24;
Vienna 1996, p. 58; Sylvester 1997,
pp. 125 ff., 173 ff.

REMARKS: Shown in New York only.

149. Jean Genet. 1954
Pencil on paper, 19¹¹/₁₆ × 12¹³/₁₆" (50 ×
32.5 cm)
Signed and dated lower right: "Alberto
Giacometti 1 septembre 1954"
Collection Eberhard W. Kornfeld, Bern

REFERENCES: Bern 1959, no. 13; Berlin
1987, no. 163; Madrid 1990, no. 50
(ref.); Dufrêne 1991, illus. no. 2; Paris
1991, no. 162 (ref.); Vienna 1996, no.
175 (ref.); Bern (coll. cat. /Kornfeld)
1998, no. 121 (ref.).

150. Annette. 1954
Pencil on paper, 16⁵/₈ × 11¾" (42 ×
29.8 cm)
Signed lower right: "Alberto Giacometti"
The Museum of Modern Art, New York.
The Sidney and Harriet Janis Collection

REFERENCES: Paris 2001, no. 120.

151. Igor Stravinsky. 1957
Pencil on paper, 18¹/₈ × 11" (46 × 28 cm)
Signed and dated lower right: "Alberto
Giacometti 1957"
Private collection

REFERENCES: Basel 1966, no. 214;
Strawinsky. Sein Nachlass — sein Bild,
Kunstmuseum Basel (coll. cat.) 1984,
no. 98.

152. Henri Matisse. 1954
Pencil on paper 19⁹/₁₆ × 12³/₁₆" (49 ×
31 cm)
Dated lower left: "5 VII 54"
Kunstmuseum Bern

REFERENCES: New York 1974, no. 179;
Paris 1991, no. 155 (ref.); Vienna
1996, no. 173 (ref.).

153. James Lord. 1954
Pencil on paper, 19⁵/₈ × 12¹³/₁₆" (49.8 ×
32.5 cm)
Signed and dated lower right: "Alberto
Giacometti 1954"
Musée Picasso, Paris

REFERENCES: Lord 1971, no. 83.

154. Eberhard W. Kornfeld. 1959
Pencil on paper, 19¹¹/₁₆ × 12⁵/₈" (50 ×
32 cm)
Signed and dated lower right: "Alberto
Giacometti 1959"; lower left: "A Ebi
Kornfeld avec toute mon / amitié"
Collection Eberhard W. Kornfeld, Bern

REFERENCES: Bern 1959, no. 26; Madrid
1990, no. 54 (ref.); Paris 1991, no.
169 (ref.); Vienna 1996, no. 178
(ref.); Bern (Kornfeld) 1998, no. 128
(ref.); Paris 2001, no. 153 (ref.).

155. Silvio Berthoud. 1959
Pencil on paper, 19¹¹/₁₆ × 12½"
(50 × 31.7 cm)
Signed and dated lower right:
"Alberto Giacometti 1959"
Kunstmuseum Bern

REFERENCES: Munich 1971, no. 144;
Tübingen 1981, [no.] Z 53 (ref.).

156. Nude, after Nature
[Nu d'après nature]. 1954
Bronze, 20¹¹/₁₆ × 5¹¹/₁₆ × 7⁷/₈" (52.5 ×
14.5 × 20 cm)
Signed on base, left: "Alberto Giaco-
metti 3/6"; back: "Susse Fondeur Paris"
Alberto Giacometti-Stiftung, Zürich.
GS 53

REFERENCES: Lord 1955, illus. p. 14;
Dupin 1962, illus. p. 267 (*Annette,
1955*); Basel 1963, no. 51 (*Figure
féminine*); Zürich (coll. cat.) 1971,
p. 160 (ref.); Zürich (coll. cat.) 1990,
no. 60; Paris 1991, no. 226 (ref.), illus.
inverted with no. 225; Milan 1995,
no. 54.

157. Standing Nude without Arms
[Nu debout sans bras]. 1954
Bronze, 22¼ × 5¹/₈ × 7⁵/₁₆" (56.5 ×
13 × 18.5 cm)
Signed and dated on base, left: "1954
Alberto Giacometti 1/6"
Alberto Giacometti-Stiftung, Zürich.
GS 52

REFERENCES: Basel 1963, no. 50 (*Etude
d'après nature*); Zürich (coll. cat.)
1971, p. 158; Zürich (coll. cat.) 1990,
no. 59.

158. Standing Nude III
[Nu debout III]. 1953
Bronze, 21¼ × 4¾ × 6⁵/₁₆" (54 × 12 ×
16 cm)
Signed and dated on base, right side:
"1/6 1953 / Alberto Giacometti"
Alberto Giacometti-Stiftung, Zürich.
GS 48

REFERENCES: Zürich 1962, no. 45; Basel
1963, no. 47 (*Nu debout II*); Zürich
(coll. cat.) 1971, p. 150; Meyer
1968, pp. 193 ff.; Zürich (coll. cat.)
1990, no. 54; Paris 1991, no. 225
(ref.), illus. inverted with no. 226 ;
Vienna 1996, no. 215 (ref.); Soldini
1998, p. 139.

159. Woman of Venice II
[Femme de Venise II]. 1956
Bronze, 47 × 6 × 13" (120.5 × 15.2 ×
33.1 cm)
Signed on base, bottom left: "4/6
Alberto Giacometti"; on back: "Susse Fr"
Private collection

REFERENCES: Venice 1956, no. 116;
Meyer 1968, pp. 196 ff.; Hohl 1972,
pp. 142 f., 280; Lord 1985, pp. 355 ff.,
485; Berlin 1987, pp. 104, 112, 142;
Washington 1988, p. 45, no. 82; Madrid
1990, p. 93, no. 229 (ref.); Bonnefoy
1991, p. 397; Paris 1991, no. 228
(ref.); Dufrêne 1994, pp. 168 ff.; Milan
1995, p. 24; Vienna 1996, p. 78;
Sylvester 1997, pp. 85, 117; Soldini
1998, pp. 136 f.

160. Woman of Venice VIII
[Femme de Venise VIII]. 1956
Bronze, 47¾ × 5⅞ × 13" (121 ×
15 × 33 cm)
Signed on base, left side: "2/6/
Alberto Giacometti"; back: "Susse
Fondeur Paris"
Alberto Giacometti-Stiftung, Zürich.
GS 56

REFERENCES: Bern 1956, no. 45; Meyer
1968, pp. 196 ff.; Zürich (coll. cat.)
1971, p. 166 (ref.); Hohl 1972, pp. 142 f.,
280; Lamarche-Vadel 1984, pp. 144 f.;
Lord 1985, pp. 355 ff., 485; Berlin
1987, pp. 104, 112, 142; Washington
1988, p. 45; Zürich (coll. cat.) 1990,
no. 62 (ref.); Madrid 1990, p. 93;
Bonnefoy 1991, p. 397; Paris 1991,
no. 231 (ref.); Dufrêne 1994, pp. 168 ff.;
Milan 1995, p. 24; Vienna 1996, p. 78;
Riehen/Basel (coll. cat.) 1997, no. 47
(ref.); Sylvester 1997, pp. 85, 117;
Soldini 1998, pp. 136 f.

161. Woman of Venice V
[Femme de Venise V]. 1956
Bronze, 43¹¹⁄₁₆ × 5⁵⁄₁₆ × 12³⁄₁₆"
(111 × 13.5 × 31 cm)
Private collection, Switzerland

REFERENCES: Venice 1956, no. 112;
Meyer 1968, pp. 196 ff.; Hohl 1972,
pp. 142 f., 280; Lord 1985, pp. 355 ff.,
485; Berlin 1987, pp. 104, 112, 142;
Washington 1988, p. 45; Madrid 1990,
p. 93; Bonnefoy 1991, p. 397; Paris
1991, p. 397; Dufrêne 1994, pp. 168 ff.;
Milan 1995, p. 24; Vienna 1996, p. 78,
no. 218; Sylvester 1997, pp. 85, 117;
Soldini 1998, pp. 136f; Saint-Etienne
1999, no. 68 (ref.).

162. Diego. 1956
Oil on canvas, 39⅜ × 31⅞" (100 × 81 cm)
Signed and dated lower right: "Alberto
Giacometti 1956"
Donald L. Bryant, Jr. Family Trust

REFERENCES: Dupin 1962, illus. p. 159;
New York (Acquavella) 1994, no. 59.

163. Yanaihara. 1956
Oil on canvas, 31¾ × 25½" (80.7 ×
64.8 cm)
Musée national d'art moderne, Centre
Georges Pompidou, Paris. Inv. AM
4573 P

REFERENCES: Dupin 1962, p. 148; Hohl
1972, pp. 170 ff., 280 f.; Lamarche-
Vadel 1984, pp. 146 ff.; Washington
1988, pp. 49, 206; Bonnefoy,
pp. 447 ff.; Paris 1991, no. 179 (ref.);
Dufrêne 1994, pp. 161 ff.; Vienna
1996, p. 58; Saint-Etienne 1999, no.
69 (ref.); Paris 2001, no. 220.

164. Portrait of Isaku Yanaihara.
1959
Oil on canvas, 36¼ × 28¾"
(92 × 73 cm)
Private collection

REFERENCES: *Derrière le miroir* (1961),
no. 5; Meyer 1968, p. 233; Hohl 1972,
pp. 170 ff.; Bonnefoy 1991, pp. 447 ff.;
Paris 1991, no. 181 (ref.); Dufrêne
1994, pp. 161 ff.; Vienna 1996, p. 58,
no. 228 (ref.).

165. Isaku Yanaihara. 1961
Oil on canvas, 39⅜ × 31⅞"
(100 × 81 cm)
Signed and dated lower right: "1961
Alberto Giacometti"
Fondation Beyeler, Riehen/Basel

REFERENCES: *Derrière le miroir* (1961),
no. 1; Hohl 1972, pp. 170 ff.; Bonnefoy
1991, pp. 447 ff.; Paris 1991, no. 182;
Dufrêne 1994, pp. 161 ff.; Vienna
1996, p. 58, no. 230 (ref.); Riehen/
Basel (coll. cat.) 1997, no. 54 (ref.).

166. Still Life with Bottles
[Nature morte avec bouteilles]. 1958
Oil on canvas, 25⁵⁄₁₆ × 31⅞"
(65 × 81 cm)
Signed and dated lower right: "Alberto
Giacometti/1958"
Collection Steegmann, on permanent
loan at the Staatsgalerie Stuttgart

REFERENCES: Zürich 1962, no. 145;
Stuttgart 1988, no. 36 (ref.); Stuttgart
1999, no. 43.

167. Tall Seated Nude
[Grand Nu assis]. 1957
Oil on canvas, 60⅝ × 23¼"
(154 × 59 cm)
Signed and dated lower right:
"1957/Alberto Giacometti"
Städtische Galerie im Städelschen
Kunstinstitut, Frankfurt

REFERENCES: Zürich 1962, no. 143;
Dupin 1962, illus. p. 150; Berlin 1987,
no. 199; Bonnefoy 1991, pp. 412 ff.;
Frankfurt (coll. cat.) 1998, pp. 58 f. (ref.).

168. Aïka. 1959
Oil on canvas, 36¼ × 28¹¹⁄₁₆" (92 ×
72.8 cm)
Signed and dated lower right: "Alberto

Giacometti 1959"
Fondation Beyeler, Riehen/Basel

REFERENCES: Dupin 1962, illus. p. 172;
Hohl 1972, p. 175; Washington 1988,
no. 87; Riehen/Basel (coll. cat.) 1997,
no. 48 (ref.).

169. Annette in the Studio
[Annette dans l'atelier]. 1961
Oil on canvas, 57½ × 38³⁄₁₆" (146 ×
97 cm)
Signed and dated lower right: "Alberto
Giacometti 1961"
Hamburger Kunsthalle, Hamburg

REFERENCES: Dupin 1962, illus. p. 168;
Berlin 1987, no. 206; Madrid 1990,
no. 308.

170. Four Figures and a Head
[Quatre figures et une tête]. 1960
Pencil on paper, 19¹¹⁄₁₆ × 14"
(50 × 35.5 cm)
Private collection

REFERENCES: New York 1974, no. 186;
Berlin 1987, no. 211; Paris 1991, no.
194 (ref.) ; Vienna 1996, no. 210 (ref.).

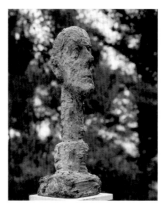

171. Monumental Head
[Grande tête]. 1960
Bronze, 37½ × 12 × 13" (95.3 ×
30 × 33 cm)
Signed on base: "Alberto Giacometti";
stamped: "Fondation Maeght"
Fondation Marguerite et Aimé Maeght,
Saint-Paul-de-Vence

REFERENCES: New York 1961, no. 4;
Dupin 1962, illus. p. 296; Huber 1970,
p. 96; Hohl 1972, pp. 175 f.; Wash-
ington (coll. cat.) 1974, p. 695 (ref.),
illus. 762; Washington 1988, no. 94;
Paris 1991, no. 276 (ref.); Saint-Paul
(coll. cat.) 1993, p. 45; Dufrêne 1994,
p. 169; Bonnefoy 1991, pp. 519 f.;
Milan 1995, p. 23; Vienna 1996,
no. 226 (ref.); Riehen/Basel (coll. cat.)
1997, no. 52 (ref.); Soldini 1998, p. 138.

REMARKS: The plaster version, with traces
of the brush before the last retouches in
the atelier, is shown on page 233.

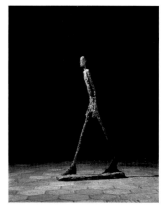

172. Walking Man II
[Homme qui marche II]. 1960
Bronze, painted, 73⅝ × 42¹⁵⁄₁₆ × 10⅝"
(187 × 109 × 27 cm)
Signed on base: "Alberto Giacometti";
stamped: "Fondation Maeght"
Fondation Marguerite et Aimé Maeght,
Saint-Paul-de-Vence

REFERENCES: Dupin 1962, illus. p. 291;
Meyer 1968, p. 203; Hohl 1972,
pp. 175 ff.; Washington 1988, p. 218;
Dufrêne 1994, pp. 144, 169; Vienna
1996, no. 225 (ref.); Riehen/Basel
(coll. cat.) 1997, no. 49 (ref.); Soldini
1998, pp. 48, 138; Saint-Etienne (coll.
cat.) 1999, p. 21.

REMARKS: Unpainted bronze shown on
page 234.

173. Tall Woman II
[Grande femme II]. 1960
Bronze, painted, 108 × 12⅝ × 22¹³⁄₁₆"
(277 × 32 × 58 cm)
Signed on base: "Alberto Giacometti";
stamped: "Fondation Maeght"
Fondation Marguerite et Aimé Maeght,
Saint-Paul-de-Vence

REFERENCES: Paris 1961, no. 26; Venice
1962, no. 75; Meyer 1968, p. 198 f.;
Hohl 1972, pp. 176, 282; Lamarche-
Vadel 1984, p. 145; Madrid 1990,
pp. 21 f.; Paris 1991, no. 273 (ref.);
Saint-Paul (coll. cat.) 1993, p. 43;
Milan 1995, p. 23; Dufrêne 1994, p. 169;
Saint-Paul 1997, no. 170 (ref.); Soldini
1998, pp. 137 f.; Saint-Etienne 1999,
no. 74 (ref.).

174. Annette. 1960
Oil on canvas, 21¼ × 19¹¹⁄₁₆"
(54 × 50 cm)
Signed and dated lower right: "Alberto
Giacometti 1960"
Private collection

REFERENCES: Basel 1963, no. 78;
Bonnefoy 1991, illus. p. 508.

REMARKS: Shown in Zürich only.

175. Annette. 1959
Pencil on paper, 19¹¹⁄₁₆ × 13" (50 ×
33 cm)
Signed and dated lower right: "Alberto
Giacometti 1959"
Private collection, Zürich

REFERENCES: *Sammlungen Hans und Walter Bechtler,* Kunsthaus Zürich 1982, pp. 68, 174.

176. Annette. 1954
Oil on canvas, 25³⁄₁₆ × 21⁷⁄₁₆" (64 × 54.5 cm)
Signed and dated lower right: "1954 Alberto Giacometti"
Staatsgalerie Stuttgart

REFERENCES: Dupin 1962, illus. p. 131; *Jahrbuch Baden-Württemberg* 13 (1976), pp. 220 f.; Stuttgart (coll. cat.) 1982, p. 137; Washington 1988, no. 73; Madrid 1990, pp. 74 ff., no. 306; Stuttgart 1999, no. 41 (ref.).

177. Annette IV. 1962
Pencil on paper, 19¹³⁄₁₆ × 12¹³⁄₁₆" (50.4 × 32.5 cm)
Signed and dated lower right: "IV Alberto Giacometti 1962"
Private collection

REFERENCES: Dupin 1962, illus. [p. 84] (*Annette III*); Bonnefoy 1991, illus. p. 506; Paris 1991, no. 261 (ref.); Soldini 1998, p. 250.

178. Annette V. 1962
Pencil on paper, 19¹³⁄₁₆ × 12¹³⁄₁₆" (50.4 × 32.5 cm)
Signed and dated lower right: "V Alberto Giacometti 1962"
Private collection

REFERENCES: Dupin 1962, illus. [p. 85] (*Annette IV*); Bonnefoy 1991, illus. p. 508; Paris 1991, no. 263 (ref.); Soldini 1998, p. 250.

179. Annette IV. 1962
Bronze, 26½ × 9½ × 9½" (67.3 × 24.1 × 24.1 cm)
Signed lower right edge: "Alberto Giacometti 6/6"; "Susse Fondeur Paris"
High Museum of Art, Atlanta, Georgia. Gift of Sara Lee Corporation. 1999.40

REFERENCES: Moulin 1964, no. 24; New York 1965, no. 71; London (coll. cat.) 1981, p. 283; Lamarche-Vadel 1984, p. 154; Berlin 1987, no. 235; Washington 1988, no. 100; Madrid 1990, no. 248; Bonnefoy 1991, pp. 509 f.; Dufrène 1994, p. 183; Milan 1995, no. 78 (ref.); Soldini 1998, p. 141; Singapore (coll. cat.) 1999, pp. 62 ff; Zürich 1999, p. 84 (ref.).

180. Annette VIII. 1962
Bronze, 23 × 10⁷⁄₈ × 9¼" (58.5 × 26.5 × 23.5 cm)
Stamped: "0/6 Susse Fondeur / Cire Perdue"
Estate of Annette Giacometti

REFERENCES: London 1965, no. 89; Hohl 1972, p. 264; Bonnefoy 1991, pp. 509 ff.; Paris 1991, no. 283 (ref.); Dufrène 1994, p. 183; Soldini 1998, p. 141.

181. Caroline. 1962
Oil on canvas, 36 ¼ × 28¾" (92 × 73 cm)
Signed and dated lower right: "Alberto Giacometti/ 1962"
Private collection, courtesy Ivor Braka Ltd., London

REFERENCES: Venice 1962, no. 37; Madrid 1990, p. 76, no. 297; Paris 1991, no. 266 (ref.); Vienna 1996, p. 59, no. 235 (ref.).

182. Caroline II. 1962
Oil on canvas, 39³⁄₈ × 31⁷⁄₈" (100 × 81 cm)
Öffentliche Kunstsammlung Basel, Kunstmuseum

REFERENCES: Basel (coll. cat.) 1970, p. 199; Rotzler/Adelmann 1970, pl. 18; Hohl 1972, p. 175, illus. p. 141; Edinburgh 1996, no. 230.

183. Caroline. 1962
Oil on canvas, 51 × 38" (129.5 × 96.5 cm)
Signed and dated lower right: "Alberto Giacometti/ 1962"
The Art Institute of Chicago. Gift through the Mary and Leigh Block Acquisitions Fund in memory of Mrs. Loula Lasker

REFERENCES: Hohl 1972, p. 175; Bonnefoy 1991, pp. 460f; Hiroshima 1997, no. 56.

184. Self-Portrait [Autoportrait]. 1960
Pencil on paper, 19¹³⁄₁₆ × 12¹⁵⁄₁₆" (50.4 × 32.8 cm)
Signed and dated lower right: "Alberto Giacometti 1960"
Klewan Collection

REFERENCES: Jedlicka 1960, illus. p. 5; Bonnefoy 1991, illus. p. 502; Vienna 1996, no. 181 (ref.); Munich (Klewan) 1997, illus. p. 12 (ref.); Paris 2001, no. 154 (ref.).

185. The Mother, Reading (frontal view)
[La Mère, lisant, de face]. 1963
Pencil on paper, 19⁷⁄₈ × 13" (50.5 × 33 cm)
Signed lower left: "Alberto Giacometti"; dated lower right: "1963"
Private collection

REFERENCES: Ascona 1985, no. 34; Zürich 1990, no. 98; Bonnefoy 1991, illus. p. 523; Paris 1991, no. 251 (ref.); Vienna 1996, no. 240 (ref.).

186. The Mother, Reading (in profile)
[La Mère lisant, en profil]. 1963
Ballpoint pen on paper, 13 × 19¹³⁄₁₆" (33 × 50.3 cm)
Signed and dated lower right: "Alberto Giacometti 1963"
Private collection

REFERENCES: Rome 1970, no. 33; Zürich 1990, no. 103; Paris 1991, no. 247.

187. Interior at Stampa
[Intérieur à Stampa]. 1959
Pencil on paper, 19¹¹⁄₁₆ × 18⁵⁄₁₆" (50 × 46.5 cm)
Signed and dated lower right: "Alberto Giacometti 1959"
Städtische Kunsthalle, Mannheim

REFERENCES: Duisburg 1977, no. 111; Berlin 1987, no. 172; Madrid 1990, no. 71.

REMARKS: Shown in Zürich only.

188. Ceiling Lamp [La Suspension]. 1963
Pencil on paper, 19¹¹⁄₁₆ × 12¹³⁄₁₆" (50 × 32.5 cm)
Signed and dated lower right: "Alberto Giacometti 1963"
Musée national d'art moderne, Centre Georges Pompidou, Paris. Inv. AM 1992-114

REFERENCES: Bouchet 1969, p. 104; Paris 1969 (Orangerie), no. 57; Lord 1971, no. 114; Soavi 1973, pp. 18, 28 ff., 48 f., illus.; Saint-Etienne 1999, no. 78 (ref.); Paris 2001, no. 171 (ref.).

189. The Studio at Stampa
[L'Atelier à Stampa]. 1964
Pencil on paper, 21⁵⁄₈ × 16¹⁄₈" (55 × 41 cm)
Signed and dated lower right: "Alberto Giacometti 1964"
Bündner Kunstmuseum, Chur

REFERENCES: Hannover 1966, no. 85; Tübingen 1981, [no.] Z 64; Berlin 1987, no. 231; Madrid 1990, no. 69 (ref.); Vienna 1996, no. 251 (ref.).

190. Hotel Room III
[Chambre d'hotel III]. c. 1963
Pencil on paper, 19¹³⁄₁₆ × 12⁷⁄₈" (50.4 × 32.7 cm)
Alberto Giacometti-Stiftung, Zürich. GS 103

REFERENCES: Martigny 1965, illus. 11; Zürich (coll. cat.) 1971, p. 231; Lugano 1973, no. 109; Tübingen 1981, [no.] Z 60; Berlin 1987, no. 229; Zürich (coll. cat.) 1990, no. 137; Paris 1991, no. 254 (ref.).

191. Large Black Head
[Grande Tête noire]. 1961
Oil on canvas, 31⁷⁄₈ × 25⁹⁄₁₆" (81 × 65 cm)
Signed and dated lower right: "Alberto Giacometti 1961"
Flick Collection

REFERENCES: Turin 1961, illus.; Bonnefoy 1991, p. 518; Vienna 1996, p. 59, no. 233 (ref.).

192. Large Nude [Grand Nu]. 1962
Oil on canvas, 68¹¹⁄₁₆ × 27³⁄₈" (174.5 × 69.5 cm)
Signed and dated lower right: "Alberto Giacometti 1962"
Collection Steegman, on permanent loan at the Staatgalerie Stuttgart

REFERENCES: Dupin 1962, illus. p. 181 (n.p.); Bonnefoy 1991, p. 392; Paris 1991, no. 278 (ref.); Stuttgart 1998, no. 37 (ref.); Stuttgart 1999, pp. 194 f., no. 44.

193. Woman and Head
[Femme et tête]. 1965
Oil on canvas, 36¼ × 28¾" (92 × 73 cm)
Private collection

REFERENCES: Lugano 1973, no. 51; Bonnefoy 1991, p. 377; Paris 1991, no. 281 (ref.); Vienna 1996, no. 237 (ref.).

194. New York Bust I
[Buste de New York I]. 1965
Bronze, 21⁵⁄₈ × 11⁷⁄₁₆ × 5½" (55 × 29 × 14 cm)
Signed on back: "Alberto Giacometti"; "4/8"; "Susse Fondeur, Paris"
Private collection

REFERENCES: Paris 1969, no. 117; Washington 1988, no. 104; London 1989 (Gibson), no. 25 (ref.); Madrid 1990, no. 255; Bonnefoy 1991, pp. 519 ff.; Paris 1991, no. 285 (ref.).

195. Lotar II. 1965
Bronze, 23¼ × 14¹⁵⁄₁₆ × 9¹³⁄₁₆" (59 × 38 × 25 cm)
Signed on back: "Alberto Giacometti 4/8"; "Susse Fondeur Paris"
Private collection, Switzerland

REFERENCES: Paris 1969, no. 121; Hohl 1972, p. 176; Madrid 1990, no. 258; Bonnefoy 1991, p. 523; Paris 1991, no. 287 (ref.); Vienna 1996, no. 256; Sylvester 1997, p. 83; Soldini 1998, pp. 253 ff.

196. Lotar III. 1965
Bronze, 25¹³⁄₁₆ × 11 × 14" (65.5 × 28 × 35.5 cm)
Signed: "Alberto Giacometti"; "5/8"
Private collection

REFERENCES: Paris 1969, no. 122; Hohl 1972, p. 176; Berlin 1987, p. 144; Madrid 1990, no. 259 (ref.); Bonnefoy 1991, p. 523; Paris 1991, no. 288 (ref); Milan 1995, p. 4; Vienna 1996, no. 257 (ref.); Sylvester 1997, p. 83; Riehen/Basel (coll. cat.) 1997, no. 55 (ref.); Soldini 1998, p. 141, Mendrisio 2000, no. 126 (ref.).

The following abbreviated text is based on the work of Reinhold Hohl, whose essential monograph of 1971 has served as a foundation for subsequent scholarship; see Reinhold Hohl, *Alberto Giacometti* (Stuttgart: Hatje, 1971). For additional material, see James Lord, *Alberto Giacometti: A Biography* (New York: Farrar, Straus, Giroux, 1985); Hohl in *Alberto Giacometti* (Berlin: Nationalgalerie, 1987); Christoph Doswalds in *Alberto Giacometti 1901–1966* (Vienna: Kunsthalle, 1996); and Hohl, ed., *Giacometti: A Biography in Pictures* (Ostfildern-Ruit: G. Hatje, 1998).

1901
Alberto Giacometti is born on October 10 in the mountain hamlet of Borgonovo, near Stampa in the Grisons (Graubünden) canton of Switzerland. His father Giovanni Giacometti is a Post-Impressionist painter; his mother Annetta Giacometti-Stampa is the daughter of one of the valley's landed families. Augusto Giacometti, an important Symbolist painter, is a second cousin of both parents.

1902
Birth of brother Diego (d. 1985).

1904
Birth of sister Ottilia (d. 1937).
In the late fall the family moves to Stampa, to live in the Hôtel Piz Duan operated by Giovanni's father.

1906
The family moves into the second floor of a house opposite the hotel. Giovanni makes an adjacent shed into a studio.

1907
Birth of brother Bruno.

The Giacometti family (Alberto, Diego, Bruno, Giovanni, Ottilia, and Annetta), 1909

1911-15
Alberto begins to send crayon and pencil drawings to his godfather, Cuno Amiet, the Fauvist painter and close family friend. (These survive from nearly every year of his childhood.)
In 1913 Alberto produces his first oil painting in his father's studio, a still life with apples on a folding table.
Shortly after Christmas 1914 he models the heads of Diego and Bruno in Plasticine.

1915-19
Alberto attends the Evangelical School in Schiers, near Chur, where he is given a small studio.

1919
Alberto spends the spring and summer in Stampa and nearby Maloja, where he draws and paints in a divisionist style. In the fall he begins studying art at the École des Beaux-Arts and École des Arts Industriels in Geneva. Painting (under the pointillist David Estoppey) comes easily to him, and in modeling (under modern sculptor Maurice Sarkissoff) he is allowed to do as he likes.

1920
At the end of March Alberto spends some ten days with Amiet in Oschwand.
In May Giovanni, a member of the Swiss Art Commission, takes Alberto with him to the Venice Biennale. He discovers the paintings of Jacopo Tintoretto in Venice and visits Padua, where he sees Giotto's Arena Chapel frescoes. From late summer on, Alberto works in Geneva before setting out for Florence in mid-November. His main impressions there are provided by the Archeological Museum, where he sees Egyptian art.
He arrives in Rome on December 21.

1921
Alberto lives in Rome with the family of Antonio Giacometti, a cousin of his parents. He falls in love with the oldest of the six children, the fifteen-year-old Bianca, and attempts to model a bust of her. He takes a small studio in the Via Ripetta, visits museums and churches, and makes drawings after the Old Masters. He also attends operas and concerts, and reads ancient and modern writers, who inspire him to draw. At the end of March or beginning of April he travels to Naples, Paestum, and Pompeii; in July he returns to Maloja.
On September 3 he travels from Innsbruck to the remote mountain village of Madonna di Campiglio with Pieter van Meurs, a sixty-one-year-old archivist. On the following day, van Meurs has an attack and dies that night with Giacometti at his side. Giacometti, not yet twenty, will never forget this death and never again sleep without a light on. He returns to Stampa by way of Venice.

Giacometti in his studio on the rue Hippolyte-Maindron, Paris, 1927

1922

On the morning of January 9 Giacometti arrives in Paris. He enrolls in a life drawing class and in the sculpture class of Émile-Antoine Bourdelle at the Académie de la Grande Chaumière. Bourdelle's teaching consists of weekly critiques with long lectures amid modeling stands. Giacometti attends the Académie until 1927, though with frequent month-long absences.

From August to October he trains with the Alpine Infantry in Herisau.

1923–24

In the Montparnasse quarter of Paris, the center of the art world, Alberto makes drawings of a skull for an entire winter.

He fraternizes mainly with other Swiss artists, among them Serge Brignoni, with whom he shares an interest in tribal art and in Surrealism. He rents a spacious atelier at 72, avenue Denfert-Rochereau.

1925

In January Giacometti moves into his second, somewhat smaller Paris atelier at 37, rue Froidevaux, with windows looking out on the Montparnasse cemetery. Diego joins him in February.

His circle of acquaintances at the Académie widens to include artists from Italy and Scandinavia, also a few Frenchmen, among them Pierre Matisse, the son of Henri Matisse, and later a prominent art dealer in New York. He enters into an amorous relationship with Flora Mayo, a twenty-five-year-old American, which continues until 1929.

In November Alberto Giacometti shows his work for the first time in the Salon des Tuileries. In the same month he takes part in the *Exposition des Artistes Suisses* in Paris.

1926

His involvement with Cubism and tribal art leads in the winter of 1926–27 to his first major sculpture, *Spoon Woman*. Giacometti exhibits two works in the Salon des Tuileries.

1927

He moves into the barracks-like studio building at 46, rue Hippolyte-Maindron, which has a common water tap and toilet in the courtyard. Diego sleeps in the loft, while Alberto beds down either in the workroom or the nearby Hotel Primavera.

In the summer, in Stampa, he produces several busts of his father. In a show of his work at the Galerie Aktuaryus in Zürich, Alberto exhibits plaster busts of his father, his brother, and a young girl. In Paris he shows the *Spoon Woman*.

1928

In February Giacometti shows six sculptures in the exhibition *Les Artistes italiens de Paris*. In the winter of 1928–29, the *Gazing Head* and other Plaque sculptures evolve.

1929

In June, along with works by Massimo Campigli, the Galerie Jeanne Bucher exhibits two of Giacometti's Plaque sculptures: the *Gazing Head* and *Figure*. They are an immediate sensation among artists and writers, and give Giacometti entrée into avant-garde circles. He becomes acquainted with André Masson, Hans Arp, Joan Miró, Max Ernst, Alexander Calder, Jean Lurçat, and Pablo Picasso, as well as with such Surrealist writers as Louis Aragon and Georges Bataille. At the suggestion of the art critic Carl Einstein, the poet and ethnologist Michel Leiris publishes a first, groundbreaking essay on Giacometti in Bataille's literary journal *Documents.*

The art dealer Pierre Loeb agrees to pay Giacometti a monthly stipend in exchange for his entire year's production or at least the right to show and represent it.

The principle of the Plaque sculptures is further varied and developed into the filigree constructions: *Man (Apollo), Reclining Woman,* and *Reclining Woman Who Dreams.*

In the fall, the art critic and later art-book publisher E. Tériade selects two works for the ambitious *Exposition internationale de sculpture* in the Galerie Georges Bernheim. In November and December the Galerie Wolfensberger in Zürich also exhibits Giacometti's *The Couple* in its exhibition *Producktion Paris 1929.*

1930

Man Ray introduces Alberto and Diego Giacometti to Jean-Michel Frank, a decorator who operates an extravagant interior-design studio. The Giacometti brothers design decorative objects for him: vases, standing lamps, and wall ornaments. Alberto also designs jewelry for the fashion designer Elsa Schiaparelli, and bronze andirons and a spidery wall relief for the banker Pierre David-Weill.

The most important patron of the Surrealists, the Vicomte Charles de Noailles, commissions a large sculpture from Giacometti for the garden of his summer residence, in Hyères on the Côte d'Azur.

In the spring Pierre Loeb presents the exhibition *Miró-Arp-Giacometti* in his gallery at 2, rue des Beaux-Arts. Giacometti's *Suspended Ball* causes a furor in the circle of André Breton, who visits the artist and urges him to join his Surrealist group. Up until the winter of 1931–32 and again in 1933 Giacometti takes part in their demonstrations and séances, but he never fully succumbs to Breton's doctrine.

In August, on an Alpine meadow in Maloja, he models three plaster stele figures as maquettes for Hyères. He inspects the site on his return journey to Paris and in December completes the model for the figures, now condensed into a single large statue.

1931

In May Giacometti signs the Surrealists' pamphlet against the *Exposition coloniale internationale.* From May 22 to June 6 the Galerie Pierre shows works of his in the exhibition *Où allons-nous?,* although Giacometti has terminated his contract with Pierre Loeb and is now represented by Pierre Colle.

In December, Giacometti's first published writing, "Objets mobiles et muets," appears in the third issue of Breton's journal *Le Surréalisme au service de la révolution,* along with Salvador Dalí's article on Surrealist objects inspired by the *Suspended Ball.*

1932

Giacometti turns toward the Surrealist left led by Louis Aragon, and until 1935 contributes a few class-warfare and anticlerical caricatures to the journals *La Lutte* and *Commune.*

In May the Galerie Pierre Colle mounts Giacometti's first one-man show. Picasso is among the first visitors. Christian Zervos devotes an article to Giacometti's sculptures in his journal *Cahiers d'art,* illustrated with several photographs by Man Ray.

For the Romanian countess Madina Visconti, Giacometti draws two views of his atelier, which present an overview of his work up to that time.

1933

In February and March Giacometti attends Surrealist meetings led by Breton and Paul Eluard; there the *Recherches expérimentales sur la connaissance irrationelle d'un objet* are

staged, as the report on them, with Giacometti's responses, states in the May edition of *Le Surréalisme au service de la révolution.*
On June 20 the Vicomte de Noailles purchases Giacometti's *The (Surrealist) Table* from the *Exposition surréaliste* at the Galerie Pierre Colle. Giacometti exhibits an enlarged version of *Cage* (1930) in the *VI Salon des Surindépendants.* The unwieldy construction is subsequently deposited on the balcony of Max Ernst's apartment, where it remains until it falls apart. Among the other exhibitors in the *VI Salon* are Hans Arp, Victor Brauner, Max Ernst, René Magritte, Joan Miró, Meret Oppenheim, Man Ray, and Yves Tanguy.
On June 25 Giovanni Giacometti dies in the Valmont clinic in Glion, above Montreux. Alberto and Diego arrive the following day. Alberto becomes ill and stays in the Bregaglia valley all summer. He loses his usual compulsion to work and his interest in Surrealist objects and constructions. Between the fall of 1933 and the spring of 1934 he creates his *Hands Holding the Void (Invisible Object), Head—Skull,* and *Cube (Nocturnal Pavilion).*

1934 ——————————
In the summer, Giacometti carves the stone for his father's grave in the San Giorgio Cemetery at Borgonovo: on the front is a relief with a bird and a star, on the back a torso of his father. In Maloja he attempts a last Surrealist figure: a tall hollow cone with the inscription "1 + 1 = 3."
In the fall, in Paris Giacometti begins to make realistic heads, both without and with models (his brother Diego and Rita Gueffier, a professional model).
The Surrealists consider this change to representation a betrayal. In late 1934 or early 1935 Giacometti is called to account by Breton at a group meeting and charged with disloyalty to Surrealism owing to his design work for Jean-Michel Frank. Giacometti abruptly walks out and leaves the Breton circle.
From December 1, 1934, to January 1, 1935, the Julien Levy Gallery in New York presents Giacometti's first exhibition in the United States, together with a Dalí exhibition. Among the twelve sculptures in marble, wood, and plaster are *No More Play* and *Hands Holding the Void (Invisible Object),* which is later acquired by Roberto and Patricia Mattà.
Giacometti loses most of his ties to Parisian Surrealist friends, although he does stay in contact with a few, among them Aragon. He turns to other artists: André Derain, Jean Hélion, and especially the young figural painters Balthus, Francis Gruber, Tal Coat, and Francis Tailleux.
In the spring he becomes acquainted with Isabel

Nicholas, a twenty-three-year-old Englishwoman, who becomes an important friend and model.
In the summer Ernst visits Giacometti in Maloja and works on stones naturally rounded by glaciers.

1936 ——————————
Alfred H. Barr, Jr., founding director of The Museum of Modern Art, New York, shows several of Giacometti's works in the landmark exhibition *Fantastic Art, Dada, Surrealism,* including *Disagreeable Object* and *The Palace at 4 A.M.,* which he acquires for the Museum.

1937 ——————————
Giacometti begins a conversation with playwright Samuel Beckett in the Café de Flore that continues during countless walks through the night in Montparnasse.
He visits Picasso in his atelier on the rue des Grands-Augustins, and they discuss his seemingly hopeless attempts to produce small-format sculptures of people seen from afar.
In Stampa, Giacometti produces two successful paintings, *Apple on a Sideboard* and *The Artist's Mother.*

1938 ——————————
Giacometti is involved in a traffic accident on October 18 in the place des Pyramides, in which his foot is broken. He fails to follow his doctor's advice to stay off his foot until the break is healed, and has a limp for the rest of his life. For a few years he occasionally uses a crutch, then a cane.

1939–41 ——————————
In 1939 Jean-Paul Sartre introduces himself to Giacometti in the Café de Flore. He and his companion Simone de Beauvoir find Giacometti to be a fascinating conversationalist and an artist "in search of the absolute," as Sartre will call his 1947 essay on Giacometti.
For the *Swiss National Exhibition* in Zürich, from May to October 1939, his brother Bruno negotiates commissions for two sculptures. But, instead, Giacometti shows his 1934 *Cube (Nocturnal Pavilion).*
At the outbreak of war on September 1, 1939, Alberto and Diego are in Maloja. On September 2 they report for duty in Chur, as the Swiss army is mobilized. Alberto is found to be unfit for military service. By mid-November he is back in Paris, and Diego joins him at the end of December. Peggy Guggenheim begins exhibiting and selling his works in New York.
On June 13, 1940, just before the arrival of the German *Wehrmacht* in Paris, Alberto, Diego, and Diego's companion Nelly decide to escape to the south—by bicycle. On June 14,

outside Etampes, they witness the bombardment of the city and the strafing of the line of fleeing refugees with machine guns from the air. On June 17 they reach Moulins, where the German advance catches up with them on the next day. They turn around and return to Paris on June 22.
In late 1940 and in 1941 Giacometti meets frequently with Sartre, Simone de Beauvoir, and Picasso.
On December 10, 1941, Giacometti applies for a visa to Switzerland to visit his mother in Geneva. He leaves Paris on December 31. Diego remains at the atelier in the rue Hippolyte-Maindron until September 1945.

1942–45 ——————————
Giacometti lives and works in Geneva. Initially he stays with his brother-in-law Dr. Francis Berthoud, the husband of his late sister Ottilia, who died in childbirth; his mother lives there as well, raising her grandson Silvio. Later he rents a sparsely furnished room without running water, making daily visits to his mother.
Giacometti produces drawings for little Silvio and has the boy model for him. His little figures and heads become smaller, the bases larger.
In the Café du Commerce Giacometti regularly encounters Albert Skira, who is building up an art-book publishing business in his hometown. From October 1944 to December 1946, Skira publishes the journal *Labyrinthe,* to which Giacometti contributes ideas, drawings, and articles. Skira also commissions the artist to make decorative vases for him. Other members of his regular circle at the café are the sculptor Hugo Weber; the painters Charles Rollier, Roger Montandon, and occasionally Balthus; the photographer Elie Lotar; the actor Michel Simon; the philosopher Jean Starobinski; and the writer Ludwig Hohl. The geologist Charles Ducloz becomes a close friend.
In October 1943, at a dinner in the Brasserie Centrale, he meets Annette Arm, who has just turned twenty. She is full of life and wishes to break free of her parents.
After Paris is liberated in the summer of 1944, Giacometti applies for the papers necessary for him to return to France, but he does not leave at first, then finally borrows the money for the trip from Annette and sets off alone.
On September 18, 1945, Giacometti returns to his atelier, and resumes work there.
In a café on the Champs-Elysées Giacometti soon runs into Isabel Nicholas, who has returned from London. They live together in a rented room in the rue Hippolyte-Maindron for three months. On December 25 she leaves him for good.

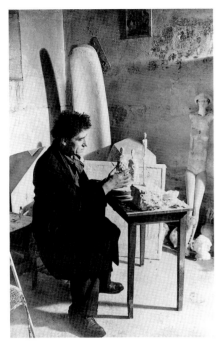
Giacometti in his studio in Paris, c. 1946

1946 ───────────────
In the winter of 1945–46 Giacometti again takes up his solitary work and his gregarious nightlife in Montparnasse and now Saint-Germain-des-Prés as well.

At first his sculpted figures continue to be tiny, but in February he has an intense experience while watching a movie, which raises his perception of people and things in space to the hyper-clarity of a vision.

By making drawings of passersby on the street he gradually finds his way to the elongated figures that characterize his mature style. Sixteen pages of reproductions in *Cahiers d'art* document this transition.

Projects for monuments initiated by Aragon, including one for Gabriel Péri, never advance beyond the design stage. Some of the new drawings are exhibited in the Galerie Pierre. For the Easter holidays Giacometti travels to Geneva, where he sees Annette. On July 6 Annette arrives in Paris, where she will stay. She gets to know Giacometti's friends and comes to terms with the primitive living conditions in the rue Hippolyte-Maindron.

1947 ───────────────
Giacometti's new concept of the figure coalesces into the so-called Giacometti style of sticklike forms: standing women in hieratic frontality, striding men as hieroglyphs of locomotion. Their rough modeling is developed in sculptures of body fragments.

Pierre Matisse offers to cast bronzes for a one-man exhibition and produce a catalogue. This

heightens Giacometti's productivity significantly. Toward the end of the year he retraces his artistic career in an eight-page autobiographical letter illustrated with sketches of his works.

1948 ───────────────
The new works can be seen for the first time in the Pierre Matisse Gallery in New York. The catalogue contains photographs by Patricia Mattà (soon to be Mrs. Matisse), Sartre's essay "The Search for the Absolute," and Giacometti's autobiographical letter, along with a list of works. The exhibition establishes Giacometti's postwar reputation outside Europe.

The first of his multifigured compositions is *City Square*.

Giacometti rents an additional room next to his atelier as a modest bedroom for Annette and himself. She now poses for him for hours at a time, mainly for paintings.

1949 ───────────────
The fame of the "new" Giacometti spreads across Paris. The dealer Pierre Loeb prevails on the artist to resume making etchings, some of them for the publications of his old friends Tristan Tzara and Georges Bataille. One of his new friends is the poet Olivier Larronde, whom he assists, as he does others, by contributing graphics for the luxury editions of his books. The mature style now begins to reveal itself in painting as well as in sculpture.

On July 19 Annette Arm and Alberto Giacometti are married at the registry office in the 14th arrondissement. Now Giacometti can take Annette with him on visits to his mother in Stampa and Maloja, where he continues to work from nature.

1950 ───────────────
The gallery of Aimé Maeght, under the artistic directorship of Louis Clayeux, offers him an exhibition in Paris. Giacometti creates a magnificent and varied series of compositions with single figures or figural groupings in different spatial situations.

Encouraged by the French commissioner for the Venice Biennale to show his work with that of Henri Laurens, Giacometti travels to Venice with several sculptures, planning to exhibit them in the French section. When he sees how Laurens's works are overshadowed by those of Ossip Zadkine, Giacometti packs up his figures and leaves.

At the instigation of old school friends from Schiers, Lucas Lichtenhan and Christoph Bernoulli, Robert Stoll presents fifteen sculptures, ten paintings, and twenty-five drawings by Giacometti in the Kunsthalle Basel in May,

in a joint exhibition with André Masson. The principal rooms are devoted mainly to Masson, which Giacometti accepts. With funds from the Emanuel Hoffmann Foundation, the Kunsthalle Basel buys *City Square* and two paintings.

In November a second show is presented at the Pierre Matisse Gallery in New York. It includes sixteen of the complex compositions from 1949 and 1950, all of which are now cast in bronze. These are sold, along with six paintings and a drawing. For the catalogue Giacometti writes the so-called "Second Letter to Pierre Matisse"; the comments on his works contained in this letter provide the basis for titles customarily used from this time on.

1951 ───────────────
Giacometti begins to search for a new direction in his sculpture by working on busts of Diego.

In June and July the postwar works are shown in Paris for the first time in the Galerie Maeght, establishing his fame in Europe as well. Aimé Maeght has Giacometti produce lithographs, in part for the gallery's journal *Derrière le miroir*. Most of them are depictions of his atelier with sculptures. Michel Leiris contributes the text "Pierres pour un Alberto Giacometti."

In November, on their way home from Stampa, Annette and Alberto Giacometti visit Henri Matisse in Nice and Picasso in Vallauris. Picasso and Giacometti have seen very little of each other since the war, and their meeting leads to an ugly encounter that ends their friendship. Giacometti declines an invitation from the Swiss Art Commission to show his work in the new Swiss pavilion at the 1952 Venice Biennale.

1952–53 ───────────────
In February 1952 the American writer James Lord meets Giacometti in the Café des Deux Magots. Lord's increasingly frequent visits to the artist's atelier and conversations with Giacometti's friends, as well as his friendship with Diego, give him an intimate knowledge of Giacometti's work and his private life. He keeps a journal about him and begins to collect material for the comprehensive biography he will publish in 1985.

Following the period of the important postwar sculptures of 1947–50, Giacometti turns to the task of modeling and painting portraits from life, rendering the models' heads as he sees them from a specific distance during hours of sittings. He is determined to get away from excessive thinness. He begins painting landscapes.

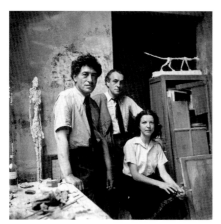
Alberto with Annette and Diego, c. 1952

Most exhibitions of twentieth-century art by now include works by Giacometti: in Paris (Musée d'art moderne), in Zürich (Kunsthaus), in Basel (Kunsthalle), and in the United States (Philadelphia Museum of Art, The Art Institute of Chicago, and The Museum of Modern Art, New York).
The Institute of Contemporary Arts in London devotes two symposia to discussions on Giacometti, the driving force behind them the knowledgeable art critic David Sylvester. Giacometti produces a portrait of him and also of the English art critic Peter Watson.
In September 1952 the Wittenborn Gallery in New York presents the first show of Giacometti's atelier lithographs, and in November 1953 the Arts Club in Chicago holds a one-man show.

1954 ——————————
In the spring the American steel magnate G. David Thompson, from Pittsburgh, visits Giacometti in his atelier. He has already purchased several Giacometti sculptures from Pierre Matisse for his huge collection of modern art, which includes groups of works by Matisse, Picasso, Fernand Léger, Miró, and Paul Klee. Now he hopes to put together the largest Giacometti collection anywhere, and if possible buy works from the artist himself. Giacometti lets him have original plaster models from the 1920s and 1930s.
Giacometti and the writer Jean Genet meet. Giacometti is fascinated by Genet's personality and adventurous life—also by his round bald head, which he draws and paints.
In May the Galerie Maeght holds its second Giacometti show, which contains new sculptures and drawings but also paintings, presenting the artist as an important painter as well as sculptor.
From June 30 to July 7 and again in September Giacometti stays with the bedridden Henri

Matisse in Nice. He draws numerous portraits of the lucid old man in preparation for a medal commissioned by the French mint. Matisse dies on November 3.

1955 ——————————
The first German museum exhibition devoted to Giacometti, comprising fifty-eight works, travels from Krefeld by way of Düsseldorf to Stuttgart. In June and July two extensive retrospectives are presented simultaneously, one by the Arts Council in London, organized by David Sylvester, the other by the Solomon R. Guggenheim Museum in New York.

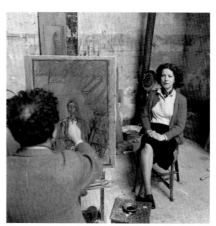
Giacometti painting Annette, 1954

On November 8, in the Café des Deux Magots, Giacometti meets with the Japanese philosophy professor Isaku Yanaihara, who has been asked to write an article on him for a Japanese journal. During Yanaihara's subsequent visits to the artist's atelier a close friendship develops between the two, one that will draw Yanaihara back to Paris each year (except 1958) until 1961.

1956 ——————————
For his show in the French pavilion of the Venice Biennale, Giacometti works on a standing female figure a little over 3½ feet tall, which he models in many different versions using the same armature and mass of clay. Diego casts each of them in plaster the following morning. Of the more than fifteen states of this Woman of Venice, nine will later be cast in bronze. In Venice, at the beginning of June, Giacometti sets up ten of these sculptures in two groups of four and six figures, along with six other sculptures.
He then travels to Bern for the June 16 opening of a retrospective of his work at the Kunsthalle organized by Franz Meyer.
In September Yanaihara sits for Giacometti for the first time, initially only for drawings and

paintings. During this visit Annette and Yanaihara become close as well. Yanaihara keeps a record of his encounters and conversations with the artist in his journal, on which he bases the Giacometti monograph he will publish in Tokyo, in Japanese, in 1958. He postpones his return to Japan for weeks.
Giacometti is unsatisfied with his painting and experiences a major "crisis" that continues until 1958.

1957 ——————————
Giacometti's dealers Aimé Maeght and Pierre Matisse arrange for the casting of numerous early works. He is now not only a world-famous artist but also a highly paid one. He passes along bundles of banknotes to his mother, his brother Diego, and various nighttime acquaintances, but allows his wife few luxuries. A second side room in the rue Hippolyte-Maindron is rented and a telephone installed. His own needs, the plaster-spotted clothing, and his habits do not change in the slightest. His first and only meal before midnight consists of hardboiled eggs and many cups of coffee in the early morning in the Café-Tabac Le Gaulois at the intersection of the rue d'Alésia and rue Didot. At night he has his own table in the Coupole.

1958 ——————————
Giacometti had been invited, in 1956, to create a sculpture for the new Chase Manhattan Plaza in New York, then under construction. The architect Gordon Bunshaft, of Skidmore, Owings & Merrill, visits him in Paris. It appears that he will be commissioned to create the open square sculpture, the Composition with Figures, that he has wanted to do for twenty-five years. He makes three roughly 4-inch-tall figures—a striding man, a standing woman, and a large head—and experiments with their placement on the architectural model.
Genet publishes Alberto Giacometti's Atelier, one of the most insightful texts about Giacometti and indeed about the work of any artist.

1959-60 ——————————
Giacometti executes full-size figures for the Chase Manhattan Plaza in several versions that are cast in bronze in 1960, but the commission has been withdrawn.
In the summer and fall Yanaihara is again Giacometti's constant model. In 1960 Giacometti also models portrait busts of him. Jacques Dupin and André du Bouchet are added to his circle of poet friends. In addition to graphics for their luxury editions he produces, between 1957 and 1960, fifty-two

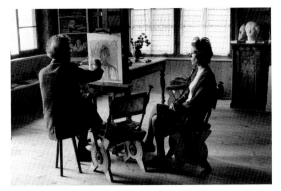
Giacometti and Annette in the studio in Stampa, 1960

etchings for Michel Leiris's *Vivantes cendres, innommées.*

In October 1959 Giacometti becomes acquainted with a twenty-one-year-old prostitute who calls herself Caroline in the bar Chez Adrien in the rue Vavin. Between 1960 and 1965 he will paint countless portraits of her that constitute the culmination of his new way of depicting reality. For Caroline's sake Giacometti endures in his last years any number of sordid experiences and lays out large sums of money. Their relationship is a trial for Annette and Diego.

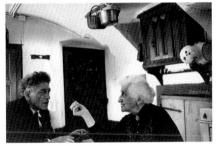
Giacometti and his mother in Stampa, 1961

1961 ————————————————

Samuel Beckett asks Giacometti to design the set for Jean-Louis Barrault's restaging of *Waiting for Godot* in the Théâtre de l'Odéon in Paris in May. After long discussions, Giacometti finally makes a barren plaster tree.

At the instigation of the publisher Tériade, Giacometti begins a large series of lithographs with views of his Paris milieu, his atelier, the streets, the cafés, and the driveway into the Mourlot printing house. It will finally be published in 1969 along with a text of his under the title *Paris sans fin.*

In August and September Yanaihara visits Paris for the last time.

In October Giacometti inspects the galleries in the main Venice Biennale building, where in the following year, by invitation and without any specific national affiliation, he will display his work as both sculptor and painter.

1962 ————————————————

The poet Jacques Dupin, who works for the Galerie Maeght, prepares a first monograph with Giacometti's help. Richly illustrated, it is published by Maeght in early May 1963, though dated 1962. Although Giacometti has given numerous interviews since 1951 and told the story of his career as a kind of autobiographical epic that has made him an almost legendary personality, he has heretofore resisted book publication.

At the beginning of June, Alberto travels with Diego to Venice to set up his individual exhibition at the Biennale. Alberto tirelessly revises the placement of the sculptures and changes the heights of their bases. He positions the figures of the Chase Manhattan Plaza grouping in such a way that they can be appreciated independently as well as in the ensemble *Composition with Figures.* As late as the night before the opening he paints certain sculptures to enhance their effect. Giacometti is awarded the state prize for sculpture, though he had hoped to be distinguished as both painter and sculptor with the Biennale's grand prize. Giacometti spends his summer weeks in Stampa, where his ninety-one-year-old mother can no longer leave the house. Here he produces his arresting portrait drawings of the old woman. A planned one-man show at the Tate Gallery is the occasion for a trip to London in the fall. Isabel Nicholas, now Mrs. Rawsthorne, introduces him to Francis Bacon, who has also painted her portrait.

The Basel art dealer Ernst Beyeler acquires the important collection of G. David Thompson,

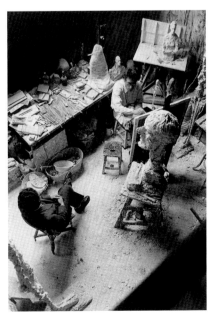
Giacometti painting Isaku Yanaihara, 1961

which in 1965 becomes the Alberto Giacometti Foundation.

In October in Paris Giacometti's stomach is X-rayed, which reveals that an ulcer has developed into a tumor. On December 2, despite his condition, Giacometti attends the opening of his retrospective at the Kunsthaus Zürich, arranged by his brother Bruno and the museum's director René Wehrli. With 300 works from fifty years it gives a full accounting of Giacometti's artistic achievement.

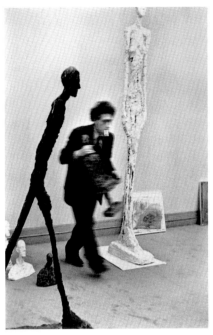
Giacometti at Galerie Maeght, Paris, 1961

1963 ————————————————

On February 6 Giacometti undergoes stomach surgery in Paris at the Rémy-de-Gourmont Clinic, then recuperates somewhat in the Hôtel L'Aiglon at 232, boulevard Raspail, where he can be more comfortable than in his atelier. He then travels to Stampa. On his return in April he passes through Milan, where he studies Michelangelo's *Rondanini Pietà.* Back in Paris, Giacometti not only resumes his daytime work but also his exhausting nighttime routines—including excessive smoking. He lives each day and undertakes each new work in the shadow of his expectation that the cancer might reappear and cause his death.

In February and March the Phillips Collection in Washington presents a Giacometti exhibition of fifty-four works.

From July to September, the 143 Giacometti works from the G. David Thompson Collection are shown in the Galerie Beyeler in Basel and formal steps toward establishing a public Swiss Giacometti Foundation are initiated.

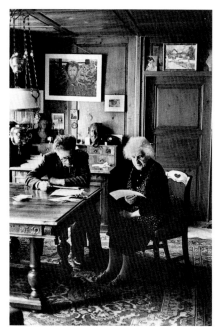

Giacometti and his mother in Stampa, 1964

1964

Giacometti spends the first weeks of January in Stampa. On January 25 his mother dies, with her family gathered around her.

Since the end of 1963, a new model has been a regular visitor to the Paris atelier, the photographer Elie Lotar. With him, Diego, and Annette as models, Giacometti works his way to the style of his last portrait busts.

When Giacometti reads in Sartre's autobiography, *The Words,* an inaccurate description of his own 1938 accident, the story of which he had repeatedly related to Sartre, he breaks off all contact with the writer.

In August he also breaks off his relationship with the Galerie Maeght out of solidarity with Louis Clayeux, the gallery's artistic director, who had been unfairly treated at the opening ceremonies of the Fondation Maeght in Saint-Paul-de-Vence on July 28. This museum near Nice, built by Josep Lluis Sert, contains an important collection of sculptures and paintings, and in its Giacometti Courtyard are the painted bronzes originally meant for the Chase Manhattan Plaza, arranged by the artist himself. From September 8 to 11 Giacometti sojourns in London, where the BBC records an interview with David Sylvester that will later be published.

From September 12 to October 1 Giacometti paints and repaints in eighteen sittings a portrait of James Lord, who photographs eleven of the various states of the painting and records their conversations. He will publish both in his 1965 *Alberto Giacometti: A Portrait.* In October Giacometti's examination at the Cantonal Hospital in Chur reveals that his cancer has not returned but that the artist is suffering from extreme exhaustion.

In November and December the Pierre Matisse Gallery in New York mounts the first exhibition devoted exclusively to Giacometti's drawings—with a catalogue text by James Lord.

1965-66

In his last sculptures of Diego and Elie Lotar, Giacometti mutilates the three-dimensional physicality of the busts but ennobles the heads with visionary gazes. The drawings for the book project *Paris sans fin* become a testimony to his life in Paris.

It is well known that Giacometti is in poor health. Offers of exhibitions, honors, publications, and requests for accompanying texts accumulate.

On June 9, 1965, The Museum of Modern Art in New York opens a comprehensive exhibition that continues until October 10, then travels to Chicago, Los Angeles, and San Francisco. On July 17 London's Tate Gallery opens the retrospective *Alberto Giacometti: Sculpture, Paintings, Drawings 1913–1965.* The artist visits this show and also the retrospective in the Louisiana Museum in Humlebaek, near Copenhagen. The Stedelijk Museum in Amsterdam exhibits Giacometti's drawings.

Giacometti in New York, 1965

In September, in Stampa and Paris, Ernst Scheidegger and Peter Münger shoot the film *Alberto Giacometti,* in which the artist paints a portrait of Jacques Dupin and talks with the poet while modeling an imaginary bust.

On October 1 Giacometti embarks on the *Queen Elizabeth* with Annette and Pierre and Patricia Matisse for New York. He not only visits his exhibition in The Museum of Modern Art repeatedly but also, at night, Chase Manhattan Plaza near Wall Street, where he positions Annette, Gordon Bunshaft, and James Lord in various groupings. He finally decides that the site would have been best served by a single standing female figure.

On November 20 the French state honors Giacometti with the Grand Prix National des Arts. At the end of November Giacometti is in Bern, where the university awards him an honorary doctorate and the Swiss president hosts a banquet in his honor.

On December 1, at the urging of Annette, Diego, and various close friends, Giacometti visits a Paris doctor, who insists that he be hospitalized immediately. Giacometti consents, and selects the hospital in Chur.

From December 2 to 4 Giacometti continues to work on busts of Elie Lotar and a painting of Caroline in his Paris atelier.

On December 5 he takes the night train from Paris to Chur, and checks himself into the hospital. Although tests do not show disease, he is treated for exhaustion and heart and circulatory problems. This assessment allows Giacometti to hope he will be able to return to Paris after a period of rest. He soon adapts to the hospital routine, talks on the telephone with his friends, and receives visits from his brothers, Annette, and Caroline; but before Christmas his condition worsens. On January 10, 1966, a pleural tap indicates a serious new diagnosis, pericarditis, an inflammation of the tissue surrounding the heart. Giacometti loses all interest in work and abandons his will to live. The next day Diego arrives from Paris. Once Giacometti sees all his relatives—Annette, Diego, Bruno and his wife Odette—and Caroline gathered around him, he recognizes that the end is near. At 10:00 on the evening of January 11, he dies of complications of pericarditis. On January 12 Diego takes the night train back to Paris for a day to heat the atelier in the rue Hippolyte-Maindron, thaw out the rags around the clay figure of Elie Lotar, and cast this last bust in plaster. He will place the bronze example on his brother's grave. On January 15 Alberto Giacometti lies in state in his studio in Stampa. His coffin is then carried through the frozen winter landscape by horse-drawn cart, followed by a long procession of mourners, to the cemetery in Borgonovo, where he was born. In addition to his relatives, many other people attend his funeral—people of the Bregaglia valley, representatives of cantonal and federal Swiss authorities and the French government, friends from Switzerland and Paris, and museum directors and art dealers from all over the world—and pay him their last respects.

Writings by Giacometti

(arranged chronologically)

Écrits/ Alberto Giacometti, edited by Michel Leiris and Jacques Dupin. Paris: Hermann, 1990, is the most complete source for Giacometti writings, bringing together texts published in diverse magazines, as well as letters and a selection of unpublished writings under the title *Carnet et feuillets*. Most of these texts appeared for the first time in Ernst Scheidegger, ed., *Alberto Giacometti: Schriften, Fotos, Zeichnungen*. Zürich: Verlag der Arche, 1958.

GIACOMETTI 1931
"Objets mobiles et muets." *Le Surréalisme au service de la révolution,* no. 3 (December 1931): 18-19. English trans. in Marion Wolf. "Giacometti as a Poet." *Arts Magazine* 48 (May 1974): 38-41.

GIACOMETTI 1933
"Poème en 7 espaces," "Le Rideau brun," "Charbon d'herbe," "Hier, sables mouvants." *Le Surréalisme au service de la révolution,* no. 5 (May 1933): 15, 44-45. Part English trans. in Lucy R. Lippard, ed., *Surrealists on Art.* Englewood Cliffs, N.J.: Prentice Hall, 1970.

"Recherches expérimentales sur la connaissance irrationelle de l'objet, sur les possibilités irrationnelles de pénétration et d'orientation dans un tableau, sur les possibilités irrationelles de vie à une date quelconque." *Le Surréalisme au service de la révolution,* no. 6 (May 1933): 11,12,14,17. [reply to questionnaires]

"Enquête: Pouvez-vous me dire quelle a été la rencontre capitale de votre vie? Jusqu'à quel point cette rencontre vous donne-t-elle l'impression du fortuit, du nécessaire?" *Minotaure,* nos. 3-4 (December 1933): 109. [reply to questionnaire]

"Je ne puis parler qu'indirectement de mes sculptures. . . ." *Minotaure,* no. 3-4 (December 1933): 46. English trans. by Ruth Vollmer and Don Gifford in "*1+ 1=3.*" *Trans/formation* 1, no. 3 (1953): 165-167. [on *The Palace at 4 A.M*]

GIACOMETTI 1934
"Le Dialogue en 1934." *Documents 34,* N.S. no. 1 (June 1934): 25. [André Breton and Alberto Giacometti]

GIACOMETTI 1945
"Un Sculpteur vu par un sculpteur." *Labyrinthe,* no. 4 (January 15, 1945): 3. [on Henri Laurens]

"A propos de Jacques Callot." *Labyrinthe,* no. 7 (April 15, 1945): 3.

GIACOMETTI 1946
"Le Rêve, le sphinx et la mort de T." *Labyrinthe,* no. 22-23 (December 15, 1946): 12-13. [text and four drawings]

GIACOMETTI 1948
[First] "Lettre à Pierre Matisse." In *Alberto Giacometti.* New York: Pierre Matisse Gallery, 1948, with an English trans. by Lionel Abel. [text with 35 sketches; written in 1947]

"Tentative Catalogue of Early Works." In *Alberto Giacometti.* New York: Pierre Matisse Gallery, 1948.

GIACOMETTI 1950
[Second] "Lettre à Pierre Matisse." Partially in *Alberto Giacometti.* New York: Pierre Matisse Gallery, 1950, with an English trans. by Lionel Abel. [12 sketches of works with texts]

GIACOMETTI 1952
"Un Aveugle avance la main dans la nuit." *XXe siècle,* no. 2 (January 1952): 71-72.

"Objets mobiles et muets," *XXe siècle,* no. 3 (June 1952): [after 68]. [new version of 1931 text]

"Gris, brun, noir. . ." *Derrière le miroir,* no. 48-49 (June-July 1952): 2-3, 6-7. [on Georges Braque]

"Mai 1920." *Verve* 7, no. 27-28 (December 1952): 33-34.

GIACOMETTI 1957
"Derain." *Derrière le miroir,* no. 94-95 (February-March, 1957): 6-7.

"Ma réalité." *XXe siècle,* no. 9 (June 1957): 35. English trans. by Lionel Abel in *Alberto Giacometti.* New York: Pierre Matisse Gallery, 1961. [reply to questionnaire]

"La Voiture démystifiée." *Arts-Lettres-Spectacles,* no. 639 (October 9-15, 1957): 1, 4.

GIACOMETTI 1959
" Assis parmi ses sculptures." *Tribune de Lausanne* (August 3, 1959). [on the death of Germaine Richier]

"Diderot et Falconet étaient d'accord." *Les Lettres françaises,* no. 758 (January-February 1959): 11.

"My Artistic Intentions." In *New Images of Man.* New York: The Museum of Modern Art, 1959.

GIACOMETTI 1962
"Comment parler de peinture aujourd'hui?" In *Gaston-Louis Roux.* Paris: Galerie des Cahiers d'art, 1962. [text on the printed invitation cards for the exhibition]

GIACOMETTI 1964
"31 Août 1963." *Derrière le miroir,* no. 144-146 (May 1964): 8-9. [homage to Georges Braque]

GIACOMETTI 1965
"Je viens d'apprendre avec grande peine. . ." *Neue Zürcher Zeitung,* no. 4951, November 21, 1965: 4. [homage to Gotthard Jedlicka]

GIACOMETTI 1966
"Notes sur les copies." *L'Ephémère,* no. 1 (winter 1966): 104-108. English trans. by Barbara Luigia La Penta in Luigi Carluccio, *Alberto Giacometti: A Sketchbook of Interpretive Drawings.* New York: Abrams, 1968.

"Tout cela n'est pas grand' chose." *L'Ephémère,* no. 1 (winter 1966): 102. [text from November 1965]

GIACOMETTI 1969
"Paris sans fin." In *Paris sans fin: 150 lithographies originales.* Paris: Tériade, 1969. [text from 1963, 1964, and 1965]

GIACOMETTI 1977
"A propos de 'La Jambe.'" In *Alberto Giacometti: Plastiken, Gemälde, Zeichnungen.* Duisburg: Wilhelm-Lehmbruck Museum, 1977. [text written February 13, 1960]

Monographs, Articles, Essays, and Dissertations

(arranged alphabetically by author)

BACH 1980
Bach, Friedrich Teja. "Giacomettis Grande Figure Abstraite und seine Platz-Projekte: Überlegungen zum Verhältnis von Betrachter und Figur." *Pantheon* 38, no. 3 (July-September 1980): 269-280.

BEAUMELLE 1997
de la Beaumelle, Agnès. "A l'occasion du Centenaire de la naissance d'André Breton, une nouvelle acquisition du Centre Georges Pompidou: Boule suspendue, 1930-1931, par Alberto Giacometti." *La Revue du Louvre et des Musées de France* 47 (February 1997): 19-20.

BEN JELLOUN 1991
Ben Jelloun, Tahar. *Alberto Giacometti & Tahar Ben Jelloun.* Paris: Flohic, 1991.

BERNOULLI 1973
Bernoulli, Christoph. *Alberto Giacometti 1901–1966: Erinnerungen und Aufzeichnungen.* Bern: Stuttgart-Vienna: Verlag Hans Huber, 1973.

BOEHM 1987
Boehm, Gottfried. "Das Problem der Form bei Alberto Giacometti." In Axel Matthes, ed., *Louis Aragon mit anderen: Wege zu Giacometti.* Munich: Matthes & Seitz/Galerie Klewan, 1987.

BOEHM 1990
Boehm, Gottfried. "Alberto, porträt-ierend." In *La Mamma a Stampa*. Zürich: Kunsthaus Zürich, 1990.

BONNEFOY 1991
Bonnefoy, Yves. *Alberto Giacometti: Biographie d'une oeuvre*. Paris: Flammarion, 1991. English trans., *Alberto Giacometti: A Biography of His Work*. Paris: Flammarion, 1991.

BONNEFOY 1991A
Bonnefoy, Yves. "Giacometti: Le problème des deux époques." *Connaissance des Arts*, no. 478 (December 1991): 60-77.

BONNEFOY 1998
Bonnefoy, Yves. *Alberto Giacometti*. Paris: Assouline, 1998.

BOUCHET 1969
du Bouchet, André. *Alberto Giacometti, dessins 1914-1965*. Paris: Maeght Editeur, 1969.

BOVI 1974
Bovi, Arturo. *Alberto Giacometti*. Florence: Sansoni Editore, 1974.

BREICHA/HOHL 1985
Breicha, Otto, and Reinhold, Hohl, eds. *Alberto Giacometti. Paris sans fin*. Salzburg: Rupertinum, 1985.

BRENSON 1974
Brenson, Michael Francis. "The Early Work of Alberto Giacometti: 1925-1935." Ph.D. diss., Johns Hopkins University, Baltimore, 1974.

BRENSON 1988
Brenson, Michael. "Giacometti's Woman with Her Throat Cut: A Disturbing Alliance.'" *New York Times*, January 3, 1988. [For a response to this article, see Rumsey Lee, "Eye to the Beholder: Giacometti's Alluring 'Woman.'" *New York Times*, February 7, 1988.]

BRENSON 1994
Brenson, Michael. "The Figure as Landscape: Giacometti's Postwar Sculpture.'" In *Alberto Giacometti*. New York: Aquavella Gallery, 1994.

BRETON 1934
Breton, André. "Equation de l'objet trouvé." *Documents* 34, N.S. no. 1 (June 1934): 17-24.

BUCARELLI 1962
Bucarelli, Palma. *Giacometti*. Rome: Editalia, 1962.

CARLUCCIO 1967
Carluccio, Luigi. *Alberto Giacometti: Le copie del passato*. Turin: Botero, 1967. English trans. by Barbara Luigia La Penta. *Alberto Giacometti: A Sketchbook of Interpretive Drawings*. New York: Abrams, 1968.

CARTIER-BRESSON 1991
Cartier-Bresson, Henri, and Louis Clayeux, *Alberto Giacometti fotografato da Henri Cartier-Bresson*. Milan: Sciardelli, 1991.

CHARBONNIER 1951
Charbonnier, Georges. "Entretien avec Alberto Giacometti." R[adio]T[élévi-sion] F[rançaise], Paris, March 3, 1951. Published as "[Premier] Entretien avec Alberto Giacometti." *Les Lettres nouvelles*, no. 6 (April 8, 1959): 20-27 and reprinted in *Le Monologue du peintre*. Paris: Juillard, 1959. [interview]

CHARBONNIER 1959
Charbonnier, Georges. "Le Monologue du peintre: Alberto Giacometti." R[adio] T[élévision] F[rançaise], Paris, April 16, 1957. Published as "[Deux-ième] Entretien avec Alberto Giacometti." In *Le Monologue du peintre*. Paris: Juillard, 1959. [interview]

CLAIR 1969
Clair, Jean. "Giacometti le sauveur." *La Nouvelle Revue Française*, no. 202 (October 1, 1969): 545-557.

CLAIR 1983
Clair, Jean. "Alberto Giacometti: La Pointe à l'oeil." *Cahiers du Musée national d'art moderne*, no. 11 (1983): 62-99.

CLAIR 1991
Clair, Jean. "Le résidu et la ressemblance, un souvenir d'enfance d'Alberto Giacometti." In *Alberto Giacometti: Sculptures, Peintures, Dessins*. Paris, Musée d'Art Moderne de la Ville de Paris, 1991. Reprinted in *Le résidu et la ressemblance, un souvenir d'enfance d'Alberto Giacometti*. Paris: L'Echoppe, 2000.

CLAIR 1992
Clair, Jean. *Le Nez de Giacometti: Faces de carême, Figures de carnaval*. Paris: Gallimard, 1992.

CLAYEUX 1990
Clayeux, Louis. "Notes sur Alberto Giacometti." *Cahiers du Musée national d'art moderne*, no. 31 (spring 1990): 5-13.

DALÍ 1931
Dalí, Salvador. "Objets surréalistes: Objets à fonctionnement symbolique." *Le Surréalisme au service de la révolution*, no. 3 (December 1931): 16-17.

DI CRESCENZO 1992
Di Crescenzo, Casimiro. "'On ne joue plus,' 1932, di Alberto Giacometti." *Venezia Arti*, no. 6 (1992): 134-138.

DI CRESCENZO 1994
Di Crescenzo, Casimiro. "From the Academy to the Avant Garde: Alberto Giacometti's Early Works in Paris (1922-1930)." In *Alberto Giacometti*. New York: Yoshii Gallery, 1994.

DI CRESCENZO 1996
Di Crescenzo, Casimiro. "Giacometti: Künstler und Revolutionär." In *Alberto Giacometti, 1901-1966*. Vienna: Kunsthalle, 1996. English trans. in the catalogue accompanying the exhibition at the Scottish National Gallery of Modern Art, Edinburgh.

DI CRESCENZO 2000
Di Crescenzo, Casimiro. "Dialoghi con l'arte: le copie del passato." In *Alberto Giacometti. Dialoghi con l'arte*. Mendrisio: Museo d'arte, 2000.

DIDI-HUBERMAN 1993
Didi-Huberman, Georges. *Le Cube et le visage: Autour d'une sculpture d'Alberto Giacometti*. Paris: Macula, 1993.

DRACH MCINNES 2000
Drach McInnes, Mary. "Alberto Giacometti, le féticheur." In *From Rodin to Giacometti: Sculpture and Literature in France 1890-1950*. Atlanta, Ga.: Rodopi, 2000.

DUFRÊNE 1991
Dufrêne, Thierry. *Alberto Giacometti: Portrait de Jean Genet, le scribe captif*. Paris: Editions Adam Biro, 1991.

DUFRÊNE 1994
Dufrêne, Thierry. *Alberto Giacometti: Les Dimensions de la réalité*. Geneva: Albert Skira, 1994.

DUFRÊNE 1994A
Dufrêne, Thierry. "Les 'places' de Giacometti ou le monumental à rebours." *Histoire de l'Art*, no. 27 (October 1994): 81-92, 106-107.

DUFRÊNE 1997
Dufrêne, Thierry. "'La Pointe à l'oeil' d'Alberto Giacometti, object à fonctionnement symbolique." *Iris*, special issue, "*L'Oeil fertile*" (Université de Grenoble) 3 (1997).

DUPIN 1954
Dupin, Jacques. "Giacometti, sculpteur et peintre." *Cahiers d'art*, no. 1 (October 1954): 41-54.

DUPIN 1962
Dupin, Jacques. *Alberto Giacometti*. Paris: Maeght Editeur, 1962. English trans. by John Ashbery, *Alberto Giacometti*. Paris: Maeght, 1962.

EVANS 1984
Evans, Tamara S., ed. *Alberto Giacometti and America*. New York: Graduate School and University Center, City University of New York, 1984.

FLETCHER 1990
Fletcher, Valerie J. "La pintura de Giacometti." In *Alberto Giacometti: Dibujo, escultura, pintura*. Madrid: Museo Nacional Centro de Arte Reina Sofia, 1990.

FLETCHER 1994
Fletcher, Valerie J. "Alberto Giacometti: The Paintings." Ph. D. diss., Columbia University, New York, 1994.

FLETCHER 1996
Fletcher, Valerie J. "Giacomettis Gemälde." In *Alberto Giacometti, 1901-1966*. Vienna: Kunsthalle, 1996.

FRITSCH 1981
Fritsch, Gerolf. "Alberto Giacometti: Kunst zwischen Begehren und Willen zum Wissen." *Das Kunstwerk* 34, no. 2 (1981): 45-52.

GENET 1958
Genet, Jean. *L'Atelier d'Alberto Giacometti*. Décines: L'Arbalète, Marc Barbezat, 1958. [text published partially in *Derrière le miroir*, no. 98 (June 1957): 3-26.]

GEORGE 1951
George, Waldemar. "Alberto Giacometti." *Art et Industrie*, no. 21 (July 1951): 25-27.

GIEDION-WELCKER 1959
Giedion-Welcker, Carola. "Alberto Giacomettis Vision der Realität." *Werk* 46, no. 6 (June 1959): 205-212.

GIEDION-WELCKER 1966
Giedion-Welcker, Carola. "Alberto Giacometti auf seiner Suche nach Wahrheit." *Das Kunstwerk* 20, nos. 1-2 (October-November 1966): 4-12.

GRAEVENITZ 1986
von Graevenitz, Antje. "De bedreiging van het oog: Obsessionele Zinne-beelden van Giacometti." *Archis*, no. 3 (1986): 11-16.

GRENIER 1982
Grenier, Jean. "Trois textes inédits: 'Alberto Giacometti vu par Sartre'; 'Un univers en expansion'; 'En souvenir de Giacometti.'" *Cahiers du Musée national d'art moderne*, no. 9 (1982): 32-35.

GRISEBACH 1987
Grisebach, Lucius. "Die Malerei." In *Alberto Giacometti*. Berlin: National-galerie, 1987.

HALL 1980
Hall, Douglas. *Alberto Giacometti's Woman with Her Throat Cut, 1932*. Edinburgh: Scottish National Gallery of Modern Art, 1980.

HOHL 1971
Hohl, Reinhold. "Giacomettis Atelier im Jahr 1932." *Du*, no. 563 (May 1971): 352-365. Partially reprinted in *Alberto Giacometti: Zeichnungen und Druck-graphik*. Tübingen: Kunsthalle, 1981.

HOHL 1972
Hohl, Reinhold. *Alberto Giacometti*. Stuttgart: Hatje, 1971. English trans., *Alberto Giacometti: Sculpture, Painting,*

Drawing. London: Thames & Hudson, 1972.

HOHL 1977
Hohl, Reinhold. "Odysseus und Kalypso: Der Mythus der existentiellen Impotenz bei Arnold Böcklin und Alberto Giacometti." In *Arnold Böcklin, 1827–1901.* Basel: Kunstmuseum, 1977.

HOHL 1987
Hohl, Reinhold. "Giacometti und sein Jahrhundert." In *Alberto Giacometti.* Berlin: Nationalgalerie, 1987.

HOHL 1988
Hohl, Reinhold. "What's All the Fuss About?: Giacometti and Twentieth-Century Sculpture." In *Alberto Giacometti, 1901–1966.* Washington, D.C.: Hirshhorn Museum and Sculpture Garden, 1988.

HOHL 1991
Hohl, Reinhold. "Ein Selbstdarstellung des jungen Alberto Giacometti," *Neue Zürcher Zeitung,* July 13-14, 1991: 62.

HOHL 1996
Hohl, Reinhold. "'Das Zeichnen ist die Grundlage aller Künste,' oder: Ist das Zeichnen die Grundlage von Giacomettis Kunst?" In *Alberto Giacometti 1901–1966.* Vienna: Kunsthalle, 1996.

HOHL 1998
Hohl, Reinhold. *Giacometti: A Biography in Pictures.* Ostfildern-Ruit: G. Hatje, 1998.

HOLLÄNDER 1971
Holländer, Hans. "Das Problem des Alberto Giacometti." *Wallraf-Richartz-Jahrbuch 33* (1971): 259-284.

HUBER 1969
Huber, Carlo. "Alberto Giacometti: 'Palais à quatre heures du matin' 1932." *Öffentliche Kunstsammlung Basel. Jahresberichte 1967–1973* (1974): 180-188. [text from 1969]

HUBER 1970
Huber, Carlo. *Alberto Giacometti.* Zürich: Ex Libris, and Lausanne: Editions Rencontre, 1970.

HÜTTINGER 1967
Hüttinger, Eduard. "Aspekte der Kunst Alberto Giacomettis." *Neue Zürcher Zeitung,* February 26, 1967: 4.

INBODEN 1987
Inboden, Gudrun. "Das Geschicht des Raumes Beobachtungen zum reifen Werk Alberto Giacomettis." In *Alberto Giacometti.* Berlin: Nationalgalerie, 1987.

JEDLICKA 1960
Jedlicka, Gotthard. *Alberto Giacometti als Zeichner.* Olten: Bücherfreunde, 1960.

JEDLICKA 1965
Jedlicka, Gotthard. *Alberto Giacometti. Einige Aufsätze von Professor Dr. Gotthard Jedlicka.* Zürich: Iniativ-Komitee für eine Alberto Giacometti-Siftung, [1965].

JULIET 1985
Juliet, Charles. *Giacometti.* Paris: Fernand Hazan, 1985. English trans. by Charles Lynn Clark, *Giacometti.* New York: Universe Books, 1986.

KESTING 1981
Kesting, Marianne. "Die Eternisierung der Fluktuation: Über den Prozess der Wahrnehmung bei Beckett und Giacometti." *Das Kunstwerk 34,* no. 2 (1981): 33-45.

KLEMM 1991
Klemm, Christian. "Überraschendes von Alberto Giacometti: Geschenke an die Alberto-Giacometti-Stiftung und eine neue Dauerleihgabe." *Kunsthaus Zürich, Zürcher Kunstgesellschaft. Jahresbericht, 1991:* 67-72.

KLEMM 1993
Klemm, Christian. "Alberto Giacomettis Meisterstück." *Kunsthaus Zürich, Zürcher Kunstgesellschaft. Jahresbericht, 1993:* 80-82.

KLEMM 1998
Klemm, Christian. "27 Bücher mit Zeichnungen von Alberto Giacometti." *Kunsthaus Zürich, Zürcher Kunstgesellschaft. Jahresbericht, 1998:* 83.

KOEPPLIN 1976
Koepplin, Dieter. "Alberto Giacometti (1901-1966). Les pieds dans le plat, 1933." *Jahresbericht der Gottfried-Keller-Stiftung 1973–1976* (1976): 181-195.

KRAUSS 1984
Krauss, Rosalind. "Giacometti." In *Primitivism in 20th Century Art.* New York: The Museum of Modern Art, 1984.

KRAUSS 1991
Krauss, Rosalind. "Sept Notes concernant le contexte de 'Boule suspendue.'" In *Alberto Giacometti: Sculptures, Peintures, Dessins.* Paris: Musée d'Art Moderne de la Ville de Paris, 1991.

LAKE 1965
Lake, Carlton. "The Wisdom of Giacometti." *Atlantic Monthly* (September 1965): 117-26.

LAMARCHE-VADEL 1984
Lamarche-Vadel, Bernard. *Alberto Giacometti.* Paris: Nouvelles Editions Françaises, 1984.

LAPORTE 1990
Laporte, Roger. "Giacometti ou la ressemblance absolue." In *Etudes.* Paris: POL, 1990: 113-146.

LEINZ 1997
Leinz, Gottlieb. "'Das Bein' von Alberto Giacometti: Erinnerungen an den Tod." *Pantheon 55* (1997): 172-188.

LEIRIS 1929
Leiris, Michel. "Alberto Giacometti." *Documents,* no. 4 (September 1929): 209-214. English trans. by James Clifford in *Sulfur 15* (1986): 38-40.

LEIRIS 1949
Leiris, Michel. "Contemporary Sculptors: VIII—Thoughts Around Alberto Giacometti." *Horizon 19,* no. 114 (June 1949): 411-417, trans. by Douglas Cooper. Reprinted in "Pierres pour un Alberto Giacometti." *Derrière le miroir,* no. 39-40 (June–July 1951): [n.p.].

LEIRIS 1978
Leiris, Michel. "Autre heure, autres traces. . ." In *Alberto Giacometti.* Saint-Paul-de-Vence: Fondation Maeght, 1978.

LEIRIS/DUPIN 1990
Écrits / Alberto Giacometti. Edited by Michel Leiris and Jacques Dupin. Paris: Hermann, 1990.

LORD 1955
Lord, James. "Alberto Giacometti: Sculpteur et peintre." *L'Oeil,* no. 1 (January 15, 1955): 14-20.

LORD 1965
Lord, James. *A Giacometti Portrait.* New York: The Museum of Modern Art, 1965.

LORD 1971
Lord, James. *Alberto Giacometti Drawings.* Lausanne: Paul Bianchini, 1971. French edition, *Dessins d'Alberto Giacometti.* Paris: Seghers, 1971.

LORD 1985
Lord, James. *Alberto Giacometti, A Biography.* New York: Farrar, Straus, Giroux, 1985.

LORD 1985A
Lord, James. "'Caresse,' 1932 d'Alberto Giacometti." *Cahiers du Musée national d'art moderne,* no. 15 (March 1985): 22-24.

LORD 1985B
Lord, James. "Sartre and Giacometti: Words Between Friends." *New Criterion 4,* no. 10 (June 1985): 45-55.

LORD 1996
Lord, James. "46, rue Hippolyte and After." In *Some Remarkable Men: Further Memories.* New York: Farrar, Straus, Giroux, 1996.

LUST 1970
Lust, Herbert C. *Alberto Giacometti: The Complete Graphics and 15 Drawings.* New York: Tudor, 1970. Reprinted as *Alberto Giacometti: The Complete Graphics.* San Francisco: Alan Wofsy Fine Arts, 1991.

MARTINI 1965
Martini, Alberto. "Alberto Giacometti: la poesia delle apparenze." *Arte antica e moderna,* no. 29 (1965): 25-38

MATTHES 1987
Matthes, Axel, ed. *Louis Aragon mit anderen: Wege zu Giacometti.* Munich: Matthes & Seitz/Galerie Klewan, 1987.

MATTER 1987
Matter, Herbert, and Mercedes Matter. *Giacometti.* New York: Abrams, 1987.

MAUR 1987
von Maur, Karin. "Giacometti und die Pariser Avantgarde bis 1935." In *Alberto Giacometti.* Berlin: Nationalgalerie, 1987. English trans., *Alberto Giacometti: Sculpture, Paintings, Drawings.* Munich/New York: Prestel, 1994.

MEGGED 1985
Megged, Matti. *Dialogue in the Void: Beckett and Giacometti.* New York: Lumen Books, 1985.

MELIS 1983
Melis, Paolo. "Architettura assai rara sulla terra: Giacometti's 'Palace at 4 A.M.'" *Domus,* no. 637 (March 1983): 24-29.

MEYER 1968
Meyer, Franz. *Alberto Giacometti: Eine Kunst existentieller Wirklichkeit.* Frauenfeld/Stuttgart: Huber, 1968.

MEYER 1991
Meyer, Franz. "Giacometti et Newman." In *Alberto Giacometti: Sculptures, Peintures, Dessins.* Paris: Musée d'Art Moderne de la Ville de Paris, 1991.

METZGER 1966
Metzger, Othmar. "Zur surrealistischen Plastik Femme couchée qui rêve von Alberto Giacometti." *Bulletin der Museen von Köln,* no. 3 (1966): 455-456.

MOULIN 1964
Moulin, Raoul-Jean. "*Giacometti: Sculptures.*" Paris: Hazan, 1964. English trans. by Bettina Wadia. New York: Tudor Publishing Co., 1964.

NADEAU 1945
Nadeau, Maurice. *Histoire du surréalisme.* Paris: Edition du Seuil, 1945. English trans. by Richard Howard, *The History of Surrealism.* New York: Macmillan, 1965.

NEGRI 1956
Negri, Mario. "Frammenti per Alberto Giacometti." *Domus*, no. 320 (July 1956): 40–48.

NEGRI 1969
Negri, Mario, and Antoine Terrasse. *Giacometti, Sculptures.* Paris: Hachette, 1969.

NOWALD 1977
Nowald, Karlheinz. "Notizen zu La Forêt." In *Alberto Giacometti: Plastiken, Gemälde, Zeichnungen.* Duisburg: Wilhelm-Lehmbruck-Museum, 1977.

PARINAUD 1962
Parinaud, André. "Entretien avec Giacometti: 'Pourquoi je suis sculpteur.'" *Arts-Lettres-Spectacles*, no. 873 (June 13–19, 1962): 1, 5. [interview]

POLEY 1977
Poley, Stefanie. "Alberto Giacomettis Umsetzung archaischer Gestaltungsformen in seinem Werk zwischen 1925 und 1935." *Jahrbuch der Hamburger Kunstsammlungen* 22 (1977): 175–86.

PONGE 1951
Ponge, Francis. "Réflexions sur les statuettes, figures et peintures d'Alberto Giacometti." *Cahiers d'art* (1951): 74–89.

PONGE 1964
Ponge, Francis. "Joca seria: Notes sur les sculptures d'Alberto Giacometti." *Meditations*, no. 7 (1964): 5–47.

RÉGNIER 1969
Régnier, Gérard. "Orangerie des Tuileries: Alberto Giacometti." *La Revue du Louvre et des Musées de France* 19, nos. 4–5 (1969): 287–294.

ROBINSON 1981
Robinson, Fred Miller. "'An Art of Superior Tramps': Beckett and Giacometti." *The Centennial Review* 25, no. 4 (fall 1981): 331–344.

ROTZLER/ADELMANN 1970
Rotzler, Willy, and Marianne Adelmann. *Alberto Giacometti.* Bern: Editions Hallwag, 1970.

ROTZLER 1982
Rotzler, Willy. *Die Geschichte der Alberto Giacometti-Stiftung: Eine Dokumentation.* Bern: Benteli, 1982.

ROWELL 1986
Rowell, Margit. "Giacometti." In *Qu'est-ce que la sculpture moderne?* Paris: Musée national d'art moderne, 1986.

SALZMANN 1977
Salzmann, Siegfried. "Käfig und Kasten im Werk von Alberto Giacometti." In *Alberto Giacometti: Plastiken, Gemälde, Zeichnungen.* Duisburg: Wilhelm-Lehmbruck-Museum, 1977.

SARTRE 1948
Sartre, Jean-Paul. "La recherche de l'absolu." *Les Temps modernes* 3, no. 28 (January 1948): 1153–1163. English trans.," The Search for the Absolute." In *Alberto Giacometti.* New York: Pierre Matisse Gallery, 1948.

SARTRE 1954
Sartre, Jean-Paul. "Les Peintures d'Alberto Giacometti." *Derrière le miroir*, no. 65 (May 1954); n.p. English trans. by Lionel Abel, "Giacometti: In Search of Space." *Art News* 54, no. 5 (September 1955): 26–29, 63–65.

SCHEIDEGGER 1958
Scheidegger, Ernst. *Alberto Giacometti: Schriften, Fotos, Zeichnungen.* Zürich: Verlag der Arche, 1958.

SCHEIDEGGER 1990
Scheidegger, Ernst. *Spuren einer Freundschaft, Alberto Giacometti.* Zürich: Verlag Ernst Scheidegger, 1990. French edition, *Traces d'une amitié.* Paris: Maeght, 1991.

SCHEIDEGGER 1994
Scheidegger, Ernst. *Das Bergell: Heimat der Giacometti.* Zürich: Verlag Ernst Scheidegger, 1994.

SCHNEIDER 1962
Schneider, Pierre. "Au Louvre avec Alberto Giacometti." *Preuves* no. 139 (September 1962): 23– 31. English trans., "At the Louvre with Giacometti." *Encounter* 26, no. 3 (March 1966): 34–39.

SCHNEIDER 1994
Schneider, Angela, ed. *Alberto Giacometti.* Munich: Prestel, 1994.

SOAVI 1966
Soavi, Giorgio. *Il mio Giacometti.* Milan: All'insegna del Pesce d'oro, 1966.

SOAVI 1973
Soavi, Giorgio. *Disegni di Giacometti.* Milan and Rome: Domus, 1973.

SOLDINI 1991
Soldini, Jean. *Il colossale, la madre, il sacro: L'opera di Alberto Giacometti.* Bergamo: Pierluigi Lubrina Editore, 1991.

SOLDINI 1998
Soldini, Jean. *Alberto Giacometti: La Somiglianza introvabile.* Milan: Jaca Book, 1998.

STOICHITA 1987
Stoichita, Victor I. "Die Hand, die Leere." In Axel Matthes, ed., *Louis Aragon mit anderen: Wege zu Giacometti.* Munich: Matthes & Seitz/Galerie Klewan, 1987.

SYLVESTER 1997
Sylvester, David. *Looking at Giacometti.* London: Chatto & Windus, 1994. Reprint, New York: Henry Holt, 1997.

TAMÓ 1991
Tamó, Miguela, Wanda Guanella, and Massimo Lardi. *Ricordando Alberto Giacometti nel venticinquesimo anniversario della morte.* Poschicavo: Edizioni Quaderni Grigionitaliani, 1991.

VANDERBEKE 1997
Vanderbeke, Birgit. "Alberto Giacometti: Schreitender Mann im Regen." *Du*, no. 678 (December 1997): 56–59.

VITALI 1963
Vitali, Lamberto, ed. *Quarantacinque disegni di Alberto Giacometti.* Turin: Einaudi, 1963.

WILSON 1993
Wilson, Sarah. "Paris Post War: In Search of the Absolute." In *Paris Post War: Art and Existentialism 1945–55.* London: Tate Gallery, 1993

WILSON 1993A
Wilson, Laurie. "Alberto Giacometti's Copies of Egyptian Art: The Louvre or Not the Louvre?" *Source Notes in the History of Art* 13, no. 1 (autumn 1993): 26–30.

YANAIHARA 1958
Yanaihara, Isaku. *Giacometti.* Tokyo: Misusu, 1958.

YANAIHARA 1962
Yanaihara, Isaku. "Pages de journal." *Derrière le miroir*, no. 27 (May 1961): 18–26.

YANAIHARA 1969
Yanaihara, Isaku. *Friendship with Giacometti.* Tokyo: Chikuma Shobo, 1969.

ZERVOS 1932
Zervos, Christian. "Quelques Notes sur les sculptures de Giacometti." *Cahiers d'art*, nos. 8–10 (1932): 337–342.

Selected Exhibition Catalogues

(arranged chronologically)

PARIS 1925
Palais de Bois, Paris. *Salon des Tuileries*, [November], 1925.

PARIS 1926
Palais de Bois, Paris. *Salon des Tuileries*, 1926.

PARIS 1927
Palais de Bois, Paris. *Salon des Tuileries*, 1927.

PARIS 1928
Salon de l'Escalier, Paris. *Les Artistes italiens à Paris*, February 3–March 2, 1928.

PARIS 1929
Galerie Georges Bernheim, Paris. *Exposition internationale de sculpture*, November, 1929.

PARIS 1933
Galerie Pierre Colle, Paris. *Exposition surréaliste*, June 7–18, 1933.

PARIS 1933A
Parc des Expositions, Porte de Versailles, Paris. *VI Salon des Surindépendants*, October 27–November 26, 1933.

NEW YORK 1934
Julien Levy Gallery, New York. *Abstract Sculpture by Alberto Giacometti*, December 1, 1934–January 1, 1935.

ZÜRICH 1934
Kunsthaus, Zürich. *Abstrakte Malerei und Plastik. Arp, Ernst, Giacometti, Gonzáles, Miró*, October 11–November 4, 1934.

LUCERNE 1935
Kunstmuseum, Lucerne. *Thèse, antithèse, synthèse*, February 24–March 31, 1935.

SANTA CRUZ DE TENERIFE 1935
Ateneo Santa Cruz de Tenerife. *Exposición surrealista*, May 11–21, 1935.

NEW YORK 1945
Art of This Century, New York. *Alberto Giacometti*, February 10–March 10, 1945.

NEW YORK 1948
Pierre Matisse Gallery, New York. *Alberto Giacometti*, January 19–February 14, 1948.

VENICE 1949
Giardino del Palazzo Venier dei Leoni, Venice. *Mostra di scultura contemporanea*, September 1949.

BASEL 1950
Kunsthalle, Basel. *André Masson, Alberto Giacometti*, May 6–June 11, 1950.

NEW YORK 1950
Pierre Matisse Gallery, New York. *Alberto Giacometti*, November 1950–January 1951.

PARIS 1951
Galerie Maeght, Paris. *Alberto Giacometti*, June 8–30, 1951. Catalogue published in *Derrière le miroir*, no. 39–40 (June 1951).

PARIS 1954
Galerie Maeght, Paris. *Alberto Giacometti*, May 1954. Catalogue published in *Derrière le miroir*, no. 65 (May 1954).

KREFELD 1955
Kaiser Wilhelm Museum, Krefeld. *Alberto Giacometti*, May 1–October 31, 1955.

LONDON 1955
Arts Council Gallery, London. *Alberto Giacometti*, June 4–July 9, 1955.

NEW YORK 1955
Solomon R. Guggenheim Museum, New York. *Alberto Giacometti*, June 7–July 17, 1955.

BERN 1956
Kunsthalle, Bern. *Alberto Giacometti*, June 16–July 22, 1956.

VENICE 1956
Padiglioni delle Nazioni [Francia] Venice. *XXVIII Esposizione Biennale Internazionale d'Arte Venezia*, June 16–October 21, 1956.

PARIS 1957
Galerie Maeght, Paris. *Alberto Giacometti*, June 1957. Catalogue published in *Derrière le miroir*, no. 98 (June 1957).

NEW YORK 1958
Pierre Matisse Gallery, New York. *Giacometti: Sculpture, Paintings, Drawings from 1956 to 1958*, May 6–31, 1958.

BERN 1959
Galerie Klipstein & Kornfeld, Bern. *Alberto Giacometti*, July 18–August 22, 1959.

SAINT-ÉTIENNE 1960
Musée d'art et d'industrie, Saint-Étienne. *Cent Sculptures de Daumier à nos jours*, spring 1960.

PARIS 1961
Galerie Maeght, Paris. *Alberto Giacometti*, May 1961. Catalogue published in *Derrière le miroir*, no. 127 (May 1961).

TURIN 1961
Galleria Galatea, Turin. *Alberto Giacometti*, September 29–October 25, 1961.

NEW YORK 1961
Pierre Matisse Gallery, New York. *Alberto Giacometti*, December 12–30, 1961.

VENICE 1962
Padiglione Centrale, Venice. *XXXI Esposizione Biennale Internazionale d'Arte, Venezia*, June 16–October 7, 1962.

ZÜRICH 1962
Kunsthaus, Zürich. *Alberto Giacometti*, December 2, 1962–January 20, 1963.

BASEL 1963
Galerie Beyeler, Basel. *Alberto Giacometti: Zeichnungen, Gemälde, Skulpturen*, July–September 1963. [book version, 1964]

WASHINGTON 1963
The Phillips Collection, Washington, D.C. *Alberto Giacometti: A Loan Exhibition*, February 2–March 4, 1963.

LONDON 1964
Arts Council for the Tate Gallery, London. *The Peggy Guggenheim Collection*, 1964.

LONDON 1965
Tate Gallery, London. *Alberto Giacometti: Sculpture, Paintings, Drawings 1913–1965*, July 17–August 30, 1965.

NEW YORK 1965
The Museum of Modern Art, New York. *Alberto Giacometti: Sculpture, Paintings and Drawings*, June 9–October 10, 1965.

BASEL 1966
Kunsthalle, Basel. *Giacometti*, June 25–August 28, 1966.

HANOVER 1966
Kestner-Gesellschaft, Hanover. *Alberto Giacometti: Zeichnungen*, October 6–November 6, 1966.

GENEVA 1967
Galerie Engelberts, Geneva. *Alberto Giacometti: Dessins, estampes, livres illustrés, sculptures*, March–April, 1967.

PARIS 1969
Galerie Claude Bernard, Paris. *Alberto Giacometti: Dessins (1922–1965)*, April 16–June 9, 1969.

PARIS 1969
Musée de l'Orangerie des Tuileries, Paris. *Alberto Giacometti*, October 24, 1969–January 12, 1970.

GENEVA 1970
Galerie Engelberts, Geneva. *Alberto Giacometti: Dessins, estampes, livres*, October 16–December 12, 1970.

ROME 1970
Académie de France, Villa Medicis, Rome. *Alberto Giacometti*, October 24–December 18, 1970.

MUNICH 1971
Staatliche Graphische Sammlung München, Munich. *Schweizer Zeichnungen im 20. Jahrhundert*, 1971–72.

LUGANO 1973
Museo Civico di Belle Arti, Lugano. *La Svizzera italiana onora Alberto Giacometti*, April 7–June 17, 1973.

NEW YORK 1974
Solomon R. Guggenheim Museum, New York. *Alberto Giacometti: A Retrospective Exhibition*, April 5–June 23, 1974.

PARIS 1975
Galerie Claude Bernard, Paris. *Alberto Giacometti: Dessins*, November 18, 1975–January 31, 1976.

DUISBURG 1977
Wilhelm-Lehmbruck Museum, Duisburg. *Alberto Giacometti: Plastiken, Gemälde, Zeichnungen*, September 17–November 27, 1977.

CHUR 1978
Bündner Kunstmuseum, Chur. *Alberto Giacometti, Ein Klassiker der Moderne 1901–1966: Skulpturen, Gemälde, Zeichnungen, Bücher*, October 22–December 3, 1978.

SAINT-PAUL 1978
Fondation Maeght, Saint-Paul-de-Vence. *Alberto Giacometti*, July 8–September 30, 1978.

PARIS 1979
Galerie Maeght, Paris. *Alberto Giacometti: Les Murs de l'atelier et de la chambre*, March 29–May 10, 1979. Catalogue published in *Derrière le miroir*, no. 233 (1979).

PARIS 1979A
Musée d'Art Moderne de la Ville de Paris. *L'Aventure de Pierre Loeb: La Galerie Pierre*, 1979.

PARIS 1980
Musée national d'art moderne, Paris. *Les Réalismes*, December 17, 1980–April 20, 1981.

TÜBINGEN 1981
Kunsthalle Tübingen. *Alberto Giacometti: Zeichnungen und Druckgraphik*, April 11–May 31, 1981.

PARIS 1984
Galerie Maeght, Paris. *Alberto Giacometti: Plâtres peints*, June 21–July 27, 1984.

ASCONA 1985
Museo Comunale d'Arte Moderna, Ascona. *Alberto Giacometti*, September 14–October 27, 1985.

NEW YORK 1985
Sidney Janis Gallery, New York. *Alberto Giacometti*, 1985.

PARIS 1985
Galerie Claude Bernard, Paris. *Alberto Giacometti: Dessins*, April 16–May 25, 1985.

CHUR 1986
Bündner Kunstmuseum, Chur. *Von Photographen gesehen: Alberto Giacometti*, January 25–March 31, 1986.

GENEVA 1986
Musée Rath, Geneva. *Alberto Giacometti: Retour à la figuration, 1933–1947*, July 3–September 28, 1986. Organized with the Musée national d'art moderne, Paris.

MARTIGNY 1986
Fondation Pierre Gianadda, Martigny. *Alberto Giacometti*, May 15–November 2, 1986.

BERLIN 1987
Nationalgalerie Berlin, Staatliche Museen Preussischer Kulturbesitz, Berlin. *Alberto Giacometti*, October 9, 1987–January 3, 1988.

DALLAS 1987
Museum of Art, Dallas. *A Century of Modern Sculpture. The Patsy and Raymond Nasher Collection*, April 5–May 31, 1987.

MEXICO 1987
Centro Cultural Arte Contemporaneo, Mexico. *Giacometti: Giovanni 1868–1933, Augusto 1877–1947, Alberto 1901–1966, Diego 1902–1985*, April–June 1987.

NEW YORK 1988
Claude Bernard Gallery, New York. *Alberto Giacometti, Drawings*, April 12–May 14, 1988.

WASHINGTON 1988
Hirshhorn Museum and Sculpture Garden, Smithsonian Institution, Washington, D.C. *Alberto Giacometti: 1901–1966*, September 15–November 13, 1988.

LONDON 1989
Thomas Gibson Fine Art Ltd., London. *Alberto Giacometti: Drawings, Paintings and Sculptures*, May–June, 1989.

ZÜRICH 1989
Kunsthaus, Zürich. *Alberto Giacometti: "Vivantes cendres, innommées,"* May 30–July 23, 1989.

BASEL 1990
Galerie Beyeler, Basel. *Alberto Giacometti*, June 8–September 30, 1990.

KIYOHARU 1990
Musée Kiyoharu Shirakoba, Kiyoharu. *Alberto Giacometti*, October 27–November 25, 1990.

LUGANO 1990
Pieter Coray Gallery, Lugano. *Alberto Giacometti: Disegni*, March 31–June 2, 1990.

MADRID 1990
Museo Nacional, Centro de Arte Reina Sofia, Madrid. *Alberto Giacometti*, November 15, 1990–January 15, 1991.

ZÜRICH 1990
Kunsthaus, Zürich. *La Mamma a Stampa: Annette—gesehen von Giovanni und Alberto Giacometti*, December 1, 1990–February 24, 1991.

PARIS 1991
Musée d'Art Moderne de la Ville de

293

Paris. *Alberto Giacometti: Sculptures, peintures, dessins,* November 30, 1991–March 15, 1992.

ANDROS 1992
Musée d'Art Moderne, Fondation Basil et Elise Goulandris, Andros. *Alberto Giacometti: Sculptures, peintures, dessins,* June 28–September 6, 1992.

LONDON 1993
Berggruen & Zevi Limited, London. *Alberto Giacometti: 26 Drawings from the Tériade Collection,* November 10–December 17, 1993.

SAINT-PAUL 1993
Fondation Maeght, Saint-Paul-de-Vence. *Collection de la Fondation Maeght: Un choix de 150 oeuvres.*

MALMÖ 1994
Konsthall, Malmö. *Alberto Giacometti: Skulpturer, Teckningar, Moelningar,* October 29, 1994–January 22, 1995.

MUNICH 1994
Galerie Klewan, Munich. *Alberto Giacometti: Zeichnungen,* 1994.

NEW YORK 1994
Yoshii Gallery, New York. *Alberto Giacometti. Early Works in Paris (1922–1930),* April 28–June 11, 1994.

NEW YORK 1994A
Acquavella Galleries, Inc., New York. *Alberto Giacometti (1901–1966): A Loan Exhibition,* October 27–December 10, 1994.

TOKYO 1994
Satani Gallery, Tokyo. *Alberto Giacometti and Isaku Yanaihara,* October 11–November 30, 1994.

BASEL 1995
Kunsthalle Basel. *Warum kopierte Alberto Giacometti ältere Kunst? Zu einigen Zeichnungen hauptsächlich im Kupferstichkabinett Basel,* 1995.

LUGANO 1995
Galleria Pieter Coray, Lugano. *La collezione di un amatore: Sculture, dipinti, disegni, grafica,* 1995.

MILAN 1995
Palazzo Reale, Milan. *Alberto Giacometti: Sculture, dipinti, disegni,* January 26–April 2, 1995.

VENICE 1995
Peggy Guggenheim Collection, Venice. *Le Sculture di Giacometti dalle Collezioni Guggenheim,* February–March 1995.

WOLFSBURG 1995
Kunstverein Wolfsburg. *Alberto Giacometti: Der ewige Jüngling. Grafik, Fotos, Gemälde, Plastiken,* 1995.

VIENNA 1996
Kunsthalle, Vienna. *Alberto Giacometti 1901–1966,* February 24–May 5, 1996.

MUNICH 1997
Galerie Klewan, Munich. *Alberto Giacometti: Zeichnungen, druckgrafische Unikate und Ergänzungen zum Werkverzeichnis der Druckgrafik von Lust,* 1997.

MUNICH 1997A
Kunsthalle der Hypo-Kulturstiftung, Munich. *Alberto Giacometti,* April 17–June 29, 1997.

SAINT-PAUL 1997
Fondation Maeght, Saint-Paul-de-Vence. *La sculpture des peintres,* July 2–October 19, 1997.

BERLIN 1998
Staatliche Museen Preussischer Kulturbesitz, Kuperstichkabinett, Berlin. *Linie, Licht und Schatten. Meisterzeichnungen und Skupturen der Sammlung Jan und Marie-Anne Krugier-Poniatowski,* 1998.

FRANKFURT 1998
Schirn Kunsthalle, Frankfurt. *Alberto Giacometti, 1901–1966: Skulpturen, Gemälde, Zeichnungen und Druckgrafik,* October 6, 1998–January 3, 1999.

MONTREAL 1998
The Museum of Fine Arts, Montreal. *Alberto Giacometti,* June 18–October 18, 1999.

STUTTGART 1998
Staatsgalerie Stuttgart. *Picasso, Klee, Giacometti: Die Sammlung Steegmann,* 1998.

SAINT-ÉTIENNE 1999
Musée d'art moderne, Saint-Étienne. *Alberto Giacometti,* March 23–June 27, 1999.

BOLOGNA 1999
Museo Morandi Bologna. *Alberto Giacometti: Disegni, sculture e opere grafiche,* June 25–September 6, 1999.

SINGAPORE 1999
Singapore Museum of Art. *Monet to Moore: The Millenium Gift of Sara Lee Corporation,* April 1–May 30, 1999.

ZÜRICH 1999
(Galerie) Art Focus, Zürich. *Alberto Giacometti: Ausgewählte Skulpturen, Gemälde und Arbeiten auf Papier. Mit einem Text von Jean Genet / A selection of Sculptures, Paintings and Works on Paper. With an essay by Jean Genet,* June 11–September 25, 1999.

CHUR 2000
Bündner Kunstmuseum, Chur. *Alberto Giacometti: Stampa-Paris,* 1999.

MENDRISIO 2000
Museo d'arte Mendrisio. *Alberto Giacometti: Dialoghi con l'arte,* September 17–November 12, 2000.

MILAN 2000
Fondazione Antonio Mazzotta, Milan. *I Giacometti: La valle, il mondo,* February 13–May 14, 2000.

PORTLAND 2000
Portland Museum of Art, Portland. *Alberto Giacometti,* 2000.

PARIS 2001
Musée national d'art moderne, Paris. *Alberto Giacometti: Le dessin à l'oeuvre,* January 24–April 9, 2001.

Collection Catalogues
(arranged alphabetically by city)

BASEL (COLL. CAT.) 1970
Öffentliche Kunstsammlung, Kunstmuseum Basel. Katalog 19./20. Jahrhundert. Basel, 1970.

BERN (COLL. CAT.) 1998
Werke aus der Sammlung Eberhard W. Kornfeld: Bern-Davos. Kirchner Museum, Davos, 1998.

CHUR (COLL. CAT.) 1989
Bündner Kunstmuseum Chur: Gemälde und Skulpturen. Chur, 1989.

COPENHAGEN (COLL. CAT.) 1994
European Art in the 20th Century: Catalogue Ny Carlsberg Glyptotek. Copenhagen, 1994.

DALLAS (COLL. CAT.) 1987
A Century of Modern Sculpture: The Patsy and Raymond Nasher Collection. Compiled by Steven A. Nash. Dallas Museum of Art, National Gallery of Art, Washington, D.C., 1987.

FRANKFURT (COLL. CAT) 1998
Das 20. Jahrhundert im Städel. Frankfurt, 1998.

LONDON (COLL. CAT.) 1981
Alley, Ronald. *Catalogue of the Tate Gallery's Collection of Modern Art other than Works by British Artists.* London, 1981.

NORWICH (COLL. CAT.) 1997
Robert and Lisa Sainsbury Collection: Catalogue in Three Volumes. New Haven, London, and Norwich, 1997.

PARIS (COLL. CAT.) 1981
100 oeuvres nouvelles, 1977–1981: Musée national d'art moderne, Paris, 1981.

RIEHEN/BASEL (COLL. CAT.) 1997
Fondation Beyeler. Munich/Riehen, 1997.

SAINT-ÉTIENNE (COLL. CAT.) 1999
Alberto Giacometti. La Collection du Centre Georges Pompidou, Musée national d'art moderne. Saint-Étienne, 1999.

SAINT-PAUL (COLL. CAT.) 1993
Collection de la Fondation Maeght: Un choix de 150 oeuvres. Saint-Paul-de-Vence, Fondation Maeght, 1993.

STUTTGART (COLL. CAT.) 1982
Staatsgalerie Stuttgart 20. Jahrhundert: Malerei und Plastik des 20. Jahrhunderts. Compiled by Karin von Maur and Gudrun Inboden. Stuttgart: Staatsgalerie, 1982.

STUTTGART (COLL. CAT.) 1999
Picasso und die Moderne. Meisterwerke der Staatsgalerie Stuttgart und der Sammlung Steegman. Stuttgart: Staatsgalerie, 1999.

VENICE (COLL. CAT.) 1985
Zander Rudenstine, Angelica. *Peggy Guggenheim Collection, Venice: The Solomon R. Guggenheim Foundation.* New York, 1985.

VENICE (COLL. CAT.) 1995
Le sculture di Giacometti dalle Collezioni Guggenheim. Compiled by Fred Licht. Collezione Peggy Guggenheim, Venice, 1995.

WASHINGTON (COLL. CAT.) 1974
The Hirshhorn Museum and Sculpture Garden, Smithsonian Institution, Washington, D.C. Compiled by Abraham Lerner. New York, 1974.

WASHINGTON (COLL. CAT.) 1980
The Morton G. Neumann Family Collection: Selected Works. Washington D.C.: National Gallery of Art, 1980.

ZÜRICH (COLL. CAT.) 1971
Die Sammlung der Alberto Giacometti-Stiftung. Compiled by Bettina von Meyenburg-Campell and Dagma Hnikova. Zürich: Kunsthaus, 1971.

ZÜRICH (COLL. CAT.) 1990
Die Sammlung der Alberto Giacometti-Stiftung. Compiled by Christian Klemm. Zürich: Zürcher Künstgesellschaft, 1990.